DISCARDED

PORTRAIT OF
DAVID HOCKNEY

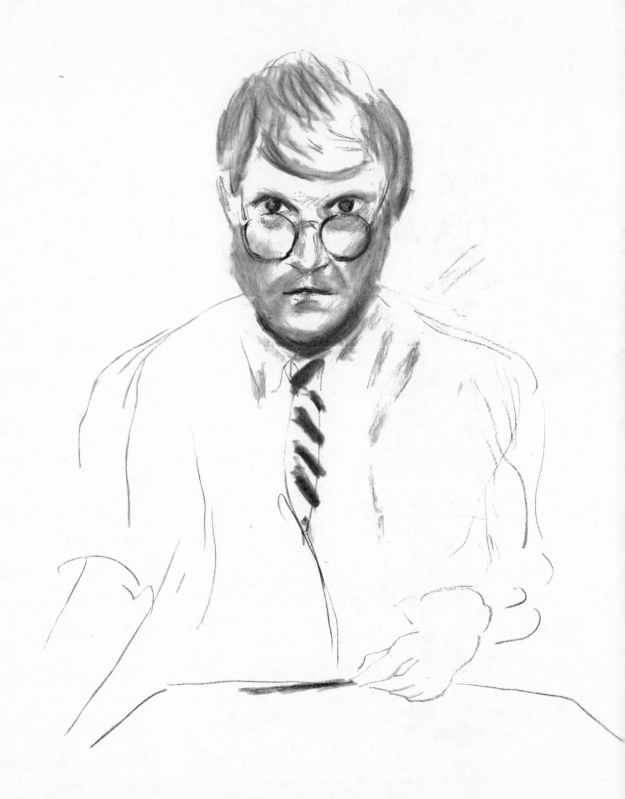

PETER WEBB

PORTRAIT OF DAVID HOCKNEY

E. P. DUTTON NEW YORK

By the same author

The Erotic Arts
Hans Bellmer

First published in the United States in 1989 by E. P. Dutton,
a division of Penguin Books USA Inc.,
2 Park Avenue, New York, N.Y. 10016.

Originally published in Great Britain
by Chatto & Windus.

Library of Congress Cataloging-in-Publication Data
Webb, Peter, 1941–
 Portrait of David Hockney.

 Includes bibliographical references.
 1. Hockney, David. 2. Artists—England—Biography.
I. Title.
N6797.H57W43 1988 760'.092 89-17203
ISBN: 0-525-24826-9

10 9 8 7 6 5 4 3 2 1

First American Edition

Endpapers. 'A Rake's Progress', Plate 1, *The Arrival*, 1963
Frontispiece. *Self-Portrait with Tie*, 1983

CONTENTS

ACKNOWLEDGEMENTS vii

FOREWORD ix

INTRODUCTION xi

CHAPTER ONE: Bradford 1937–1959 1

CHAPTER TWO: London 1959–1962 19

CHAPTER THREE: London 1962–1963 51

CHAPTER FOUR: America 1963–1967 63

CHAPTER FIVE: Europe and America 1967–1970 90

CHAPTER SIX: Europe, America and Asia 1970–1973 109

CHAPTER SEVEN: Paris 1973–1974 133

CHAPTER EIGHT: Europe, America and Australasia 1974–1977 147

CHAPTER NINE: New York and Los Angeles 1977–1980 170

CHAPTER TEN: America and China 1980–1983 194

CHAPTER ELEVEN: America, Japan and Mexico 1983–1985 213

CHAPTER TWELVE: Los Angeles 1985–1988 228

CONCLUSION 243

LIST OF ILLUSTRATIONS 247

NOTES 255

CRITICAL BIBLIOGRAPHY 267

INDEX 277

ACKNOWLEDGEMENTS

This book is not an 'authorized' biography with all that that entails. It has, however, been written with its subject's co-operation, and my first debt of gratitude must therefore be to David Hockney with whom I have had many long conversations over the years. I am also very grateful for all the help I have received from his family: his mother Mrs Laura Hockney, his sister Margaret, and his brother and sister-in-law, Paul and Jean.

I have been fortunate enough to have had valuable advice and useful information from Hockney's close friends Celia Birtwell, Ossie Clark, Gregory Evans, Ian Falconer, Henry Geldzahler, David Graves, the late Christopher Isherwood, Nathan Kolodner, John Kasmin, Ron Kitaj, George Lawson, the late Mo McDermott, Patrick Procktor, Vera Russell, Peter Schlesinger, Sir Stephen Spender, Ann Upton and Nick Wilder.

Other friends, acquaintances and colleagues of Hockney who have helped me in various ways include Lawrence Alloway, Ferrill Amacker, Billy Apple, Don Bachardy, Adrian Berg, Mark Berger, Claude Bernard, Peter Blake, Werner Boninger, Derek Boshier, the late Mark Boxer, Jim Bridges, Richard Buckle, Stephen Buckley, Margaret Burton, Thierry Cadet, Sir Hugh Casson, Patrick Caulfield, Tchaik and Melissa Chassay, Peter Cochrane, Paul Cornwall-Jones, John Cox, Michael Craig-Martin, Don Cribb, Aldo Crommelynck, Peter Crutch, Ken Cuthbert, Janet Deuters, John Dexter, Anthony Dowell, the late Lord Dufferin and Ava, André Emmerich, Sylvia Eyton, Sidney Felsen, John Fleming, Pauline Fordham, Michael Foreman, Raymond Foye, Betty Freeman, Ron Fuller, William Gaskill, Mark Glazebrook, Connie Glen, Peter Goulds, Lord Gowrie, Derrick Greaves, Roger de Grey, Ken Grose, Tom Hall, Richard Hamilton, Jack Hazan, Yves-Marie Hervé, Howard and Sam Hodgkin, Frank Johnson, Allen Jones, Jane and Aaron Kasmin, Peter Kaye, Michael Kullman, Pat Kurs, Eugene Lambe, Arthur Lambert, Mark Lancaster, the late Peter Langan, Jack Larson, Dante Leonelli, Marco Livingstone, John Loker, June Lyle, Mike McLeod, Robert Mapplethorpe, Don Mason, Gregory Masurovsky, Robert Medley, Robert Miller, Danny Moynihan, Yves Navarre, David Oxtoby, Maurice Payne, John Pearson, Lord Pembroke, Peter Phillips, John and Willow Prizeman, Morrie and Rita Pynoos, David Rand, Geoff Reeve, Johnny Reinhold, Cliff Richard, John Richardson, Tony Richardson, Doug Roberts, Philippine Rothschild, Charlie Scheips, Chris Scott, Fred Scott, Colin Self, Max Shepherd, Wayne Sleep, Richard Smith, Jerry Sohn, Derek Stafford, Nikos Stangos, Norman Stevens, Denis

Taplin, Rod and Brenda Taylor, Maurice Tuchman, Ted Tuersley, Alan Turner, Keith Turner, Ken Tyler, Mike Upton, Denise Vale, Mike Vaughan, Ken Wathey, Professor Carel Weight, Billy Wilder, Dr Patrick Woodcock, Bernard Woodward, Alfred Young and Brian Young.

For help in a variety of ways I am grateful to Victor Arwas, Andrew Bradford, David Cheshire, Mark Clements, Emmanuel Cooper, Lynn Creighton, Ian Darragh, Alison Douglas, Joe Fitchett, Beth Houghton, Charles Ingham, David Platts, Bernard Reynolds, Ron Serlin, Dr Robert Short, Gillian Thomas, Gray Watson, Tim Webb, Simon Wilson and Jonathan Wright.

The following gave me assistance with obtaining photographs: Stephen Abis, Ellie Angel, Mathew Bernstein of Waddington Galleries in London, Debra Burchett of Gemini Printers in Los Angeles, Cavan Butler of Hockney's office in London, Marabeth Cohen of Tyler Graphics in New York, Miriam da Costa of the Bernard Gallery in Paris, Michael Deakin, Janet Foreman, Sarah Fox-Pitt of the Tate Gallery Archives in London, Antoinette Godkin and William le Gallais of the Knoedler-Kasmin Gallery in London, Kathleen Gregg of the Architectural Press in London, Dennis Hopper, Isabelle King of the Whitechapel Gallery in London, James Kirkman, Charles Krewson, Karen Kuhlman of Hockney's office in Los Angeles, Dona Lebron of the Emmerich Gallery in New York, Jorge Lewinski, Richard Littlewood, Bob Marchant, Helen O'Neill of the Glyndebourne Opera Company in Sussex, Geoffrey Parton of Marlborough Fine Art in London, Caroline Porter of Sotheby's in London, Gerald Scarfe, John Sheeran and Caroline Krzesinska of the Bradford City Art Gallery, Juliet Simpkins of Madame Tussaud's in London, Jocelyn Stevens and Suzie Allen of the Royal College of Art in London, John Torson, and Lady Helen Windsor of Christie's in London.

I wish to record my gratitude to all those listed above, for without them I could not have written this book.

FOREWORD

I wrote to David Hockney on 1 January 1970. I was teaching at the Art College in Coventry, in the heart of Britain's industrial Midlands, and I felt the students desperately needed contact with the excitements of the London art scene. I had admired Hockney from afar, and I thought he would be the ideal person to wake the students from their lethargy. So I wrote to ask him if he would come and visit the college.

The reply came by return of post. 'I really don't think I'm a very good speaker, but if you really think your students would be interested in hearing me talk about my work I'll come. In any case, I'd like to see Coventry's new cathedral.'

There was no difficulty in recognizing the blonde hair and round glasses at Coventry Station, and he greeted me with 'Hello, I'm here. I don't think much of Coventry so far.' We drove to the cathedral and he looked intently at Graham Sutherland's enormous tapestry of *Christ in Majesty*. He much preferred the burst of light in John Piper's Baptistry window. 'That's great, I love it,' he said in his broad Yorkshire accent.

I had put up posters advertising David Hockney's talk, and collected together a sequence of slides of his work. He was surprisingly nervous and he told me he had never done anything like this before. I introduced him to a packed audience of staff and students, though it was hardly necessary, as he was already one of the best-known of the younger generation of British artists. I projected slides of his work and he talked about the images in an amusing and seemingly casual way which, in actual fact, gave a great deal of insight into his motivations and working methods. The students loved it and kept him talking and answering questions for two hours. As I drove him back to the station he was exhilarated. 'Was it OK? Are you sure I didn't go on too long? Do you think the kids enjoyed my stories about gay life in California?'

In the next week the Hockney lecture was the main talking point in the college. Everyone present seemed to have been captivated by him, even if they did not really like the work. I was inundated with queries as to why nothing substantial had been published on him, and where one could go to see his paintings. His influence was soon very apparent in the Fine Art Department, and there was enormous demand for places on the college trip to see his exhibition at London's Whitechapel Gallery a few months later. One student in the audience that day was particularly fired with enthusiasm. Many years later he became Hockney's Los Angeles dealer.

What particularly struck me about David Hockney's talk was his enormous ability to communicate, both through the work itself and through his discussion of the work. It was seemingly effortless, yet clearly the result of careful thought and total dedication. And he had so easily overcome his audience's suspicions of the seriousness of the whizzkid from the art world of London. His fresh, direct approach to the task of explaining how he made his art was a real eye-opener for the roomful of impressionable young art students. But, at the same time, it was obvious to me that there was more to David Hockney than the amusing raconteur or the charming *faux-naïf*. I felt that here was a real talent and a talent that would last.

Eighteen years have gone by since that January day in Coventry. David Hockney is now one of the best-known artists in the western world. Opinions differ as to the degree of success he has achieved, but no one can ignore his contribution to the art of the mid-twentieth century. During the intervening years I have kept in contact with him and I have frequently had the opportunity of watching him at work and of talking to him about his art and his ideas. Much has been published on him over the years, running the whole gamut from gossip-column tittle-tattle through expensive picture books to serious art criticism. Hockney's own autobiographical exercise, *David Hockney by David Hockney*, is a unique document which will never be replaced, and is one of the most readable and honest works of its kind. But it in no way gives a full and accurate picture of David's life up to the date of its publication in 1975, for it has too much of the feeling of a slide-show, which is in fact how it came into being, and it tends to ignore biographical details not directly related to specific images. Marco Livingstone's *David Hockney* of 1981 affords real insight into certain of his works, but by its very nature, as a strictly art-historical survey, it fails to catch the flavour of the man. Until now there has been no biographical study of the interrelations between David Hockney's life and work. It has been my intention in this book to tell the story of his life in order to illuminate his work and to evaluate his achievement. Because Hockney's life and work have been so closely interwoven since his college days, I set out to track down and interview about 150 people who have played important roles in his life from his earliest years. The recollections of these people together with already published material and my own interviews with David Hockney over the years have provided the framework for my examination of his work.

As he begins his second half-century with a major retrospective exhibition in America and Europe, it is perhaps a good moment for the interest kindled at Coventry many years ago to bear fruit in this first biographical study which will, I hope, cast new light on the life and work of David Hockney.

INTRODUCTION

David Hockney professed in his student days to see no point in the study of art history. Indeed he nearly failed to gain the RCA Diploma because of his lack of interest in the subject. Today he forms a part of that art history.

Every artist is a product of his time and his past, but for David Hockney the art of the recent past means much more than that of the present. Once having advanced from student enthusiasms, he has looked to two artists in particular for artistic and psychological guidance, for confirmation of his role as artist and communicator. These artists are Van Gogh and Picasso.

Van Gogh came from a dark northern country and moved south in search of the sun. David Hockney came from the north of England and moved to southern California where he found light and warmth. Like Van Gogh, he is aware of a dark side to his character, but he has found that his move south has enabled him to keep it out of his work. For David Hockney sees himself as a painter of joy rather than despair, an interpreter of Van Gogh's belief that 'the painter of the future will be a colourist such as has not yet been seen'.

In choosing to live in the south, David Hockney has followed the example not only of Van Gogh but also of Cézanne, Gauguin, Renoir, Matisse and Picasso. On his frequent visits to the south of France he has been thrilled to find the Provence of Van Gogh and Cézanne and the Alpes Maritimes of Matisse and Picasso come to life before his eyes, confirming him again and again in his belief that intense colour just cannot be found in colder climates such as England. But he is no slave to fashion, and he has chosen southern California as his south of France. That he, as a foreigner, has succeeded in creating an unforgettable image of his adopted home is one of his greatest achievements, an achievement he shares with Van Gogh.

David Hockney feels that the sun represents the light of the intellect and the warmth of sexuality, and Picasso would surely have agreed with him. Both artists have sought in their work a marriage of pleasure and intelligence, and it is this central theme that David Hockney also admires in Picasso's late and, until recently, little appreciated paintings and drawings. David Hockney was in fact one of the first to draw attention to the great achievements of Picasso's later years, and just as an appreciation of Cubism lay behind the younger artist's painterly and photographic experiments of the late seventies and early eighties, so Picasso's late paintings have inspired much of Hockney's most recent work.

David Hockney is perhaps the most truly popular serious contemporary artist; his popularity rivals that of Van Gogh and Picasso today. He is a communicator, and is almost as ready to use television or the written word as he is to communicate through his art. For his first television discussion of another artist's work he chose Van Gogh's *Café At Night*. More recently he has concentrated his attention on Picasso, who has been his subject in both television programmes and lectures. In his own book, *David Hockney by David Hockney*, he continually makes clear the debt he owes to forerunners such as Van Gogh and Picasso. In fact, he refers to over fifty artists, ranging from Uccello, Bosch and Michelangelo to Goya, Hogarth and Bacon, a clear enough indication that his awareness of the importance of art history has grown considerably over the years. To talk to him today is to realize that he is fully aware of his place in the history of twentieth century art.

PORTRAIT OF
DAVID HOCKNEY

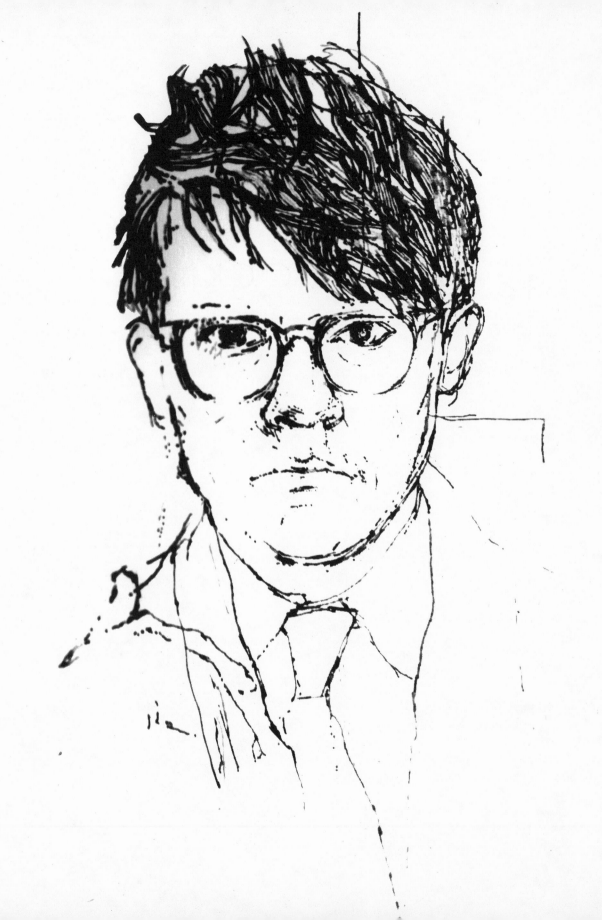

CHAPTER ONE

BRADFORD 1937–1959

Bradford is not an attractive city. Recent attempts to remove the grime and dirt of the nineteenth century have done little to alter the forbidding sense of alienation which a young and ambitious local art student would have felt thirty years ago. One of Bradford's most famous sons, David Hockney, was born at St Luke's Hospital on 9 July 1937, while his family were living at 61 Steadman Terrace. Twenty years later he left the Art College, and the city, and has never since thought of it as his home. This is not to suggest that he is in any way ashamed of his origins. He has retained his accent as well as his northern sense of humour and his down-to-earth realism. He has paid regular visits to his family over the intervening years. But as soon as he was able to think for himself, he knew that he must escape from Bradford if he was to make something of his life. He wanted to be able to live and to make a living on his own terms, from practising art. He is quite convinced today that the decision to leave Bradford was the first step along the road to achieving his present status as one of the best-known artists in the world.

Hockney came from what he described to me later as a 'radical working-class family'.[1] His maternal grandfather was a smartly-dressed man who drove a horse and cart through the streets of Bradford, picking up second-hand furniture which he sold in his little shop where his wife also sold sweets to local schoolchildren. The couple were officers in the Salvation Army until the local Citadel closed down and they joined the Methodist Church. They gave their five children a basic education at the local secondary school, and David's mother Laura has remained a practising Methodist and a strict vegetarian, teetotaller and non-smoker throughout her eighty-six years. His paternal grandfather was a dispenser for a doctor's surgery until he lost his job through excessive drinking. He then became a clerk in a club in his home town of Hull. David's father Kenneth was one of ten children, five of whom died young. He was a bright and talented young man who, no doubt, would have shone if he had had access to a good education. When he married Laura in the twenties, he settled in Bradford as an accountant's clerk, and one of the couple's first decisions was that their own children would have the best possible education.

Laura Hockney was from the start the real power in the marriage. She produced four sons and a daughter and exercised a strong influence on all of them, expecting regular attendance at the local Methodist Chapel and enforcing her and her husband's strict rules

Self-Portrait, c. 1955

of no smoking or drinking in the home. She did not attempt to impose vegetarianism on her family, although David flirted with it for a while, and she was quite prepared to cook meat for six people and a nut rissole for herself. She was a very loving mother, always ready to welcome and entertain her children's friends, and David has remained absolutely devoted to her. All the children were educated at local grammar schools, and all have made a success of their lives. Paul, the eldest, has his own accountancy business and is a former Lord Mayor of Bradford. Philip emigrated to Australia twenty-five years ago with a family but no job, and now runs his own highly-respected engineering company, making road tankers which he designs himself. Margaret is a qualified nurse with her own clinic of natural medicine in Bridlington. David is number four and his younger brother, John, is a successful designer and display artist in Australia.

If Laura Hockney was the home's power-source, Kenneth Hockney provided the character. His politics were radical and he supported various causes with real passion. He joined CND marches for which he made his own banners, and was a regular attender at local disarmament meetings as well as a subscriber to *Peace News*. He used to leave copies of the paper at strategic sites such as on Bradford buses or on benches in the city's public squares and parks. He wrote numerous letters to world leaders – Nasser, Stalin, Mao – pointing out the necessity of nuclear disarmament. During the war he was a conscientious objector, for which he was ostracized, and worked in an engineering factory. He later gave vigorous support to Sydney Silverman's anti-hanging Bill, and was invited to the House of Commons to see the final vote. Recalling his father's experience, he was a strong teetotaller, and he was an even stronger opponent of smoking. He used to hire a hoarding in Forster Square in the centre of Bradford and climb up a ladder to paint messages such as 'Ban Smoking' or 'Smoking Can Kill'. He would then sit in front of his handiwork giving out badges saying 'Don't Smoke'; in later life he wore a badge which read 'Non-Smoker and Healthy at 70'. For a while he refused to attend his chapel because he considered they were not strict enough about smoking.

Kenneth Hockney had a reputation in Bradford for being an eccentric, and he lived up to it, often to the embarrassment of his family. A favourite toy of his was an inexpensive portable tape recorder. He would record classical music and then insist on playing it at CND meetings in spite of the terrible quality of reproduction. He also had the habit of placing the recorder under his chair at home and drifting off to sleep to the noisy sounds of railway trains. At one time he decided to sell his portable billiard table and, not having a telephone, he included the number of the phone box at the end of the street in the advertisement. When David came home from school that day he was surprised to find his father sitting in a comfortable armchair beside the phone box waiting for calls. Kenneth Hockney was very careful about his appearance. He loved to wear a bow tie, and for variety would carefully apply gummed paper spots. He kept various boxes of false teeth

1 David Hockney as wolf cub, c. 1947
2 (clockwise from upper left) John, David and Kenneth Hockney, 1955
3 (clockwise from upper left) David, Margaret, Philip, Paul, Laura, Kenneth and John Hockney, 1976

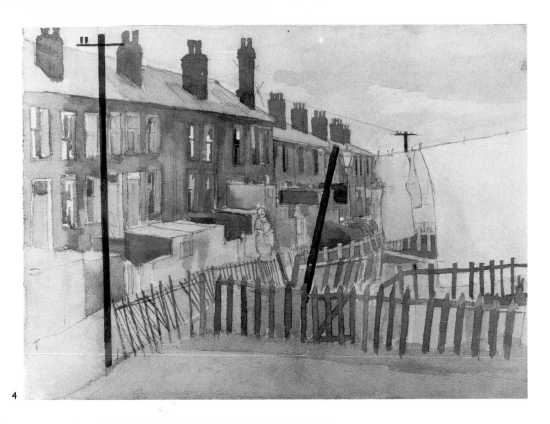

4

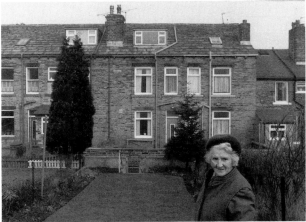

5

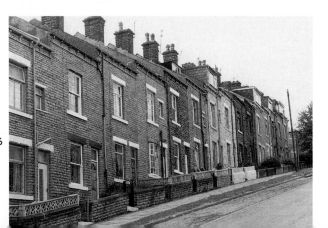

6

4 *Hutton Terrace, Bradford*, 1955
5 Laura Hockney outside Hutton
Terrace, 1985
6 Steadman Terrace, Bradford, 1987
7 *Bolton Junction*, 1956
8 *Bradford*, by Derek Stafford, 1954
9 *Rawson Square, Bradford*, by Frank
Johnson, 1955

David Hockney was born on 9 July 1937
while his family were living in Steadman
Terrace, Bradford. He spent the first
twenty years of his life among the
monochrome streets of this northern
city, mostly in Hutton Terrace in the
suburb of Eccleshill. His first artistic
efforts were scenes of this small area.
Note-book sketches in watercolour
were followed by more ambitious oil
paintings. The latter were strongly
influenced by the works of his teachers
at Bradford Art College, Derek Stafford
and Frank Johnson, scenes of the city in a
muted range of colours.

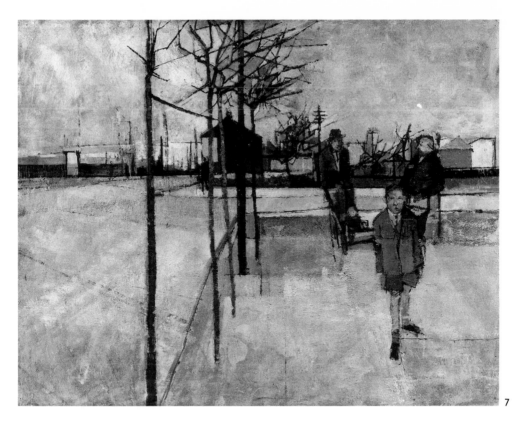

7

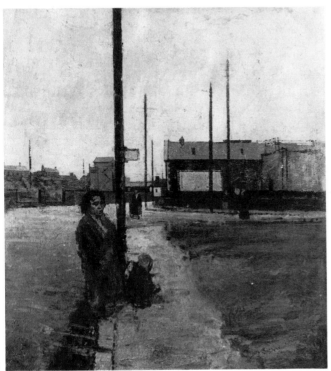

8

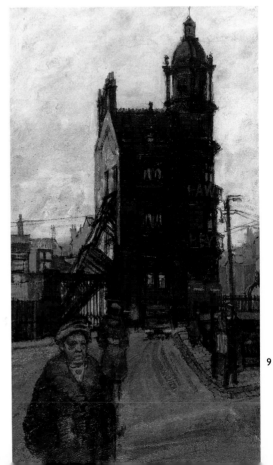

9

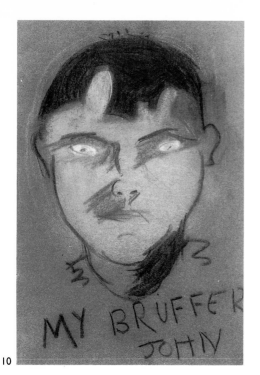

MY BRUFFER
JOHN

10

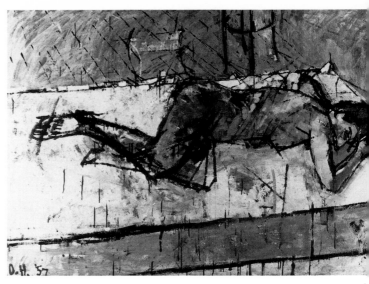

D.H. '57

1

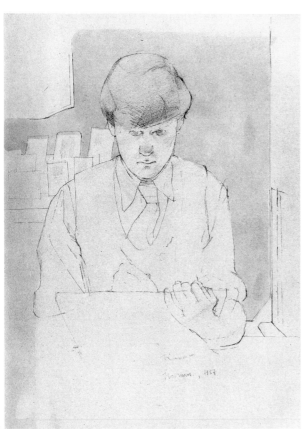

12

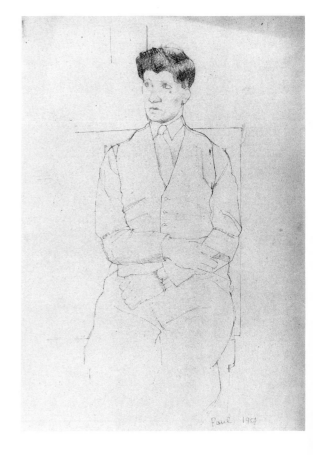

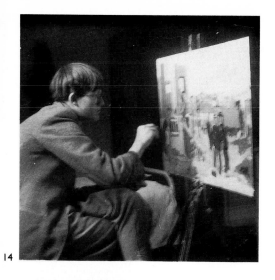

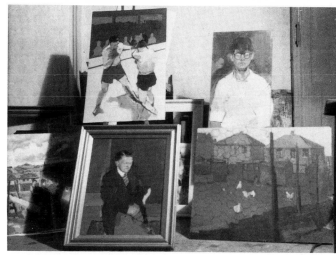

14

15

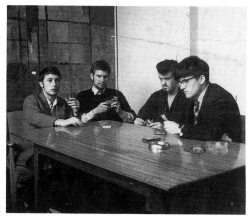

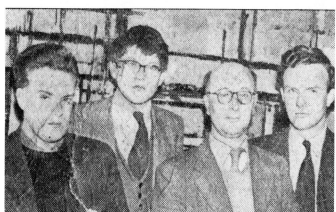

16

17

10 'My Bruffer John', c. 1950

11 *Nude*, 1957

12 *Norman Stevens*, 1954

13 *Paul Hockney*, 1954

14 Hockney painting in the attic at Hutton Terrace, 1954

15 Hockney's early oils, Hutton Terrace, 1954

16 (left to right) John Loker, Norman Stevens, David Oxtoby and David Hockney playing poker, Bradford Art College, 1956.

17 (left to right) David Fawcett, David Hockney, Frank Johnson and Derek Stafford, Bradford Art College, 1957

18 (left to right) David Hockney (wearing cap), Rod Taylor, John Loker, with poster, CND March, Aldermaston, 1958

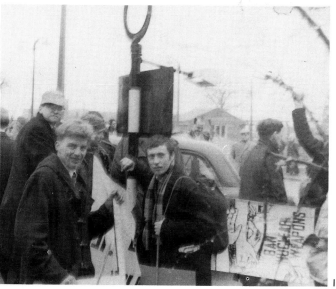

18

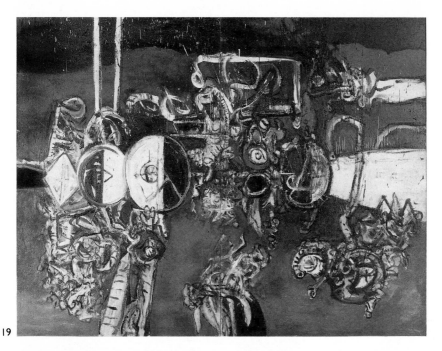

19

19 *Sacrifice*, by Alan Davie, 1956

20 *For the Dear Love of Comrades*, 1960

21 *Erection*, 1959

At the Royal College of Art in London Hockney was determined to abandon his Bradford manner for a more modern approach. Inspired by the British abstract expressionist painter Alan Davie, he created symbolic images with references to his own sexual development.

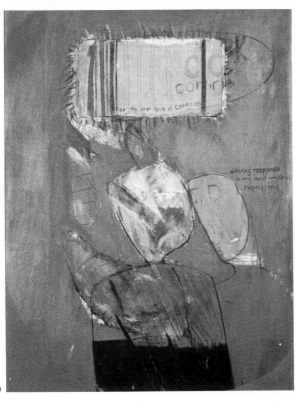

20

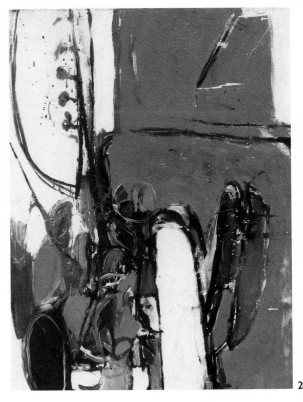

21

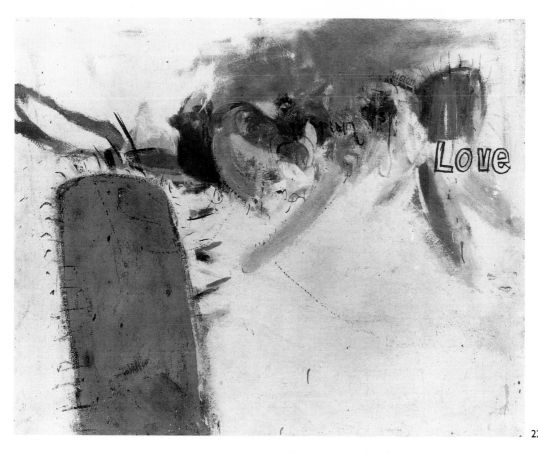

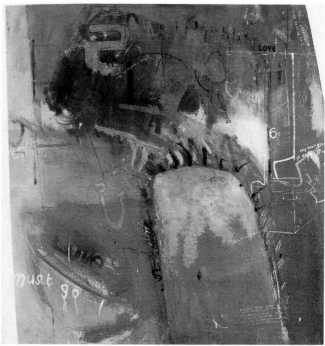

22 *The First Love Painting*, 1960

23 *The Third Love Painting*, 1960

At the end of his first year and the beginning of his second year at the RCA Hockney created a series of 'Love Paintings'. As he said, 'the source of all art, the source of all creativity, is "love".' These are colourful abstract images with strong phallic references as well as scribbled graffiti from public lavatories and carefully transcribed lines from a Whitman poem.

24

25

26

24 (clockwise from top left) Peter Phillips, David Hockney
and Peter Crutch at the Royal College of Art, 1961

25 *The Bradford Mafia at the Royal College of Art* (1960),
by David Oxtoby, 1976: (left to right) John Loker,
Norman Stevens, David Hockney, David Oxtoby,
Michael Vaughan, Douglas Binder

26 David Hockney in the RCA Christmas Revue, 1961

labelled 'best', 'second-best' et cetera, and would choose a pair according to the importance of the occasion. He possessed many different pairs of spectacles for the same reason. He always wore two watches, and when challenged on this point would answer, 'One is wrong'. He was very hard of hearing in later life and could choose from a variety of deaf aids. When visitors bored him he would turn down the volume and then ignore them unless David's name was mentioned, at which point he would suddenly come to life again. He was also a diabetic but took little interest in the special diet this necessitated. Laura Hockney had to pay special attention to this on his behalf, but when he was out alone he frequently forgot about his sugar intake. Often this caused him to collapse in the street and she would have frantic telephone calls from the local hospital.

At parties, Kenneth Hockney was in his element. At Christmas time he would always sing 'Why doesn't Santa Claus bring something to me?', and on other occasions he would regale his audience with an inimitable rendition of his favourite song, 'Little Willie Woodbine', complete with improvisations where he forgot the words. He loved plays and concerts and was a regular Saturday afternoon attender at Bradford's Alhambra Theatre, whether for music-hall, straight plays or grand opera, often taking David with him. He had attended evening classes at the local art school, and loved drawing and painting. He taught himself signwriting for his posters and street hoardings, and took great care in painting old bicycles and prams to look brand new, much to the young David's fascination. In about 1950 he decided to modernize the house by covering all the panelled doors with hardboard and then painting a sunset on each one. David thought they were wonderful.

It is easy to see the strong influence that Kenneth Hockney exerted on the development of his son David. In addition to the handicap of deafness, David inherited from him a commitment to peace and nuclear disarmament and a love of art, music, opera and theatre. Kenneth Hockney always gave David encouragement and taught him the value of enthusiasm. David learnt from his father to be an individualist, to be himself at all times. He was always grateful for his father's example and support. I asked him once what he had most valued in his father, and he replied: 'He taught me not to care what the neighbours think.'[2]

David spent the whole of his childhood in Bradford except for six months when the family were evacuated to Nelson in Lancashire during the war. Steadman Terrace was a row of very small terraced houses clinging to a hill, with a bath which doubled as a table in the kitchen, and an outside lavatory. The family used to push their washing down the hill in a pram to the public wash-house. In 1942 a bomb fell on the terrace, one of only a few to fall on Bradford. The family were sheltering under the stairs in a space only seven feet long. They heard the plane overhead; then there was a terrible explosion as the bomb fell. One of David's earliest recollections is the sound of his mother screaming. She was

nearest the door and felt the full blast. The family spent the night crammed into the tiny space, saying their prayers and reading from the Bible. In the morning they discovered that the bomb had fallen at the far end of the terrace and that their house was hardly damaged at all.

In 1943 the family moved to 18 Hutton Terrace in the Bradford suburb of Eccleshill. This was still only a terraced house, but it had an attic with two bedrooms, which was a great advance for the growing family of six people. They became regular members of the congregation at the Victoria Road Methodist Church, where David shocked his Sunday School teachers by making cartoon drawings of Jesus. A little later he would often be seen drawing on the fly-leaves of hymn-books during the sermon. When he became famous the books were checked but every drawing had been torn out. Norman and Nora Todd used to write little operettas for Sunday School entertainments, and all the Hockney children took part. In the late forties David won prizes at the Church eisteddfods for his drawings, and at Sunday School sing-songs and Scout gang shows he was much in demand for a speciality act. In his clean white shirt and smart grey shorts he would stand on the stage beside an easel on which were fixed sheets of shelf paper. At one show he would do lightning sketches of any member of the audience who chose to come forward. On another occasion he would draw caricatures of animals, such as the back view of a cow looking over its shoulder, while his brother Paul made the audience sing 'Old Macdonald Had a Farm', stamping his feet in time with the song.

During this period David and the other Hockney children attended the Wellington Road Primary and Junior School in Eccleshill, except for Paul who had gone to Bradford Grammar School. Money was tight: Kenneth Hockney's wages had risen from £3 a week before the war to £4.10s. in the forties, but it was not easy to feed and clothe the whole family on such an income. Nevertheless, David managed to visit the cinema regularly, always sitting in the cheapest seats, and his father took him to the Alhambra Theatre quite frequently. When he was about ten, he saw the Carl Rosa opera company's production of Puccini's *La Bohème*, which he loved, and this began a life-long infatuation with the world of opera. At this time he also filled a sketch-book with remarkably assured pastel drawings of clowns and historical figures and a portrait of 'My Bruffer John' (see plate 10). On their second-hand bicycles, painted to look brand new by their father, the Hockney children often went on day-trips in the Yorkshire Dales with their sandwiches and rolled mackintoshes. They would either buy fish and chips before riding home or spend their money on a train ride with their bicycles in the guard's van. On a trip to Grassington they stayed in a youth hostel near a luxury hotel, and David announced solemnly that one day he would be rich enough to stay at the hotel.

In 1948 David followed Paul's example and won a scholarship to Bradford Grammar

School, one of the best schools of its kind in the country, which could boast the famous artist Sir William Rothenstein among its former pupils. David's last primary school report read: 'David has done excellent work this year . . . I could do with more like him.' By this time he had decided that he wanted to be an artist, although he was not too clear what that entailed. The art he saw around him consisted of posters and Christmas cards, and he assumed that the paintings reproduced in books were spare-time activities done in the evenings. At Bradford Grammar School he found he had just one and a half hours a week for art, and this immediately became the one part of the curriculum he really enjoyed. When he discovered that he had to specialize in serious subjects like classics or science or modern languages, with no art at all from the second year onwards, he was furious until he realized that there was also a bottom form where art lessons were continued. He therefore horrified the scholarship authorities by failing all his tests to ensure relegation to the non-academic level. He knew there was a Regional College of Art in Bradford with a junior section, and in 1950 he asked to be transferred. However, the Director of Education insisted that he stay at the Grammar School to complete his general education before considering a specialization in art. David was angry at the decision. He already had a slight inferiority complex, since many of the pupils came from wealthy backgrounds, and his scholarship gave him, on top of his school fees, only five shillings a term for clothes and bus fares. He felt guilty at being a financial burden on his parents. Although perfectly capable of academic work, he continued to put all his efforts into art, thus receiving poor results and term reports in almost every other subject. He gained a reputation among the teachers for being frivolous, and stories about his school exploits are legion. Asked to write an essay on cricket, he handed in one page with four words: 'Wet day, no play.' When the Duke of Edinburgh addressed the school on Speech Day, the boys were told to look at him all the time. For the inevitable essay project which resulted, David wrote about getting a stiff neck from staring at the Duke from the end of the row. On a cross-country run, an activity he detested, he rode a bicycle for part of the course and won the race. Unfortunately a master had seen him from a passing bus, and there was a public announcement that he had been disqualified and would be punished by the Headmaster.

David's school-books provide evidence of how he spent his time at school. Mathematics lessons gave him the chance to draw the cacti in the maths room. His biology note-books contain the occasional class work such as 'Plan of Cricket Field Showing Types of Trees' or 'The Cell of the Canadian Pond-Weed' interspersed with pages of caricatures of teachers and fellow pupils. For another class he drew a procession of toys and young children made up of squares and circles, and the master wrote underneath: 'This is just silly. I said GEOMETRY'. But he also put his abilities to more useful ends. He won numerous ten-shilling prizes from the *Daily Express* Satchel Club for drawings, and

in 1952 he won second prize in an *Eagle* comic competition for an Ingersoll watch Christmas advertisement. The first prize was won by sixteen-year-old Gerald Scarfe, who was later to become the famous cartoonist. David also won a fifteen-shilling prize from a local wool-processing company, Airedale Combing, for his sketches resulting from a visit to their mill. In his spare time David was still a keen Boy Scout, and he took great trouble with his Scout note-books. One describes a trip to the Lake District in 1948, with amusing accounts of various incidents complete with photographs and sketches. Another is entitled 'Log Book of the Panther Patrol of the 4th Bradford East (Eccleshill Church) Troop, 1951, by Patrol Leader David Hockney'. This includes a visit to a Soap-Box Derby in Scarborough, a church bazaar, bonfire night and a Christmas party, each event being the subject of a cartoon drawing. At school, David received great encouragement from the art master, Reginald Maddox, and also from his English master, Kenneth Grose. To this day he remembers being introduced to Robert Herrick's poem 'Delight in Disorder':

> A sweet disorder in the dress
> Kindles in clothes a wantonness:
> A careless shoe-string in whose tie
> I see a wild civility:
> Do more bewitch me than when art
> Is too precise in every part.

The poem influenced his attitude to his own clothing from then on. In his autobiography David described an incident in his English class when he was asked for an essay he had failed to write. He had spent all his time on a collage self-portrait (see plate 27). 'He said where is your essay? Can I read it out? I had the collage with me for the art class and – I was, I suppose, a cheeky schoolboy – I said I haven't done the essay, but I've done this. And he looked at the collage, and he said Oh, it's marvellous. I was so taken aback because I expected him to say you terrible person.'[3] Kenneth Grose remembers David with affection: 'I liked art, and I found him an attractive and likable boy. I liked the unorthodox and felt no need to be strict. But it was very difficult to get any work out of him, and his spelling was terrible. He was by no means dumb, but he would do nothing willingly except draw. He could have ended his school career much higher academically if he had tried, but he would only make the effort for art.'[4]

Ken Grose edited the school magazine *The Bradfordian*, and often asked David for drawings. David used scraper-board for bold contrast in ambitious contributions such as local scenes and biblical illustrations, and made line drawings for cartoons which show the influence of newspaper artists such as Low, Giles and Heath Robinson. He enjoyed

'The Scouts Jumble Sale', c. 1952

making fun of the sports activities he so disliked, and he did a wonderful series of images to illustrate an article about a school lecture by the sculptor Reg Butler. The creator of *The Unknown Political Prisoner* described his working methods as involving welding machines and oxyacetylene burners rather than the usual chisels and clay, and David depicted him trying to explain this to the bemused schoolboys. He loved reaching an audience in this way, and he was especially proud of the posters he made for the Debating Society, the Art Club and the college dramatic productions. He was very pleased whenever anyone complimented him on an image they had seen on the noticeboards, which he thought of as exhibiting places. As he said later, 'That was the first time I had the opportunity to carry out my fantasy about being an artist.'[5]

In spite of his reputation for frivolity, David had great powers of concentration and a store of natural intelligence which enabled him to pass most of his GCE Ordinary Level examinations in 1953. Apart from Art, one of his best results was in English Literature,

where the question paper asked for a stage set for *Twelfth Night*. He had rather less good fortune with his weakest subject, French. Despairing at the questions, he wrote on the front page 'I'm afraid I know no French but will draw some pictures instead.' He failed the exam. During his last term, in the summer of 1953, he won the Art Prize, as he had done every year, and as he went to receive it there was a tremendous cheer from the whole school. He was a popular and much-liked character, and the Headmaster, Mr R. B. Graham, was sufficiently clear-sighted to see that he had a promising future ahead of him. He wrote on his last report: 'Best wishes to him in his new start. He will be glad to be rid of the "figure of fun" and to establish himself as a sincere and serious person by steady work and merit.'

David was determined to move straight into Bradford College of Art, but first he had to convince his parents. Their other children had had to find jobs immediately after leaving school. Paul had wanted to be an artist but had instead joined an accountancy firm. David was more devious. He took a folder to interviews with commercial art studios in Leeds, and when, as he expected, they told him to go to art college, he used this information to persuade his parents. Thus he enrolled at Bradford College of Art in September 1953 with a grant of a whole £40 a year.

He wanted to make a good impression on his first day at art college, so he tried to make himself look like a professional artist. He arrived wearing black jacket, white shirt, grey tie, brown moleskin trousers and brown boots, the ensemble being completed with a very long woolly red scarf, with his black hair combed forward in a fringe over his pale face. He was ushered into Frank Johnson's first-year anatomy class, and was considerably embarrassed to find himself standing next to a nude female model for the first time. Worse still, a voice boomed across the room: 'What's this fucking thing, a Russian peasant?' But he was soon made to feel at home among the group of students who had moved up from the junior department of the college: Bernard Woodward, Rod Taylor and Dave Oxtoby whose reference to a Russian peasant caused David to be known as 'Boris' throughout his four years at the college. The group was joined a year later by John Loker, Peter Kaye and Mike Vaughan. The art students had already heard of David: one of their tutors, Mr Whitehead, had also taught him at Bradford Grammar School, and he had told them of the brilliant schoolboy who was more talented than any of them.

The students at the college were divided into two groups, those who wanted a career in commercial art and those with GCE certificates who studied painting with the intention of becoming teachers. As David had declared his intention of becoming an artist, he was put into the commercial art course, but he soon realized this was not what he wanted and he asked to transfer to painting. When asked if he wished therefore to be a teacher, he explained that, on the contrary, he wished to be an artist. He was told that this was impossible without a private income, but he insisted and, since he had GCEs, he was

allowed to join the course that led to the National Diploma in Design, specializing in painting with lithography for the first two years and in painting alone for the last two. In the year ahead of him were two students who followed his example and moved back a year to join him as painters: David Fawcett, who was tragically killed in a plane crash in the late seventies; and Norman Stevens, who became David's closest college friend and later made a successful career as a prize-winning and widely collected artist and an Associate of the Royal Academy. The other students in David's group were specializing in graphic design since they did not have GCEs, and all were to meet with considerable success: John Loker and Mike Vaughan as professional painters exhibiting regularly in London and around the world; Dave Oxtoby as an artist specializing in the world of popular music and as the subject of the cult book *Oxtoby's Rockers* of 1978; Peter Kaye as Painting Lecturer at Norwich School of Art; Bernard Woodward as a commercial designer and consultant to companies in the Far East; and Rod Taylor as a weaver and proprietor of a craft centre in Yorkshire.

The teaching at Bradford College of Art was entirely geared to the two stages of the NDD, the Intermediate Examination which for David involved a life drawing, a figure composition and a lithograph, and the Final Assessment, for which a figure composition, a life painting and a life drawing had to be completed under examination conditions. The week was made up of classes in perspective, anatomy, life drawing, figure composition, lithography, and the occasional art history lecture. David was thrilled at the contrast with the Grammar School, and he so enjoyed the work that he used to stay on for evening classes which were provided for members of the public. The teaching was academic but not old-fashioned, and most of the staff were recent appointments. The Principal, Fred Coleclough, was really an administrator who favoured a commercial training leading to jobs in industry. He had little sympathy with students who wanted to paint. John Fleming was Head of the Department of Design and Painting, and from his experience of working with Frank Pick for London Transport, he favoured the design courses.

Fortunately for David, there were three painting tutors from whom he could obtain strong support and encouragement. Frank Lyle had worked with Harry Thubron and Tom Hudson at Leeds College of Art, where the new concept of a Foundation Course in Art and Design was being developed. Frank Johnson was a sympathetic and self-effacing painter from Leicester whose work showed the influences of Sickert and particularly the Euston Road school. Most important of all was Derek Stafford. He was only twenty-four and, after graduating from the Royal College of Art, he had spent a year fishing for mackerel at Mevagissey in Cornwall. He represented every painting student's romantic dream of the bohemian artist. He had a studio in North Parade near the college and remembers one day seeing David's inquisitive face peering in through the window. From then on, David and his friends were always welcome to visit him and watch him at work.

During this period he was exhibiting with Derrick Greaves, John Bratby and the Kitchen-Sink painters, the progressive group centred on the Beaux Arts Gallery in London who were trying to create a styleless art which reflected the realities of everyday life. He represented southern sophistication among the provincial painters of the north, and the students placed him on a pedestal. They would visit him for extra tutorials, and he also gave lively parties which further endeared him to the group. In the summer, he would take David and his college friends to Wharfedale for fishing and sketching trips.

The painting staff were vital links with the outside world. Frank Lyle invited tutors and artists from Leeds and Wakefield such as Harry Thubron, Tom Hudson, Terry Frost, Hubert Dalwood and Alan Davie to come and talk to the students, and Derek Stafford arranged trips to Edinburgh, London, Leeds and Wakefield to see the galleries and museums. All the painting tutors used David as a model, but only Frank Lyle's portrait has survived. Derek Stafford also encouraged David and his friends to aim for post-graduate courses at London art colleges. Hockney remembers him as the most important influence on his development at college, and he has a vivid recollection of David: 'He was the motivator for the whole group. He was a real hard worker, giving his work his total attention and effort. No other student put so much into his work as David, and yet he was an amusing character to have around as well. He was very impressive, one could tell he would go far.'[6]

The ideas promulgated in the painting department of the college were inspired by theories of Basic Design being taught at Leeds. Drawing was seen as a process of seeing and thinking rather than of imitation. The students were told to feel their way through the form, to make marks on the page or the canvas in order to take control of the surface, to use line and tone rather than colour to define space, and never to be precious about their pictures. A great deal of work has survived to demonstrate David's total involve-ment in the college painting course. An anatomy sketch-book from his first year contains studio drawings of the female life model as well as numerous sketches of skulls, skeletons, muscles and anatomical details. There are many life drawings in charcoal, pencil or wash, some of which show the dotted line technique favoured by artists such as Martin Froy, who came over from Leeds for a day's teaching from time to time. Sketch-books from 1954 and 1955 are full of quick studies of figures in the street, in bus queues, in cafés, at concerts or in college. There are Bradford street scenes, views of the station, lorry parks, caravan sites, sketches of David's home and of members of his family (see plates 4, 12, 13). One sketch-book contains scenes of various Yorkshire towns and villages, with careful annotations, plus drawings of figures with cycling gear and knapsacks, and notes of mileages from Hutton Terrace to each of the places visited. Another concentrates on self-portrait drawings, a project set by Derek Stafford. Sometimes David draws himself sitting opposite a mirror, including the reflection as

well, and at other times he concentrates with great seriousness on his face (see page xiv). A series of images shows him standing by a table wearing a black waistcoat and striped trousers. These are studies for his first lithograph, *Self-Portrait* of 1954, where he sits in front of the sideboard in his living room against the yellow striped wallpaper and purple patterned carpet, wearing his black waistcoat, white shirt, black and white tie and pinstriped trousers, with his arms folded and his National Health glasses and Russian peasant fringe. David did lithography as his subsidiary subject with Peter Parker, a strict disciplinarian who was concerned only with technique. David followed his self-portrait with *Woman with Sewing Machine*, for which his mother modelled, an image in six colours which makes great use of wallpaper patterns and fireplace tiling. He also made *Fish and Chip Shop*, an interior view of a place in Eccleshill which he visited frequently, depicting the proprietors serving a customer. He gave them a copy, which for many years hung on the wall getting covered in grease. In this same year, 1954, he also made a lithograph of a woodland scene in greens and reds entitled *Autumn*, which he submitted for his Intermediate Examination and for which he received a mark of 60 per cent. For Christmas he printed a card with an image of John Fleming's stripey cat, and he made about ten ceramics of the cat in 1955, one from the original mould with indented stripes which broke, and the rest from a second smooth mould (see plate 29). Each was painted differently before being fired. He worked with Bruce Adams in the Ceramic Department, and he also produced a plate with his self-portrait in the centre plus his name and the date 1955 inscribed around the edge. In the same year he made a linocut of Eccleshill Methodist Church for the cover of its centenary celebration booklet. He made no attempt at geometric exactitude, and some members of the congregation complained that the church looked as if it was falling down.

David's sketch-books and folders give interesting clues as to his artistic interests at this period. There are references to London exhibitions of work by Picasso and Stanley Spencer, copies of works by Degas (bronze *Dancer*) and Cotman (*Greta Bridge*) and numerous poster-colour compositions inspired by Sickert. David made posters for concerts, and also page after page of drawings in the concert hall with careful annotations: 'Second Bassoon, Hallé, Saturday 29th'; 'Beethoven's Symphony No. 1'; 'Listening to Sibelius'. He was keen to introduce his new friends to classical music, and he persuaded Norman, Peter, John and Rod to go with him to St George's Hall in Bradford to sell programmes so that they could attend the concerts of the Hallé Orchestra without paying. He would always sit as close to the platform as possible to have a good view for drawing. He told me recently: 'I have always responded to good music, it really moves me. I have never been able to play an instrument or read music, but I can't remember a time when I didn't like to listen to it, firstly on the radio and then at concerts. Live music was what I really loved. I had my free seat at St George's Hall all the way through my

time at college, and I would just sit and listen and draw. It was lovely.'⁷ He did not, however, manage to interest Bernard and Dave in the concerts. They were both rock and roll fans, and together with John they formed a skiffle group with Norman as their singer. They used to play at college parties in the Common Room where Bernard and Dave ran a soup-kitchen at lunchtimes. Some of the group used to play cards there during studio hours until John Fleming found out and made certain it was left locked up. Peter had painted a large abstract geometrical mural on the wall and he used to do signwriting for local shops to make extra money. He received a commission to paint a mural of a fairground in Daley's Bookshop in Bradford and got John and David to help him. They were paid £40 for the job. Later on, David and Norman and Dave painted a mural for the Ling Bob pub at Wilsden, near Bradford. The landlord hated it and refused to pay. Rod told him he was a fool since it would be worth a fortune one day, but it was soon covered over. The lads enjoyed a drink whenever they could afford it; their favourite pubs were the Coronation Bar, the Manville Arms, the Boar's Head and the Queen in Bridge Street, which was the subject of two Hockney linocuts. All had pianos, and Rod would play while David, if merry enough, would sing his favourite songs: 'I'm Looking Over a Four-leafed Clover' and 'Bye Bye, Blackbird'.

 David's group of student friends in painting and graphic design were all male. Girls at the college tended to study dressmaking or window-display. Although most of the group had girlfriends, they tended to stick together as 'the boys' inside and outside college. David's sexuality was rather a mystery to them all. He was very friendly with two college girls, Barbara and Terri, and was known to take bus rides over the moors to visit a girl called Shirley. At a party in the studio one evening, his friends tried to pair him off with a girl called Ruth without any success. He did not seem turned on by any of the girls he knew, but nobody thought anything of it.

By the time David had passed his Intermediate Examination and started the last two years of his course, he had, as at school, become known as 'a real character'. He had decided to model himself on Stanley Spencer, the eccentric English religious artist still living at this time in Cookham. His brother Paul was doing his National Service with the RAF at Maidenhead, and David persuaded him to visit Spencer. Paul told me about it later: 'I knocked on Spencer's door and a little chap, unkempt, dirty, really in need of a good wash, appeared. He was wearing little National Health glasses and looked a real mess. I explained that my brother was an artist and admirer, and he invited me in. The house was a tip. There was rubbish and papers and pictures and oil paints and brushes everywhere. You could hardly move. He was really eccentric and reminded me of my Dad. He was painting *Christ Preaching at Cookham Regatta*, a massive painting which he told me he had already spent five years on. I got his autograph for David.'⁸

David was eager to hear about Spencer from Paul, and he imitated the painter by walking about wearing a bowler hat and long woolly scarf, in a heavy black overcoat with drooping shoulders, carrying an old umbrella and pushing a pram containing his painting materials. When Paul was at home, David would ask him if he was coming to the bus stop with him in the morning, and Paul would answer 'Not yet,' because he was embarrassed at the way everyone stared at David in the street. In the mid-fifties, no one in Bradford had seen anything quite like it. But David took no notice at all.

On at least two occasions, when out painting with the group, he asked everyone to give him a tanner to jump in the canal. Each time he jumped in fully-clothed and wearing his bowler hat, climbed out again, went home to change, returned to collect his sixpences and carried on painting. On another famous occasion, Rod Taylor bought some large old portraits from the Bradford Liberal Association and sold them to his fellow students as cheap canvases. They splashed lead white paint all over them, a cheap way to prepare them but dangerous since the paint is poisonous. But John Fleming discovered them and told the caretaker to dump them outside in the rain, as he would not allow the students to use large canvases. David was so angry that he sat on the bonnet of Fleming's car when he tried to drive home and made him agree to the canvases being returned. David's passions were also aroused by nuclear weapons. He had followed his father's example and joined the Campaign for Nuclear Disarmament. He would go to political lectures at the Mechanics Institute and, together with Rod, Peter, Dave and John, he would go on Aldermaston anti-nuclear marches (see plate 18). The group designed political posters at Rod Taylor's father's house, with David usually drawing the image (for example, a man's hand holding a baby) and the others adding the lettering (in this case, 'His future is in your hands'). They would screen-print them in the cellar, to Mr Taylor senior's concern, since he daily expected the house to be raided by the police.

During their last two years at college, David and his friends worked in bread factories in the summer and for the Post Office at Christmas in order to supplement their grants. One expense was regular trips to London. Sometimes they would hitch-hike, but usually they bought a day-return train ticket at half past midnight on Saturday morning, arriving in time for breakfast and a day's visits to Bond Street galleries and the Tate. They saw shows of Picasso, Bacon, Soutine, Kokoschka, Magritte, Dubuffet, the Kitchen-Sink school, Stanley Spencer and Roger Hilton. In the evenings they would go to the cinema before catching the midnight train home. On other occasions they would hitch-hike to Leeds or Wakefield where they saw the work of Alan Davie and Norman Adams. Davie's work would influence Hockney later on. Frank Johnson and Derek Stafford used to exhibit at the Royal Academy Summer Exhibitions, and in 1957 they persuaded David Hockney and David Fawcett to submit pictures. Both were successful, and Hockney's entry was a painting entitled *Mount Street, Bradford*. The local paper, the

Bradford Telegraph & Argus, ran a story on the achievement of the art college in having four Royal Academy successes, complete with a photograph of the artists posing in front of Peter Kaye's mural (see plate 17). In the same year, David had two paintings accepted for the Yorkshire Artists' Exhibition held at Leeds Art Gallery. One was *Post Office Road, Eccleshill* and the other *Portrait of My Father* (see plate 28), which was sold for £10, David's first sale. He celebrated by standing all his friends a drink at the pub next day, telling them, 'I've just sold my Dad.' In the early 1970s Norman Stevens visited Bernard and Rose Gillinson in Leeds and saw the painting on their wall. He met Denis Healey, the Labour politician and local M P, there, who proudly declared that he had attended the same school as David. The Gillinsons had bought the portrait at the suggestion of their friend Frank Lyle. When it came on the market some years later, Hockney bought it back and has it hanging in his studio to this day.

David had begun painting seriously in oils after his intermediate Examination in 1955, although he had experimented earlier with a painting of a vase of flowers on a Winsor and Newton canvas board costing 2s. 4d. in 1951. This had been followed in 1954 by a self-portrait, a picture of two boxers, a view of a hen-run at the back of Hutton Terrace and a scene of council houses being built at Thorpe Edge near his home (see plates 14, 15). During the second half of the painting course, students were encouraged to go out and examine their environment rather than concern themselves with what they thought constituted 'Modern Art'. Since Bradford was black and white and murky green and grey, these were the colours they were encouraged to use. Matisse and Bonnard were thought to be an irrelevance to such an activity; instead, the students were instructed to pay attention to Sickert's sense of atmosphere and use of tone and to Mondrian's concern with interval. *Portrait of My Father* was what David called his first serious painting, an exercise in tonal values rather than colour. His father was very concerned that it should turn out well, and rigged up an arrangement of mirrors so that he could monitor its progress. Whenever he criticized David for not using enough colour, back came the reply that 'This is how they paint at the Art School.'[9]

During the next two years, David made a series of paintings of the area of Bradford where he lived. He would wheel his pram, full of his painting materials, out into the streets, choose a good vantage point, set up his easel and start work, often on an old canvas he had found in a junkshop. A few days later he would take the painting into college for Derek Stafford's advice or approval. Most of the pictures depict the little streets of Eccleshill, but sometimes he would venture a little further to Idle or Apperley Bridge to the north, and to Fagley or Undercliffe to the south. The paintings show neat little Victorian terraces or slightly grander, semi-detached houses in a muted range of colours giving the monochrome feeling of atmosphere so characteristic of the area (see

plate 7). There is clear reference to the Bradford scenes painted by Derek Stafford and Frank Johnson at the same period (see plates 8, 9), and they in turn owe something to the influence of the Euston Road school, an influence prevalent in English art schools in the fifties. Particular to Hockney, however, is the care with which he concentrated on one small area of suburban Bradford, trying to capture the essence of a few square miles.

David's progress during these two years can be seen from comparing Eccleshill images of similar format and design. Two views of the spot where Bolton Road meets Idle Road at Bolton Junction are conventional topography and show the limited tonal range and careful use of interval characteristic of his paintings of 1955 and 1956. But a comparable view of Norman Lane at Bank Top dating from 1957 concentrates on a sign reading 'Danger Road Works', a red warning lamp on a metal stand and two workmen bending over a brazier, which together create an almost abstract design of lines and shapes in the centre of the composition. A similar concern with more adventurous experimentation can be seen in two other large canvases of 1957, a full-length portrait of Kenneth Hockney and a reclining nude depicting the college model Moira posing in the studio beside an electric fire (see plate 11). David is here trying to simplify the forms and reduce them to their essentials, a progressive move from exact representation towards a more sophisticated approach to style.

In the summer of 1957 David took the National Diploma in Design Examination. Six hours a day for a week he worked on the reclining nude painting of Moira and a series of life drawings, and these were submitted together with scenes of Eccleshill and its surroundings. He received a First Class Diploma with Honours, and the nude painting was chosen for inclusion in a touring exhibition of art school work. He had already sent a folder of work to the Slade School of Art and the Royal College in London and had been chosen for interview at both. On the way to the Slade one of his teeth fell out, and he sat through the interview with his mouth full of blood. The Royal College interview went more smoothly, and he was offered places at both colleges. On the advice of Derek Stafford he chose the Royal College and accepted a place on their post-graduate course in painting to begin in September 1959 after his National Service. Norman Stevens also gained a place at the Royal College, to be followed a year later by John Loker and Peter Kaye, and at the same time Dave Oxtoby and Mike Vaughan were successful at the Royal Academy Schools. David had no intention of fighting as a National Serviceman in a colonial war in Cyprus and registered as a conscientious objector, with the help of Rose Gillinson. John, Peter and Rod Taylor did the same the following year.

During the summer term, David and John had entered paintings for a Landscape Scholarship on the understanding that, if either were successful, the money would be shared. David won £60, and the two of them decided to spend the summer painting landscapes in the Constable countryside of Suffolk. They put an advertisement in an East

Anglian newspaper requesting 'cottage or shack for two students to paint in', but received no replies and instead decided to visit another artists' Mecca, St Ives in Cornwall. They spent a night at a pub in St Austell, then travelled by bus to Derek Stafford's former haunt, Mevagissey. They could find no cheap accommodation and studio space, so they moved on to St Ives, where they borrowed a wheelbarrow and pushed their tin trunk containing two hundredweight of materials up a steep hill to a derelict barn full of chickens. Here they awaited the arrival of the cheque for £60, which reached St Austell Post Office two days later. Since no one would honour the cheque and they were by now broke, they walked down to St Ives, found Barbara Hepworth's studio, knocked on the door and, with supreme arrogance, asked her to cash it. They fully expected to be invited in for tea, being fellow-artists, but the sculptress rather curtly directed them to the Penwith Art Society, where they were lucky enough to get their cash. In the same post they had received an offer of a cottage in Suffolk, so they pushed the heavy tin trunk down the hill again and caught the night train to Ipswich.

John and Margaret Burton of Kirton, near Felixstowe, had seen the advertisement and, after replying, had received a neat letter in green ink from Kenneth Hockney assuring them that David was a good boy who regularly attended the local church. They had written therefore offering their outhouse, an old horseman's cottage with two rooms, running water, gas stove, outside lavatory and no bathroom, for 30s. a week. They received no reply until the telephone rang in the middle of one Sunday lunch. David and John were stranded in Ipswich and could somebody come and collect them? Despite his surprise, John Burton fetched them in his car and Margaret put half the meal aside for them. So began a happy six weeks of painting and drawing, as well as drinking in the local pub.

David and John were a scruffy pair of young artists, who caused quite a stir in the little village of Kirton. They would ride out into the country each day on bicycles borrowed from the Burtons, with their painting materials strapped to their backs. One day David had an accident and was lucky not to be hurt; on another occasion they were apprehended by the local police who thought they had escaped from borstal. They took sheets of hardboard with them, which they had first painted with white Dulux undercoat. They would set up their easels on the village green and paint the rather ugly shops, or spend the day at Kirton Creek on the River Deben, carefully recording the lines of telegraph poles marching across the countryside. Their paintings, none of which seems to have survived, were constructed with horizontal and vertical lines and used a great deal of black and white paint with chrome yellows and acid greens. Margaret Burton had been to art school herself and loved having them around, but she did not appreciate their paintings, which she later described to me as 'eyesores, the least attractive subjects they could find, the furthest away from pretty pictures you could imagine.'[10] But two members of the Deben

Art Group, Denis Taplin and Ken Cuthbert, saw the pair's work and invited them to exhibit with their amateur members at a local show. David and John were delighted at the chance of making some money and sent along a pile of paintings and drawings priced from 5s. to £5. They were given a corner of their own and sold every single picture, making the useful sum of £30.

On his return to Bradford in the autumn of 1957, David found that his registration as a conscientious objector had been accepted, and he was put to work in St Luke's Hospital as a medical orderly in the skin diseases ward. He spent a year at the hospital and hated the work, but he did find time to do some drawings of the patients. In the summer of 1958, John Loker and Peter Kaye left Bradford College of Art and registered as conscientious objectors; they decided to do their service in Hastings. David joined them and they found a lovely little cottage at St Leonards on Sea for £3 a week. It was seventy steps down from the main road and overlooked the sea. A further 140 steps took them conveniently to the Gardener's Arms pub on the sea-front. Here they stayed from the summer of 1958 until September of 1959, David working as a nursing auxiliary at St Helen's Hospital in Hastings and John and Peter doing agricultural work. Dave Oxtoby had been exempted from National Service on grounds of ill-health, and he came down from Bradford to stay at the cottage. Norman Stevens used to come from London for weekends. He had also gained exemption owing to lameness resulting from polio, and he was already in his second year at the Royal College of Art. Another visitor was David Fawcett, who was now teaching art in a school at Deal. It was an agreeable period, except when they were nearly evicted from the cottage after John was prosecuted for urinating into the sea.

The friends passed their time reading *Peace News*, *Tribune* and the *Bradford Telegraph & Argus*, which were all sent regularly by David's father. David's letters home tell of his attempts to find work on the land since, by now, he had had enough of hospital work. He reassures his parents about his living conditions: 'We are keeping house very well indeed, in fact I think we can congratulate ourselves. We even washed some sheets the other day, and I ironed them all – they were "Persil White".'[11] He asks his father to sell off his Bradford pictures cheaply, except for *The Road Menders* which he thinks is worth around £10. The group enrolled at Hastings College of Art for evening classes in life drawing, and David managed to produce quite a few paintings during this period, some of which show his first flirtations with abstraction. He was already beginning to realize that he had so far ignored modern art, but that was soon to change. September 1959 arrived, and with it the start of his course at the Royal College of Art in London and his first major step on the road to international fame.

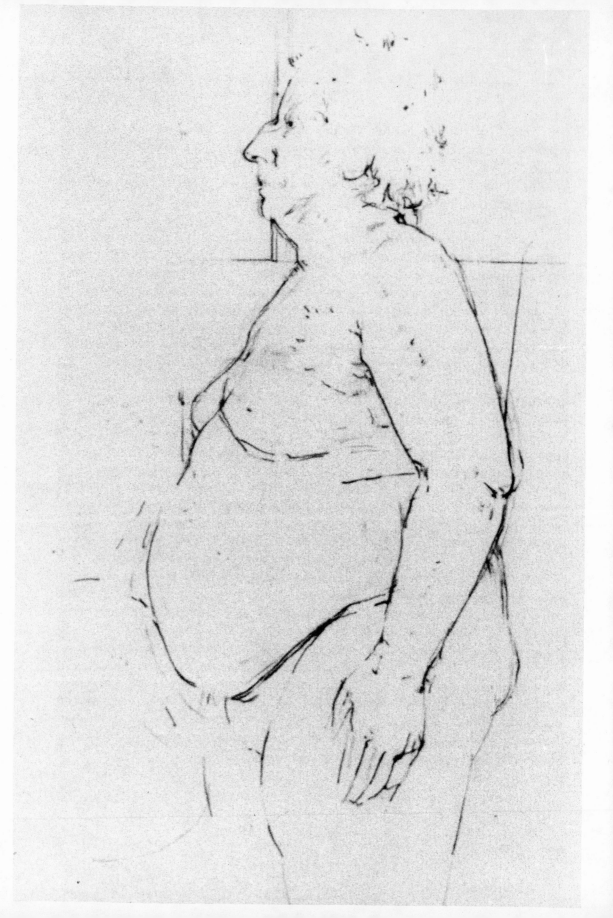

CHAPTER TWO

LONDON 1959–1962

The dream of escape to London came true when Hockney arrived to take up his place in the Painting School of the Royal College of Art in September 1959. So began three years of post-graduate study that would see the transition from unknown but talented provincial art student to critically acclaimed entrant into the London art world.

Norman Stevens, who was entering his final year at the Royal College, was a ready-made guide for the new arrival, and David felt at home much more quickly than had been the case at Bradford College of Art. He made many new friendships at this time, both at the Royal College and the nearby Slade School of Art. There was a degree of rivalry between the two colleges, Slade students being considered more orthodox and serious artists with a sense of tradition, compared with those at the Royal College who were thought of as brash, adventurous and determined to make a splash in the art world. David found an atmosphere totally different from that of Bradford College of Art. There seemed to be no taboos and no rules, except that life drawing was compulsory. Painting students could use any size of canvas or hardboard and could work in bright or sombre colours and oil or emulsion. The Principal, Robin Darwin, direct descendant of both Josiah Wedgwood and Charles Darwin, was a successful painter turned administrator who loved power and responsibility. Having taught at the Slade and found it rather old-fashioned, he had set out to make the Royal College stronger and more exciting than any art college England had previously known. He had collected an interesting team of painting tutors which included Carel Weight, Roger de Grey, Ceri Richards, Ruskin Spear, Robert Buhler, Rodney Burns and Sandra Blow. The Head of Painting, Carel Weight, was highly respected as a painter and teacher, and he had a studio in college where students were welcome to watch him at work. He had been instrumental in setting up the annual Young Contemporaries exhibitions of art-school work. Ruskin Spear was a figurative artist in the Sickert tradition and was one of the friendliest of the tutors. Rodney Burns, who was also figurative, had a houseboat moored on the Seine in Paris, where he welcomed students in the vacations. Roger de Grey, later President of the Royal Academy, was renowned for his Cézannesque abstract landscapes and his chain-smoking of Gauloises cigarettes, a habit that was widely imitated in the college. Sandra Blow produced large abstracts in which paint was mixed with sand, and she was especially admired as a role-model bohemian artist. Robert Buhler exhibited idiosyncratic figura-

Life Drawing, c. 1959

tive pictures at each Royal Academy Summer Exhibition, and he had a relaxed and cynical approach to the students, warning them: 'Be careful or you'll end up like me.'

Darwin also encouraged figures from the art world to visit the painting studios; during David's three years these included Francis Bacon, Richard Hamilton, Terry Frost, Joe Tilson, Peter Blake, Dick Smith, the critics Lawrence Alloway, John Russell and Suzy Gablik and the American artists Larry Rivers and Mark Rothko. He also prided himself on the number of rich collectors he brought to the studios.

Hockney soon became part of a wide circle of new friends, many of whom would later make names for themselves in the art world. These included Ron Kitaj, Derek Boshier, Allen Jones, Peter Phillips, Pat Caulfield and Adrian Berg at the Royal College, and Patrick Procktor and, later, Colin Self at the Slade. Derek Boshier from Yeovil School of Art had met David at the interviews two years earlier when they had got drunk on Guinness together. On the first day of term he recognized him and said, 'So you got in too, did you?' They became firm friends. Hockney was determined to be noticed, as on his first day at Bradford. Boshier remembers that he wore a blue boilersuit and black desert boots and had crewcut dark hair surmounted by a German Panzer tank unit cap. He liked to chain-smoke Capstan Full Strength cigarettes. He had a dry sense of humour and appeared very eccentric and rather shy, preferring not to look people in the face and continually curling his hair into little spirals on top of his head with his right hand like Stan Laurel. His strange appearance and strong northern accent made him seem like a foreigner, and he played on this during his first term. His friends all had fashionable Italian-style haircuts from the local barber, Peter Nichols in South Kensington, but David insisted on his hair being cut to one eighth of an inch all over his head. Late one night, on a tube train, a drunken Irishman twice knocked his cap off his head and threatened to beat him up on behalf of German concentration camp victims. A rather shaken David told the story to staff and students at college next day. Carel Weight was deeply shocked but Robin Darwin merely chuckled.

On arriving in London, David had moved in with Norman Stevens, who had a small flat in Kempsford Gardens, Earls Court. There was no room to paint, so he spent as long as he could at the college, only leaving the studios when the building was locked up at nine in the evening. Then he would go to one of the local pubs. The Hoop & Toy, opposite Peter Nichols' barber shop in South Kensington, was where two college painting students, Barry Bates (later known as Billy Apple) and Mike McLeod went drinking. At the Queen's Elm he would find Derek Boshier, Peter Phillips and Allen Jones and here often Norman Stevens would be playing darts, an activity that never really interested David. Another darts player was Geoff Reeve, a textiles student at the college who was also a keen photographer who took many photographs of David in the studio during 1960 and

1961. After the pubs closed, David and his friends could go to the two coffee bars in the area which stayed open late. The Troubadour at the corner of Brompton Road and Earls Court Road had poetry readings and jazz sessions. Hades (later known as Chompers) near the college at the bottom of Exhibition Road was the favourite haunt of two of David's fellow-students Don Mason and Fred Scott, who had the flat below Norman Stevens in Kempsford Gardens. When they were finally thrown out of the coffee bars, the group would often go to the flat Derek Boshier shared with Barry Bates on the corner of Cromwell Road and Warwick Road, which was the nearest to the college. Here, if they were lucky, they indulged in a stew made from Oxo cubes and water with a slice of bread and a bottle of beer, for spare cash was in very short supply. David's grant was only £266 per year. When Derek Boshier moved into a larger flat in Holland Park with Peter Phillips and Mike Upton, a painting student with Dave Oxtoby and Mike Vaughan at the Royal Academy Schools, the gang made that their new base. But however heavy a night he had had, David would always be in the studio to begin his work next morning.

The only aspect of the course that Hockney disliked was Art History and General Studies. Darwin had instituted a programme of lectures the year before, as part of his long-term plans to gain university status for the college. The idea was to give students an 'intellectual' input and increase their general awareness of the world around them. Basil Taylor lectured on Art History and Michael Kullman covered areas of philosophy, logic and scientific thought. The idea of being told to read Aristotle did not appeal to David, but he enjoyed Kullman's company when out of college. Michael Kullman was a very clever and rather self-opinionated man who struck some people as an eccentric genius, whilst others considered him mad. He had his own seminar group of 'thinkers' among the students, which included Ron Kitaj and Adrian Berg, and Hockney often joined their unscheduled discussions. Kitaj and Berg, who were both in their late twenties, soon came to be counted among Hockney's closest friends. Adrian Berg found him 'a refreshing breath of fresh air from the north. He was unmuddled by a lot of art theory, everything was new and exciting to him. But he was no dopey northerner, he had already got things worked out. I am sure he always intended to be a success right from the start. Students were segregated in years, and as I was a year ahead I did not notice him immediately. Then one day Ron Kitaj said "Have you spoken to this guy Hockney?" I found him in the Plaster Cast Room doing a marvellous drawing of a skeleton.'[1]

Kitaj has a vivid recollection of his introduction to Hockney: 'I arrived the same day and you couldn't miss him. He looked extraordinary. We were in the Cast Room and I watched him spend his first week drawing a skeleton. It was the most beautiful drawing I had ever seen in an art school. I offered him £5 for it and he accepted. In the second week he did a more elaborate skeleton drawing which I was able to buy many years later from a

dealer, but for rather more than £5. We became close friends very quickly, and have been like brothers ever since.'[2]

During the first half of his first term, David completed three large and highly detailed drawings of the skeleton: two show it suspended from the ceiling, and in the third it is reclining on the floor of the studio. This was partly an exercise in concentrated drawing after two years of manual work outside an art college environment, but also a deliberate attempt at making his presence felt. In this he succeeded, for everyone was impressed, including the staff who from then on knew that, whatever his faults, Hockney could *draw*. He also spent a great deal of this time in the Life Room producing an impressive collection of life drawings, some hesitant and others very assured but never laboured, using pen and ink, green crayon, sharp pencil and even, at times, the stub of a soft pencil (see page 18). From this period also dates at least one large oil painting in a Euston Road school manner of a female nude model seated in the studio by a little circular electric fire.

In November 1958 David had seen the retrospective exhibition of Jackson Pollock paintings held at London's Whitechapel Art Gallery, and he had also heard people discussing the Tate Gallery's 1959 show entitled 'The New American Painting', which he had missed. He found that there were two groups of painting students at the college, a 'traditional' group who continued the work they had been doing on their National Diploma courses, and a 'modern' group who were much more concerned with the art of their own time. These seemed to be the brightest, most adventurous ones. They were all busily at work producing Abstract Expressionist paintings on the three-foot by four-foot sheets of hardboard provided by the college. They were interested only in what was happening in America. Hockney found it difficult to be inspired by Jackson Pollock, whose enormous paintings seemed to him totally lacking in any human content whatsoever. And yet he felt a real need to pay attention to concepts of modern art. In 1958 he had been impressed by an exhibition of work by the British Abstract Expressionist Alan Davie at Wakefield Art Gallery. He had met the artist and talked to him about the paintings on show. Though influenced by Pollock, Davie worked on a much smaller sale, and used his imagination to create symbolic images which contained references to the visible world, and to which he gave titles such as *Entrance to a Paradise*, *Witches' Sabbath*, *Sacrifice* (see plate 19). Hockney felt much more drawn to Davie's Modernism, and spent the second half of his first term working in a similar manner. The resulting paintings on hardboard were mostly destroyed or painted over, but they represented a conscious attempt to communicate the sensation of painting rather than the appearance of the visible world. Refusing to copy Pollock and his followers in their use of anonymous titles such as 'Red and Green Number Three', Hockney named his abstract pictures by reference to his own feelings, attitudes and moods, for example *November*, *Erection* (see plate 21), *Accumulation*, *Growing Discontent*. By the end of term he felt he had

exhausted this approach. He took a welcome break and returned to Bradford for a family Christmas. While away from home he had decided to live as a vegetarian, and his mother made a special festive chicken-shaped nut roast for herself and David, with added chicken trimmings for the meat-eaters of the family.

When Hockney returned to college in January 1960, he faced a dilemma. He wanted to be a 'modern artist', and yet he was not satisfied with his abstract paintings of the previous term. He felt a real need for meaningful subject-matter, yet he was afraid to go back to figurative work, as this might mean ignoring contemporary developments in the art world and he might be considered a reactionary in the college. So he turned to his friend Ron Kitaj for advice. Kitaj was American and rather older than Hockney. After army service he had studied at the Ruskin College of Art in Oxford before joining the Royal College. He was very widely read and highly intelligent, and also very knowledge-able about contemporary art in both America and Europe. Hockney had felt drawn to him from the start, and always found his advice useful. Kitaj told him: 'Painting is research. Your work should explore what most interests you. Don't just talk about vegetarianism, paint vegetarian propaganda pictures.' Hockney later said this was the best advice Kitaj ever gave him.[3] By now he had declared himself a 'militant vegetarian' and could often be found in the canteen handing out leaflets condemning the cruelty involved in making the sausages on sale at lunchtime.[4] So he immediately began a series of non-figurative paintings with titles like *Two Cabbages*, *Bunch of Carrots*, with patches of red and green as well as words written in paint – 'lettuce', 'tomatoes', 'cabbages', 'carrots'. All seem to have disappeared or been painted over, but these pictures, which Hockney described as 'absurd and interesting' showed him his new direction. They were followed by other abstract images with words: *Shame*; *Red, White and Prison*; *Gandhi* (referring to the Indian statesman's vegetarianism) and 'Tyger' (four paintings which allude to William Blake's poem 'The Tyger' from *Songs of Experience*). Hockney took the idea of including words in his pictures from Cubism, where words are often used as clues to the subject-matter. He loved reading poetry, and taking words from Blake was a way of demonstrating the parallel between the poet's careful choice of words and his own.

A painting of this spring 1960 series, in oil and sand on canvas and measuring only ten inches by seven inches, was exhibited at the Piccadilly Gallery in London in 1965 as *Yellow Abstract*, but close examination reveals its correct title, the barely legible word 'Queer'. David's deliberate use of this derogatory term was the beginning of a new series of propaganda paintings, this time drawing attention to his sexual orientation. In Bradford, his friends had found his sexuality a bit of a mystery, since he showed little sign of interest in girls. For his part, David had become aware during his mid-teens that he found boys more sexually attractive than girls, but a city like Bradford provided very few opportunities during the fifties for this to be developed, and he, like so many boys

before and since, felt unable to confide in his family or friends. At the Royal College he had a gay friend in Adrian Berg, who encouraged him to take further Ron Kitaj's advice to paint what was important to him. *Queer* was his first tentative step in this direction. Although seemingly abstract, the image can be read as a Davie-like symbol of homosexual self-oppression when compared with a series of drawings and paintings dating from the summer term which are all studies for what can be considered Hockney's first important painting, a four-foot by three-and-a-quarter-foot canvas entitled *Doll Boy* (see plate 31). The pictures show a gradual progression from suggested forms to a clear image of a male figure, labelled 'unorthodox lover' in one study, staggering under the forces that oppress him: his consuming need for love (a pink heart in one image) and his awareness of antagonism to gayness (a large red shape in another).

In the final painting, he wears a dress embroidered with the word 'queen', and written alongside are graffiti suggestive of the desperation of public lavatory walls: 'Your love means more to me' and 'Valentine'. He bears the name 'Doll Boy' and, in addition, the inscription '3.18', and musical notes issue from his mouth. Hockney has borrowed the schoolboy code of one of his favourite poets, the homosexual Walt Whitman, in which 1 = A, 2 = B and so on. Thus 3.18 = C.R., which identifies the figure as the singer Cliff Richard. Hockney was at this time infatuated with Cliff Richard and had decorated his studio cubicle with photographs of the singer whose current hit record was entitled 'Living Doll'. The song was about a girl, but David changed the sexual roles and made Cliff his 'Doll Boy', the object of his love and at the same time his chosen symbol of sexual repression.

In a recent conversation, Hockney told me: 'I think that all artists are autobiographical and can't be anything else.'[5] From *Doll Boy* onwards, a large proportion of his work has been concerned with his homosexuality or, at least, has reflected that sexual preference. In his autobiography, he wrote: 'What one must remember about some of these pictures is that they were partly propaganda of something I felt hadn't been propagandized, especially among students, as a subject: homosexuality. I felt it should be done. Nobody else would use it as a subject.'[6] And he told Marco Livingstone: 'The moment you can learn to deal with [homosexuality] in art, it's quite an exciting moment, just as in a sense when people "come out" it's quite an exciting moment. It means they become aware of their desires and deal with them in a reasonably honest way.'[7] He had long conversations with Adrian Berg about gay literature that summer term, and he read the poems of Cavafy and Walt Whitman's *Leaves of Grass*. Among his paintings were *Cliff*, a large heart with the singer's name above it, and *Bertha Alias Bernie*, an image of a boy in a dress inspired by a transvestite story in a gay magazine. He ended his first year at the Royal College with two pictures which he called his 'Love Paintings'. He told me recently: 'The source of all art, the source of all creativity, is love. If anybody thinks

there is something more important, I would like to know what it is.'[8] *The First Love Painting*, a name chosen to parody Jackson Pollock's anonymous titles, is a four-foot by three-and-a-half-foot canvas, abstract in the Davie manner, composed of gestural strokes in a range of pinks and purples on a creamy white ground (see plate 22). A large phallic shape fills the left-hand side, and one can read the words 'sperm', 'suspicion' and 'love'. *The Second Love Painting* is, by contrast, a tiny picture in oil mixed with sand which, though also basically abstract, can be seen to represent a heart inscribed with the word 'love'.

Hockney's drawings were much more admired by the staff than his paintings; nevertheless, his end of year report read: 'Rather a brilliant student who might do anything.' His group as a whole were seen as trouble-makers because they seemed to take so little notice of the tutors, and they were told to leave experimenting until their final year. The Principal, Robin Darwin, wanted to make an example by expelling one student and Allen Jones was chosen. He had been heavily criticized for painting the nude model in Fauvist colours in spite of the darkness of the room and the grey daylight, and was given news of his expulsion one night at the end of term. Norman Stevens drew up a petition to have him reinstated, and many students signed, but Darwin ignored it.

During the summer vacation, Hockney met up with Rod Taylor and Norman Stevens and they painted designs for wallpapers in order to make some money. They submitted their efforts to Crown Wallpapers but only one design – by Hockney – was sold. Another idea was to sell some paintings, so Hockney hired the Desormais Gallery in the castle at Skipton near Bradford for three weeks in August at a cost of 25s. per week. Dave Oxtoby, Mike Vaughan, John Loker and Rod Taylor brought work along and Hockney showed thirteen of his Royal College pictures including the four 'Tyger' paintings, the two 'Love' paintings and two now lost pictures named after Walt Whitman's collection of poems *Leaves of Grass*. Only Dave Oxtoby did well: he sold twelve paintings, whereas Hockney sold none. His father took numerous photographs to record the exhibition, but, to David's annoyance, hardly a single one was in focus. This was not his first exhibition of the year. He had shown two paintings with the 'Yorkshire Artists' in Leeds, two with the 'London Group' and two at the 'Young Contemporaries' in London.

Norman Stevens graduated at the end of Hockney's first year, and when Dave Oxtoby, John Loker and Pete Kaye arrived the following September they all moved into the Kempsford Gardens flat. A hardboard partition was built across the bedroom, but it was very cramped, and David moved into the garden shed recently erected by the landlord, for which he paid a low rent of 7s. 6d. a week. The shed had a bed, table, bookcase, chest of drawers, electric fire and window. He did not like to spend long there, as the fire ate up his sixpences. The whole group liked their landlord, who worked as a film-extra, most recently in the *The Trials of Oscar Wilde*. Earlier, he had starred in the music-halls as one

of the Bennett Brothers, and he loved to entertain the students with songs and stories. David was in the habit of sleeping late; Dave Oxtoby would knock on the shed door to wake him up, whereupon Hockney would stamp his shoes on the floor and pretend he had got out of bed. Eventually the four would walk to the Royal College, and Dave would go on to the Royal Academy Schools. Since he had no cooking or washing facilities in his shed, Hockney often had a bath in one of the college sinks, where he was once discovered by Professor Carel Weight. He would then brew himself a cup of tea in the studio. He placed a regular order with the milkman and always left his empty bottle outside the studio door.

Hockney's friends from Bradford found that he had changed since they had last seen him. He was now openly gay and also more relaxed. At first he had worried about how they would react to his gayness, but they merely asked him why, in the past, he had seemed interested in one or two Bradford girls, to which he replied that they had been very boyish girls.

At the start of his second year at college, Hockney found that a new student had decorated the walls of his cubicle with photographs from American male physique magazines. This was Mark Berger, an American in his late twenties, who was very open and relaxed about being gay. They soon become firm friends; they would spend their time discussing the homosexual poets Whitman and Cavafy, or classical music, or the Mardi Gras parades in New Orleans, Berger's home town. He introduced Hockney to gay places and people, and so enabled him to come fully to terms with being homosexual. He was very friendly with some gay people who shared a house in Highbury Grove with Janet Deuters, a Royal College painting student who had flaming red hair set off by a white powdered face. She and her flatmate, Sylvia Eyton, threw wild parties; since they lived far from the college, they used to signpost the streets in the Highbury area so that the students could find them. On one such evening, Berger introduced Hockney to 'Spanish Rick', a male prostitute who had bouffant hair, wore a black cloak over lurex trousers, and lived on watercress sandwiches and purple-heart pills. Later they all went to a gay club where Rick was involved in a violent fight. Hockney was not too impressed with this particular introduction to London gay life.

Hockney's first painting of the new academic year was *Adhesiveness*, a word used by Whitman to signify close friendship between men. Part of the picture recalls Davie's abstracts in its free brushwork, but, in the foreground, are two clearly defined, mechanical figures engaged in sexual activity. They are labelled '4.8', for David Hockney, and '23.23', for Walt Whitman, and the Whitman figure also bears a tiny '3.18' for Cliff Richard. At first sight they seem to be engaged in the 69 position, but close inspection reveals that they could, as well, both be standing upright, one with his tongue in the mouth of the other whose penis enters the body of the first. *Adhesiveness* remains

one of Hockney's most explicit pictures; it was a dramatic way to start the year, and it was one of his earliest sales, for it was bought by the photographer Cecil Beaton for £40. It was followed by *The Third Love Painting* (see plate 23), which is close to the first in that series, with the same large phallic shape against an abstract background, but much more richly coloured and with a proliferation of graffiti, many gathered from the Earls Court underground station lavatories. These include 'Britain's future is in your hands', 'Ring me anytime at home' and 'My brother is only 17', together with 'Come on David admit it', and there are obscene drawings hidden in the mixture of oil paint and sand. Also prominent in the painting are the last lines of Whitman's poem of 1860, 'When I Heard at the Close of Day'.

> For the one I love most lay
> sleeping by me under the same
> cover in the cool night,
> In the stillness in the autumn
> moonbeams his face was
> inclined towards me,
> And his arm lay lightly around
> my breast, and that night
> I was happy.

The painting suggests a comment on the co-existence of spiritual love with animal lust, and the inclusion of so much writing serves to engage people's curiosity, making them take notice and look closely at the picture.

Other paintings dating from autumn 1960 continue in the same vein. *Going to be a Queen for Tonight* has the word 'queen' twice emblazoned among the abstract shapes, and *My Brother is only 17* and *Oh For a Gentle Lover* also use lavatory graffiti. Yet these pictures were not concerned only with homosexuality: in formal terms they reflect Hockney's interest in Dubuffet, who had two exhibitions in London in 1960. Hockney admired the anonymity and childlike lack of style in Dubuffet's sticklike figures, and his use of graffiti and textural paint effects which recalled the roughness of walls. He wrote a spoof review of the graffiti in the Royal College men's lavatories for a student news-sheet at this time, entitling it 'The Latrine Gallery, SW7'. But his concern with a rather anonymous style helped him to distance himself from subject-matter that could so easily develop into a form of personal neurosis.

Hockney's largest painting to date was also produced during this autumn term. This was *View of Bradford from Earls Court* (see plate 30), a six-foot by four-foot mixture of oil and sand on board in bright blues, reds and purples on a creamy white background. On

the right of the picture appears the phallic shape of two of the 'Love Paintings' as well as four figures walking down its side. In the top left corner are five rows of stencilled men in black and red. Above the phallus are written the words *Labor Omnia Vincit* (work conquers all), the motto on the Bradford City coat of arms, which David had seen on the Bradford buses on his daily trips to school and college. The painting can be seen as an extension of the 'Love' series, an ironic backward glance at the work-orientated world of Bradford from the more enlightened viewpoint of London, where the hard-working Hockney had discovered the importance of the pleasure principle. It is an impressive painting and, rather appropriately, Hockney later presented it to his old school.

In the spring of 1960 Hockney had seen the Francis Bacon exhibition at the Marlborough Gallery in London and had been very impressed. He especially loved the male nudes: 'One of the things I liked about them was that you could smell the balls.'[9] He felt Bacon had demonstrated that the human figure was still a meaningful image in contemporary art. He liked the way Bacon left parts of the canvas unpainted, and also the way he used second-hand material such as photographs and paintings as his sources in order to use their flatness. He found this technique again in the targets, flags and numbers of Jasper Johns, whose works were illustrated in the art magazines of the day. This equation of the painting with the object it represents was a lesson to be learnt from contemporary American art. Hockney had seen the catalogue of the 1959 '16 Americans' show at New York's Museum of Modern Art, which included Robert Rauschenberg's statement: 'Any incentive to paint is as good as any other. There is no poor subject. Painting relates to both art and life. Neither can be made. I try to act in that gap between the two.' Before the end of the autumn term, Hockney experimented with flatness by using the flat, decorative surface of playing cards in a series of images. He and his friends often played cards in the studio, and Mark Berger had a book about the history of playing cards. First was a tiny canvas, *Composition e 3*, which included part of a playing card, soon followed by the freely painted copies of the King of Hearts, *K for King* and *Kingy B*, with their rich reds, blues and gold. Mark Berger used the latter as the background to a large portrait of Hockney at this time, into which he also incorporated a photograph of Cliff Richard (see plate 51). Hockney also made four large pen-and-ink drawings of court cards which he pasted together on a piece of cardboard and gave to Peter Blake, who would often come into the studio to talk to the group. He first copied these onto a copper plate and made an etching entitled *Three Kings and a Queen*, enjoying the pun on the word for a homosexual.

By the end of the autumn term, Hockney was working in the Print Room; he was running out of painting materials and he had heard that everything was provided free for students in the Department of Printing. He had never made an etching before, although he had always been interested in graphic processes. He was lucky to find a print student

named Ron Fuller who was happy to show him the basics of etching. Fuller found Hockney a very good pupil who picked up the techniques very fast and was soon making his own prints. His first was entitled *Myself and My Heroes*, an image divided into three compartments. In the first is Walt Whitman, who is given a halo, and it is inscribed with quotes from his poems: 'When I thy ports run out', 'for the dear love of comrades'. In the second is Mahatma Gandhi, also with a halo and with the inscriptions 'love', 'Mohandas', and 'vegetarian as well'. Hockney puts himself in the last compartment, wearing his army cap, and he inscribes it with his name and 'I am 23 years old and wear glasses'; he did not think he had anything more interesting to say about himself. He has put his initials above a little heart below which are the initials of his two heroes. Ron Fuller helped him to proof the etching and it was printed in an edition of about fifty in early 1961. He followed this with *Three Kings and a Queen* and *The Fires of Furious Desire*: this shows Hockney himself with a large heart with the word 'love' and the title, an allusion to William Blake's poem 'The flames of furious desire'. These two images were also proofed and printed at the beginning of 1961. All three, with their use of hardground incised lines and heavy aquatint, show an astonishing grasp of etching techniques in someone with no graphic training.

Before the end of the autumn term Hockney painted his first picture of a packet of tea: 'I did *The First Tea Painting* after the playing cards. It was flat but with figuration in it. One day at breakfast in the studio, I was wondering what to do next, because I was running through all the playing cards, and I saw the Typhoo tea packet, my mother's favourite, the one I always used. But then a tea packet isn't flat, is it? So I thought I would do one that wasn't flat.'[10] The little oil painting shows the front of the tea packet in the top half; a large red heart bearing the letter 'L' dominates the lower half, which is otherwise bare canvas and paint scratches, showing the recent influences of both Bacon and Dubuffet. He would return to this subject the following term.

Once he had 'come out', Hockney became a more exuberant and gregarious person, as he demonstrated at the end of the autumn term: 'I remember that Patrick Procktor rang and said the Christmas dance at the Slade was going to be a drag ball and would I come. I said: 'Oh, all right, I'll come.' So I went to Woolworths and I got these eyelashes and make-up and I had a T-shirt printed with 'Miss Bayswater' on it. I had these rubber tits – you glued them on – and I shaved my legs. I thought I'll swish into the Slade at 9.30. I arrived and I was the only one in drag. I thought, fucking hell! What a terribly dull lot of people. Even Patrick had let me down. The organizers had deliberately chosen a drag ball and none of them bothered to dress up. I was told that one other person had gone in drag before me, a man in a crinoline dress, but he had left because he was the only one.'[11]

Every Christmas, the Royal College staged a revue which was eagerly awaited by London art students and their friends and was always sold out. In 1960 Mark Berger was

in charge, and the chosen theme was 'The Hollywood Musical'. Dressed in top hat and tails, he danced and sang 'Cheek to Cheek' with Janet Deuters, following that with 'I'll Climb a Stairway to Paradise' with Pauline Boty, a vivacious painting student who was the girlfriend of Peter Blake. Each number was accompanied by a chorus of girls in ostrich feathers. Pauline also sang a spoof of a deodorant advertisement, 'My Armpits are Charmpits', revealing her armpits at the climax. More raunchy was Janet Deuters in a striptease to the song 'You've Got to Have a Gimmick' from *Gypsy*, a real bump and grind number in a costume she had designed herself. Roddy Maude-Roxby, a brilliant visual arts student, who was later well-known in the London theatre world, performed two pieces with Derek Boshier, a conversation between Errol Flynn and Beethoven, and a mime to music which was so well received that they were invited to perform it again at a birthday party for Marcel Marceau at The Troubadour. Mark was determined to involve Hockney in the show, but met with understandable resistance after the Slade fiasco. Janet got him drunk and eventually he appeared in a bathrobe and boots and sang his father's favourite, 'Little Willie Woodbine', even breaking into a Yorkshire clog dance.

When he returned to college after the Christmas vacation, Hockney continued to work on the theme of the Typhoo tea packet with *The Second Tea Painting*. A pencil drawing shows his original idea of the front of the packet contrasted with a drawing of a bird. The painting follows this composition, with the addition of a Bacon-like shape in the left foreground that may be a figure surmounted by a heart. Bacon's influence can also be seen in the areas of bare canvas, recalling *The First Tea Painting*, but also in structural lines which seem to suggest an isometric projection similar to the 'cages' in which Bacon's figures are often isolated. This idea was the basis of *The Third Tea Painting*, or *Tea Painting in an Illusionistic Style* (see plate 33), completed later in the spring term. So as to represent the Typhoo packet in perspective, he created the painting in isometric projection using four different canvases for the lid, the inside, the front and the side: 'I can remember a precise moment when I realized that the shape of the picture gave it a great deal more power. To make a painting of a packet of tea more illusionistic, I hit on the idea of 'drawing' it with the shape of the canvas. The stretcher is made up from sections and I made the stretchers myself. It was quite difficult stretching them all up – the back is almost as complicated as the front; it took me five days.'[12] The advantage of this method was that, since the canvas was now illusionistic, he could ignore the need to create space and concentrate instead on the flatness of his painted image. As part of his attempt to bring the human figure back into his work, he painted a seated male nude behind the lettering of the packet and therefore clearly inside it. The man appears to be sitting on a lavatory with his trousers round his ankles, so the banal lettering of the

package becomes graffiti on the walls around him. The word 'tea' appears four times, and on the side it is mis-spelled 'tae': '. . . it's drawn in perspective and it was quite difficult to do. I took so long planning it that in my concern for flatness or abstraction I spelt it wrong.'[13] The painting is a striking image with an almost surreal effect of an illusionistic tea packet with a nude man seated inside. The idea of making a shaped painting was not entirely new. Hockney may not have known about the shaped canvases by Jasper Johns of 1960, but he certainly discussed the idea with Dick Smith, the British artist who had graduated from the Royal College in 1956 and who created shaped extensions to rectangular canvases for many paintings from 1960 to 1963. The concept was soon used by Barry Bates (Billy Apple) and also by Allen Jones for his 'Bus' series in 1962.

The 'Young Contemporaries' exhibition for 1961 was held at the RBA Galleries in February. Peter Phillips, Allen Jones, Patrick Procktor, Derek Boshier and Mike Upton were on the executive committee, and the Royal College group of Hockney and his friends was well represented in the show. Their pictures reflected their collective determination to reject distinctions between abstract and representational painting and to look for subject-matter in the world around them: advertisements, mass-produced objects, photographs, graffiti, popular culture. Hockney's exhibits were *Doll Boy*, *The Third Love Painting* and the first two 'Tea Paintings', the third not being completed in time. These fitted in well with the sources of imagery in the works of Boshier (toothpaste tubes), Jones (buses and pin-ups), Phillips (pinball machines and advertisments) and Kitaj (magazine illustrations and photographs). In order to make maximum impact, these works were all hung as a group, so that a new student movement could be recognized. In the catalogue, the critic Lawrence Alloway (who was on the selection committee) noted how the Royal College students connected their art with the city: 'They do so, not by painting factory chimneys or queues, but by using typical products and objects, including the techniques of graffiti and the imagery of mass communications. For these artists the creative act is nourished on the urban environment they have always lived in. The impact of popular art is present, but checked by puzzles and paradoxes about the play of signs at different levels of signification in their work, which combines real objects, same size representation, sketchy notation, printing and writing.' Alloway had coined the term 'Pop Art' in the fifties in relation to objects of popular culture exhibited at the Institute of Contemporary Arts in London, and he did not use the words in his catalogue essay for the 'Young Contemporaries' of 1961. Nevertheless, 'Pop Art' was the term used by critics to describe the work of the Royal College group, and the label stuck. Hockney in particular was singled out for attention and admiration in what Ray Watkinson called 'by far the most significant Young Contemporaries Exhibition since they started.'[14]

The exhibition brought early recognition for all the members of the group. Their attitudes were quite independent from that aspect of contemporary American art soon also to be known as Pop, and they knew little of Richard Hamilton's 1950s experiments. But only Phillips found the label acceptable. Boshier considered it too general, and Jones has often pointed out that he used mass-produced imagery only for its formal qualities. Kitaj told me recently: 'Pop Art was a figment of the critics' imaginations. It was not a group at all. I've always despised the idea of pop. I have no interest in popular music or popular culture and never have had.'[15] And in a conversation about the 'Tea Paintings', Hockney assured me he did not see them as Pop Art: 'The Typhoo packet was just lying around because I made my own cups of tea in college. I wasn't interested in the design of the packet, I just thought I could use the image somehow. I saw no connection between packaging, advertisments, things like that, and my art. Neither the pop world nor the subject matter of Pop Art interested me much. I suppose the "Tea Paintings" are as close to Pop Art as I ever came. But I never thought I had much connection with Pop Art myself.'[16]

The 'Young Contemporaries' show brought Hockney to the attention of the London art world and also earned him a £40 prize. At about this time, Richard Hamilton went to the Painting Studio at the Royal College from the Interior Design Department where he taught part-time. He had been asked to choose a student for a £5 prize, and he chose Hockney because of his humour and his talent. Hockney won first prize in the Junior Section of John Moore's Exhibition at Liverpool, and also received what seemed to him an enormous sum, £100, from Robert Erskine of St George's Gallery for *Three Kings and a Queen*. This had been in competition at 'The Graven Image' show without his knowledge. Alastair Grant, the Head of Print-making, had found the proof of the etching in the drying racks in his Print Room just before Christmas, and had sent it in for the competition, along with other works by his own students. There was some embarrassment when it was discovered that the winner of the prize was not one of his students. But more important for Hockney than winning these four prizes was the fact that the 'Young Contemporaries' show introduced his work to a young employee of a London art gallery, John Kasmin.

Kasmin had been born in England but brought up in New Zealand. When he returned to England as a young man he described himself as a poet; but, in order to make a living, he went to work for Victor Musgrave at Gallery One in D'Arblay Street in 1958, and became an agent for Musgrave's wife, the photographer Ida Kar. In 1959 Kasmin moved to the Kaplan Gallery in St James Street, and then on to Marlborough Fine Art in Bond Street in the autumn of 1960. When they opened their New London Gallery, Kasmin became the manager. Meanwhile he had married Jane Nicholson, granddaughter of the artist Sir William Nicholson and niece of Ben Nicholson. Early in 1961 an Oxford

undergraduate, Sheridan Dufferin, the Marquis of Dufferin and Ava and an Irish peer, met Kasmin and discussed the idea of giving financial backing to young British artists. When Kasmin went to the Young Contemporaries show in February he was, therefore, on the lookout for young talent, and as soon as he saw the Hockney paintings he knew he had struck gold. He immediately bought *Doll Boy* for £40. He told me, 'I adored David's work from the start. When I met him at the show, I found him shy, sweet, trusting and nice in his black crewcut hair and glasses. He had a sort of gifted impudence which really attracted me. And he obviously had an extraordinary natural talent. I knew he would be a success, and his open homosexuality and use of gay imagery would be to his advantage since gay people always have money to spend on art.'[17]

At first Kasmin tried to interest the directors of Marlborough Fine Art in Hockney's work, but without success, although another employee, James Kirkman, was immediately impressed and later collected Hockneys when he became a dealer. Kasmin took Sheridan Dufferin to meet Hockney in his Earls Court garden shed, and Lord Dufferin agreed to back Kasmin if he went independent and acted as Hockney's dealer and agent. Kasmin therefore left Marlborough and began to show Hockney's work at his home in Ifield Road, Earls Court. He was then selling Hockney paintings for between £50 and £100, and drawings for between £8 and £12. He took Hockney out to lunch at the Vega restaurant in Leicester Square and offered him a contract guaranteeing him at least £600 a year from the day he left college (it was illegal for a full-time student to sign a financial contract). In return, he would have exclusive rights to sell Hockney's work throughout the world except in the Gilbert and Ellice Islands, the one place he would allow Hockney to keep for himself. Hockney immediately accepted. At the end of the meal, Kasmin was presented with a bill for eighteen shillings. Both of them were stunned. Hockney had never seen such a lunch bill and asked if it was too much. Kasmin replied that, on the contrary, it was too little and he expected his accountant would complain.

Interest from outside was gratifying, but Hockney still had his course to complete. In the spring term of 1961 Carel Weight set the students a project: he wanted them to paint a transcription of a famous painting. Boshier chose Blake's *Elohim Creating Adam*, and Hockney decided on Ford Madox Brown's *Work*, completed in 1863. He was thinking of a pendant to *View of Bradford from Earls Court* and, in the sketch-book which contains the studies for *The Second Tea Painting*, he made numerous drawings that keep to the arched shape of Brown's painting but have very little else in common with it. The large phallus from *View of Bradford from Earls Court* becomes one of the figures on the right-hand side of the Brown; the word 'work' is written prominently in each sketch, and the little stencilled men appear at the top. At this point Hockney abandoned the idea in favour of Brown's *The Last of England* (see plate 36), completed in 1855. With its image of the sculptor Thomas Woolner and his wife emigrating to Australia, this has even more

pathos than *Work*. Brown wrote: 'The husband broods bitterly over blighted hopes and severance from all he has been striving for. The young wife's grief is of a less cankerous sort.'[18] Hockney's transcription rejects all such sentiment, just as it rejects Pre-Raphaelite sharp focus. He depicts himself (4.8) with his arm around his fantasy lover (D.B., for 'Doll Boy' or Cliff Richard). However, he keeps to Brown's circular format and even copies the gold mount and frame, emblazoned with the title made into a question: 'The Last of England? Transcribed by David Hockney 1961' (see plate 35).

Many of the spring term paintings continue the personal investigation of love and sexuality begun the previous year, often with the humour implicit in *The Last of England*? *The Fourth Love Painting* (see plate 65) also shows two figures embracing, one of which is labelled '4.8', beside a big red heart and the word 'Valentine'; but carefully written and printed at the top are the figures '69' and the sentence 'I will love you at 8 pm next Wednesday'. This is a paraphrase of W. H. Auden's 'Homage to Clio': ' '"I will love You forever" swears the poet. I find this easy to swear to. I will love you at 4.15 pm next Tuesday; is that still as easy?' *Figure in a Flat Style* (see plate 68) presents a much more serious view of his sexuality as well as continuing the explorations of style begun with *Tea Painting in an Illusionistic Style*. Although a much less complicated arrangement, this picture also varies the usual rectangular format by having a small square canvas for the head, a vertical rectangle for the torso and the wooden supports of an easel for the legs. The head and legs are rather cursory images, but the torso has a large heart and carefully drawn arms and hands which, by their superimposition over a penis and testicles, clearly signify masturbation. The painting would seem to be a very personal self-portrait; it includes the phrase from Blake 'the fires of furious desire' which had been used on the earlier etching which was also a self-portrait. The colour is especially striking: the variations of red, blue and purple, so characteristic of Hockney's work of this period, are here used with a vibrant intensity.

During this spring term Hockney proofed and printed the etchings which he had begun in the autumn. He was fortunate to be able to count on the continuing help of Ron Fuller. He also worked on various new images: *Kaisarion with all His Beauty* was inspired by Cavafy's 'Alexandrian Kings':

> Kaisarion was standing a little forward,
> dressed in pink tinted silk,
> on his dress a garland of hyacinths,
> his belt a double row of sapphires and amethysts;
> his shoes were tied with ribbons
> embroidered with rose coloured pearls.

27 *Self-portrait*, 1954

This striking collage was Hockney's first self-portrait.

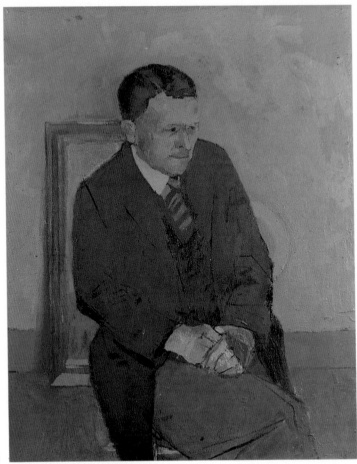

28

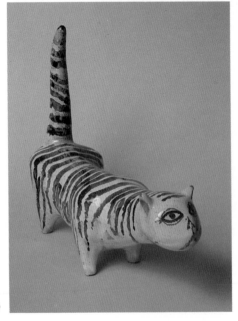

29

28 *Portrait of My Father*, 1955
29 *Cat*, 1955
30 *View of Bradford from Earls Court*, 1960

Hockney's early efforts at Bradford Art College depicted his immediate surroundings, his father, a friend's cat. Later, he looked back without nostalgia at the world he had left behind, creating an ironic souvenir of the work-orientated world of Bradford from the more enlightened viewpoint of London. This is an impressive painting demonstrating his concerns with abstraction and symbolism, which appropriately he later presented to his old school in Bradford. It has only recently come to light.

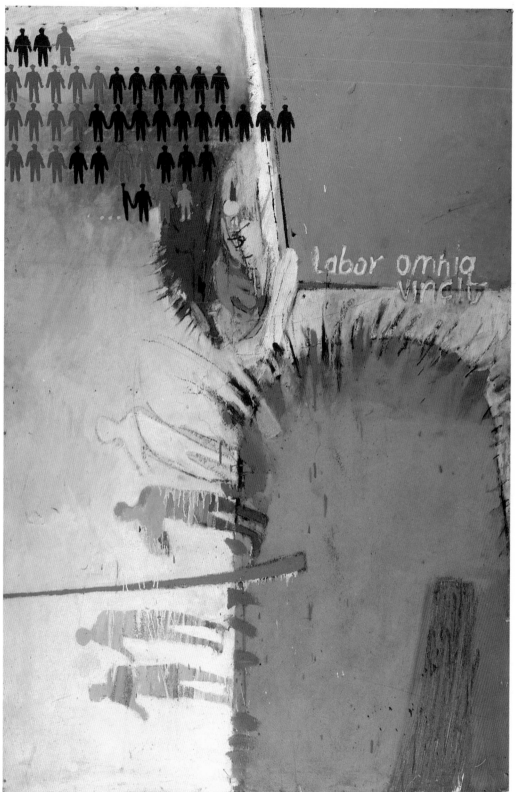

30

31 *Doll boy,* 1960

32 *The Cha-Cha that was danced in the early hours of 24th March,* 1961

33 *Tea Painting in an Illusionistic Style*, 1961

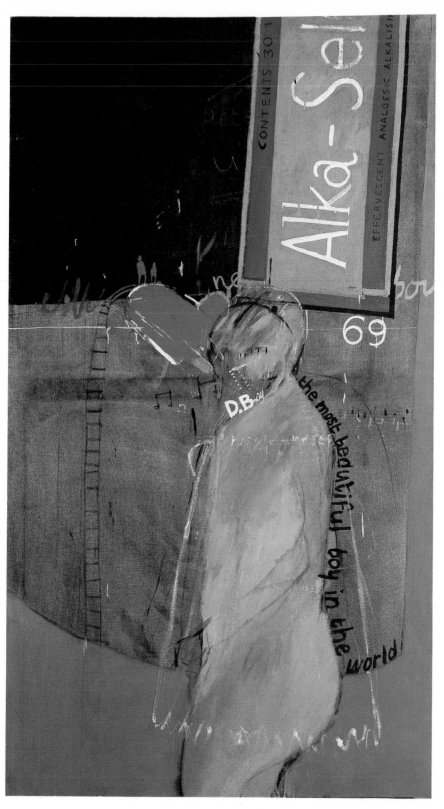

34 *The Most Beautiful Boy in the World*, 1961

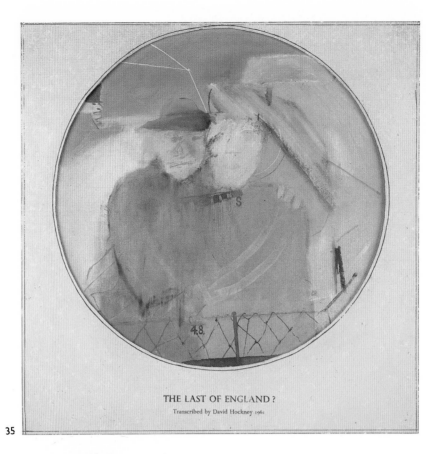

THE LAST OF ENGLAND?

Transcribed by David Hockney 1961

35

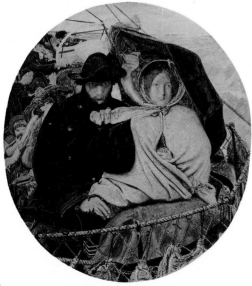

36

35 *The Last of England?*, 1961

36 *The Last of England*, 1855, by Ford Madox Brown

At the Royal College, students were set the project of copying a famous painting and Hockney chose Brown's *The Last of England*. He rejected the pathos of the original as well as its sharp focus. Instead, he depicted himself (labelled 4.8 in his alphabetical code which equalled D.H.) with his arm round his fantasy lover, Cliff Richard (D.B. for Doll Boy). However, he kept Brown's circular format and added the title made into a question: *The Last of England?*

The image of Kaisarion in his dress is in no way a literal interpretation, and the print is experimental, making use of metal-blocks from the Print Room, including Britannia's head, the Royal coat of arms and pointing hands. It was also the first time he had used a colour – red – in a print. He followed this with a sequence of five images, 'Gretchen and the Snurl'. Mark Berger had written a fairy story for his boyfriend in New York which he typed onto good quality paper, leaving spaces for Hockney's tiny prints. The result was sent to Mark's friend, but two years later an edition of the five prints was published without the text. The story tells of two lovers, Mark and Gretchen (a boy in drag) whose city is eaten up by a monster called Snatch, but who are protected by a flexible creature known as a Snurl, and live happily ever after. Another etching was *Alka Seltzer*, which shows a naked boy in a transparent dress being watched by another male figure, with an Alka Seltzer packet in the background. The boy is designated 'the most beautiful boy in the world' and 'D.B.' (Doll Boy). This continuing fantasy is developed in the painting *The Most Beautiful Boy in the World* (see plate 34) which repeats the image of the naked boy in a transparent dress. He is labelled with the title of the picture and also 'D. Boy', and he has a red heart beside him. Notes of music issue from his mouth, as in the original 'Doll Boy' paintings, but instead of bending under the weight of self-oppression he stands upright in front of the Alka Seltzer packet, an emblematic slice of blue in a dark painting otherwise relieved only by the vivid red of the heart. The colours of this important picture have however been adversely affected over the years. It was bought by Lord Gowrie, later to be Minister for the Arts and Chairman of Sotheby's, when an undergraduate at Balliol College, Oxford. He paid Kasmin £70 out of college funds and it hung in the Junior Common Room. But his fellow students hated it and thought it a great joke to throw cups of tea at it, so it was eventually sold back to Kasmin at cost price. In spite of its treatment, one can still make out numbers on the boy, not '3.18' for Cliff Richard now, but '16.3', which stands for a new sexual fantasy, a boy named Peter Crutch.

Hockney was in the college bar with Mark Berger one day when he suddenly interrupted the conversation to remark upon a tall, attractive, neatly dressed boy drinking nearby. 'Oh! he's just so beautiful.'[19] It was the start of another one-sided romance, with the difference that Peter Crutch was at least approachable, unlike Cliff Richard. Peter was a straight student in the Furniture Department who was in Hockney's year at the Royal College. They would occasionally meet in the college bar or in Hades coffee bar in South Kensington, and Hockney sometimes invited him to the Painting Studio to see his work; but he did not introduce him to his friends, who found Peter rather a mystery. Peter remembers Hockney with great affection today: 'David lent me the poems of Walt Whitman, and I found the Painting Studio much more interesting than the Furniture Department. We became good friends and he didn't come across as

gay at all to begin with. Later I began to realize that he had some feeling for me, but there was no problem. In any case, I think David was much more into voyeurism and fantasy than the physical side. He got on well with my girlfriend Mo Ashley from the Fashion Department, who shared his love for Cliff Richard.'[20]

Peter Crutch replaced Cliff Richard in Hockney's affections and, apart from being 'the most beautiful boy in the world', he was the subject of many other pictures, including *The Cha-Cha that was Danced in the Early Hours of 24th March* (see plate 32). Friday nights were often special nights in the college bar; on 23 March the Temperance Seven played and there was a late extension into the early hours as it was the end of term. Peter was there with Mo and other girls from Fashion and, when he was rather drunk, he began to dance on his own. At one point a student called Judy Mossay asked him to look after her handbag while he was dancing a cha-cha. This gave Hockney the idea for a painting: a gyrating figure of indeterminate sex, holding a handbag and clearly labelled 'Peter', is reflected in a mirror; two hearts are entwined, and the words 'cha cha' are written across the picture, together with 'I love every movement' from Johnny Tillotson's hit record 'Poetry in Motion'. Across the background are words from packaging, as had been the case with Typhoo tea and Alka-Seltzer, but here they are from a tube of ointment and surely have a deliberate double meaning: 'penetrates deep down, gives instant relief'. The rather smudgy painting of Peter, and the large areas of bare canvas, are further examples of Hockney's indebtedness to Francis Bacon.

Peter Crutch remembers that Hockney was especially interested in mirrors and mirror-images at this time. Hockney has told me that mirrors and glass have fascinated him for most of his life: 'Glass is like water – you can't really describe them, can you? When I was twelve I came across those wonderful lines by the mystical poet George Herbert:

> A man may look on glass,
> On it may stay his eye,
> Or if he pleases through it pass,
> And there the heaven espy.

Later this made me think about images and mirror-images, surfaces and non-surfaces, flatness and space.'[21] A painting of 1961 entitled *Boy with a Portable Mirror*, which shows Hockney pushing along a chest of drawers with a little mirror on top, seems to be the earliest example of the use of a mirror. A black chalk drawing, *Self-Portrait with Mirror and Cigarettes*, shows a figure labelled '4.8' kissing his reflection in the mirror which is inscribed with the name 'Capstan'. Above him is the word 'admit', recalling the lavatory graffiti of *The Third Love Painting*, 'come on David admit it'. An etching,

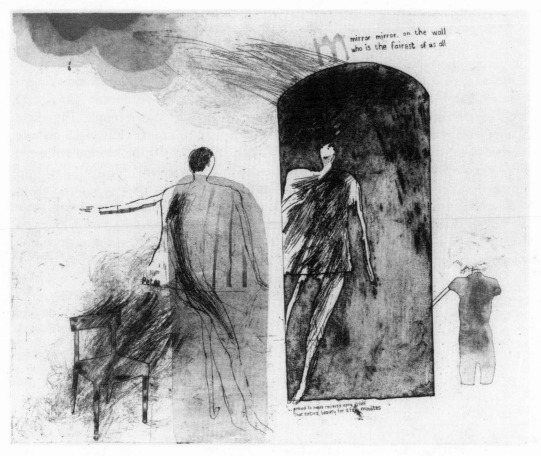

Mirror, Mirror on the Wall, 1961

Mirror, Mirror on the Wall (see above), reverses the image of Peter doing the cha-cha in the painting. It shows him, clearly named, dancing beside a chair, recalling the subject he was studying, in front of his reflection in the mirror. Above is the quote 'Mirror, mirror on the wall, who is the fairest of us all' from *Snow White and the Seven Dwarfs*, and below are the last two lines from Cavafy's 'The Mirror at the Entrance':

> But the old mirror which had seen, and seen,
> in the many years it had been
> in existence, thousands of things and faces;
> the old mirror was glad now
> and was proud to have received upon itself
> that entire beauty for a few minutes.

This same spring and summer, Hockney experimented with watercolour. *Hero, Heroine and Villain* (see plate 41) shows a large male face surmounted by three figures, like a thought-bubble. The two figures on the left are embracing: the male is labelled 'hero' and '16.3' (Peter Crutch), and the female is inscribed 'heroine' (presumably his girlfriend Mo). To the right stands another male figure, labelled 'villain' and '4.8' (David Hockney), which seems to imply that Hockney wishes to separate the couple. The whole is another fantasy image, relating to Hockney's feelings for Peter Crutch. Its delicate washes of pink and blue and the spidery ink drawing show that he had looked at the drawings of Klee and Wols; the same is true of another watercolour, *The Most Beautiful Boy in the World* (see plate 45), where one head has been conjured out of a large blob of blue paint in the surrealist manner of using chance images. This drawing shows two male figures embracing, one labelled '4.8' and the other 'D.B.', and the title. Behind the second figure is the shape of the Alka-Seltzer packet, which relates it directly to the earlier painting of the same name, but, at the same time, it is a study for a four-foot by five-foot oil painting on hardboard entitled *We Two Boys Together Clinging* (see plates 43, 64), a colourful and striking picture and the clearest evidence of Hockney's indebtedness to Dubuffet (see plate 44). This shows two boys in a passionate kiss, one with 'never' written by his mouth and the other replying 'yes', a reference to the second line of the poem 'We Two Boys Together Clinging' from Whitman's *Leaves of Grass*:

We two boys together clinging,
One the other never leaving,
Up and down the roads going,
North & South excursions making,
Power enjoying, elbows stretching, fingers clutching,
Arm'd and fearless, eating, drinking, sleeping, loving,
No law less than ourselves owning, sailing, soldiering, thieving, threatening,
Misers, menials, priests alarming, air breathing, water drinking, on the turf or the
 sea-beach dancing,
Cities wrenching, ease scorning, statutes mocking, feebleness chasing,
Fulfilling our foray.

Lines five and six of the poem appear at the right of the painting, and the poem's title is written boldly across the two figures. To the left appear graffiti, as in another Whitman-inspired painting, *For the Dear Love of Comrades* (see plate 20), and at the bottom right is a purple heart and the large letters '4.2' (D.B.). Thus *We Two Boys Together Clinging* relates to both *Doll Boy* and *The Most Beautiful Boy in the World*. The connection with Cliff Richard goes further. Although Hockney loved the opening line of the poem, as a beautiful image of homosexual love, he had also been attracted by a newspaper article

with the headline 'TWO BOYS CLING TO CLIFF ALL NIGHT'. His first reaction had been to imagine this as the fulfilment of his sexual dreams, but closer inspection revealed that the article concerned a Bank Holiday climbing accident near Eastbourne. But the sexual fantasy embodied in the painting is more complex: the left-hand figure is labelled '4.8', (D.H.), but on his partner are the numbers '3.18' (C.R.) and also '16.3' (P.C.). Thus Hockney has portrayed himself making love to his ideal fantasy, a combination of Cliff Richard and Peter Crutch.

At the beginning of the summer term, Hockney met Peter in Hades coffee bar and told him he had stretched two small canvases but didn't know what to paint. Peter offered to model for him, and so Hockney painted his first specific portrait since *Portrait of My Father* of 1955. He painted Peter's head and torso on the larger of his two canvases and then decided it looked incomplete. Peter naïvely suggested he used the smaller canvas for his legs and then fit them together, and Hockney did exactly that. The result is another shaped canvas, showing the full-length portrait of Peter in a purple jacket with a little red heart, a green shirt and fashionably narrow dark blue trousers (see plates 40, 69). Hockney has written the words 'My friend who is the m . . .' and the title *Peter C* is printed on the canvas using old-fashioned wooden letters from the Print Room. Peter was known to all his friends as Peter C.; Crutch was considered a rather unattractive name.

At the end of May, Hockney wrote to Mark Berger who had returned to New York, telling him of his excitement at having completed this picture: 'Brother, T.M.B.B.I.T.W. [*The Most Beautiful Boy in the World*] has really caught on now. I've been doing a reasonably "straight" portrait of him – with his name set up in type and printed on the canvas. I did this before he came over, printing it on 2 canvases thus – [two diagrams], intending to do 2 heads, but as he stands so beautifully, I joined the two together and did a full length picture, but as the canvases are different sizes, it looks thus – [diagram]. He's given me an absolutely marvellous photograph of himself – unbelievable. He tells me how he used to do ballet dancing in some pretty black leather shoes with a little black bow on each – isn't he the sweetest. I gave him (amongst other things) a set of my engravings, all inscribed to him with all my love and xxxxxx'.[22]

During the summer term of 1961 many of the Royal College staff were involved in a major outside project, the interior design of the S.S. *Canberra*, the new cruise liner built by the P & O Line. The company's chairman, Donald Anderson, was the brother of Sir Colin Anderson, Provost of the college, so the college was given this prestigious job. Head of the School of Interior Design was Hugh Casson, later to be President of the Royal Academy, and he was in charge of the whole project. Artists invited to contribute included Ruskin Spear, Julian Trevelyan, Humphrey Spender and Edward Ardizzone.

John Wright, Senior Tutor in Interior Design, planned a teenagers' room with pin-tables, drinks machines, a jukebox and television. He offered Hockney the job of decorating the walls and so he spent a few days in Southampton. The walls had been covered with natural wooden boarding, so he decided to decorate them using an electric poker. The result was witty childlike drawings adorned with graffiti, an extension of his college paintings (see plates 46, 47). A boy called Jack was adorned with 'Save the Last Dance for me', the title of a pop song by the Drifters. A woman called Honey, and labelled '50 year old teenager', danced a cha-cha. There were references to 'Nelly Dean', 'Bye Bye Blackbird', 'The Monster from the Deep', 'Dracula'. There was a 'Handsome Milkman, 21', and a boy called Red who was told 'get your hair cut' and replied 'no, never'. Maisie (36.25.36) embraced cigarette-smoking Jack as in *We Two Boys Together Clinging*, and he told her, 'You're never alone in the Strand or Piccadilly', a skit on the current cigarette advertisement 'You're never alone with a Strand'. Hockney described the work in a letter to Mark: 'I finished the "mural" on this ship – and saw it last night on a newsreel at the Forum, Fulham Road. I had quite a crazy ten days down there – the crew continually coming up to see me and watch. As I was working, a cabin boy came up and asked me to write his name up. I agreed and he told me it was "Jesse". I thought, well, it could be a boy's name, and promptly wrote it. Ten minutes later he came back with all his mates (all aged about 16), all wanting their names up – "Betty", "Judy", "Susan" etc. All in a day's work eh!'[23] Hockney's idea was that teenage passengers would feel free to add their own graffiti. Unfortunately, his images soon began to be obscured by a mass of often rude additions, and they were finally boarded over when the teenagers' room became the ship's camera shop.

One day, out of the blue, somebody in the college offered Hockney a return air ticket to New York for £40. He could not believe that it was possible to go to America so cheaply, so he asked Kasmin for the money and bought the ticket. His £100 prize money from Robert Erskine for *Three Kings and a Queen*, plus an extra £100 for the *Canberra* mural would provide his pocket money, and so he left London at the beginning of the vacation in early July for two months in New York. Mark Berger had invited Hockney to stay at his parents' house in Long Beach in the suburbs. He was in hospital recovering from hepatitis when Hockney arrived, but he was allowed home soon afterwards. Mark's stepmother loved the strange young Englishman, even though he did not change his clothes and have a bath every day, which she thought essential. His father was less impressed, and considered Hockney a slob. It did not help that he was in the habit of leaving drawing materials all over the house, and once spilt ink on the living-room carpet. When Mr Berger remonstrated, Hockney offered to sign the carpet so that it would be worth a fortune one day. When lobster was served for dinner, he was horrified.

Although a vegetarian, he had agreed to eat fish, but the lobster was too much like an animal, and he refused to touch it. He disapproved of Mr Berger's habit of spraying insecticide around the kitchen every day, and made a watercolour sketch of a man with the words 'crawling insects' written all over the ground under his feet and a large aerosol can spraying the insects. He made use of this the following year in England when he painted a canvas called *The Cruel Elephant*, which shows a man sitting on top of an elephant and little insects, together with the words 'crawling insects', in the grass below. He explained this at the time: 'I'm a vegetarian, and this shows in a lot of my paintings, particularly in the elephant picture. The elephant is trampling on the grass and crushing the insects; it wouldn't be a cruel animal without a man on its back and I've put a little anonymous man up there.'[24] Hockney was to give up vegetarianism in the harsh winter of 1962, when his doctor told him that a diet of baked beans was not going to keep him alive and healthy.

One incident above all others made Hockney unwelcome to Mark Berger's father. One evening, Mark and he were watching television in the house with Barry Bates from the Royal College, who was also visiting New York, and Ferrill Amacker, a friend of Mark's from New Orleans. They were all a little drunk when an advertisement for Lady Clairol hair colouring came on the screen: 'Blondes have more fun. Doors open for a blonde.' Hockney announced that if that were so, he was going to dye his hair. The others all agreed to do likewise and they went out to buy some Lady Clairol from the drugstore. They set to work immediately, and by the time Mark's father returned home, all four were blonde. He was furious, and said he was not having such behaviour in his house.

Hockney moved into Ferrill Amacker's apartment in Brooklyn. Ferrill was a painter and photographer from a rich family, and therefore did not need to earn his living. Hockney and he became close friends. Ferrill knew all the gay clubs and cruising areas of the city and, since Hockney was too shy to visit such places on his own, the two went around together. In Mark Berger David had an excellent guide to the galleries and museums, and so all his needs were being met. Robert Erskine had given him an introduction to William Lieberman of the Museum of Modern Art and, to Hockney's utter astonishment, Lieberman bought copies of *Mirror, Mirror on the Wall* and *Kaisarion* for the Museum's collection. All the prints he had brought with him were sold in New York, making him richer by $200. Lieberman arranged for him to use the facilities of the Pratt Institute, where he made an etching, *My Bonnie Lies Over the Ocean*. The print is inscribed 'New York, July 1961' and shows, on the left, a figure labelled 'D.H.' on top of a skyscraper holding a giant American flag. Above the sea in the middle of the image is written the title, and on the right is a man with a letter 'P' holding a Union Jack and the words 'My bonnie lies over the sea'. Hockney had written to Peter Crutch from New York saying how much he missed him. He printed the etching on his

return, sticking a one-cent postage stamp with the head of George Washington on top of an etched figure of a man by the skyscraper on each print, and he gave the first proof to Peter inscribed 'To Peter C. with all my love', together with a pile of American cha-cha records.

The only artist Hockney met in New York was Claes Oldenburg, who was hanging a new exhibition of *papier mâché* shirts and ties at the Green Gallery. But he loved his first experience of the country where he would later live: 'The life of the city was stimulating, the gay bars – there weren't many in those days; it was a marvellously lively society. I was utterly thrilled by it, all the time I was excited by it. The fact that you could watch television at three in the morning, and go out and the bars would still be open, I thought it was marvellous. And I did quite a lot of drawings then.'[25]

Hockney returned to college in September 1961 with sketch-books full of drawings in a spiky pen-and-ink style. He was determined to make something of them but, first, he began work on his largest painting to date, *A Grand Procession of Dignitaries in the Semi-Egyptian Style* (see plate 63). He had bought a stretcher measuring seven feet by twelve feet in the summer from a student who could not afford the canvas, realizing that such a picture would assure him of a large space in the Painting Studio at the beginning of the autumn term. He had earlier been interested in the anonymity and the flatness of Egyptian friezes, examples of which he had seen in the British Museum. For such a large composition involving, for the first time, three figures, he felt Egyptian art was the best guide, but, since his composition was not as flat as an Egyptian frieze, he thought it correct to use the term 'semi-Egyptian style'. In New York he had read a new translation of Cavafy's poems, and 'Waiting for the Barbarians' seemed to him to suggest the necessary scale for such a large canvas. Cavafy wrote ironically about Roman officials donning their finest embroidered togas and choosing their most ostentatious jewellery in order to 'dazzle the Barbarians'. In Hockney's version, an ecclesiastic in a bishop's mitre, an Egyptian-looking soldier wearing his medals, and an industrialist with a top hat and three rows of stencilled workers (as in *View of Bradford from Earls Court*) on his jacket parade their self-importance across the canvas, while little men inside them reveal their true stature. They stand on a stage along which is written the painting's title; above them are the tassels of a curtain, so that the essential theatricality of the scene is stressed. This was an idea he was to take further the following year.

Two other paintings of autumn 1961 refer to New York. *Sam Who Walked Alone by Night*, another shaped canvas showing a boy with heavy lipstick, wearing a pink dress, with his name beside his heart, was inspired by a story about a transvestite in a gay magazine. It is another example of Hockney's interest in the childlike art of Dubuffet.

I'm in the Mood for Love is based on two New York sketches and shows Hockney as a horned devil in glasses, sandwiched between two very phallic skyscrapers, one of which he is clasping. There is graffiti from the subway: 'To Queens Uptown'; 'No Smoking'; 'BMT', and also the date 'July 9th', his birthday. The letter 'P' appears in the sky, and a badge from New York bearing the title of the painting used to be attached to the canvas until it was stolen.

Hockney wanted to make something effective out of the sketch-books he brought back from New York, and he hit on the brilliant idea of producing an updated version of Hogarth's 'Rake's Progress' engravings, transferring the story of a young man's experiences on first visiting London in the eighteenth century to New York two hundred years later. In this way he had a structure in which he could use his own drawings and memories. Originally he planned to produce eight prints, as Hogarth had done, using the same titles, but Robin Darwin was so impressed by the plan that he asked Hockney to make a total of twenty-four images for the college to publish under its own imprint, the Lion and Unicorn Press. This proved to be too difficult and time-consuming, and a compromise of sixteen etchings was agreed. These took two years to complete, and necessitated a further visit to New York in 1963. The college asked Hockney to find someone who would write an accompanying text, and Lord Gowrie, who used to visit Hockney in the studio to see his latest work, suggested a young American poet, David Posner. The finished volume, illustrated with reproductions of Hockney's prints, was published in 1963, and included Posner's blank-verse poem about the low life of America, which made no attempt to parallel the images. Paul Cornwall-Jones of Editions Alecto saw the proofs in the Print Department of the college and immediately offered Hockney £5,000 for the plates and the right to publish them. The money was to be paid over two or three years, but Hockney was absolutely delighted, as it would enable him to go and live in America for a year at the end of 1963.

The sixteen etchings of 'A Rake's Progress' use hardground and aquatint and are printed in red and black. They show, in their varied subject-matter, an amazing grasp of the wide possibilities of the medium. The images come from Hockney's recollections of New York, his sketch-books and, in one case, a photograph by Cecil Beaton, 'Death in Harlem'. The first plate shows the rake (Hockney) arriving with his suitcase on the Flying Tyger air charter from London and viewing the skyscrapers of New York with amazement. Hogarth's title *Receiving the Inheritance* is interpreted in the second scene as the rake selling his print of *Myself and My Heroes* to William Lieberman, who beats him down from $20 to $18. The next two scenes show the Rake visiting the presidential monuments in Washington, and attending a gospel concert given by Mahalia Jackson in Madison Square Garden; both are based on Hockney's personal experiences. The plate *The Start of the Spending Spree and the Door Opening for a Blonde* shows the Rake,

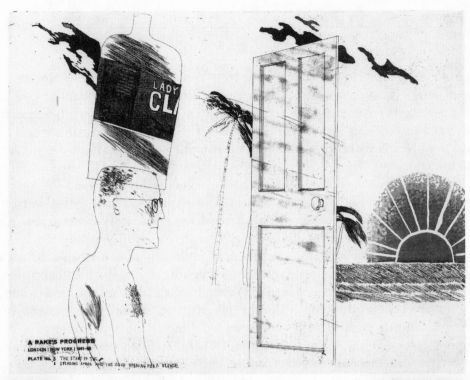

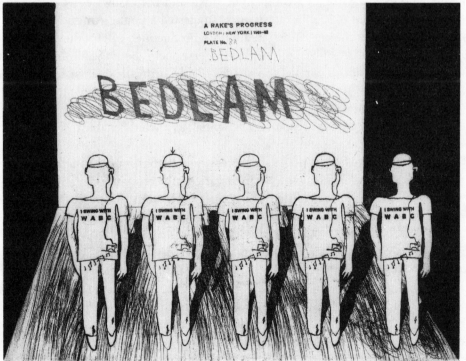

'A Rake's Progress', Plate 3, *The Start of the Spending Spree and the Door Opening for a Blonde*, 1963

'A Rake's Progress', Plate 8a, *Bedlam*, 1963

transformed by a bottle of Lady Clairol, approaching a door which opens onto a sunrise representing his rising hopes. He then watches athletic young men running in Central Park and feels ashamed to be a *7-Stone Weakling*. The following scenes show his slow decline through too much drinking in gay bars, his marriage to an old maid for her money, the evaporation of all his funds and his eventual incarceration in Bedlam. Unlike Hogarth's madhouse, this is shown to be symbolic of a total loss of individuality in a mindless society of robots tuned into transistor radios, all wearing T-shirts printed with 'I swing with WABC'. In both conception and execution, 'A Rake's Progress' must be considered one of the highest achievements of Hockney's early career.

Janet Deuters and Derek Boshier were heavily involved in the college's Christmas revue for 1961, and persuaded Hockney to join them. During the previous May, he had written with great enthusiasm to Mark Berger in New York about a drag show he had seen in the Portobello Road, in which 'a young boy came on to sing "I'm just a girl who can't say no" and "I enjoy being a girl" with of course the obvious twist to the words.' He added: 'The funny thing was that he made the most gorgeous woman – blonde hair, and a tight long red sequin dress, with a white fur cape.'[26] For the revue, he borrowed Janet's costume from her *Gypsy* act of the previous year, added an outrageous blonde wig and performed a duet with her of 'I'm Just a Girl who Can't Say No' to rapturous applause. The moment was recorded for posterity via the camera of Ferrill Amacker (see plate 26).

At the end of 1961, the Registrar of the Royal College, Mr Moon, wrote to Fred Coleclough of Bradford College of Art about Hockney's progress. He listed seven 'solid and impressive' achievements including prizes, commissions and exhibitions, and gave an interesting official view of Hockney: 'He has become the College's No. 1 Character, whose influence extends out beyond the Painting School, and his work and doings are watched by all up and coming students. He still spends most of his time painting, but has done a number of very interesting etchings which have created a great deal of notice. He visited the United States in the summer, and returned with a yellow crewcut, smoking cigars and wearing white shoes. I think it was the funniest sight I have ever seen! However, that is wearing off; the cigars have all run out, and I imagine he has pawned his shoes.'[27]

Mark Berger, who since September had been in Florence on a Fulbright Scholarship to study Italian art, invited Hockney to visit him for Christmas. Ferrill Amacker had also decided to spend some time in Italy, so he joined Hockney in London in December. Michael Kullman was driving his little Mini-van to Berne for Christmas and offered them both a lift. Since it was Ferrill's first trip to Europe, he sat in the front with Michael while Hockney had to make do in the back. As they drove through Switzerland, Ferrill was stunned by the views, but Hockney, in the back of the van, could only catch the occasional glimpse of a mountain. They took a train from Berne to Florence, where they

stayed in Mark's flat. Hockney had expected Florence to be beautifully warm, but it was very cold with snow on the ground, 'like a Dickensian London Christmas card'.[28] Although he made visits to the Uffizi Gallery, he stayed indoors by the fire most of the time, reading *The Times* and doing a series of sketches of the trip though Switzerland. In some he showed himself sitting in the back of the van amongst a series of towering mountains. These were to be the basis of two paintings on which he worked as soon as he returned to college. *Painting in a Scenic Style* shows his seated figure with lines extending behind to show that he is in movement. In the background are mountains painted in broad bands of colour, in imitation of geography book illustrations and of the abstract paintings of the Cohen brothers, to make the point that he had not actually seen them. This was followed by *Flight into Italy – Swiss Landscape*, a larger and more complicated painting which shows Hockney seated in the back of the van behind Michael, trying to catch a glimpse of the mountains. Amongst the diagrammatic peaks from the previous painting is one carefully observed snowy mountain copied from a postcard. The heights of the mountains are marked, together with signposts to Paris and Berne, and by the van's exhaust is written 'that's Switzerland that was'.

February was the month of the 'Young Contemporaries' Exhibition. After the splash made the previous year by Hockney and his friends which had led them to be labelled 'Pop Artists', this show saw them revert to their individual identities. Works submitted by Boshier and Phillips were in the same vein as the previous year, but Hockney was determined to gain maximum exposure and publicity for the development and variety of his work. He chose, therefore, to exhibit four of his recent paintings and to retitle them, so creating a homogenous display of his own. Each work was prefixed 'Demonstration of Versatility'; the four pictures chosen were *Tea Painting in an Illusionistic Style, Figure in a Flat Style, A Grand Procession of Dignitaries in the Semi-Egyptian Style* and *Painting in a Scenic Style*. Thus he drew attention to his work in the gallery, just as he assured himself of extra space in the catalogue by his long titles. In a letter to the American painter Larry Rivers, who had recently visited the Royal College and expressed interest in his work, Hockney explained: 'I deliberately set out to prove I could do four entirely different sorts of picture like Picasso. They all had a subtitle and each was in a different style, Egyptian, illusionistic, flat – but looking at them later I realized the attitude is basically the same and you come to see yourself there a bit.'[29]

The fascination with style as a subject was something Hockney had picked up from Kitaj, and the confidence to experiment in this way was the result of many hours spent at the Picasso exhibition of 1960. The 'Young Contemporaries' show was extensively discussed by the art critics, and Hockney was singled out by John Berger in the *Observer* and Ray Watkinson in *The Arts Review* for special comment. *The Times* critic wrote of

the 'raspberry-blowing "new surrealist school" (for want of a better name) at the Royal College of Art', and mentioned David Hockney as 'its present star turn'.[30] The result was that Hockney was chosen as one of four exhibitors 'whose work shows special promise', and they were invited to mount a group show at the Institute of Contemporary Arts in the summer.

The 'Young Contemporaries' show served to confirm the existence of a school of British Pop Art in the eyes of the public. Hockney never saw himself as belonging to such a group, and it is significant that, when Ken Russell made a television film in early 1962 called *Pop Goes the Easel*, the four artists he chose were Peter Blake, Derek Boshier, Pauline Boty and Peter Phillips. He did not consider Hockney to be representative of the label. In fact, Hockney appeared at the end of the film at a party in Dick Smith's studio. Peter Blake, Derek Boshier and Peter Phillips have consolidated their positions as leading figures in British painting; Pauline Boty, a very talented artist, sadly died a few years after Russell's film was made.

Hockney made three lasting friendships at this time. In a house in Ladbroke Grove, Notting Hill Gate, shared with singers Rod Stewart and Long John Baldry, lived Mo McDermott, a fabric design student from Salford College of Art who greatly admired Hockney's paintings at the 'Young Contemporaries' show. He engineered a meeting with Hockney at a party given by artist Brett Whiteley who lived next door. Recently he recalled that first meeting: 'I told him I'd loved his paintings, but he was very shy. He realized I came from the north and told me he did, too. So we had that in common. Then I told him I'd been modelling at St Martin's, and he asked me if I'd model for him. He said they only had female models at the Royal College and most were rather fat and ugly and did nothing for him. So I agreed. I went along to the studio next day and the college paid me £12 per week. People complained that Hockney was allowed his own model, but really anyone could have used me if they had wanted to.'[31] Mo remained one of Hockney's favourite models and was to become his full-time assistant. He died in 1988. At Salford, Mo had been very friendly with another fabric design student, Celia Birtwell. She followed him to London and shared a flat with Pauline Boty in Addison Road, Bayswater, where Derek Boshier and Peter Blake had a studio. She did not get to know Hockney well until a few years later, when she married Ossie Clark. Since then she has been his greatest confidante and most frequent model. 'Ossie' was the nickname of Raymond Clark from Oswaldtwistle in Lancashire. He met Celia and Mo when he was studying fashion at Manchester College of Art and they all became close friends. When Hockney visited Manchester in 1962, Norman Stevens, who was teaching at the college, introduced Ossie to him. Hockney found him very attractive and friendly and, when Ossie joined the Royal College School of Fashion later in the year, they saw a great deal of each other.

In spite of his increasing fame in the London art world, Hockney continued to appear at the Royal College each day as the time of final assessment approached. During the spring and summer terms he completed many more paintings, including *Help* (see plate 62), a tiny canvas produced for a friend's elaborate wooden frame, which shows a little man shouting the title as he tries to escape from the constrictions of the frame; and *The Snake*, an amusing variant on a Jasper Johns 'Target' painting. *Teeth Cleaning, W11* (see plate 66) continues the humorous theme with its image of two men having oral sex in the 69 position, each erect penis represented by a tube of Colgate toothpaste. But it contains hints of sexual violence as well: beside the tube of vaseline are rows of threatening teeth that seem about to devour the phalluses, and chains manacle one of the participants. In an interview in 1975, Hockney spoke about bondage: 'I've been involved with a few people who wanted me to tie them up and I found it quite exciting sometimes if you are turned on by the person. It's an interesting idea. But real sadism I couldn't take. It's not my idea of fun sex at all.'[32]

Every painting student at the Royal College was required to submit at least one life painting for his final assessment. Hockney's pictures were not acceptable, and so, in the summer term of 1962, he produced *Life Painting for a Diploma*, a deliberately cheeky title for a copy of a male physique magazine cover showing a muscle-man in a posing pouch. Beside him Hockney pasted one of his skeleton drawings from his first weeks at the college. His friends followed his example: Peter Phillips collaged pin-ups onto a life painting and stencilled 'model' across the painting, and Derek Boshier copied poses from pin-up magazines he had bought at South Kensington underground station. Hockney's second work in this vein was less highly finished: *Life Painting for Myself*, which shows Mo (misspelt 'Moe') both standing and sitting in a corner of the studio, with his discarded jeans and sweatshirt beside him. The title of each painting is written on the canvas in Hockney's handwriting, but on the second painting appear the words 'don't give up yet?' in some unknown wit's writing, which he decided to leave as part of the picture.

Another requirement was that all students should have a pass in Art History and General Studies. Hockney, Barry Bates and three other students were informed in April that they had failed that part of the assessment and could present themselves for further consideration in a year's time if they produced additional General Studies work. Hockney felt that this was similar to being told to stay in after school for being a naughty boy, and he refused. He had objected to the General Studies course in his first year. He had produced only one essay, on a subject – Fauvism – in which he had no choice. It was an average piece of work showing little enthusiasm and no originality, and Michael Kullman marked it C+. Hockney told the Registrar, Mr Moon, that he had no intention of submitting more work and did not particularly want the Diploma. He proceeded to produce his own Diploma in the Print Room, using a metal-block with the title and coat of

arms of the college. To this he added the figure of Robin Darwin, accompanied by a crescent moon for the Registrar and supporting Michael Kullman, who was shown with two faces. Bowing their heads in shame at the base of the image were Hockney and the other four failed students.

When the Examinations Board met in early June, Darwin announced that he was intending to award the very rare distinction of a gold medal to Hockney as an outstanding student. He was horrified to hear that his General Studies marks indicated that he had failed his Diploma. With a stroke of his pen he changed the marks, saying that the arithmetic was wrong and, in any case, to fail such a student would hold the college up to ridicule. When an announcement appeared on the college noticeboard to the effect that Hockney and one other student had passed but that the other three had failed, Hockney went to see Mr Moon and complained that this was grossly unfair. The result was that all five were awarded their Diplomas. To this day, Hockney feels angry about the whole matter.

At the Convocation ceremony in July, at which the politician Sir David Eccles, the writer Sir Herbert Read, the car designer Alec Issigonis and the architect Sir Basil Spence were honoured with Fellowships, there was speculation among the students as to whether Hockney would or would not receive his Diploma. When the convenor announced 'The gold medal for work of outstanding distinction is awarded to David Hockney, School of Painting', he went up to collect it wearing a gold lamé jacket in place of the required academic gown. The applause was deafening. He then proceeded to collect not only the Diploma of an Associate of the Royal College of Art, First Class, but also the College Life Drawing Prize. It was a triumphant end to a sparkling college career.

It was Janet Deuters who suggested the gold jacket. She had seen it on sale at Cecil Gee's shop in Charing Cross Road, and Hockney rushed to buy it on the day before the ceremony. She also found gold carrier-bags in Camden Town, and bought one for herself and one for him. Both jacket and carrier-bag soon entered into the popular mythology that gathered around Hockney. It was said that he collected his gold medal from Robin Darwin in a gold carrier-bag, and that he wore his gold jacket regularly from then on. In fact, he acquired the bag after the ceremony, and only wore the jacket on one other occasion, when Lord Snowdon came to photograph him for the *Sunday Times* in May 1963.[33]

the house of a man who had made the Journey to Mecca. Luxor. Oct '63.

CHAPTER THREE

LONDON 1962–1963

During the summer term, Hockney had, by chance, met an American boy named Jeff Goodman who was asking at the Arts Council Shop in Baker Street for information about cultural life in London. He was wearing a checkered jacket and had real blonde, wavy hair. Hockney grew very fond of his new friend but Jeff wanted to tour Europe and left London soon afterwards. Hockney gave him Mark Berger's address in Florence, and arranged to meet him there in July. So, after the end of term, he and Janet Deuters and Sylvia Eyton bought three single tickets from Victoria Station to Florence to stay with Mark. Ferrill Amacker was also living in Florence, and Jeff Goodman turned up quite soon. The group visited the museums of Florence and Rome and then spent a few days at the seaside resort of Viareggio, where they were all saddened to hear of the death of Marilyn Monroe, which took some of the joy out of their holiday. In Viareggio Hockney made drawings of boys at a swimming pool and of men under a large clock advertising Fiat Motors. He loved Italian boys, who he thought were among the most beautiful in the world, and, back in Florence, he drew some of them as ideas for a painting of Michelangelo's young lover Cecchino Bracci.

Hockney and Jeff then took the train to Berlin via Munich. He had read Christopher Isherwood's Berlin stories and wanted to see if the gay bars still existed. He found the Kleinst Kasino and wrote the address on the page of his sketch-book which also included a drawing of a leaping leopard copied from a picture he saw in a museum. Other drawings were done in the Pergamon Museum, where he was amused to catch sight of Jeff standing next to a seated Egyptian female sculpture, so that they looked like man and wife. He was horrified to witness the shooting of a young East German trying to escape to the West, so much so that he recounted the experience in a letter to his sister Margaret.

Hockney felt lonely on his return to a cold English winter because Jeff had gone back to America, so he immediately started work on a series of paintings inspired by his summer holiday experiences. These included *In Memoriam Cecchino Bracci*, a curious coffin-shaped canvas of Michelangelo's young lover who died at the age of fifteen, with a laurel wreath containing his name; and *Picture Emphasizing Stillness*, in which the Berlin leopard seems to be about to attack two unaware nude men, although David has written between them the words 'they are perfectly safe. This is a still' to emphasize the impossibility of communicating a sense of urgency in a painting. *Berlin: A Souvenir* is a

The House of a Man who had Made the Journey to Mecca, 1963

seven-foot-square canvas with the word 'Berlin' emblazoned across the top in blue above scenes of the life in Berlin's gay bars. One can make out a nude boy, a transvestite and a dancing couple among the brightly coloured and spirited paintwork which marks the end of Hockney's use of Abstract Expressionist techniques.

By the autumn of 1962, Hockney had been featured in four important London exhibitions, in addition to his Diploma show at the Royal College. After the 'Young Contemporaries' came 'Four Young Artists' at the Institute of Contemporary Arts in July, followed by 'Image in Progress' at the Grabowski Gallery in August. This included Boshier, Jones and Phillips, and each artist was asked to provide a statement for the catalogue. Hockney wrote: 'I paint what I like, when I like, and where I like, with occasional nostalgic journeys. When asked to write on "the strange possibilities of inspiration" it did occur to me that my own sources of inspiration were wide, but acceptable. In fact, I am sure my own sources are classic, or even epic themes. Landscapes of foreign lands, beautiful people, love, propaganda, and major incidents (of my own life). These seem to me to be reasonably traditional.'

In November the Royal College put on an exhibition entitled 'Towards Art? The contribution of the RCA to the Fine Arts, 1952–62'. Not only was Hockney invited to contribute two life drawings and two paintings (*I'm in the Mood for Love* and *Going to be a Queen for Tonight*), but he was also commissioned to design the poster, the invitation and the catalogue cover. In the college journal, *Ark*, Dick Smith chose three graduating students – Boshier, Phillips and Hockney – as his tips for future success, and of Hockney he wrote: 'Hockney's paintings have the look of an ad-man's Sunday painting. This is not a criticism for it demonstrates that there is now the possibility of a two-way exchange between the selling arts and the fine . . . Hockney as a personality is bound up with his paintings. The paintings can serve as letters, or diary-jottings or mementoes: the figures *are* portraits; events portrayed *did* happen; someone *did* dance the cha-cha at three in the morning.'[1] And the popular press was beginning to notice him as well. *Town* magazine reproduced a photograph of him patting the shoulder of the muscle-man in *Life Painting for a Diploma*. In the accompanying article, Emma Yorke described him thus: 'His hair is an improbable buttercup yellow and his heavy spectacles give an air of ridiculous seriousness to his face . . . His head glints in the sun like a newly thatched cottage.' David supplied the obliging quote: 'I wish I could dye the whole of Bond Street blonde, every man, woman and child. I don't really prefer blonde people but I love dyeing hair.'[2]

The *Town* article stated that Hockney lived 'in a dingy basement in Ladbroke Grove. He is looking desperately for a studio to work in as his term at the Royal College has come to an end.' For part of the year he had shared a flat with Mike McLeod in Lancaster Road, Notting Hill Gate, but had then moved into Mo McDermott's house in Ladbroke Grove.

One day in the autumn he met Don Mason in the street, who told him that his aunt had offered him her flat round the corner, at 17 Powis Terrace, but he could not afford the rent. Hockney quickly visited the first-floor flat and fell in love with it. Kasmin agreed to put up the key money in exchange for storage space, and so Hockney obtained the lease. He was to live at that address for nearly twenty years, eventually owning the whole house. Derek Boshier and Peter Blake had a studio nearby in Addison Road, though both lived elsewhere, Peter with Dick Smith in Turnham Green, and Derek with Pauline Fordham in Putney. Pauline had been a Fashion student at the college, and she was a friend of Dick Smith with whom she had previously been at college in St Albans. Both Mike Vaughan and Dave Oxtoby were living in Notting Hill Gate, and Mike Upton had a flat in Colville Square at the end of Powis Terrace. He was now married to Ann who, with her long red hair, was a well-known model at St Martin's College of Art. Like Hockney, she was a vegetarian, and they often cooked for each other. He had obtained a modelling job at the Royal College for her and they used to have tea together in the café of the Victoria and Albert Museum. They became close friends and have remained so.

Hockney's flat in Powis Terrace consisted of two rooms with kitchen and bathroom, and to him it was like a palace after his previous accommodation. At last he could paint and live in the same place; and it only cost £5 a week. He used his bedroom as his studio. At the foot of his bed was a chest of drawers and, as it was the first thing he saw every morning, he painted 'Get up and work immediately' in careful roman lettering across it. For the first time in his life he had a home of his own, where he could entertain his friends. Patrick Procktor would often come from Kentish Town to play chess until late in the night and, at weekends, the flat was never empty. On Saturdays Derek Boshier and Pauline Fordham would travel to the Portobello Road market where they would meet Peter Blake and Pauline Boty, and perhaps Patrick Procktor and Mo McDermott, and they would all search for bargains among the clothes stalls before going to Hockney's flat for afternoon tea. The place was always in complete chaos, with dirty clothes and unwashed crockery and full ashtrays and an empty fridge, but there was always plenty of tea. Other callers would arrive and eventually the whole group would move off to a nearby pub and restaurant. It was a far cry from the Earls Court garden shed.

Hockney was now receiving his £600 a year from Kasmin and he was also teaching one day a week at Maidstone School of Art. He had been invited by Gerard de Rose, an eccentric and colourful painting teacher who loved bringing new talent like Patrick Procktor, Mike Upton, Dave Oxtoby and Norman Stevens into the college. When he died in 1987, de Rose stipulated in his will that beer, cigarettes, a telephone and a video recorder were to be placed in his coffin in case he woke up. Hockney proved to be a hard taskmaster as a tutor. He painted the slogan 'work' in four-foot-high letters on the studio wall and, when he posed the male model on a sheet of the *Daily Mirror*, he insisted the

students draw every detail including the newsprint. One day he told them to saw their hardboard paintings in half, then took them to the local river and ordered them to throw the bits in. He felt that this was the way to teach them not to become too precious about their work.

In his new studio in Powis Terrace, Hockney worked on the most important painting that resulted from his summer trip, *The First Marriage*. This developed from drawings made in his Berlin hotel room and the painting *Man in a Museum* of September 1962, all of which record the moment when he caught sight of Jeff Goodman in the Pergamon Museum standing next to a seated wooden Egyptian figure: 'From the distance they looked like a couple, posing as it were for a wedding photograph. This amused me at first, but then I rather liked the idea of the marriage of styles, as it were. The heavily stylized wooden figure – with the real human being.'[3] In *The First Marriage*, the two figures are shown exactly as he remembered the scene, with the 'bridegroom' standing politely beside his 'bride' who has sat down, perhaps because she is a little tired. The figures are stylized, the wife more than the husband, to give the picture unity. They have been given an ambiguous setting with a palm tree and a Gothic church window (an association with marriage). The concentric rings of the sun and the bride's ear-ring and breasts are another amusing comment on the 'Target' paintings of Jasper Johns, and the large expanses of bare canvas which negate any sense of illusion are a further debt to Francis Bacon. There is also a reference to Larry Rivers in the smudgy painting and the selective references to parts of the body.

Towards the end of 1962, when *The First Marriage* was completed, Hockney made drawings for a second version of the idea. He wanted to place the scene in a specific setting, so he created an isometric projection of a room by fitting three canvases together, an idea he had used for *Tea Painting in an Illusionistic Style*. This marriage of styles, painted in early 1963, therefore became an exercise in illusionism and perspective in contrast to the flatness of the first version. The figures are seated on a sofa in a domestic interior beside a wallpapered wall and next to a table complete with bottle of wine and two glasses. Curtains hang behind them and the carpet is patterned like a mosaic, a reference to the bride who was inspired by an Egyptian stone princess which he had seen in the Pergamon Museum in Berlin.

Hockney felt that *The Second Marriage* contained elements of domesticity and theatricality which could be fruitfully developed further, although he decided to abandon the idea of a shaped canvas. *The Hypnotist* continues the theatrical theme, with two figures in confrontation on a stage. A preliminary drawing entitled *Two Figures on a Stage* shows two men kissing, but this was rejected in favour of two separate men. A hypnotist's act seemed to provide the format for such a composition; in fact, the idea was suggested by a scene between Vincent Price and Peter Lorre in the film *The Raven*. Mark

Berger, on a visit from America, posed for hours, with his hands held out, for the hypnotist, who faces his innocent helper from the left-hand side. As with *The First Marriage*, Hockney made an etching of *The Hypnotist*, and the reverse image, with the hypnotist exercising his powers from the right side, demonstrated to him how important it was to remember that people read pictures from left to right.

At the same time as *The Hypnotist*, Hockney began work on a series of domestic scenes which he saw as a way of returning to the activity of painting from life as he had done with *Life Painting for Myself*. Once again he used Mo McDermott as the model, this time standing naked on the bed in Powis Terrace for *Domestic Scene, Notting Hill Gate*. He decided to make a very selective version of his flat, and so included only the essentials as they presented themselves to his eye: a standard lamp, a curtain, a vase of flowers. Later he added the figure of Ossie Clark, sitting in the chintz-covered armchair, but he did not bother with the floor or the ceiling. He made preliminary drawings of both Mo and Ossie, but painted the figures straight from life.

Domestic Scene, Broadchalke, Wilts was painted entirely from drawings made on a visit with Joe Tilson and Peter Phillips to the writer and ballet critic Richard Buckle, who had rented a cottage in Wiltshire. Hockney drew Peter and Joe sitting on the sofa in front of the window, and also the table with vase of flowers and the bentwood bamboo plant-stand. These elements were incorporated into the second domestic scene on his return to London. Richard Buckle was organizing an exhibition for Stratford-upon-Avon to celebrate the 400th anniversary of Shakespeare's birth. Leonard Rosoman, Ceri Richards, Peter Phillips and Peter Blake were involved, and Buckle persuaded Hockney to make a drawing of medieval and modern characters on the road to Stratford which was reproduced in the catalogue and enlarged by a scene-painter for the exhibition in 1964.

Domestic Scene, Los Angeles (see plate 52), the last in the series, is entirely imaginary, since Hockney's first visit to California was not until 1964. It shows two naked boys; one is soaping the back of the other, who is taking a shower. The chintz-covered armchair and telephone were painted from life in Powis Terrace and the vase of flowers from an illustration in a women's magazine. The pose of the two boys was taken from *Physique Pictorial*, a Los Angeles gay publication that specialized in photographs of young men in mildly homosexual situations – wrestling, swimming, showering et cetera (see plate 54). Jockstraps or – in this case – aprons were worn, since frontal nudity was not at this time legally permitted.[4] The painting represents Hockney's fantasy about California as the land of beautiful, semi-naked boys. It also shows an interest in depicting water that was to preoccupy him during the following years. Showers were to become a favourite subject. He had had one installed in Powis Terrace soon after his arrival. He made many pencil and coloured crayon drawings of Mo and other friends in his shower in late 1962 and early 1963, as well as similar scenes inspired by photographs in *Physique Pictorial*.

Many of these drawings concentrate on the buttocks, as the area of particular erotic interest to him. *Two Men in a Shower*, painted later in 1963, is a direct result, since the man on the left is painted from *Physique Pictorial*, and the man behind the shower curtain is Mo painted from life in Hockney's bathroom.

Two Men in a Shower is also significant in that it marks the start of Hockney's exploration of the possibilities of the curtain motif: 'The form of the curtain first made me interested in it as a subject, and then it dawned on me that it could be even more interesting because it was flat – the magic word again. A curtain, after all, is exactly like a painting; you can take a painting off a stretcher, hang it up like a curtain: so a painted curtain could be very real. All the philosophical things about flatness, if you go into it, are about reality, and if you cut out illusion then painting becomes completely "real". The idea of the curtains is the same thing.'[5] *Still Life with Figure and Curtain*, which explores the motif further, is an exercise in abstraction. The picture-plane is filled with a hanging patterned curtain in front of which stands a mannikin-like figure, some fruit, and the vase of flowers from the first domestic scene.

One day soon after Hockney had begun this painting, he happened to be visiting the National Gallery and came across some new acquisitions, a sequence of seventeenth-century frescoes by Domenichino, transferred to canvas. They were painted to look like tapestries, with borders and tassels hanging along the bottom and an inch or so off the floor. In one, *Apollo Killing Cyclops*, the tapestry had been turned back a little to allow room for a dwarf who was standing in front of it. This inspired *Play within a Play* (see plate 67), a six-foot by six-and-a-half-foot canvas in which Kasmin stands beside a chair in the narrow space between a tapestry relating to *The Hypnotist*, which forms the backdrop behind him, and a sheet of perspex covering part of the painting in front of him. Kasmin's hands, nose, chin and part of his jacket are painted on the perspex where they touch it as he tries to escape from this prison. Hockney wrote in his autobiography: 'Kas had always wanted me to paint him but I'd never got round to it as I couldn't really decide how to do it. Now it seemed appropriate to trap him in this small space between art and life.'[6] Here Hockney is playing complicated visual games with reality and illusion; if some of his experimental pictures seem to add up to little more than a joke, this one is an impressive achievement. In 1970 he was to develop the idea further. He had the painting transcribed into a tapestry so that the double 'Play' became a triple 'Play'. His painting of Kasmin seems to illustrate his statement in the catalogue of the 1964 'New Generation' exhibition at the Whitechapel Art Gallery that the two poles of his work – concern with human drama and delight in technical devices – could often be found side by side.

Another painting in the curtain series is *Seated Woman Drinking Tea, Being Served by Standing Companion*. The two nude women, in front of a curtain beside a vase of flowers, were copied from a photograph in Eadweard Muybridge's book *The Human*

Figure in Motion of 1887. Hockney had recently bought this volume for help in drawing the figure; he knew Francis Bacon used it for compositional ideas. He kept the title of Muybridge's photograph because he loved the dry humour of omitting to mention that the two women were nude. The next painting, *Closing Scene*, shows two curtains being closed, with a glimpse of a woman and a painted backdrop between them. It illustrates Hockney's love for the way curtains 'are always about to hide something or about to reveal something.'[7] This is also true of the last in this series, *Two Friends and Two Curtains*, a rather surreal image in which two giant heads, one in profile and one full-face, are partly obscured by a plain black and a patterned red curtain.

The domestic scenes and the curtain series occupied Hockney throughout 1963, although he also completed at least ten other paintings in this productive year, including *I saw in Louisiana a Live-Oak Growing*. The title is the first line from a poem by Hockney's favourite poet, Walt Whitman.

> I saw in Louisiana a live-oak growing,
> All alone it stood and the moss hung
> down from its branches,
> Without any companion it grew there
> uttering joyous leaves of dark green,
> And its look, rude, unbending, lusty, made
> me think of myself,
> But I wonder'd how it could utter joyous
> leaves standing alone there
> Without its friend near, for I knew I could not.

Hockney thought these were marvellous lines about a man looking at a tree; to stress the fact that the tree is completely alone, he painted it upside down. The poet is in the foreground, and Hockney has written the first line of the poem issuing from his mouth, the last time he was to use graffiti-writing in a picture.

In 1962 the *Sunday Times* had commissioned an illustration from Hockney for a story they were going to publish about a Colonial Governor in a hurry, and he made at least four coloured crayon and pen-and-ink drawings showing the pompous gentleman with his medals and his uniform. In September 1963 the newspaper contacted him again. They were sending artists to various places to make drawings for their colour magazine – Philip Sutton to Tahiti, Jann Haworth (Peter Blake's wife) to California – would he like to go to Bradford? He replied that he had only recently escaped from Bradford and certainly did not want to go back, but he would go to Honolulu. To his surprise, he was offered a

ticket to Egypt, which he quickly accepted. He spent most of October there, and made about forty coloured crayon drawings. (The *Sunday Times* never used them because President Kennedy's assassination forced a change of plan.)

Hockney had earlier been influenced by Egyptian art, so it was now very exciting for him to see it in its own setting. In Cairo he made drawings in the museum and in the house of a gentleman he met called Mr Milo, a lecturer at the University of Cairo. He drew the Great Pyramid and the Sphinx and also the view from the Nile Hilton. He visited Alexandria and made drawings in the Cecil Hotel; he travelled to Karnak where he drew the tomb paintings and on to Luxor where he spent ten days, for it was the place he enjoyed most. His drawings here concentrate on everyday life: a yoghurt salesman walking home with a box on his head; a garage with a giant poster of Nasser on the wall; a little Egyptian house with a helicopter drawn on the side to show that the occupant had made the journey to Mecca (see page 50). In most of these images he makes a feature of Arabic calligraphy, which he much admired. One, of a book of matches, is inscribed 'these matches belong to David Hockney in Arabic', and he found someone to write out the message in Arabic which he then copied onto the match-book. Beside it he has drawn a bottle and glass with the ever-present flies, which so annoyed him, crawling all over them. On his return he painted *Four Heads (Egyptian)*, as well as *Great Pyramid at Giza with Broken Head from Thebes*, which was ready just in time for his first one-man show in December.

When Kasmin had made a contract with Hockney in 1961, he had agreed to give him a show as soon as he had acquired his own premises. He opened his gallery in New Bond Street in March 1963 with an exhibition of Kenneth Noland's 'Target' paintings. Through his contacts with Larry Rubin, the Paris-based partner of Knoedler's Gallery in New York, Kasmin had developed a taste for contemporary American painting and, besides Noland, he also showed the work of Jules Olitski. Among English artists, he was now promoting Dick Smith and Robyn Denny. Hockney was therefore the odd man out, the only figurative artist in Kasmin's stable of talent. This meant that he was already seen by many collectors and critics as part of an avant-garde group, the Kasmin group. When the New York dealer Charles Alan visited Kasmin in London he was very impressed with Hockney's work and showed some examples in his gallery later in 1963.

Kasmin had been giving Hockney great support and encouragement for two years, and in December 1963 he presented his first Hockney exhibition, 'Paintings with People in'. On show were many of the works of 1963 including *The Hypnotist*, *Domestic Scene, Notting Hill Gate*, *Domestic Scene, Broadchalke, Wilts*, *Play within a Play* and four other curtain paintings, and the recent Egyptian canvas, a total of ten paintings plus a selection of drawings. Every painting sold, a rare occurrence in itself, but especially so for an artist's first exhibition. The most expensive work was *Play within a Play*, which was

priced at £350. At the same time, Editions Alecto Gallery in London was showing Hockney's recently completed 'Rake's Progress' series and other prints. Critical reaction to both shows was enthusiastic. Nigel Gosling wrote in the *Observer* that 'there is something irresistibly fresh-faced' about his work,[8] and Keith Roberts in the *Burlington Magazine* mentioned his 'superb sense of rhythm and interval'.[9] Edwin Mullins wrote of Hockney's 'considerable achievement' (*Sunday Telegraph*)[10] and Bryan Robertson was of the opinion that 'the sequence of prints is happily a total success' (*The Times*).[11] In the *Sunday Times*, John Russell wrote that Hockney 'has given foreign visitors something to bite on when they ask what is happening in British art'.[12]

Hockney was in the right place at the right time. Dealers were hungry for new stars and collectors were keen to acquire good contemporary British art. His was a totally genuine talent and he was head and shoulders above most of the competition. Kasmin's backing helped him enormously, but he was being shown elsewhere as well. Peter Cochrane was very encouraging and supportive, and he was included in Edward Lucie-Smith's 'One Year of British Art' at Tooth's Gallery where Cochrane ran the contemporary department. Hockney was featured in 'British Painting of the Sixties' at the Whitechapel Gallery, in John Moore's Annual Exhibition in Liverpool and at the 'Third Biennale of Young Artists' at the Musée d'Art Moderne in Paris. He also had work exhibited in New York, Zurich, and Ljubljana. He was not alone in gaining access to the public. Most of his friends had also found London galleries where their work was shown regularly: Kitaj at Marlborough Fine Art, Jones, Phillips and Berg at Tooth's, Procktor at the Redfern Gallery, Oxtoby at Victor Musgrave's Gallery One, Boshier, Blake and Caulfield at Robert Fraser's Gallery. But none of this extraordinary group of early-sixties artists had achieved the success now enjoyed by Hockney.

1963 was not only a productive year in terms of Hockney paintings and Hockney exhibitions; it was also the year that saw his reputation fully established with both the critics and the wider public. Especially important in this respect was the *Sunday Times* colour magazine feature, 'British Painting Now', written by David Sylvester for its special issue in June. Sylvester called Hockney 'as bright and stylish a Pop artist as there is', and he listed his honours at the Royal College as well as his acquisition of a gold lamé jacket. In Lord Snowdon's accompanying photographs, Hockney wears the jacket both in the streets of Notting Hill Gate and in his studio, in front of *Domestic Scene, Los Angeles*.[13] Subsequently he was interviewed on television, took part in a debate at the ICA, and was frequently featured in the newspapers: 'Top of the Hips' (*Observer*); 'Hic, Haec, Hockney' (*Tatler*). The press discovered that he was articulate, disrespectful, humorous and genuine. He had the easy charm and naïvety of a country boy and the sophistication of an adopted Londoner. With his blonde hair, distinctive glasses and bright clothes, he was ideally photogenic and, more important still, he loved publicity.

Anyone could interview him, and he would always provide good copy. He was ready to discuss his homosexuality with a candour which disarmed those who might be critical. In fact, his gayness contributed to his appeal, it was an important part of his glamorous image in those early days of 'Swinging London'. He loved the private views of new exhibitions, the smart parties and the clubs, and photographs in the press *showed* him loving them. What he wore was considered as interesting as what he painted, and the *Daily Express* later featured him in 'The Young Peacock Cult' as epitomizing the 'Pop Art Look'.[14] Later, too, he would be one of the backers of his friend Pauline Fordham's fashion shop, Palisades, off Carnaby Street, for which Derek Boshier designed the decorations and publicity material. And he was also involved in the enormous success of his other friends, fabric designer Celia Birtwell and fashion designer Ossie Clark, and of their company, Quorum. Hockney embodied the mood of the period, and he found himself being consulted on a wide range of topics as a representative voice of his age-group as well as a leading figure in British art. By 1965 he would be featured in three books: in *David Bailey's Box of Pin-ups* he appeared alongside John Lennon and Paul McCartney, Mick Jagger, Michael Caine, Rudolf Nureyev, Jean Shrimpton and Vidal Sassoon.[15] Mario Amaya designated him one of the principal artists of British Pop in *Pop as Art*[16] and he was described in *Private View* by Bryan Robertson, John Russell and Lord Snowdon as a 'glittering meteor' and a 'hero figure for his generation'.[17]

'Fourteen Poems by C.P. Cavafy', Plate 6, *In an Old Book*, 1966

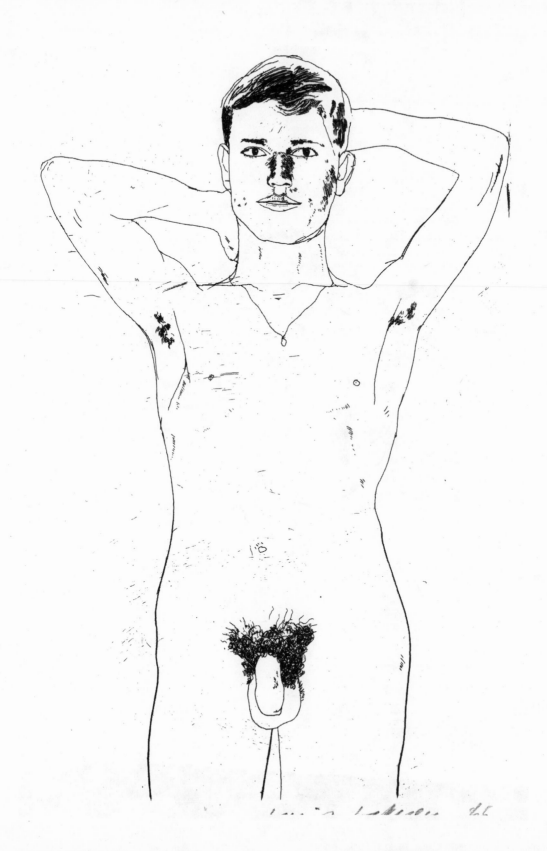

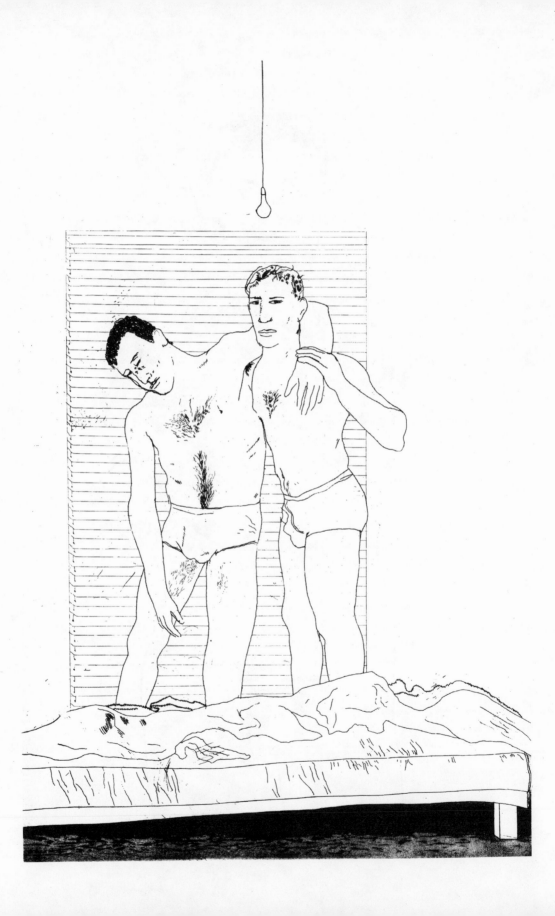

CHAPTER FOUR

AMERICA 1963–1967

Hockney had earned enough money from the Kasmin show and from the sale of 'A Rake's Progress' to feel financially secure for the first time, and so he decided to spend a year in America. He left London for New York in December 1963, immediately after the two exhibitions of his work at Kasmin's and Editions Alecto. In New York he stayed in Mark Berger's studio apartment on Christie Street and went back to the Pratt Institute workshop where he made two etchings. One was a strange portrait of the writer of nonsense limericks, Edward Lear, standing by a palm tree, in a theatrical scene with curtains either side reminiscent of the paintings from a few months earlier. The other was *Jungle Boy*, a nude and hairy man under a palm tree facing a large snake. This was inspired by Mark Berger, whose abundant body hair was a source of great amusement to Hockney, and who kept snakes in his studio.

One of the big new names on the New York art scene at this time was Andy Warhol, whose studio was a popular meeting place for the younger artists, writers and media people. Hockney found his way there one evening with his American friend Jeff Goodman, and this marked the start of a friendly rivalry between Hockney and Warhol who were soon each to achieve star status at the centre of separate groups of New York friends and admirers. That same evening Hockney met the actor Dennis Hopper (at that time working in television but later to make the cult film *Easy Rider* with Peter Fonda) and Henry Geldzahler, a curator of twentieth-century art at the Metropolitan Museum in New York. Like Warhol, they too were to become close friends of his. Geldzahler, in particular, would later play an important role in his life, as travelling companion and as fount of knowledge about contemporary American art. Both men were of similar age and homosexual, and they shared a love of opera, good food and travel. Hockney's total obsession with painting was paralleled by Geldzahler's enormous enjoyment in collecting both art and artists. Hopper invited Hockney to visit him at the television studios and, a few days later, photographed him with Andy Warhol, Henry Geldzahler and Jeff Goodman on the set of *Naked City* (see plate 61).

Whatever the attractions of New York, Hockney's real purpose in returning to America was to visit California. His fantasies about America centred around beautiful suntanned beach boys, the sort of boys who filled the pages of *Physique Pictorial*, which he had collected avidly in London. The magazine originated in Los Angeles, so that was

'Fourteen Poems by C.P. Cavafy', Plate 10, *One Night*, 1966

his destination, even though his New York friends advised him that San Francisco was a far more attractive city to visit.

After seeing in the New Year in Times Square with Mark Berger and Jeff Goodman and a few thousand other people, Hockney flew to Los Angeles at the beginning of January 1964. The New York art dealer Charles Alan had given him an introduction to Oliver Andrews, a Californian sculptor who exhibited with him. Oliver met David at the airport and dropped him at the Tumble Inn Motel in Santa Monica, in the district of the city that lies along the Pacific coast. Hockney was really excited to be there at last. As he recalled in an interview in 1970: 'Somehow I instinctively knew that I was going to like it. And as I flew over San Bernardino and looked down – and saw the swimming pools and the houses and everything and the sun, I was more thrilled than I've ever been arriving at any other city, including New York.'[1] In the evening he walked on to the beach looking for Los Angeles, not realizing that the city centre was eighteen miles away. In the distance he saw some bright lights, and presuming this was the city, he walked for two miles only to find that it was a large petrol station. Next day he bought a bicycle.

His mental picture of Los Angeles was strongly coloured by the writing of John Rechy whose novel *City of Night* he had read in London. Rechy had written with real sexual passion about the sleazy underworld of gay bars and cruising parks around Pershing Square. Hockney saw from a map that Wilshire Boulevard, which begins by the sea in Santa Monica, runs all the way to Pershing Square (see plate 82). He cycled along Wilshire Boulevard for hours, slowly realizing how enormous distances are in Los Angeles, and when he finally arrived at 9 pm, the square was deserted. There was nothing to do but have a cold beer and cycle back again.

Next day he told Oliver of his disappointment and learned that no one went to Pershing Square at night. Oliver said that it was unheard of to cycle in Los Angeles: everyone had a car, which was the only way to get around. The same day, Hockney bought a Ford Falcon, his first car (see plate 60), and had some basic driving lessons from Oliver. The following day he went to the testing station, answered a few easy questions, drove about a bit and was given a driving licence. He was excited to have his own transport but scared by all the traffic. To practise driving, he got on to a six-lane freeway and could not screw up enough courage to find his way off again. So he found himself sixty miles away in San Bernardino. Seeing a sign reading 'Las Vegas 200 miles', he drove on, and practised in the quiet of the desert. After trying his luck in a gaming hall, and winning some money, he drove back to Santa Monica the same evening.

Hockney found himself a small studio overlooking the sea in Venice and rented a little apartment nearby on Pico Boulevard, Santa Monica. Then he began to explore the city; one of his first visits was to the studio of *Physique Pictorial*. Here he found a very kitsch swimming pool surrounded by plaster statues of young men in the style known as

Hollywood-Greek. The owner would employ boys off the streets or straight out of the city jail to strip off and pose by the pool. Some were rather rough with very muscled bodies and others were the pretty boy-next-door type. As David said later: 'I must admit I have a weakness for pretty boys; I prefer them to the big, butch, scabby ones. I was quite thrilled by the place.'[2] The *Physique Pictorial* studio reminded him of the poems of Cavafy, the Greek homosexual writer he so admired, and Los Angeles seemed to epitomize Cavafy's favourite city, Alexandria: 'The hot climate's near enough to Alexandria, sensual; and this downtown area was sleazy, a bit dusty, very masculine – men always; women are just not part of that kind of life. I love downtown Los Angeles – marvellous gay bars full of mad Mexican queens, all tacky and everything.'[3]

Just up the road from his Santa Monica apartment was San Vincente Boulevard with its luxurious houses, each with obligatory palm trees and cactus gardens. All the year round the wide central reserve, planted with exotic trees, is the favoured haunt of an endless stream of joggers: athletic young Californians in their colourful shorts who run on through Palisades Park and along Ocean Avenue to Muscle Beach. Here by Santa Monica pier the beautiful young men put their tanned and muscular bodies through not too strenuous workouts on the parallel bars or join in friendly games of handball in the hot Californian sunshine. Others skate by on the sidewalk or carry their surfboards down to the waves. For David, who was still very shy and had never been particularly promiscuous, it was paradise, the paradise of the voyeur that he was then and has remained ever since.

All along Muscle Beach are open-air showers to wash away the perspiration of the gymnast or the sea-salt of the swimmer. Showers are an integral part of Californian life, as Hockney had learnt from *Physique Pictorial* which had, in turn, inspired him to paint *Domestic Scene, Los Angeles* the previous year in London. Among his first Californian paintings were two shower scenes. *Boy About to Take a Shower* (see plate 73), described by him as 'an invention but based on observation of athletic American young men'[4] shows a naked man adjusting the shower-head in a flat space, with a tiled wall to one side of him and the leaves of a large plant on the other. *Man Taking Shower in Beverly Hills* (now owned by London's Tate Gallery) shows the figure under the water-jet in a more spatially elaborated tiled area fronted by a drawn-back curtain which recalls the experiments of the 1963 paintings. There is a glimpse of a table and chairs in a room beyond, and in the foreground is a carpet and a plant whose leaves have been used to cover the bather's legs since, as Hockney was honest enough to admit, he was having trouble painting the feet. 'Americans take showers all the time – I knew that from experience and physique magazines. For an artist the interest of showers is obvious: the whole body is always in view and in movement, usually gracefully, as the bather is caressing his own body.'[5] In these two paintings, and the slightly later *Man Taking*

Shower, far more care has been taken with the flesh of the bodies than in *Domestic Scene, Los Angeles*. Hockney was now using acrylic instead of oil paint. He had discovered that American acrylic was superior to the English variety, and he found the texture and the available colours very much to his liking. He could work faster and more effectively as there was no appreciable drying period. He was now very excited by the problem of painting moving water slowly and carefully as it flows over and bounces off the naked body. Water and the male nude are two of his favourite subjects, which are perfectly brought together in the shower series, as they soon would be in the swimming pool paintings.

As had happened previously in Egypt, so now the new environment of California inspired Hockney to execute many drawings; the subjects of the majority in this case were boys. The study for *Boy About to Take a Shower* is a highly finished coloured crayon drawing based on a photograph obtained from the *Physique Pictorial* studio. But other, less detailed studies of boys in showers, undressing or lying in bed, were drawn from life or immediately after casual sexual meetings (see plate 53). These capture the immediacy of a real event, and date from the period in spring 1964 when David had sufficiently overcome his shyness to sample the gay life of the city. In his autobiography he writes: 'The only time I was promiscuous was when I first went to live in Los Angeles. I've never been promiscuous since. But I used to go to the bars in Los Angeles and pick up somebody. Half the time they didn't turn you on, or you didn't turn them on, or something like that. And the way people in Los Angeles went on about numbers! If you actually have some good sex with somebody, you can always go back for a bit more, that's the truth. I know a lot of people in Los Angeles who simply live for sex in that they want somebody new all the time, which means that it's a full-time job actually finding them; you can't do any other work, even in Los Angeles where it's easy. I can go a long time without sex.'[6]

The first sign of Hockney's fascination with swimming pools (which, for many of his admirers, are his personal trademark), appears in *California Art Collector*, one of his earliest Californian paintings. Kasmin had come to Los Angeles to see Hockney, and he took him to meet various collectors of contemporary art. Hockney was amazed at the opulence of their houses and their life-styles. It seemed to him that it was always the wife who had the time to show off the collection, while the husband was out earning the money to pay for it. So his *California Art Collector* is a rather tongue-in-cheek image of a lady on a little terrace beside her deep-blue pool fringed with palm trees. Hockney found that comfortable armchairs and fluffy carpets were characteristic of the Beverly Hills houses, so his collector has one of each. She also has a sculpture by William Turnbull, very popular in Los Angeles in the sixties, and a primitive tribal mask which cleverly counterpoints her own head in the painting. The roofed patio, however, is not

37

38

37 David Hockney at Nailsworth Carnival, Gloucestershire, June
1961

38 (left to right) Richard Bawden, David Hockney, Fred Scott and
Geoff Reeve at Nailsworth Carnival.

39 Peter Crutch with *The Cha-Cha that was Danced in the Early Hours of 24th March* in the RCA Painting School, 1961

40 David Hockney and Peter Crutch with *Peter C.* in the RCA Painting School, 1961

41 *Hero, Heroine and Villain*, 1961

In the spring term of 1961, Hockney became very fond of a straight student of furniture at the RCA, Peter Crutch. Hockney painted him dancing the cha-cha with his girlfriend Mo's handbag in his hand and then made a full-length portrait of him on two unequal-sized canvases nailed together. Hockney's feeling for his new friend are light-heartedly revealed in (41). The two figures on the left are embracing: the male is labelled 'Hero' and '16.3' (Peter Crutch in Hockney's alphabetical code) and the female is inscribed 'Heroine' (presumably his girlfriend Mo). To the right stands another male figure labelled 'Villain' and '4.8' (David Hockney), which seems to imply that Hockney would like to separate the couple and have Peter for himself.

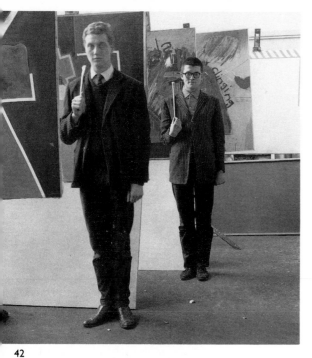

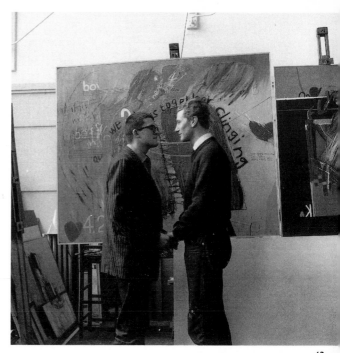

42

43

44

45

42 Derek Boshier and David Hockney in the RCA Painting School, 1961

43 David Hockney and Derek Boshier in front of *We Two Boys Together Clinging* in the RCA Painting School, 1961

44 *Spinning Round*, by Jean Dubuffet (detail), 1961
Dubuffet's graffiti style influenced Hockney.

45 *The Most Beautiful Boy in the World* (study for *We Two Boys Together Clinging*), 1961

46

47

46, 47 Teenagers' Room, S.S. *Canberra*

48 David Hockney and Ferrill Amacker, New York, summer 1961

49 David Hockney's Diploma Show, RCA, June 1962

50 Mark Berger and David Hockney, New York, summer 1961

51 *David Hockney with Cliff Richard*, by Mark Berger, autumn 1960

During the summer term of 1961, Hockney was invited to decorate a room for teenagers on the S.S. *Canberra*, the new luxury P. & O. cruise liner. In the summer vacation Hockney made his first visit to New York where he stayed with his friend Mark Berger who had previously painted him with a pin-up of Cliff Richard. Here he met Ferrill Amacker and the three dyed their hair blonde.

49

50

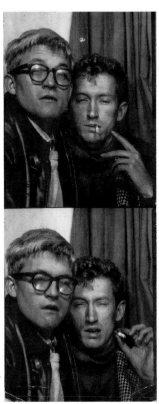

48

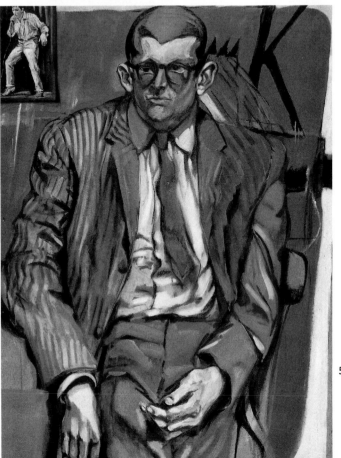

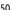

51

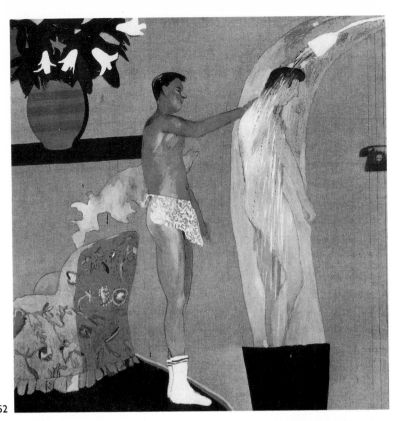

52

52 *Domestic Scene, Los Angeles*, 1963

53 *American Boys Showering*, 1964

54 *Physique Pictorial* magazine, Los Angeles, Fall 1957

55 *Physique Pictorial* magazine, Los Angeles, January 1963

56 *Two Boys Aged 23 and 24*, Plate 2 of 'Fourteen Poems by C.P. Cavafy', 1966

57 *He Enquired After the Quality*, Plate 3 of 'Fourteen Poems by C.P. Cavafy'

58 *Dale and Mo*, 1966

59 *Those Bottles Should Be Handkerchiefs*, 1966

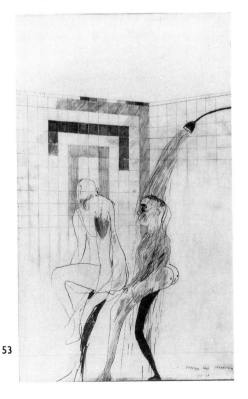

53

54

55

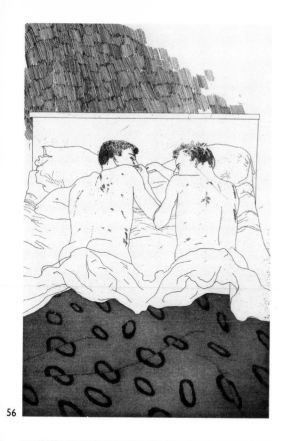

56

57

58

59

60

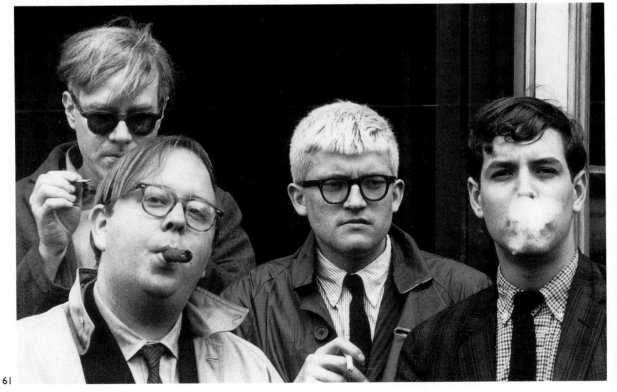

61

60 David Hockney, Iowa 1964

61 (left to right) Andy Warhol, Henry Geldzahler, David Hockney,
Jeff Goodman in New York in December 1963

Californian: Hockney borrowed it from Giotto, both to add to the gentle artistic joke and to facilitate the spatial exploration which he was simultaneously pursuing in the shower scenes.

His first real friendship in California was with the English writer Christopher Isherwood (see page 184). Some years earlier, he had read Isherwood's novels; his visit to Berlin in 1962 had given him the opportunity of seeking out the gay bars that figure in *Goodbye to Berlin*. Isherwood had settled in Santa Monica, which he had described as 'a real paradise on earth: the climate can be marvellous, the scenery is lovely and the boys are so beautiful.'[7] Armed with an introduction from Stephen Spender (see page 184), whom he had met in London, Hockney summoned up the courage to telephone him. The result was an invitation to tea and the start of a close friendship that ended only with the writer's death in 1986. Isherwood lived with his lover, the American artist Don Bachardy, and the couple shared a passion for art and artists as well as a good eye for new talent. Hockney took a folder of work with him on that first visit; Isherwood and Bachardy were especially impressed by the 'Rake's Progress' etchings. Isherwood and Hockney took to each other immediately. As Isherwood said later, 'Oh David, we've so much in common: we love California, we love American boys, and we're from the north of England.'[8] Their northern roots were important to each of them, though Hockney was very much aware of the big difference between their family circumstances. Isherwood, for his part, loved Hockney's northern accent, and much regretted having lost his through going to public school and university.

In the relaxed atmosphere of California, Isherwood had long since come to terms with his homosexuality and he was very outspoken in his support for gay causes. He was both impressed and amused by Hockney's cycling exploits in search of the world of John Rechy, and he and Don Bachardy were able to give him useful advice about gay life in Los Angeles. Hockney benefited enormously from contact with the couple, and soon became a regular visitor at their Santa Monica house. They, in turn, found him an immensely appealing character, so independent and resourceful, and introduced him to various of their close friends. These included Jack Larson, the author and librettist for Virgil Thomson, and Jack's friend, the film director Jim Bridges whose later films included *The China Syndrome* and *Urban Cowboy*. They remember Isherwood ringing one day to say that an exciting young artist had appeared on his doorstep. They were fascinated as much by Hockney's strange accent and dyed blonde hair as by his extraordinary drawings, and they have remained firm friends. Another important meeting was with Nicholas Wilder, who dealt in contemporary art. They had lunch and soon were on close terms. Wilder remembers his first impressions vividly: 'He obviously knew where he was going, he had initiative, was generous and amusing, and there was so much humour in his work – I loved it.'[9] He was later to become Hockney's dealer, but for the moment

Hockney was very happy to have been offered a show by Charles Alan in New York.

For Hockney, the fantasist from London, the main attraction of Los Angeles was its beautiful boys, but once he had established himself in his Santa Monica studio, the city's greatest effect on his art was its architecture. Hollywood and Beverly Hills constitute a picturesque mixture of Egyptian temples, Scottish baronial halls, English mock-Tudor mansions, Spanish ranch-houses and the occasional grounded flying saucer. Frank Lloyd Wright and his son Lloyd each designed innovative and romantic houses, and Richard Neutra and Rudolf Schindler brought the Bauhaus tradition from Europe. For good measure there are also the extraordinary futuristic houses of John Lautner. In his Ford Falcon, Hockney spent days exploring the architectural richness of Los Angeles. What fascinated him most was the everyday style of Californian functionalism, the plain white office blocks and simple two-storey houses along the palm-tree lined streets of the less fashionable areas of the city – Wilshire Boulevard, Melrose Avenue, Olympic Boulevard. These he began to draw and paint with deadpan humour as epitomizing the fast-living, money-conscious, throw-away society he saw around him. The lettering of his Royal College pictures is now used in a more pronounced manner, so that streetsigns and road-markings are made to play an important part in the images, deliberately labelling the pieces of the city which he pins down on the canvas, glittering in the sun against a clear blue sky. The buildings themselves are carefully stylized as simple geometric shapes that give the impression of a city set in aspic, and the paintings betray a fascination with a sense of place that had been absent in Hockney's work since his Bradford years of preparation, when he had similarly attempted to capture his personal view of his immediate surroundings. But there is a new maturity in these views of Los Angeles, for the economy of detail and simplification of form, with the neat Letraset captions below the images, show an increasing concern with pictorial devices relating to the ideas of Modernism. This is a far cry from the straightforward techniques with which he had earlier sought to reproduce the look and feel of the back streets of Bradford. At the Royal College, Hockney's work had shown a real concern with concepts of modern art; as he later wrote in his autobiography: 'I have never thought my painting advanced but in 1964 I still consciously wanted to be involved, if only peripherally, with Modernism.'[10] In his new use of acrylic paint he was now breaking with the thick, painterly textures of Abstract Expressionism and achieving a thin, smooth surface which was yet able to embody a brilliant range of colours. Clearly he had taken note of the vivid impact achieved by Frank Stella and, at the same time, the underlying humour of Tom Wesselmann.

Hockney's images of the city have since come to play a major role in many people's visual conception of Los Angeles, whether or not they have ever been there, but he was not

alone in choosing such subject matter. Memory tends to be selective, however, and in an interview in 1975 he said: 'In London I think I was put off by the ghost of Sickert and I couldn't see it properly. In Los Angeles, there were no ghosts; there were no paintings of Los Angeles. People then didn't even know what it looked like. And when I was there, they were still finishing up some of the big freeways. I remember seeing, within the first week, a ramp of freeway going into the air, and I suddenly thought: "My God, this place needs its Piranesi, Los Angeles could have a Piranesi, so here I am!"'[11] The Californian artists Edward Rusche and Joe Goode had been painting images of Los Angeles in the early sixties, and Hockney saw Rusche's 1964 exhibition of Hollywood houses and gasoline stations.[12] But Rusche's series of graphic drawings of office and apartment blocks with palm trees, so close to Hockney's *California Bank* and *Building, Pershing Square, Los Angeles* (1964) (see plate 81), date from 1965, and it seems likely that the influence worked both ways. Hockney's reasons for visiting California had had nothing to do with contemporary art: 'Los Angeles is a very sexy city, partly because it is the most "Mediterranean" of American cities – the climate is sunny, the people are less tense than in New York, life goes on at a slower rate. When I arrived I had no idea if there was any kind of artistic life there, and that was the least of my worries. I found out later that there were quite a few good artists in Los Angeles, and I got to know them, but they weren't the main attraction which California had for me.'[13]

In the summer of 1964 Hockney was invited to teach for six weeks at the University of Iowa. This presented an interesting challenge and gave him the opportunity of seeing more of the American countryside, so he drove via New Mexico, Oklahoma and Kansas to Chicago, picking up hitch-hikers and staying in cheap motels, and then doubled back to Iowa City. He found the whole area rather boring: it was very flat except for the occasional undulating hill, and all the towns had exactly the same kind of wooden buildings. But he was given a studio in the university, and in six weeks he painted four pictures as well as completing *Man Taking Shower in Beverly Hills* which he had brought with him rolled up in the back of his car. *Iowa* shows farm buildings and a tree in a flat landscape with a couple of little hills, but the interest in the painting lies in the dark clouds that form a dramatic contrast with the ordinariness of the landscape. The violent thunderstorms that could suddenly engulf the sky helped relieve the monotony of the countryside, and so more than half of Hockney's image of Iowa is taken up with the broad and colourful brush-strokes of the clouds. He also painted a similarly schematic view of *Arizona*, which he had visited on his travels, but here there are only a few tiny clouds in a clear sky dominated by a rock formation towering above the desert, with a red Indian and a pile of stones in the foreground. He returned to a favourite subject in *Cubist Boy with Colourful Tree*, which he described as 'an American athlete painted in a decorative Cubist manner.'[14] The boy, who wears only a T-shirt, stands in front of a curtain and the picture

is full of stylistic tricks, which he termed 'Cubist' in the sense that they were conceptual rather than perceptual.

Ossie Clark had come out to America for the first time and visited Hockney in Iowa, and together they drove back to California. In Los Angeles they saw the Beatles perform at the Hollywood Bowl on their first American tour, a rare event for Hockney, who has never had much interest in pop music. Derek Boshier was in California, on a Stuyvesant Foundation scholarship, and the three friends drove through the desert to the Grand Canyon and then on south to New Orleans. Derek remembers that, as soon as people heard their accents, they asked if they knew the Beatles. Hockney and Ossie had a *Gay Guide to America* and were always visiting gay bars which Derek found very boring, so in Louisiana he left them saying he was off to find some girls. In New Orleans Hockney and Ossie stayed with Ferrill Amacker for a few days and then drove on to New York to visit Mark Berger. Hockney spent a while with Dick Smith, who had rented a loft in Greenwich Village, and here he met the English artist Mark Lancaster for the first time.

Coinciding with his visit, an important event now took place in New York: his first American exhibition, at Charles Alan's gallery. On show were many of the recent American paintings, including *Building, Pershing Square, Los Angeles; Wilshire Boulevard, Los Angeles; California Art Collector; Boy About to Take a Shower; Man Taking Shower in Beverly Hills; Iowa; Arizona* and *Cubist Boy with Colourful Tree.* The exhibition received good reviews and every painting was sold. This marked his debut on the American art scene.

On his return to London in December 1964, Hockney was invited by Richard Hamilton to give one of a series of artists' talks about recent work at the Institute of Contemporary Arts in London. He chose to discuss homosexual imagery in America. He showed slides of gay magazine artists like Spartacus and Tom of Finland and then, to people's surprise, proceeded to show some super-8 silent films of soft pornography. In *Leave My Ball Alone* a guy discovers a Discobolos statue holding a ball. He steals the ball, the statue comes to life, and they wrestle together in the nude. In another, two young guys playing ball inadvertently throw the ball among the nude bottoms of some sunbathers. When they try to retrieve it, suggestive horseplay results. In the third, a policeman pulls a boy into a prison cell and strips him. The boy then strips the policeman which results, once more, in playful wrestling. Hockney stopped the films from time to time in order to make mock-serious comparisons with the photographs of Eadweard Muybridge, and also repeatedly pointed out the absurdity of the contrived situations. The evening was a great success.

Hockney's first painting on returning to London was *Picture of a Hollywood Swimming Pool.* In Los Angeles he had made many drawings of pools, one of which was

the basis of the London painting. His main concern was a formal one: how to paint water in motion. Here the surface patterns use imagery inspired by Bernard Cohen and the later work of Dubuffet. The stylized result does suggest a rippling surface while demonstrating that Hockney was still involved with Modernist ideas. In early 1965 he continued to work on this theme: *California* and *Two Boys in a Pool, Hollywood* have an added human interest, but the concentration is on the shapes and colours of the water surface rather than the two boys in each picture. And *Different Kinds of Water Pouring into a Swimming Pool, Santa Monica*, a development of two California drawings, almost moves into pure abstraction with its diagrammatically observed approximations of moving water.

These experiments with Modernism continue throughout 1965, firstly in London with a series of still life paintings and *Portrait Surrounded by Artistic Devices*. This latter image was based on a drawing of his father, but, as with the still lifes, the artistic devices dominate the picture-plane. The series was continued when Hockney travelled to Boulder to teach at the University of Colorado in the summer of 1965. Here he painted *A Realistic Still Life*, *A More Realistic Still Life* and *A Less Realistic Still Life*. All these paintings of 1965 show knowledge of the technique of staining raw canvas with thin acrylic practised by Morris Louis and, especially, Kenneth Noland whom Hockney had met through their common dealer, Kasmin. But the crucial figure behind the series is Cézanne, whose famous, basic shapes appear in all of them. The titles demonstrate an approach which is far from hero-worship. Hockney did not agree with Cézanne that everything in nature could be reduced to the cylinder, the sphere and the cone. As he said: 'You cannot escape sentimental – in the best sense of the term – feelings and associations from the figure, from the picture, it's inescapable . . . Because Cézanne's remark is famous – it was thought of as a key attitude in modern art – you've got to face it and answer it. My answer is, of course, that the remark is not true.'[15] Thus the 'artistic devices' of the *Portrait*, a pile of cylinders, are shown to be merely patches of colour, and the real centre of attention is revealed as the almost naturalistically painted portrait of Hockney's father. The element of humour is a crucial ingredient in these works, seen most clearly in the largest painting executed in Colorado, *Rocky Mountains and Tired Indians*. The college campus bordered the Rocky Mountains, but David's studio had no windows, so the situation reminded him of the circumstances of *Flight into Italy – Swiss Landscape* of 1962. He described the Colorado painting as follows: 'The whole picture is an invention from geological magazines and romantic ideas (the nearest Indians are at least three hundred miles from Boulder). The chair was just put in for compositional purposes, and to explain its being there I called the Indians "tired".'[16]

In Boulder, Hockney met Dale Chisman, a student who had been exempted from the Vietnam draft because of a car accident. They became close friends. While Hockney was

in Boulder, various of his college friends were also visiting America. Patrick Procktor was teaching at the University of Iowa and thought nothing of travelling 900 miles to visit him at weekends. Colin Self had been drawing and painting in New York and, on his travels, spent three weeks with Hockney. Norman Stevens also found his way to Boulder. At the end of the term, the four decided to drive to Los Angeles in Hockney's Oldsmobile Starfire, stopping on their way to see the old Colorado goldmines, San Francisco's Golden Gate Bridge and Disneyland. At first they all stayed in two rooms at the Tumble Inn Motel in Santa Monica, but Patrick had been asked to paint a picture for the actor Laurence Harvey and his companion, Joan Combe, and soon he moved with Hockney into their guest house. Hockney was working on a series of six coloured lithographs on aluminium for Ken Tyler at the Gemini Workshop. Entitled 'A Hollywood Collection', these prints were imagined as an 'instant art collection' for a Hollywood starlet, and each image – still life, landscape, portrait, nude et cetera – includes a carefully-drawn frame around the design, inspired by a framer's shop in front of the printer's studio. The titles, *Picture of a Simple Framed Traditional Nude Drawing* and *Picture of a Pointless Abstraction Framed Under Glass*, for example, show the Hockney wit and humour that underlie the series.

Hockney had to return to London for a show at Kasmin's gallery. 'About a week before I left Hollywood I met in a gay bar a ravishingly beautiful boy. It was lust on my part, sheer lust, and I thought, fantastic! And I took him home that night . . . Robert Lee Earles III was his real name, Bobby Earles, and he was beautiful, a real Hollywood, California boy, blonde hair, marvellous.'[17] He invited Bobby Earles to accompany him and Patrick Procktor to London. They drove to New York together, with Patrick becoming increasingly annoyed. He had taken an instant dislike to the newcomer. In New York they stayed with Mark Berger and all four of them attended a Halloween party in drag, which was later commemorated in a painting by Patrick.[18] Hockney, Patrick and Bobby crossed the Atlantic in the S.S. *France* and were welcomed home by Mo McDermott, Kasmin, Pauline Fordham, Ossie Clark, Mark Lancaster and a group of friends at Waterloo Station. Hockney had advised them by postcard that he was arriving with Mr Dream. His card to Mo was dated Los Angeles, 10 October 1965, and read, 'I will be back in London about noon on November 1st at Waterloo Station from the S.S. *France*. I am bringing back a marvellous work of art, called Bob. Love, David.' But Bobby soon grew bored with London, having no interest in anything but sex and finding no equivalents to the Hollywood gay bars. Ossie Clark found him a 'dumb blonde bleached whore' and christened him 'Miss Boots'. Mark Lancaster remembers him complaining that the Powis Terrace flat was a dump, and demanding to meet the Queen and the Beatles. Finally, Hockney admitted his mistake and put him on a plane back to Los

Angeles. By chance, he met him later working as a go-go dancer on Laguna Beach, and soon after heard, with great sadness, that he had died of an overdose of drugs. What survives is a fine crayon drawing entitled *Bob, SS 'France'* (see page 88), which concentrates on what Hockney called Bob's 'marvellous beautiful pink bottom'. [19]

The Kasmin exhibition of December 1965 was titled 'Pictures with frames, and still-life pictures', and included many of his recent experiments in America. Critics were quick to spot the change of direction since his 1963 show and to recognize that he was no longer to be classified as a specifically English artist. Edward Lucie-Smith wrote in *Studio International*: 'Chameleon-like, he has become a Californian, and his art has taken on some of the characteristics of the environment . . . All of this tends to align Hockney with the brutalities of American pop, rather than with the lollipop English variety . . . The sardonic, humourless irony of the show makes him seem a more impressive if a less charming artist.' [20]

Hockney's drawing of Bob on the S.S. *France* was a careful image of observed reality and Hockney's work of 1966 demonstrates, in Marco Livingstone's words, 'a shift away from self-conscious style in favour of depiction.' [21] An early example is a drawing from January showing Ossie Clark sitting in Hockney's living room at 17 Powis Terrace. The figure is placed with great precision on a stool between an easy chair and a work table on which is a pencil sharpener, a pencil and a piece of headed notepaper inscribed 'for Ossie with love from David, January 1966 xxxx'. Thus the image is tied to a particular place and time and celebrates an important relationship. Later the same month, Hockney travelled to Beirut to soak up the atmosphere and create some drawings for a set of engravings relating to the poems of Cavafy, which Paul Cornwall-Jones of Editions Alecto proposed to publish. Los Angeles had seemed to Hockney on arrival to suggest Cavafy's Alexandria with its barely concealed flavour of homosexual love, but Alexandria itself was too spoilt, and Beirut stood in well for the pre-war Alexandria of Cavafy's poems. Many images of 1961 had referred to Cavafy, and in 1965 he had discussed an edition of Cavafy prints with Stephen Spender, but he had found copyright problems with the existing translation by John Mavrogordato. Spender introduced him to Nikos Stangos, a young Greek poet who spoke perfect English, and it was decided to proceed with a new translation by Stangos and Spender.

Hockney returned from Beirut after two weeks with many sheets of careful pen-and-ink drawings of the daily life of the city, and proceeded immediately to make about twenty etchings, with the help of his assistant Maurice Payne. This was his first set of engravings since 'A Rake's Progress' of 1961–3, and it presented few of the technical problems of the earlier images, with their great variety of tones and reliance on aquatint. The Cavafy etchings are, in fact, superb line drawings that vividly demonstrate Hockney's new fascination with observed reality. The Beirut drawings provided the

architectural settings for plates 1, 4, 7 and 13. Plate 13, a portrait of Cavafy, uses an exact transcription of a drawing of a police station as its background. Plate 3 (see plate 57), which illustrates the poem 'He Enquired After the Quality', shows a man selling handkerchiefs to another man, and is closely based on a drawing of a man selling bottles in the bazaar (see plate 59). Plates 2, 5, 8, 9 and 11 all come from a series of drawings of pairs of boys in Hockney's bedroom in London. For instance Plate 2, *Two Boys aged 23 and 24* (see plate 56), is very close to a drawing of Mo McDermott with Dale Chisman who had come over from Colorado to spend a few months with Hockney while he studied at the Slade (see plate 58). Plates 6 and 10 come from male physique magazines, and Plate 12, *Beautiful and White Flowers*, is inspired by Hockney's earlier 'Domestic Scenes'.

'Fourteen Poems by C.P. Cavafy',
Plate 4, *To Remain*, 1966

'Fourteen Poems by C.P. Cavafy',
Plate 7, *The Shop Window of a Tobacco Store*, 1966

The etchings were made with no particular poem in mind. At first Hockney had wanted to include a variety of Cavafy poems, but finally it was decided to concentrate on the homosexual ones. The completed prints were spread over the floor at Powis Terrace, and Hockney, Nikos Stangos, Maurice Payne and Paul Cornwall-Jones made a final selection of thirteen. The unused ones, depicting very similar subjects, were never published.[22] Stangos chose which poems would go with the chosen prints, including of

course Hockney's favourites, 'To Remain', 'In an Old Book' and 'He Enquired After the Quality'. Thus the prints are not literal illustrations of the poems but visualizations of their nostalgia for fleeting but memorable sexual encounters; the feeling of authenticity generated by the images is due to Hockney's own personal experiences. They were instantly acclaimed. Writing in *The Times*, Edward Lucie-Smith spoke of their 'staggering virtuosity', and described them as 'not only the best work I have seen by the artist, but probably the finest prints produced in England since the war.'[23] The Arts Council made a film about the creation of the prints, entitled *Love's Presentation*, which concentrates on the technicalities of the etching process.

Maurice Payne had already been working at Editions Alecto for a few years when he was asked to become Hockney's assistant on the Cavafy project. They made a very good team, and it was the start of a long working relationship. He looks back with real pleasure on their first collaboration: 'David was very quick to pick up technical information. I found he was extraordinarily clever. I was only the tool to help him carry out his ideas, though I think my enthusiasm and my sympathy for the project spurred him on a lot. The Cavafy prints are a great portfolio, they are really tough, you can see the effort that has gone into them, you can follow the flow of the line. They have much more impact than the rather more correctly drawn Grimm prints of 1969.'[24] Hockney was the latest in a line of English-speaking admirers of Cavafy that included E. M. Forster, D. H. Lawrence and T. S. Eliot. Forster met Cavafy in Alexandria and gave a wonderful pen portrait of the poet in *Pharos and Pharillon*.[25] While artist in residence at King's College, Cambridge, Mark Lancaster became friendly with Forster and in 1968 introduced Hockney to the ninety-year-old novelist. They discussed Cavafy and Hockney's illustrations, which Forster found rather shocking. 'They used not to show all that in my day,' was his only comment.[26]

In parallel with his Cavafy etchings, Hockney was also designing sets and costumes for a revival of Alfred Jarry's *Ubu Roi* at London's Royal Court Theatre. The artistic director, William Gaskill, was also from Bradford, and it was his policy to extend the boundaries of theatre by employing painters as designers. Hockney knew the play but had never designed for the theatre and only agreed to the project after reading Jarry's stage directions: 'Don't bother about scenery, just put up a sign saying "Polish Army".' So he decided on the concept of a simple drawing for each scene which would be enlarged by the scene painters to a twelve-foot by eight-foot painting, much smaller than the stage itself. There was little wing space at the Royal Court but plenty of height, so each painting could be lowered onto the middle of the stage with ropes, 'like a joke toy theatre', in Hockney's words.[27]

Well aware of the Absurdist background to the play, he designed very basic costumes which turned the actors into walking assemblage sculptures. Max Wall played Père Ubu;

his costume was a huge pear-shaped construction decorated with a target, inspired by Jarry's own drawings, and a bright green bowler hat. He remembered later: 'My own first entrance in the play was made from beneath the stage as I was hauled up to stage level on a lift while sitting on a toilet that matched up with the backdrop on which was painted a cistern and lavatory chain.'[28] Mère Ubu wore high-heeled boots with spurs, and a black dress with breasts on the outside complete with red nipples which could light up thanks to a concealed battery. The Polish Army was just two people with a banner tied round them saying 'Polish Army'. For other scenes, actors placed letters on the stage spelling 'Parade Ground' or 'Royal Palace'. The director, Iain Cuthbertson, gave Hockney free rein and the result was a wonderful collection of inventive ideas and an experience which he greatly enjoyed. *Ubu Roi* was the first step in what was later to become one of the most important aspects of Hockney's career.

The Cavafy etchings and the *Ubu Roi* designs were exhibited at Kasmin's gallery in the summer of 1966. Hockney immediately returned to California, where he stayed for a year, the longest period he had spent abroad up to that time, and a sign of his growing affection for that part of the world which was eventually to become his permanent home. The sybaritic life-style of his new acquaintances had an obvious appeal to the working-class lad from Bradford; their sundrenched houses, complete with palm trees and deep-blue pools, epitomized for him the two essential attractions of California: the warmth and brightness of the light, which were quite foreign to an Englishman, and the sexiness of bronzed boys lazing by the pools, who had, of course, been one of his prime reasons for visiting California in the first place. Now his immediate reason for returning was an invitation to teach painting for six weeks at the summer school of the University of California at Los Angeles. Into his class here walked an eighteen-year-old Californian boy who seemed the personification of all his cherished fantasies.

Peter Schlesinger (see plates 75, 77) was studying a world history course at the Santa Cruz campus and had enrolled in the summer school, as he wanted to make art his career. Hockney was immediately drawn to this shy, slim, fair-haired, attractive student and invited him out to a film and to dinner. A friendship developed during the six weeks of the course, and the two men continued to see each other after it had ended. Peter began to rely on Hockney a great deal: one evening early in their friendship, he telephoned for help after he had hitched a lift with a man who tried to proposition him for sex. Peter was from a strict Jewish family with two brothers who had gone to Israel to dedicate themselves to Zionism. His father worked for the coastguard service. Like many boys from such a religious and middle-class background, he found it difficult to come to terms with his own sexuality. At Santa Cruz he had dated his female French teacher, and now, in Los Angeles, he was becoming aware of his gayness. This caused great upset in the family, and his parents insisted on sending him for psychiatric help.

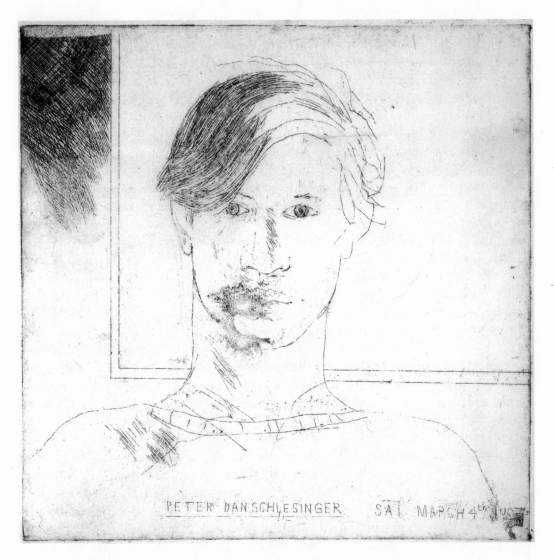

Peter Schlesinger, 1967

Hockney was staying in Nick Wilder's Larabee Drive apartment in West Hollywood at this time, and he agonized for hours with Nick over his new friendship with Peter. He was deeply in love, but it took time, and a great deal of understanding, before Peter was able to reciprocate. By the end of summer, however, their relationship had developed into what was for both of them their first great romance. As Hockney later told Marco Livingstone: 'It was incredible to me to meet in California a young, very sexy, attractive

boy who was also curious and intelligent. In California you can meet curious and intelligent people, but generally they're not the sexy boy of your fantasy as well. To me this was incredible; it was more real. The fantasy part disappeared because it was the real person you could talk to.'[29]

During the summer of 1966, Peter often stayed with Hockney at Nick's apartment, or in the little studio Hockney had rented on Pico Boulevard. In August, Mark Lancaster came to Los Angeles for two weeks and found Hockney supremely happy. He took an instant liking to Peter, and the three of them had a marvellous holiday seeing the sights of the city. Mark had a good camera, unlike Hockney, who made do with a Polaroid, so he was commissioned to take all the holiday photographs: Hockney and Peter under a giant hotdog sign and beside Liberace's giant candelabra on La Cienega Boulevard; Hockney with a giant orange on his head, which was advertising orange juice; Hockney and Peter at Forest Lawns Cemetery with a copy of Michelangelo's *David*.

Peter became Hockney's favourite model almost as soon as they met. The first drawing is entitled *Peter, Swimming Pool, Encino, California* (the town where he lived); curiously, it shows much more concern with the patterns on the surface of the water than with the features of the boy in the swimming trunks reading beside the pool. *Peter, Pico Boulevard, Los Angeles* has him reading a novel in an armchair in Hockney's studio, and in *Henry and Peter* he is having coffee with Hockney's friend Henry Geldzahler, on a visit from New York. Two drawings entitled *Peter, Royal Pacific Motel, San Francisco* show him, firstly, in his underwear and then in the shower. A sequence of images drawn in Santa Cruz in October, when Peter returned to college, shows him reading D. H. Lawrence on a park bench, sitting up in bed, and lying asleep in various motel bedrooms. *Dream Inn, Santa Cruz* is a particularly successful expression of the artist's obvious affection for the beautiful naked boy on the bed. All of these drawings capture an intimacy and informality which require no posing and no artistic devices. The happiness of the relationship they celebrate had brought a new assurance to Hockney's graphic art.

Through his friendships with Christopher Isherwood and Don Bachardy, Jack Larson and Jim Bridges, and Nick Wilder, Hockney was coming in contact with collectors and art lovers who lived in the fashionable area of Beverly Hills, and certain of his paintings show a fascination with the life-style of such people, with their geometrical homes and their contemporary art works. Earlier it had been the buildings that caught his attention; now it is the occupants, and the titles of the paintings, *Beverly Hills Housewife* (see plate 72) and *American Collectors*, betray the gentle humour that has prompted the images.

Hockney had already tried out the theme with *California Art Collector* of 1964, but whereas this lady sitting in her Giotto-inspired loggia between her primitive mask and her Turnbull sculpture had been a complete invention, *Beverly Hills Housewife*, the first

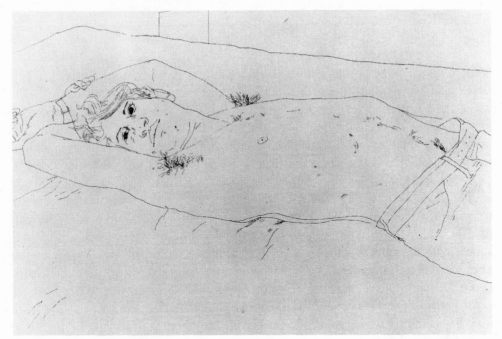

Peter, 1968

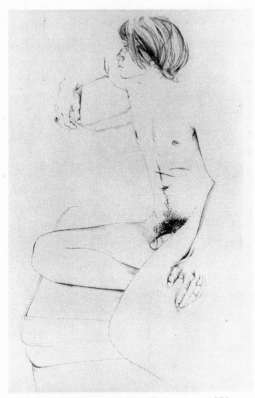

Peter Schlesinger, by Don Bachardy, c. 1970

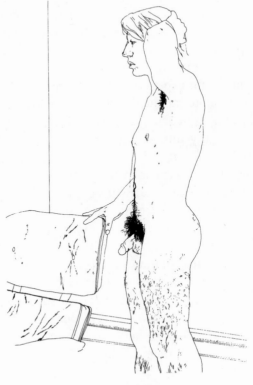

Peter, 1969

painting he began on his return to California, was a portrait of Betty Freeman. Measuring six feet by twelve feet, this was his largest and most ambitious painting since *A Grand Procession of Dignitaries in the Semi-Egyptian Style* of 1961 and, because of the limitations of his tiny Pico Boulevard studio, he had to paint it in two sections. Once again he seems to have turned to an early Renaissance prototype: Mrs Freeman and the objects around her have been positioned very deliberately, in a carefully defined space that recalls stage-like images such as *The Flagellation of Christ* by Piero della Francesca, whom Hockney had always greatly admired. The later painting is far more satisfactory than *California Art Collector* because it is based on careful observation of Mrs Freeman's house.

Hockney had been introduced to Betty Freeman by Jack Larson, and she remembers that he asked if he could paint her on her terrace very soon after they first met. He took three or four black-and-white Polaroid photographs of the setting and of her Corbusier chair with zebra-skin cover, and he did one pencil drawing of her head in profile: these he used as his studies for the painting. The chair, the trophy head, the barbecue, the inevitable Turnbull sculpture, the view through the house to the front garden and the reflection in the window of the swimming pool and palm trees are all based on careful observation. But the result is by no means a copy of a photograph, for Hockney's rather fuzzy snapshots give very little detail, and the important compositional element of the palm in the foreground of the painting is his invention. The simplification of the forms and the bright, intense blue sky, green grass and fuchsia dress show Hockney's continuing experiments with American acrylic paint, and create an effect which is far from photographic. He spent many months working on the picture, and it stands at the beginning of a long sequence of large-scale, strongly coloured, meticulously composed and highly finished figurative paintings which date from 1966 to 1974. *Beverly Hills Housewife* succeeds in creating a vivid evocation of the affluent Hollywood life-style, depicted with ironic detachment. Betty Freeman herself shares the joke: she sees herself as 'just one of the artistic objects on display'.[30] She is, in any case, far from the typical Beverly Hills housewife, since she promotes concerts of contemporary music and holds soirées in her home where musicians such as Pierre Boulez and Karl-Heinz Stockhausen perform.

The third painting in the 'Collectors' series dates from two years later, from 1968. *American Collectors* is subtitled 'Fred and Marcia Weisman', and the relationship of the couple to each other is as much the subject as their relationship with the art works around them, in this case a Henry Moore seated figure, a totem pole and the usual Turnbull sculpture. As with Betty Freeman's portrait, Hockney has relied on photographs rather than studio sittings, but by 1968 he had acquired a better-quality camera, and the studies for *American Collectors* were sharp colour prints that seem to have dictated the final look

of the picture. This makes for a less interesting painting but a more amusing comment. Fred stands to attention facing the Turnbull pile of stones; Marcia faces the viewer and almost mimics the Moore figure. To her left stands the totem pole which Hockney could not resist including because it so reminded him of her. Betty Freeman enjoyed the joke at her expense and her painting today hangs over her dining-room table; Fred and Marcia Weisman's collection of contemporary art is outstanding, even for Los Angeles, but they have sold their Hockney portrait and today it hangs in the Chicago Art Institute.

Hockney's fascination with the Hollywood life-style was not confined to its art collectors. The subject that most engaged his attention, and inspired six major paintings in the very productive year of 1966, was the swimming pool. As we have seen, he had been attracted to the ubiquitous pools from the start of his first visit to California, and he had featured them in *California Art Collector* and *Picture of a Hollywood Swimming Pool* of 1964. The following year, with *California* and *Two Boys in a Pool, Hollywood*, he had added the figurative element of suntanned, nude male bodies, but these were subservient to the main concern, which was with Modernist ideas of surface shape and pattern in the rendering of water. The 1966 series marked the way forward with its clear and consistent portrayal of reality.

Hockney had been fascinated by the problems of painting water in his shower pictures; now he found water in pools an equally stimulating challenge. 'Water in swimming pools changes its look more than in any other form. The colour of a river is related to the sky it reflects, and the sea always seems to me to be the same colour and to have the same dancing patterns. But the look of swimming pool water is controllable – even its colour can be man-made – and its dancing rhythms reflect not only the sky but, because of its transparency, the depth of the water as well. So I had to use techniques to represent this.'[31] The first of the new series, *Sunbather* (see plate 74), shows a naked male lying face-down on a towel beside a pool, but he occupies only a quarter of the picture, at the very top, for the rest is made up of the pool water. Hockney had noticed that, in strong sunlight, a still surface will be full of dancing lines with the colours of the spectrum. In *Sunbather*, the sun shines through the water, creating a spaghetti-like pattern of violet and yellow.

The sunbather was copied from a magazine picture, but the water was painted from photographs Hockney had taken of dancing water. Photographs were taking on even more importance for him as his paintings were becoming increasingly concerned with observed reality. That summer Hockney asked Mark Lancaster to take some pictures of Nick Wilder. Hockney and Mark were staying in Nick's apartment on Larabee Drive. Hockney wanted close-up photographs of Nick standing in his pool, so Mark had to wade into the pool to take them. These and other photographs formed the basis for *Portrait of*

Nick Wilder (see plate 79), Hockney's first absolutely specific portrait since his college days, and an important further step. He wrote in his autobiography: 'To me, moving into more naturalism was a freedom. I thought, if I want to, I could paint a portrait; this is what I mean by freedom.'[32] It is not only a specific portrait of Nick Wilder but also of his pool and his apartment (see plate 78). Hockney has deliberately chosen a straightforward frontal view of the severely rectilinear architecture, with little perspective reference other than the gentle curve of the pool, in order to create a flat and almost shadowless image, paralleling that of *Sunbather*. The deep blue sky, reflected in the abstract blue and green designs on the surface of the pool, fills the painting with sunlight and creates a sense of space, but the flatness of the composition is enhanced by the border of unpainted canvas around the picture. This was a deliberate device, which he had used before, to 'make the picture look more like a painting' in Hockney's words;[33] although he was now making fewer concessions to Modernism, he was nevertheless still keen to stress the primacy of the picture-plane, and the essential artificiality of painting reality in two dimensions.

The series of pool paintings continued with *Peter Getting Out of Nick's Pool* (see plate 80). The setting is the same as for *Portrait of Nick Wilder*, but the viewpoint has been lowered so that there is no sky and only the lower storey of the apartment building. At seven-foot-square it was Hockney's second-largest single canvas to date, and especially important as it was his first painting of Peter Schlesinger. The pool-surround has now been straightened so that it forms a horizontal line of blue tiles spanning the picture-plane (as in *Sunbather*) and, together with the restriction of the setting to the balcony and french windows of the apartment and the enlarged surround of unpainted canvas, this gives the picture a considerably flatter effect than *Portrait of Nick Wilder*. The three-quarter-length nude figure of Peter levering himself out of the pool and looking over his shoulder is placed exactly at the centre of the canvas, giving a vertical accent to the horizontals of the picture; thus it becomes the focal point to a far greater extent than is the case with Nick Wilder's head and shoulders in the lower part of his portrait. Once more photography played an important role in the genesis of *Peter Getting Out of Nick's Pool* which, with its square format within a plain border, at first glance suggests a photographic print. Peter did not pose for the painting at all. He had returned from Los Angeles to his college in Santa Cruz in the autumn and, on a weekend visit, he had been asked to pose in the nude, draped over the bonnet of his 1953 MG sports car. He recalls Hockney saying: 'Pretend you are getting out of a pool,'[34] which is not easy if you are grasping the headlights and trying to avoid damaging yourself on the radiator cap. Further photographs were taken of him leaning on a chair in Hockney's Pico Boulevard studio, and the most successful pose was copied onto the canvas regardless of the shadows across his back in the Polaroid. The diagonal lines used to denote the glass of the window

behind the pool were copied from advertisement graphics, but the serpentine shapes for the surface of the pool are free interpretations of observed reality.

One day towards the end of 1966, Hockney was browsing through the papers on a Hollywood news-stand when he found a magazine about how to build swimming pools which contained a photograph of a splash. He immediately saw great possibilities in painting a splash rather than simply the flat surface of a pool, and the result was a series of three paintings. *The Little Splash*, only sixteen by twenty inches, showing the corner of a house with a pool and a diving board and a splash, took only two days to paint. *The Splash* followed, much larger at six-foot-square, repeating the scene with more elaboration of the building and the view beyond the pool. This, however, Hockney felt to be a mistake, as the background now distracted attention from the splash. He therefore painted *A Bigger Splash* (see plate 70), at eight-foot-square the largest of his whole Californian series. The vivid blue sky and ultramarine water take up most of the canvas, and were painted with rollers. The house and pool-surround make a broad horizontal across the centre, and the diving board is placed at the lower right-hand side. Against these flat slabs of colour is placed the splash, a complicated arrangement of lines and patches of white acrylic which took two weeks to paint. The result is one of the most effective and memorable of all Hockney's images of California. The viewer is never quite certain whether this is an abstract or a figurative composition. Hockney himself feels that it is figurative in the sense that a figure has just disappeared under water but, at the same time, abstract because of the way it was carefully built up in stripes of colour.[35] He sees it as one of his most consciously planned and inventive pictures. Part of its fascination lies in the playful manipulation of observed reality in terms of abstract design, but the intensity of the image results from the viewer's awareness that an event captured by the camera in a fraction of a second has taken weeks of effort to recreate.

A Bigger Splash has caught the imagination of many commentators. Marco Livingstone probably reads too much into it when he writes: 'There is something jarring about the apparent depopulation of Los Angeles . . . Unconsciously, perhaps, a sense of isolation emerges, not so much the sombre melancholia of Giorgio de Chirico's metaphysical paintings as a feeling of aloneness as induced by Edward Hopper's pictures of deserted American city streets.'[36] Henry Geldzahler has written: 'We are somehow not concerned with the absence of the figure, obviously present an instant ago. The subject of the painting is the explosive wetness of the splash in contrast to the warm and fragrant stillness of the setting . . . the result has the charm of a nineteenth-century French academic painting.'[37] But Charles Harrison feels a stronger effect: 'Nothing disturbs the emptiness of the scene. Even the splash in the swimming pool, painted from a photograph, is frozen by the time and patience of its execution. The bright Californian

sky flattens the forms and bathes all in a uniform technicolor daylight. The world is the world of the photograph. There is no continuity and no possible development. The figure whose plunge is recorded by the splash will never surface in this world.'[38]

The Californian pool paintings have become synonymous with the name David Hockney, even though they form a tiny part of his total work to date. But they constitute the aspect of his work that is the most popular, in the best sense of the word. It is unusual for a creative artist to achieve such popularity, but the appeal of such paintings is obvious. For the English viewer they represent all that is attractive and different about southern California: the warmth of the sun, the pursuit of pleasure, the affluence of the rich. In Marco Livingstone's words, 'Hockney's idyllic vision of carefree life in LA is unashamedly that of a foreigner.'[39]

However, the images of Hockney's love affair with California are saved from the pitfalls of sentimentality by the artist's ironic sense of detachment, and writing from an American viewpoint, Henry Geldzahler sees this as a typically English trait.[40] To support his argument he calls upon Nikolaus Pevsner ('The English portrait conceals more than it reveals, and what it reveals, it reveals with studied understatement.'[41]) and Jane Austen, who wrote that the English style was achieved 'by burying under a calmness that seems all but indifference, the real attachment.'[42] Perhaps the most extraordinary achievement of these paintings is that a provincial Englishman has created a widely accepted image of Los Angeles and has made southern Californians look with new eyes at their own environment. Geldzahler wrote that in California 'an affection for the deadpan coolness of America clutched [Hockney's] heart,' and went on to describe the 1966 paintings as 'a catalogue of the Los Angeles art world in which Hockney spent his Californian years that will stand for the period much as Evelyn Waugh's *The Loved One* stands for the earlier Los Angeles of Forest Lawn and other excesses.'[43]

In December Hockney travelled to New York to meet Patrick Procktor; Peter Schlesinger was spending Christmas with his family. Hockney and Patrick stayed with Mark Berger and visited galleries and museums. They spent some time with Hockney's dealer and friend Charles Alan, who had given him the very successful 1964 show and who was planning another for 1967. Charles was presented with three pen-and-ink souvenirs of the visit: his portrait drawn by Hockney, Hockney's drawing of Patrick inscribed 'Patrick Procktor in New York for Charles, Happy Channukah 1966, love from David', and Patrick's drawing of Hockney inscribed 'David at 81st Street, 22nd December 1966, for Charles with love from Patrick'. Hockney and Patrick were alone for Christmas Day, and had their festive dinner at Horn and Hardarts Café, surrounded by homeless down-and-outs.

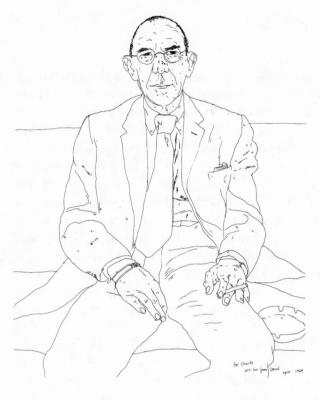

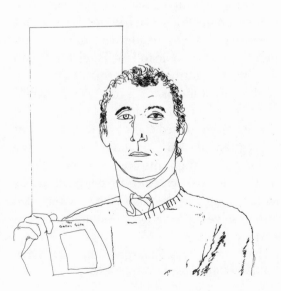

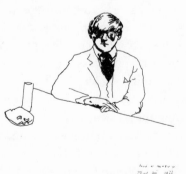

(Left) *Charles Alan*, 1969

(Below left) *Patrick Procktor in New York*, 1966

(Below) *David at 165 E 81st Street*,
by Patrick Procktor, 1966

In January 1967 Peter Schlesinger transferred from Santa Cruz to the art course at the Los Angeles campus of the University of California; for the next six months he lived with Hockney in the little studio on Pico Boulevard. When Peter was away at college during the day, Hockney would paint. At this time he was still working on *Peter Getting Out of Nick's Pool* as well as four little swimming pool paintings later framed together as *Four Different Kinds of Water*. He also painted *A Lawn Sprinkler*, which provided another opportunity of experimenting with ways of painting water. In the evenings the couple would eat out, as their kitchen was infested with cockroaches. The studio was in a run-down house in a seedy part of the city, but they were very happy to be living together as lovers at last. They never went to bars as Peter was under-age, so they kept the refrigerator full of Californian white wine and enjoyed a peaceful life as they had no telephone. They would often go to the cinema in the evening and then sit in bed together and read and drink wine. At weekends they would go and swim in Nick Wilder's pool, where there was always a crowd of beautiful young boys, or they would visit Christopher Isherwood and Don Bachardy or Jack Larson and Jim Bridges. Hockney would often play chess with his nextdoor neighbour, Ron Davis, an abstract artist. Davis won their very first game and said, 'That's what comes of playing with geometric artists.' Hockney won their second game and said, 'That's what comes of playing with figurative artists who know what to do with a queen.'[44] Hockney recalled in 1975 that this was certainly the happiest period he had ever spent in California, even though the studio was the worst place he had lived in.

In the spring of 1967 he started a ten-week contract teaching at the University of California at Berkeley near San Francisco. He taught from Tuesday to Thursday, and would usually fly there on the Monday and return on the Friday, so having his weekends with Peter. He taught a graduate seminar in painting: students would bring in their work and he would give his opinion and then a group discussion would follow. He already had a reputation as a bright young English artist painting the southern Californian scene, even though he had yet to exhibit his work in California. One of his group, Alan Turner, remembers that he was an exciting, amusing and helpful teacher who liked to have social contact with his students.[45] Turner and Hockney often played chess together and went on anti-war marches. Hockney had not forgotten his early involvement with the Campaign for Nuclear Disarmament in England, and he was quite prepared to risk being deported from America as an undesirable alien by participating in demonstrations against the Vietnam war. His class was a talented group: besides Alan Turner, it included others who have gone on to make a name for themselves in American contemporary art – Joel Pearlman, Susan Hall, Paul Cotton and Mary Heilman.

In Berkeley Hockney stayed in a hotel and had the luxury of a large studio with north light at the university. Here he completed *A Bigger Splash* and painted *A Neat Lawn* (see

plate 83), a large and ironic picture of a Hollywood house, with lawn and sprinkler, and a further pretext for painting water. And here he painted *The Room, Tarzana*, another eight-foot-square canvas and one of his most ambitious Californian pictures.

The initial inspiration for *The Room, Tarzana* (see plate 71) was a chance event that paralleled the genesis of the 'Splash' series. One day Hockney happened to see an advertisement for Macy's furniture store in the *San Francisco Sunday Chronicle*. The product on offer was a 'Bates' famous "Piping Rock" bedspread with a difference . . . it's pre-ironed for life'. In the accompanying photograph the 'parrot green' bedspread covered the bed so neatly and precisely that it looked to Hockney like a piece of sculpture. Here was an ideal subject for a painting: a direct transcription of the photograph showing the bed, the bedside table with its lamp and a potted plant, the open window with its shutter and the fluffy carpet. The one element lacking was a figure, and Hockney knew that Peter lying on the bed would complete the composition perfectly. The photograph only showed the lower part of the room, so Hockney cut it out and pasted it on a sheet of cardboard. Then he enlarged the view up to the ceiling in pencil and sketched in a boy lying face-down on the bed (see plate 84). The photograph was now ready to serve as the model for the painting, except for the figure of Peter. So Hockney brought him up to Berkeley and photographed him lying face down on a table. At this point a problem came up: the bed in the advertisement was at a diagonal, and the room was strongly lit from the open window. Hockney, therefore, had to arrange Peter very carefully so that the table was at the correct angle and the light from the window was coming from the right direction. Only then was he satisfied that the painting could proceed.

The Room, Tarzana differs from all the preceding Californian paintings in being based on the interplay of diagonals rather than horizontals and verticals. The relation of the bed to the table, the shutter and the rug requires a complicated use of geometry which gives the picture a perspective depth deliberately denied to all the others, where flatness was paramount. Hockney has copied the photograph accurately, except for 'correcting' the bedside table so that it more convincingly fits into the corner of the room behind the shutter. He has emphasized the sculptural look of the bed and added a large pillow to support Peter's head. And, most importantly, he has given great emphasis to the shadows, which in turn means that he has concentrated his attention on the clear, all-enveloping sunlight that fills the room. Shadows had played little part in the previous Californian paintings, which were uniformly lit. Now for the first time real light itself becomes a subject, light as it flows across the room from one identifiable source. The acrylic colours used are strong but very limited in range: a vibrant green set against cool blues and white, with only the yellow bedstead and the pink of the flesh to hold the spectator's attention in the centre of the picture.

The title of the painting is a private joke, as Hockney explained to me later: 'Peter was

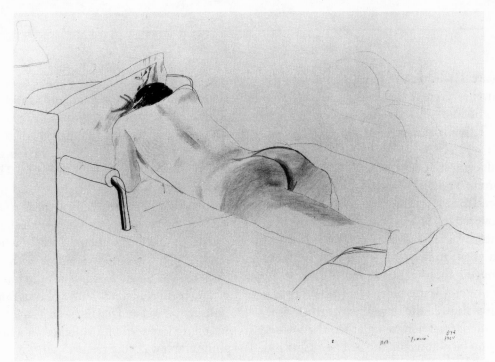

Bob, SS 'France', 1965

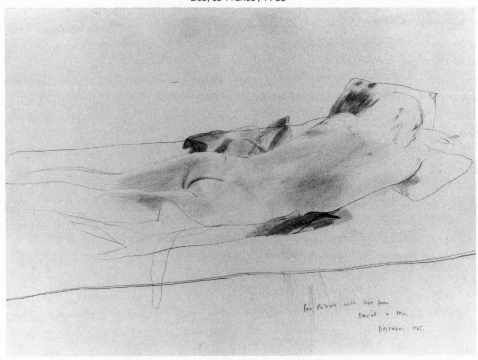

Mo, 1965

worried that his parents who live in Encino would see the picture in a magazine and recognize him. So I told him not to worry – I'd call it "The Room, Tarzana" (another suburb of Los Angeles) so they would know it wasn't him!'[46] Peter is the focal point of *The Room, Tarzana* and wears just a white T-shirt and white socks. This was exactly as Hockney had asked him to pose; for him, this is the uniform of the desirable all-American boy, and that was the role Peter was to play in the painting. The clothes are clearly signifiers, and Peter's position face-down on the bed is also crucial to the picture's meaning. For Hockney, the young male bottom is the peak of sexual excitement. From the three 'Shower' paintings of 1964 and 1965 to *Sunbather* and *Peter Getting Out of Nick's Pool* of 1966, as well as in numerous drawings of his friends, careful emphasis is always placed on the bottom. Peter and Mo both recall how often Hockney would ask them to pose 'bottom uppermost'. When looking at *The Room, Tarzana*, it is difficult not to recall Boucher's *Mademoiselle O'Murphy* of 1752 (see plate 86), and this beautiful young girl reclining on her chaise longue and displaying her superb behind is a voyeur's delight which was certainly at the back of Hockney's mind when he painted the figure of Peter. Boucher was celebrating his love for Louise O'Murphy in eighteenth-century fashion by concentrating his attention on the highly finished and almost tactile flesh of her body as she sinks into the silks and satins of her couch. Hockney's fetishistic image is painted in twentieth-century terms, but is no less a personal celebration.

CHAPTER FIVE

EUROPE AND AMERICA 1967–1970

In June 1967, when Peter's term was finished and Hockney's teaching contract had ended, they left California together for New York and then sailed to England on the *Queen Elizabeth II*. It was Peter's first visit to Europe, and he immediately fell in love with London. As soon as they had settled into Hockney's Powis Terrace flat, they made plans for the future. The ideal solution would be to live together in London, and so Hockney applied to the Royal College of Art and to St Martin's College of Art for a transfer from UCLA for Peter. After interviews, both colleges turned Peter down; he later heard that he had been suspected – wrongly – of trying to pass off Hockney's less successful work as his own. This meant that he had only three months' holiday before he would have to leave and return to college in Los Angeles. Hockney bought a Morris Minor convertible and spent July showing him the tourist sights of southern England: Winchester, Salisbury, Stonehenge, Wilton House, Hampton Court, Oxford, Cambridge. Hockney's birthday, 9 July, was celebrated by Lindy Dufferin with a party for him and her husband Sheridan, whose birthday it was as well. It was an opportunity to introduce Peter to his London friends; it was also an occasion when he met the veteran painter Duncan Grant, who much admired his work. In August Hockney and Peter decided to drive through France to Italy. Hockney had been invited to visit various friends who would be on the continent for the summer, and he asked Patrick Procktor to join the party. It was some years since he had last spent the summer travelling round Europe: 'I'd been so full of America for five years, but coming back to Europe you realize it's certainly more interesting to drive round than America. America's wonderful as landscape, but every time you pull into a restaurant you know what the menu's going to be. Gets you down a bit.'[1]

The three friends drove via Paris to the critic Mario Amaya's house in Lucca. From here they undertook a cultural tour of Italy: after Pisa, Arezzo, and Tivoli they visited Rome, where Hockney did some beautiful pen-and-ink drawings of Peter lying naked on his back on their bed in the Albergo da Flora, and one coloured crayon drawing of his suntanned back which concentrates on his pale pink bottom. Next, they stayed with Ferrill Amacker in Florence and then spent a week on the beach at Viareggio, which Hockney had so enjoyed on his visit in summer 1962. Their route back to England took them through the south of France to the Dordogne, where they stopped for a few days

near Souillac in the village of Carennac, staying in the château which Kasmin and his family had rented for the summer (see plates 91, 92, 93).

For many years Carennac and the surrounding countryside would be Hockney's favourite spot for summer holidays. The château was part of a complex including a church and priory, all dating originally from the eleventh century. Fénelon had written *Télémaque* there in the eighteenth-century when he spent fourteen years as Prior, and it had become popular with British visitors when the English entrepreneur, Henry Oyler, settled there at the turn of the century. Kasmin had read Oyler's book *The Good Earth*, which described Carennac as the romantic centre of the Aquitaine, with its historic connections with England and its magnificent cave-paintings which constituted 'the cradle of civilization'. This had led Kasmin to explore the village, where he found the beautiful château overlooking the river Dordogne. It had been a hotel that failed, and he was able to rent it together with Howard Hodgkin and his family. Here they spent many idyllic summers, and they were always delighted to welcome those friends who were able to visit them. There were six bedrooms in the château, plus a large room in the tower where all the children of Kasmin, Howard and their visitors slept in sleeping bags. At the bottom of the garden was the Tour St Elois with its terrace and long table where people ate their meals, and such occasions were the subjects of many of Hockney's Carennac drawings. Everyone had a job: children helped with the vegetables and the adults pitched in with the washing-up. The cooking was Kasmin's responsibility: he loved the old kitchen range, and would not allow anyone to touch his beautiful kitchen knives. It was all very relaxed and informal. During the day people would play *boules* in the garden, swim in the river Dordogne at nearby La Treyne, or visit the wonderful open-air markets and church festivals at neighbouring villages, and there were often firework displays on the island opposite the château. The local wine flowed at all times and, by evening, everyone was usually in a happy state of intoxication.

Jane Kasmin remembers Hockney arriving unexpectedly one day in August in his little Morris Minor with Peter beside him and the six-foot Patrick Procktor doubled up in the back.[2] They loved the place and spent a very happy week there with the Kasmins, the Hodgkins, the Cornwall-Joneses, and Brian Young. Hockney found a spa in the hills at Alvignac where he and Peter went to take the waters, and every day he drove ten miles to the town of St Céré for the English newspapers. He and Brian spent many hours playing poker, a habit he had acquired at the Royal College. He did many pen-and-ink drawings: Peter asleep, Kasmin reading in his very grand bed, a view of the château from the garden (see plate 94), but he also painted three watercolours of Jane Kasmin, Howard Hodgkin and Julia Hodgkin (see plates 105, 106). He had tried this medium before without much success, but Patrick Procktor was busy painting in watercolour this summer so Hockney decided to try again, using high quality Perrigot Masvre paper. As well as the three

Carennac portraits, he produced *Peter Drying Himself in Anguillara* and *Peter Having a Bath in Chartres* during the trip, but he was not happy with the lack of clearly defined form in these paintings, and finally gave his watercolour paints to Patrick.

Back in London, Hockney found he had a pile of snapshot souvenirs of the tour, and these, together with boxes of photographs lying around his studio, made him decide to organize them properly, in chronological order. He bought a big, strong album from Wallace Heaton in Bond Street and began to sort them out. The earliest were from a visit to Cambridge in 1960. There were many souvenirs of holiday trips: New York (1961), Berlin (1962), Paris (1963). From 1964 he had kept scores of photographs of his first visit to Los Angeles as well as scenes of family occasions in Bradford. For the years 1965 to 1967 he found snapshots of many of his friends including John Kasmin, Patrick Procktor, Mark Lancaster, Derek Boshier, Peter Phillips, Pauline Fordham, Sheridan Dufferin, Mo McDermott, Ossie Clark, Norman Stevens, Colin Self, Mark Berger, Billy Apple, Ferrill Amacker, Nikos Stangos and Robert Earles III. He had also kept photographs he had used for such paintings as *Beverly Hills Housewife*, *Portrait of Nick Wilder*, *Peter Getting Out of Nick's Pool* and *The Room, Tarzana*. And he found many photographs of Peter Schlesinger: alone or with David and his friends, nude or clothed, in America or in England. A large selection of these photographs was carefully mounted in the album, and this spurred Hockney to buy a good camera (a Rollei) for the first time. The immediate result was roll after roll of film of Peter in the Powis Terrace flat. Sometimes he was chatting casually to friends or posing for the camera with Hockney. But others are a voyeur's delight; there were whole series of images of Peter in the shower, or in a jockstrap, or in T-shirt and white socks, or in jeans with the zipper open, or lying naked on his stomach among the bedclothes. Hockney was now taking photography much more seriously; he has continued to mount his photographs in Wallace Heaton albums. Volume One covers the period from 1960 to 1967, but Volume Two was filled between September and Christmas of 1967. Later volumes sometimes cover simply one month or even a few days. To date he has filled well over one hundred. Michael and Christian Blackwood made a film based on these albums in 1971 entitled *David Hockney's Diaries*, in which he gives a commentary on a selection of his photographs.

In September Hockney did many precise pen-and-ink drawings of Peter at Powis Terrace and put the finishing touches to *The Room, Tarzana*, which he had brought with him from California for a show at Kasmin's gallery in January 1968. He changed the pillow behind Peter's head from green to blue, and worked on the modelling of his body. At the end of the month the two of them flew to Brussels for an exhibition, 'Young British Painters', in the Palais des Beaux-Arts, in which six of Hockney's paintings were on show including *Boy About to Take a Shower* (1964), *Rocky Mountains and Tired*

Indians (1965) and *Different Kinds of Water Pouring into a Swimming Pool, Santa Monica* (1965). Hockney was clearly one of the stars of the show, and at the opening he found many of his friends, including Peter Blake, Joe Tilson, Peter Phillips, Derek Boshier, Patrick Caulfield and Mark Lancaster. Peter had to leave almost immediately afterwards to continue his studies in Los Angeles and, for the first time in fifteen months, Hockney found himself facing a period alone.

When he was living in Powis Terrace after leaving the Royal College, Hockney had spent a great deal of his time with his friend Patrick Procktor. They had a lot in common: both recently graduated and trying to make their way as artists, both gay and liking the same clubs and pubs. They had also explored America together, but as soon as Hockney had met Peter, other friendships had taken second place. In October 1967, with Peter away in Los Angeles, Hockney once more spent a lot of his time with Patrick, and put most of his energy into an eight-foot square portrait of him entitled *The Room, Manchester Street*. The title refers to the address of Patrick's home in London, but at the same time it links the painting with that other portrait of a close friend, the recently completed *The Room, Tarzana*. Although it has none of the erotic overtones of Peter's portrait, *The Room, Manchester Street* shows the same concern with the problem of depicting light. Once again the light source is clearly defined, but here it is two windows rather than one. The figure of Patrick is placed between them, and also in front of them, so that a *contre-jour* effect is created. The acrylic colours are appropriately muted in scale: a range of pale blues, purples and greys bathed in the soft daylight filtering through the Venetian blinds. The result is a particularly English pendant to the bright, sun-filled Californian portrait of Peter.

The Room, Manchester Street shows Patrick in his studio, standing in profile, reminiscent of Egyptian painting, silhouetted against the wall between the windows. The room is almost clinically neat and tidy, with a full wastepaper basket to the left, a desk with chair and Anglepoise lamp to the right, and nothing else. Patrick interprets the brimming wastebin as evidence of his ability to discard rather than hoard things.[3] It would certainly seem that the picture as a whole is a humorous comment on the difference between the neatness of Manchester Street and the chaotic untidiness of Powis Terrace where it was actually painted.

Patrick feels flattered to have been painted by Hockney but considers the image of himself to be unflattering. It is characteristic of Hockney's portraits that he makes no attempt to flatter. They are images created for himself, not for the subject of the painting. He has made it a rule not to accept commissions for portraits, preferring instead to paint only those people he chooses to paint. Only once has he broken this rule, and the resulting portrait – of Sir David Webster for Covent Garden – he now considers less than successful.

That autumn Hockney also painted *Some Neat Cushions* from a little drawing he had made in California; *A Table* from a photograph that had a sculptural quality recalling the Macy's advertisement he had used for *The Room, Tarzana*; and *Two Stains on a Room on a Canvas*, an experiment with the American techniques of diluting acrylic paint with water and detergent so that it sinks into the raw canvas as if it were blotting-paper. Morris Louis and Kenneth Noland made whole paintings in this way, but Hockney just made one orange and one blue stain and then painted the rest of the picture around them conventionally, as an interior. These were simple statements in paint; nevertheless they have provided grounds for complicated interpretation. Marco Livingstone writes of *A Table*: 'It is the very act of looking with such unaccustomed intensity that turns a prosaic scene into something like an apparition.'[4]

Hockney was restless without Peter, and found time for visits to the lovely old house owned by Paul and Ianthe Cornwall-Jones at St Mawes in Cornwall with Mo McDermott in October, and to Cecil Beaton's home at Castle Combe in Wiltshire with Richard Buckle in November. He also travelled to exhibitions in Amsterdam and Hamburg with Kasmin. At the beginning of December it began to snow heavily in London; Peter arrived from the sunshine of Los Angeles for his Christmas holidays. The period of separation had been difficult for both of them, and Peter had applied for a transfer to the Slade School of Art in London. After an interview he was accepted for the course beginning in September 1968. To celebrate this success, Hockney and Peter went to Paris for Christmas with Patrick Procktor and Ossie Clark. They saw the Ingres exhibition at the Petit Palais and spent many hours in the Jeu de Paume Impressionist Museum. They stayed into the new year, and Hockney found time to make two coloured lithographs on zinc at the Desjobert studio. This was the idea of Paul Cornwall-Jones, who had now left Editions Alecto and started his own print publishing house, Petersburg Press. Paul had suggested Hockney should go back to print making, but with something less graphic and more adventurous than the Cavafy series. He and Kasmin travelled to Paris with two of Hockney's American drawings, and these became the prints: *Tree* and *Rocks, Nevada*. Hockney was short of money at the time and so made arrangements to sell the prints for 300 francs the pair through his friend Jean Léger, who was a designer in an advertising agency and worked for Helena Rubinstein. The previous year, Jean had visited London with his lover Alexis Vidal, a rare-book dealer, and the novelist Yves Navarre. Jean had bought a drawing of Peter and very soon became one of Hockney's closest friends.

Hockney and Peter returned to London in January 1968 for his fourth one-man show at Kasmin's gallery. This one he called 'A splash, a lawn, two rooms, two stains, some neat cushions and a table . . . painted'. The exhibits were *A Bigger Splash*; *A Neat Lawn*; *The Room, Tarzana*; *The Room, Manchester Street*; *Two Stains on a Room on a*

Canvas; Some Neat Cushions, and *A Table.* His last painting show at Kasmin's had been in 1965 (*Two Boys in a Pool, Rocky Mountains and Tired Indians* et cetera); the new exhibition was proof of the enormous progress he had made, as most London art critics were quick to appreciate. Hockney had caused a stir by winning first prize at the prestigious John Moore's Exhibition in Liverpool at the end of 1967 with *Peter Getting Out of Nick's Pool.* During the year he had had a very well-received show of his recent Californian paintings at Charles Alan's Landau-Alan Gallery in New York, and had also exhibited in group shows in Cologne, Pittsburgh, Ljubljana, Vancouver, Manchester, and the Yale University Art Gallery in Connecticut. He had featured prominently in the Arts Council of Great Britain's 'Drawing Towards Painting' touring exhibition and also in the 'Young British Painters' show which he had visited in Brussels in October and which travelled to Berlin and Lausanne. The new Kasmin show was the climax to a very successful year.

After the opening of the exhibition, Hockney and Kasmin flew to New York. Peter had already returned to college in Los Angeles, but he joined them in New York and they drove together across America to California. Hockney was keen to use his new camera, and took many photographs of the trip through Pennsylvania, Ohio, Iowa, Nebraska, Utah and Colorado to San Francisco and Los Angeles. He had decided to spend the remaining six months of Peter's UCLA course with him in California, and so they rented a tiny penthouse on 3rd Street in Santa Monica which dated from 1934 and was, therefore, considered historic. Hockney also found a small studio in a little wooden house on the other side of the road, and here he painted three seven-foot by ten-foot canvases, *Christopher Isherwood and Don Bachardy, American Collectors (Fred and Marcia Weisman)* and *California Seascape.* Kitaj was teaching at Berkeley and Hockney often visited him there or had him to stay in Santa Monica, where he introduced him to his friend Christopher Isherwood, whom Kitaj had longed to meet. Dick Smith was living on the coast at Corona del Mar and suggested that Hockney should paint the view from his window. He produced a little watercolour and was so pleased that he decided to paint a large picture of the scene. The resulting canvas shows the view across the marina with its yachts and palm trees to the unbroken horizon of the sea beyond. But the view is seen from inside the house, so that a deep pile carpet fills the foreground, curtains hang either side of the seascape, and the top of the painting is part of the wall. The result is a picture within a picture; it is saved from too much formality by the extra glimpse of the sea from a second window to the left. Rich greens and blues create a sunny California, but the view outside is dangerously close to a photographic transcription.

While painting *California Seascape* in the little Santa Monica studio, Hockney was also working on the other two big canvases, discovering that large studios, while very pleasant, are certainly not essential. *American Collectors (Fred and Marcia Weisman)*

was a continuation of his drily humorous observations of Californian life. The problem that interested him most arose from the use of two figures in one composition. The earlier 'Marriage' paintings and 'Domestic Scenes' had included two figures, but his recent portraits, Nick Wilder, Peter Schlesinger, Patrick Procktor, had all been of one individual. David decided early in 1968 that he wanted to experiment with a large double portrait and, as his models, he chose his close friends Christopher Isherwood and Don Bachardy (see plate 109). This was no casual decision. It was convenient because they lived a few blocks down the street in Santa Monica. But much more important was the fact that they were a very successful gay partnership. They had met in 1953 when Isherwood was forty-eight and Bachardy was eighteen. Isherwood had given Bachardy support and confidence throughout his art training and early years of establishing himself, and was very proud of his later success. Isherwood in turn found real love and devotion with his much younger friend. They were to live together for thirty-three years until Isherwood's death in 1986, and during that time they were hardly ever apart. They were both strongly creative people who gave each other inspiration and encouragement. They provided the ideal role-models for Hockney and Peter. The painting, therefore, was not designed simply as an exercise in composition, but also as an examination of an intimate relationship.

Hockney began by drawing Isherwood and Bachardy again and again to get to know their faces. He also took many photographs of them in their home and found that, whenever he asked them to relax, Isherwood would sit with his right foot resting on his left knee and look at Bachardy who would himself always look at Hockney. This gave him the pose for the picture, and the living room with its large table beside the window seemed a good setting. He did two sketches and a squared-up watercolour on the spot in preparation for the final work, which was painted in his studio. The image of the two friends sitting side by side in their armchairs is therefore true to life, as is the bowl of fruit placed exactly in the centre of the table in front of them, together with the dried corncob, which was later eaten by a rat. Hockney has added a neat pile of volumes of the *Encyclopaedia Britannica* on the table in front of each figure; these he had merely moved from their usual place elsewhere in the house. He has chosen to close the blue shutters of the window behind the couple, not wishing to repeat the *contre-jour* of *The Room, Manchester Street*. Instead he has used the light from the window on the right-hand side to unify the composition and to cast distinct shadows on the table and across the faces. The whole picture is designed to be read from right to left, rather than the more conventional manner of left to right as in the contemporary *American Collectors*. The eye follows Isherwood's gaze towards Bachardy, then forward to the left-hand pile of books, and past the still life on the table to the other books in front of Isherwood. Thus the two men are related to each other compositionally and emotionally.

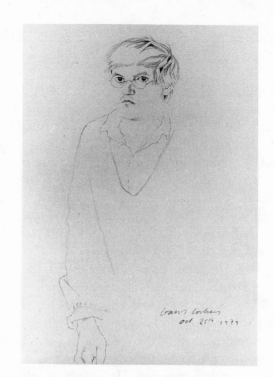

David Hockney, by Don
Bachardy, 1979

(Below) *Don Bachardy,
Santa Monica,* 1966

Although he had taken photographs and made preliminary drawings, Hockney wanted to paint the portraits of Isherwood and Bachardy from life. Isherwood sat a number of times in the studio while Bachardy was abroad. Hockney recalled later that these sessions often developed into long discussions about their respective relationships: 'He'd talk about Don being in England. I do remember he said Oh, David, don't ever get too possessive about your friends; let them feel free. Later I think he was a bit hurt that Don stayed away a long time. Still, it was good advice, though when it happens to you, it's not quite like that; you do feel that it's unavoidable.'[5] Hockney was pleased with the portrait of Isherwood but could not get on with the second figure while Bachardy was away, and so completed the other two paintings, *California Seascape* and *American Collectors*, in his studio. In June, Peter left college and went to visit his parents while Hockney travelled to London with the incomplete rolled-up painting of Isherwood and Bachardy. But Bachardy had left London just before he arrived, and so his portrait had to be finished from photographs. Hockney felt that it suffered accordingly: it was more tightly painted than would have been the case had it been done from life, and was therefore not as successful as the portrait of Isherwood.

In his introduction to Hockney's autobiography, Henry Geldzahler discusses *Christopher Isherwood and Don Bachardy* as an example of the 'new spatial development' in Hockney's work after the 'flattened, modernist space and composition of the California pool and splash paintings'.[6] He was taken to task by the critic Peter Fuller for ignoring the content and meaning of the painting, and Hockney agrees with Fuller's criticism: 'Henry refuses, and Modernism itself refuses, to take sentiment into account. I do take sentiment into account . . . If a picture has a person, or two people, in it, there's a human drama that's meant to be talked about. It's not just some lines.'[7] During the seventies Hockney was to come under attack for 'abandoning Modernism' and for being quite prepared to accept labels like 'sentimental' and 'illustrational'. His best work in the vein of naturalism, such as *Christopher Isherwood and Don Bachardy*, already shows the direction in which he was moving.

Hockney was not happy alone in the Powis Terrace flat and so, at the end of June, he and Kasmin flew to Paris for a few days and then drove down to Carennac. They spent a relaxing week at the château, then visited the deserted hill-village of Les Beaux and Stephen Spender's house near St Rémy on their way to Nice, where they stayed at the Hotel Negresco with Charles Alan. Back in England, Hockney went for a weekend to St Mawes in Cornwall where Allen Jones, Richard Hamilton (see page 184) and the critic Gene Baro were spending the summer. In August he flew to Northern Ireland to stay with Lindy and Sheridan Dufferin at Clandeboye. Among their house-guests were John and Jane Kasmin and Howard and Julia Hodgkin. Back in London, he made many visits to the large Matisse exhibition at the Hayward Gallery. Peter arrived at last at the end of

62 *Help*, 1962

63 *A Grand Procession of Dignitaries in the
Semi-Egyptian Style*, 1961

Humour played an important role in Hockney's
early work. When a friend gave him an elaborate
wooden frame, he painted a man shouting for help
as he tried to escape from its constrictions.
(63) was inspired by Cavafy's poem 'Waiting for the
Barbarians', about Roman officials dressing up to
impress their visitors. Hockney chose a bishop, a
general and an industrialist parading their
self-importance with little men inside them
revealing their true stature.

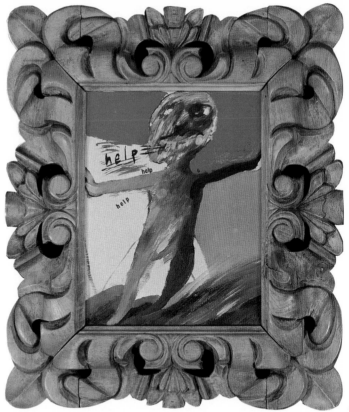

62

63

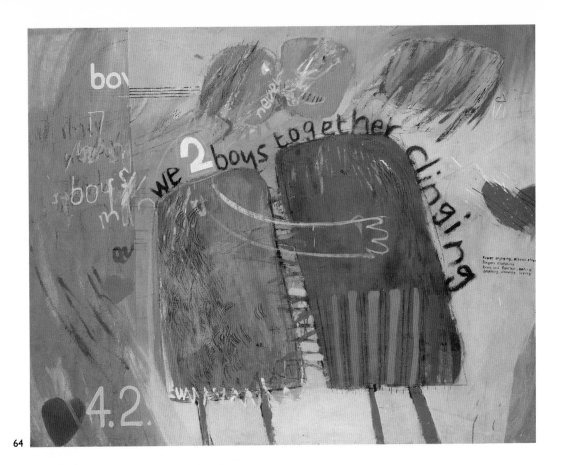

64

65

64 *We Two Boys Together Clinging*, 1961

65 *The Fourth Love Painting*, 1961

66 *Teeth Cleaning, W11*, 1962

67 *Play Within a Play*, 1963

Hockney's Royal College paintings often contain sexual references.

(64) inspired by Whitman's homosexual poem was prompted by a newspaper headline TWO BOYS CLING TO CLIFF ALL NIGHT. Hockney first imagined this as the fulfilment of his fantasy about Cliff Richard, although closer inspection revealed it to be an account of a climbing accident near Eastbourne.

(65) also shows two men embracing and the prominent figures 69 relate it to (66), a humorous yet disturbing image of male love-making.

66

67

68 *Figure in a Flat Style* (detail), 1961

69 *Peter C.*, 1961. Portrait of Peter Crutch

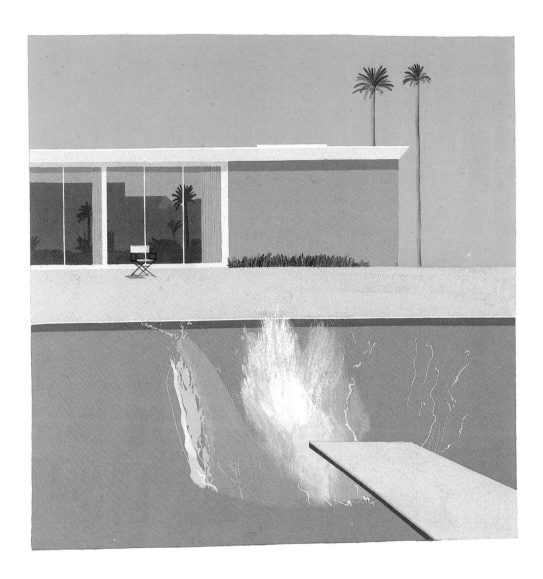

70 *A Bigger Splash*, 1967

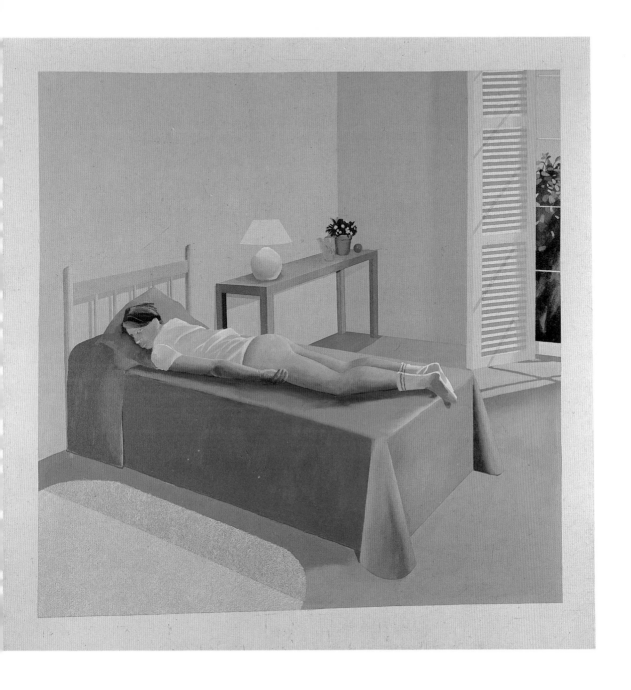

71 *The Room, Tarzana*, 1967

Inspired by an advertisement for a bedspread, this became one of Hockney's most ambitious Californian paintings, a complicated interplay of diagonals illuminated by the strong sunlight. It also stresses his erotic admiration for American boys epitomized here by his young lover, Peter Schlesinger.

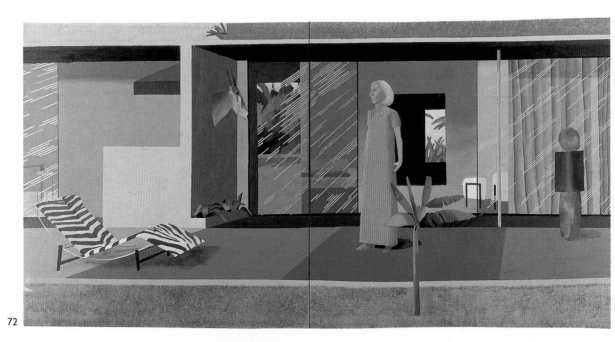

72

73

72 *Beverly Hills Housewife*, 1966/7
73 *Boy About to Take a Shower*, 1964
74 *Sunbather*, 1966

August. His arrival was celebrated in a series of careful pen-and-ink drawings showing him naked on their bed with the bedside table and telephone (see plate 77).

But Hockney's wanderlust was unabated, and he immediately took Peter to Paris to stay with Jean Léger and Alexis Vidal in their rue de Seine apartment on the left bank near St Germain-des-Prés. Then they drove via Colmar (where they saw Grünewald's altarpiece) and Strasbourg to Mainz and took a steamer up the Rhine to Cologne. Hockney spent most of the time photographing the castles on the hills above the river as references for the brothers Grimm's *Fairy Tales*, which he was planning to illustrate. He also took the opportunity of visiting the big Documenta IV exhibition of contemporary art in Kassel, in which he featured as one of the main representatives of Great Britain. The show served to consolidate his growing reputation in Europe, for in this same year his complete graphic work had been shown at the Galerie Mikro in Berlin, and he had also been included in the thirty-fourth Venice Biennale, 'British Art Today' in Hamburg, 'European Painters of Today' at the Musée des Arts Decoratifs in Paris, 'Young Generation: Great Britain' at the Akademie der Kunst in Berlin, and 'L'Art Vivant 1965–1968' at the Fondation Maeght in Paris, as well as exhibitions in Florence, Brussels, Vienna, Stockholm, Darmstadt and Bremerhaven.

In September Peter began his course at the Slade School of Art, and so became a resident of 17 Powis Terrace. Hockney had never been house-proud: the flat was only incidentally a place to eat and sleep, mainly it was a studio. While he had been living in Los Angeles various of his friends had been invited to use it, including Mo McDermott, Mark Lancaster and Stephen Buckley. Alan Turner from his class at Berkeley had fled to London to dodge the draft for Vietnam, and he had been given the flat, together with Hockney's printed stationery to help him apply for jobs. Peter found it really squalid. He was used to a certain amount of comfort in California, and he determined to make his mark – both in the flat and in the relationship – by buying nice furniture and decorative objects and creating a real home. He began by scouring the Portobello Road market and then went further afield. Among his purchases were a copy of a curved-backed wooden chair by Mackintosh, a very fashionable Brion Vega stereo unit from Italy and a large glass table on chromium-plated legs by Altra which was to appear in various drawings and paintings. He had a good eye for a bargain and had soon built up a collection of beautiful Art Nouveau glass vases and lamps. He also bought two semi-cylindrical mirrors like polished steel columns that had been designed for the old Berkeley Hotel. But Hockney's northern upbringing had made him rather a puritan where money was concerned, and when Peter bought a £400 leather sofa from Harrods, he reacted by pointing out rather forcefully that his father had never earned much more than that amount in a year.

During the day, while Hockney worked on the painting of Isherwood and Bachardy, Peter would either be at the Slade or in the studio he had rented from Kitaj nearby in Regent's Park. Peter was happy to be living and working in London, but life with Hockney was not easy for the young art student from California. He was by now a well-known figure in London life, and not just in art circles, and the flat was hardly ever without visitors because he loved lots of company. His closest friends were Patrick Procktor, Ossie Clark, Celia Birtwell, and Mo McDermott. Peter knew and loved them too. There were many other friends who were delighted to see Hockney back in London: Kitaj, Norman Stevens, Ann and Mike Upton, Mark Lancaster, Stephen Buckley, Pauline Fordham, Kasmin and many more, as well as acquaintances, journalists and hangers-on, all of whom felt free to drop in on 17 Powis Terrace. A few showed open resentment of the important role Peter now played in Hockney's life, and Peter often felt that Hockney was much too ready to welcome all and sundry into their home. He was quite prepared to fetch the drinks while Hockney held court in the evenings, but their happiest times were when they were alone or with their closest friends.

Hockney had acquired a reputation in the early sixties as something of a playboy and party-goer, but on returning to London in 1968 after four years in America he found he had a different perspective on London life. He disliked the exclusiveness of the social round and the clubs with their membership fees and rules, and he objected strongly to the licensing laws which he saw as killing off the night life: 'The nice thing about America is that the bars are open very late; you don't have all that farting around with clubs and membership and salad on a plate, something ridiculous, because anybody can go in and drinks are cheap . . . The one good thing about swinging London was there was a lot of energy released from working-class kids – that hadn't happened before; the Beatles and Rolling Stones and all that. But it was eventually killed, I think, by English conservatism.'[8]

In October the couple were travelling again, this time to the film director Tony Richardson's home in the south of France. Richardson was born and brought up in Shipley near Bradford; he had met Hockney in the early sixties when Director of the Royal Court Theatre in London. He had discovered that they shared not only common roots and a northern sense of humour, but also a love of sunshine and the clear light of the south. In 1966 he had bought Le Nid du Duc (The Nest of the Night Owl) near St Tropez, a tiny hamlet of six cottages tumbling down a hillside. From the sixteenth century, peasant families had scratched out a living by growing cork oaks in the poor soil, but by the 1950s it was a ruin. Richardson had restored the buildings and installed a swimming pool, and whenever he was there he liked to fill the place with his friends. Hockney's visit in 1968 was the first of many he was to make to Le Nid du Duc over the years; with its communal life centred around the pool and the terrace where meals were

eaten, it provided him with another Carennac. On this first visit he spent hours photographing the pool, for it was exposed to wind and weather, unlike its Californian counterparts, and the ever-changing surface fascinated him. He was now using photography not merely for snapshots but for information that would help his work, as on the Rhine cruise. In nearby St Maxime he photographed the sunrise over the harbour as well as carefully composed views of trees in front of buildings. And in the village of La Garde Frenait he took a photograph of Peter in the street under an amusing shopsign. Before leaving, he gave Richardson a large and beautifully accomplished crayon drawing based on this photograph, with the detailed head and shoulders image of Peter counterpointing the sign above him against the vaguely suggested buildings and the clear blue sky.

On his return to London, Hockney immediately began work on four paintings based on recent holiday photographs: *Schloss* shows a medieval castle among trees on a rock; *Parking Privé* is a study of a group of palm trees by a carpark in front of an office building in the south of France; *L'Arbois, Sainte-Maxime* is a large hotel almost completely hidden by trees; and *Early Morning, Sainte-Maxime* is a rather lurid pink and purple version of a Monet sunrise which concentrates on the track of the sun reflected in the sea. Although a preliminary drawing exists for *L'Arbois*, all four paintings are in fact direct transcriptions of squared-up photographs, and *Early Morning* does not even have the benefit of an unusual angle in the original image. This slavish use of photography seems a disappointing step along the path of naturalism. Hockney had been taking notice of the American Photo-Realists, although he never went so far as to use their technique of projecting a colour slide onto the canvas and painting it as a reproduction. But, in retrospect, he decided that these paintings were not successful and that *Early Morning, Sainte-Maxime* was his worst picture.

While working on these four paintings in the winter of 1968–69, Hockney was also planning a double portrait of Henry Geldzahler and Christopher Scott (see plate 110) to follow the recently completed picture of Christopher Isherwood and Don Bachardy. Henry Geldzahler and Christopher Isherwood were both close friends of his, and, like him, they each had a much younger male lover. Geldzahler and his lover were staying in London in October when Hockney mentioned to them that he would like to use them in a further examination of a relationship. He had depicted them before: a lithograph dating from spring 1967 shows them in their room at the Château Marmont Hotel in Hollywood, a popular landmark where people from the art world always stayed when visiting Los Angeles. Geldzahler is seated in an armchair with Scott lying beside him on a sofa. Only fifteen prints were made by Ken Tyler at Gemini, each with different additions by Hockney. Tyler was also working for Frank Stella at the time, and a little Stella lithograph is collaged onto each image as a picture on the wall. Hockney has

written 'Hand Printed Lithographs' above Geldzahler's head in one copy, has given him a moustache, beard and a hat in another, and a dress in a third. In one copy he has drawn coloured lines between the sitters' mouths to indicate the intimate nature of their relationship, and it was this aspect he wished to develop in a large painting.

Hockney flew to New York in December to spend a week at Geldzahler's apartment in the Wyoming Building on 7th Avenue, where he made careful drawings of Geldzahler and Scott and of their large thirties sofa. He also took photographs of their living room with the Gilbert Rhode Art Deco lamp, and of the view of New York buildings from Scott's study. After a few days in bed with a painful attack of influenza, he flew back to London. He had bought some magazines on 42nd Street with titles like *Golden Boys* and *Naked Youth*, full of artistic photographs of boys, old-fashioned and very tame. At London Airport the magazines were seized by the Customs and Hockney, who was still recovering from influenza, became very angry and said he would take the matter to court. Since he had acquired the magazines for reference material as much as for his own pleasure, he obtained the support of Kenneth Clark and Norman Reid, Director of the Tate Gallery, and he asked the National Council for Civil Liberties for help in fighting the case. His father had been a tireless campaigner for worthy causes, and, since leaving home, Hockney had never been afraid to stand up for gay rights. The affair gained much publicity and the magazines were returned to him without any legal proceedings being taken.

Hockney spent January and February 1969 painting the seven-foot by ten-foot canvas. He chose to place Geldzahler at the centre, sitting on the pink sofa which dominates the composition. The scene is the living room with the Art Deco lamp, but behind Geldzahler is the view from Scott's study. Scott stands rather awkwardly to the right of the painting, balancing the lamp at the left. In the foreground is the Powis Terrace glass table with a vase of tulips, Hockney's favourite flower. Photographs taken over the two months show the progression of the painting. The view from the window was completed as soon as the composition was drawn on the canvas; then the sofa was painted, as well as the two figures. The floor was red at first, then changed to brown, then blue and finally parquet, but this presented enormous difficulties because of the perspective of all the lines. Hockney attached twenty-five pieces of masking tape so that they radiated from the vanishing point two inches above Geldzahler's head, in order to solve the problem. Finally the table and the lamp were added, as well as the highlights in Geldzahler's glasses and polished shoes ('If I were Jan Van Eyck I'd put my whole picture in that little reflection.'[9])

The finished painting makes an interesting comparison with the portrait of Isherwood and Bachardy. The figures of Henry Geldzahler and Christopher Scott do not sit side by side but are clearly separate from each other, and Scott, standing awkwardly in his

raincoat, seems to have been given a rather temporary role in the central figure's life. Hockney hardly knew Scott at this time, and he was not aware that the relationship between the two men was very close. They were to stay together for another ten years. Hockney spoke amusingly of the painting as St Henry radiating light, visited by an angel in a raincoat, and the writer Kynaston McShine compared it to a traditional Annunciation. The composition does indeed suggest the triptych format of an altarpiece, although Henry looks more like a seated Buddha than the Virgin Mary.

After an Easter visit to Paris and then to Le Nid du Duc with Peter, Ossie and Celia, Hockney began work on his etchings for the Grimms' *Fairy Tales*. He had made some experimental prints inspired by 'Rumpelstiltskin' in 1961 and 1962, and now he wanted to make a whole book, in the manner of the earlier Cavafy edition. He loved the stories and had read all 220 of them over the years, especially admiring the illustrations by Arthur Rackham and Edmund Dulac, as well as less well-known artists. He eventually chose twelve stories, but in the event only did engravings for six. The project was to be published by Paul Cornwall-Jones once more, who approached Christopher Isherwood for a new translation. Isherwood did not want to do it and suggested W. H. Auden, but he refused, saying there was nothing wrong with existing translations. Eventually a new translation was commissioned from Heiner Bastian in Berlin, a collaborator with the artist Joseph Beuys, who had previously worked at the City Lights Bookstore in San Francisco with the writer Lawrence Ferlinghetti.

Hockney loved the directness of the language of the Grimm brothers and the elements of magic in the tales, and his illustrations to each of his chosen six focus on his imaginative response to descriptions in the text rather than the more usual fashion of concentrating on the most important events in the narrative. For instance, he chose 'Old Rinkrank' because it starts with the words 'A King built a glass mountain', and he was fascinated by the problem of drawing a glass mountain. He made six or seven attempts, at one point smashing a sheet of glass and drawing the jagged pieces piled up in a big heap, before finding the solution: he depicted a tree and a house with a glass mountain in front which distorts their reflection. In one of the most disturbing stories, 'The Boy who left home to learn fear', Hockney interprets the description of the sexton disguised as a ghost standing 'still as stone' (changed to 'perfectly still' in the published translation) as a tall rock surrounded by stones, recalling Magritte's paintings of ordinary objects made out of stone. Magritte is also the influence behind the 'Rumpelstilzchen' image of a room full of straw which the miller's daughter has to spin into gold, for Hockney has used the surrealist painter's games with scale in painting an apple or a rose which fills a whole room.[10]

For some of the images Hockney has used his own preliminary studies: a drawing of a

comfortable armchair in the library at Clandeboye becomes 'Home' in 'The Boy who left home to learn fear', epitomizing the family environment he is about to leave, and photographs of castles, churches and other buildings taken on the Rhine trip in the previous September have been used in illustrations to all the stories except 'Rumpelstilzchen'. For 'The Little Sea Hare', the images of the youngest boy hiding in the raven's egg and the fish's belly have been done from specially posed drawings of Mo at Powis Terrace. Hockney has used a wide range of earlier artists including Carpaccio for costumes, Uccello for the Prince on horseback in 'Rapunzel', Dürer for the frontispiece showing Catherina Dorothea Viehmann, a source of many of the tales, Hieronymus Bosch's *Virgin and Child* for the enchantress with the baby Rapunzel, and Leonardo da Vinci for the trees in this image and for the cook in 'Fundevogel'.

The work of engraving the copper plates was carried out by Hockney with his assistant Maurice Payne on special tables set up in the Powis Terrace studio. The acid bath was kept on the little balcony outside, because otherwise the fumes would have filled the whole flat. The finished etchings form a more complex project than anything he had attempted before. His new technique of cross-hatching instead of using aquatint achieves a much richer range of tones. The Grimm engravings have the exuberance and vitality of 'A Rake's Progress' with a more mature understanding of graphic techniques; they are more inventive than the Cavafy illustrations with the rather limited scope of their subject-matter. The fairy tale illustrations show an extraordinary range of imagery including portraiture, landscapes, architecture, imaginative compositions and pure inventions.

The book was designed by Hockney working with Eric Ayres, with the prints integrated into the text which was set by hand in old-fashioned typeface and printed at the Oxford University Press. It was then shipped to Amsterdam, where the plates were printed by Piet Clement, and completed books were bound in blue leather in Cologne and published by the Petersburg Press in London in the summer of 1970. At the same time, Paul Cornwall-Jones persuaded the Oxford University Press to publish a miniature version which was produced photographically and sold at £1 a copy. This proved tremendously popular, and in the end 60,000 were printed. Hockney was delighted, since he has always wanted his work to be available to everyone. Of course the little version has none of the richness of the original engravings of *Six Fairy Tales from the Brothers Grimm*, which Hockney now considers to be one of his major successes. They are certainly successful as a collection of memorable and at times brilliantly inventive images, but as visual counterparts to the often disturbing stories, they only hint at the darker side. As Marco Livingstone has pointed out: 'Hockney's characteristic detachment furnishes considerable humour and insight into the underlying themes of the stories, but fails to convey their more tragic or morbid aspect.'[11]

The Grimm engravings occupied Hockney from March to December 1969 to the

exclusion of any painting. In June, he and Peter went to Paris with Patrick Procktor and then to Beaune to see the Roger van der Weyden altarpiece and on to visit Stephen Spender at Saint-Rémy and the nearby asylum where Van Gogh spent a year. Their next stop was at Le Nid du Duc where Tony Richardson's other guests included Celia and Ossie, Kasmin and Geldzahler. They took the opportunity of visiting Matisse's chapel at Vence and the Fernand Léger Museum at Biot. Hockney made a very characteristic drawing of Patrick sitting in a wicker chair with his paper on his knees and his paintbox in one hand, gazing intently at the subject of his latest watercolour. In September Hockney took Peter and Ossie to Vichy. He loved spas, and in particular he loved the pretty town of Vichy and its formal garden in the shape of a triangle with the deliberately false perspective of two rows of trees which diminish in size as they meet at the point of the triangle. He took photographs and made drawings of Ossie and Peter in the park in preparation for a painting, and on his return he made similar plans for a double portrait of Ossie and Celia, which he was not able to start until the following April. The Vichy studies became the seven-foot by ten-foot canvas *Le parc des sources, Vichy*, which he began in January 1970.

Hockney visited New York in November for an important exhibition of his work at André Emmerich's gallery. Charles Alan had closed his gallery owing to ill-health. André Emmerich, one of New York's leading dealers in contemporary art, had been an associate of Kasmin since the early sixties. They had often shown each other's artists – Kasmin showed Kenneth Noland and Morris Louis in London while Emmerich showed Anthony Caro in New York. Although Emmerich specialized in abstract and colour-field artists, one of his staff, Robert Miller, greatly admired Hockney's work and persuaded Emmerich to take him on. So it was that in November 1969 Hockney had his first show at the prestigious gallery of André Emmerich. Included were such important recent works as *Christopher Isherwood and Don Bachardy*, *Henry Geldzahler and Christopher Scott* and *American Collectors*, as well as *California Seascape* and the works resulting from the south of France holiday of 1968. The exhibition was a success in spite of Clement Greenberg, the art critic and supporter of colour-field painters, who was seen to shake his head and mutter 'This is not art for a serious gallery.'[12] Thus began a working relationship between Hockney and Emmerich which has lasted to the present day.

The ten-month period without painting was the longest since he had gone to the Royal College, and had been preceded by the extremes of naturalism in the four holiday-inspired landscapes and the portrait of Geldzahler and Scott. The Grimm etchings had been a welcome respite from the problems of naturalism: 'Somehow I've been a lot freer in the graphic work than in the painting. Somehow a kind of painting block took over. Probably in the end acrylic paint did it, the burdens of it, whereas I think in everything

else, in the graphic work, there is a delight in the medium itself.'[13] *Le parc des sources, Vichy* was his first painting after the break for the Grimm etchings, and shows the false perspective that so fascinated him, with the two rows of trees seeming to lead into the far distance. He described them as a marvellous conceptual sculpture with strong surrealist overtones, and so his intention was to paint a picture about illusion. But in the foreground are three chairs so that he, Ossie and Peter can view the scene. Ossie and Peter are therefore sitting with their backs to the viewer, but Hockney's chair is empty since he has had to get up to do the painting. In this way the painting has become a picture within a picture; Hockney was tempted to call it 'Painting within Painting', echoing the Kasmin portrait of 1963 entitled *Play within a Play*. However, it is basically a naturalistic scene and, as such, it caused Hockney continuing difficulties. My first contacts with Hockney were at this time, he having lectured to my students in Coventry in January 1970, and I remember him vividly describing his attempts to blend acrylic colours in this picture in order to achieve a naturalistic effect.

In March, after a visit to New York with Celia to see Charles Alan, whose illness had progressed and who, in fact, did not have long to live, Hockney travelled with Peter and Christopher Isherwood to visit Tony Richardson at Le Nid du Duc. The three friends visited Arles, where Van Gogh had spent the year 1888, and then stayed a few days with the art critic Douglas Cooper at the Château de Castille near Nîmes. Cooper had been a close friend of Picasso, and the artist had been in the habit of staying at the château when attending bullfights at Arles or Nîmes. At first he would always take a drawing as a gift, but later this changed to a kilo of caviar. Cooper had commissioned a mural from Picasso in 1962 for the *magnanerie*, the area where silkworms were kept in old Provençal buildings. Picasso's image of horses and riders was drawn in sand-blasted cement; Hockney took a series of photographs which would later furnish ideas for paintings. He spent many hours looking at Cooper's fine collection of Picasso paintings, and arguing with Cooper's assertion that Picasso's late work showed a sad decline in ability. Picasso was living in Provence at this time, and he was to die three years later. Hockney has always regretted never having had the opportunity of meeting the twentieth-century artist he most admires.

In February 1969 the Whitworth Art Gallery in Manchester had given Hockney a small exhibition which included twenty-eight paintings plus a selection of prints. Since then, Mark Glazebrook had been planning a major retrospective for the Whitechapel Art Gallery in London. He had been an original partner in Editions Alecto with Paul Cornwall-Jones, and had fallen in love with Hockney's work when he saw his Royal College of Art Diploma Show in 1962. He had bought a drawing from Hockney at that show, thus becoming one of his first patrons, and he had acquired *Picture Emphasizing*

Stillness (1962) and *Play within a Play* (1963) as soon as they were painted. When he took over the Whitechapel Art Gallery in the late sixties, his first decision was to mount a Hockney retrospective. Hockney helped with the choice of pictures and gave Glazebrook a long and interesting interview for the catalogue, but he did not see the exhibition until the opening on 1 April, having returned from France the previous day.

Forty-five paintings were on show at the Whitechapel retrospective, ranging from *Doll Boy* of 1960, through *We Two Boys Together Clinging, Tea Painting in an Illusionistic Style, Berlin: A Souvenir, Play within a Play, Man Taking Shower in Beverly Hills, Beverly Hills Housewife, A Bigger Splash, The Room, Tarzana* and *Christopher Isherwood and Don Bachardy* to *Le parc des sources, Vichy*. The complete graphic work was included, 116 items, as well as a selection of forty-seven drawings. Mark Glazebrook's excellent catalogue contained, in addition to the interview with Hockney, an attempt at a complete list of all known paintings since 1960, mostly with reproductions and some also with comparative material, as well as a biographical note, a list of exhibitions and a selected bibliography. To defray part of the enormous costs of the exhibition, Hockney had at the suggestion of Norman Stevens made a lithograph, *Pretty Tulips*, in an edition of 200. The whole edition sold out, as did the catalogue, which had to be reprinted.

Hockney had been apprehensive that his early paintings would look merely embarrassing, but, in the event, he was pleasantly surprised by the experience of seeing ten years' work all together for the first time. It made him aware of how his art had progressed, and of how consistent had been the progression. 'It dawned on me how protean the art is; it's varied, with many aspects, many-sided. I should have known it, and probably did half-know it, but you don't fully realize things like that. I'm not saying I didn't know the weaknesses of the pictures, but seeing the whole body of his work, I think, is quite good for any artist. It's a shock and you see all the faults, but you see the virtues too.'[14] The attendance figures at the gallery were astonishingly high, and the exhibition brought out the superlatives from the critics. The joy and wit and colour of the work was welcomed, while at the same time the underlying seriousness of the artist was appreciated. Admirers were delighted and detractors were impressed. Writing in *Apollo* magazine, James Burr said: 'His ability to parody the good manners of picture-making is brilliant . . . His appropriation of other styles is touched with capricious humour.' He ended his review with a far-sighted comment: '[He] seems to have reached a point of development that looks ominously like a *cul-de-sac*, but no doubt by some unusual act of visual agility he will extract himself and continue his distinctively eccentric painting progress, without which English painting would be markedly the poorer.'[15] The thirty-two year old artist from Bradford was clearly a force to be reckoned with. The golden boy had come of age.

for Arthur
with love from David
April 1971 Hollywood

CHAPTER SIX

EUROPE, AMERICA AND ASIA 1970–1973

The last entry in the catalogue of the Whitechapel exhibition read: 'Untitled, 1970, acrylic on canvas. 84 × 120 inches (unfinished), double portrait of Celia Birtwell and Ossie Clark.' However, there was no question of exhibiting this painting. Hockney had done sketches for the composition in late 1969 and, since then, had taken photographs and made drawings, but the painting itself was hardly started and was causing him great problems. Of all his work, this comes closest to naturalism, a concept which had caused him immense worries in 1968 and 1969. In fact, the picture occupied Hockney for almost twelve months before leaving his studio as *Mr and Mrs Clark and Percy* in February 1971 (see plates 87, 112).

Hockney had known Ossie Clark for many years. Celia Birtwell was a more recent addition to his circle of close friends, but she was soon to become one of his favourite models. Both Ossie and Celia achieved great success in the world of fashion design, and they married in 1969, with David as their best man. The painting was conceived as a marriage portrait, perhaps an updated version of Van Eyck's Arnolfini Couple of 1434; it was, in any case, a natural continuation of the series that had included *Christopher Isherwood and Don Bachardy* and *Henry Geldzahler and Christopher Scott*. As with the two previous pictures, Hockney chose to set the scene in the Clarks' own home, in Linden Gardens in the Notting Hill Gate area of London, with the couple placed on either side of the living-room window which gave on to their balcony and the buildings beyond. The *contre-jour* that this composition necessitated was a great technical problem, since Hockney was determined to catch the balance of tonal values in the muted London light. This relates it to Hockney's only other painting of London, *The Room, Manchester Street* of 1967, which is also structured around a *contre-jour* effect.

Although Hockney took photographs of the room and made sketches of Ossie and Celia *in situ* (see plates 88, 89), the picture was painted in the Powis Terrace studio, to give him more room to work. The couple spent many hours there posing; every attempt was made to reproduce the light effects of their own living room. The figures are painted almost life-size, which Hockney found very difficult: in particular, Ossie's head was repainted about twelve times, so that the acrylic paint in this area is very thick. The surface of the whole picture is uneven, with the thinly-painted blank wall spaces contrasting strangely with the continually reworked figures. The thick varnish which has

Paul Miranda, 1971

been applied to the painting does not improve it, although it comes over extremely effectively in reproduction.

Mr and Mrs Clark and Percy was exhibited at the National Portrait Gallery in London, together with related drawings and photographs, in February 1971, and was bought by the Tate as a pendant to their only Hockney, *The First Marriage* of 1962. To this day it remains the most popular painting in the Tate's collection and one of Hockney's best-known images. Part of its fame is due to the fact that it works so well in reproduction; but also important is the fact that Ossie and Celia are rightly remembered as major figures in the artistic rejuvenation of England in the sixties. They feel that only chance has made their portrait so well known, and they are somewhat embarrassed to be widely recognized as a result of it. Ossie remembers the day Hockney came to take some photographs for the basic composition. He had only just got up and so had no shoes on. He slumped into a chair with a cigarette, and Blanche, one of their white cats, jumped onto his lap. Celia was standing on the other side of the window with her hand on her hip, and Hockney said, 'That's perfect.'[1] He later added their Art Deco vase and lamp, and called the cat 'Percy', the name of Blanche's son, because it sounded better.

Percy links the Hockney with the Van Eyck marriage portrait in which Giovanni Arnolfini and his wife are accompanied by their pet dog, a traditional symbol of fidelity. Their picture is full of symbolism which would have been perfectly comprehensible to Van Eyck's contemporaries, just as *Mr and Mrs Clark and Percy* can be read today as a portrait of a relationship. Hockney said of it recently: 'I think it works because you feel their presence, you feel the presence of two people in a weird relationship. Ossie is sitting down and Celia is standing up. Yet you know it should be the other way round.'[2] The Clarks' marriage had been unconventional from the start, and their portrait seems to show an awareness of the tensions that were to lead to divorce. Attempts have been made to read far more into the picture: Percy has been seen as representing Ossie's erection, and it has been thought significant that the print on the wall is a scene from Hockney's 'A Rake's Progress'. Perhaps rather more attention should be paid to its title, *Meeting the Good People*.

Mr and Mrs Clark and Percy occupied Hockney throughout the whole of 1970. He completed only three other paintings during this period, each based on photographs taken on his trip to the south of France in March. *Three Chairs with a Section of a Picasso Mural* and *A Chair with a Horse Drawn by Picasso* both relate to Douglas Cooper's Château de Castille, where Hockney had been so impressed with the Picassos, but he has wittily concentrated his attention on the brightly-coloured ordinary chairs at the expense of the monochrome mural behind them. *The Valley* is a simplified and almost abstract painting of the view from Tony Richardson's property at Le Nid du Duc; it would later serve as a study for the background of *Portrait of an Artist* of 1971–2.

Hockney's love of travelling has provided him with the inspiration for many paintings such as these of 1970, but the more direct results are drawings made on the spot and further material for his photograph albums. During 1970 he filled eight albums with travel photographs, and spent a part of every month abroad, producing a series of fine drawings in ink and coloured crayon. A trip in May to stay at Sheridan and Lindy Dufferin's house in Clandeboye, Ireland, with Ossie and Celia, Henry Geldzahler and Christopher Scott and Kitaj and Peter Schlesinger produced many images of Ossie and Celia including *Ossie Wearing a Fairisle Sweater*, a complicated and highly accomplished crayon drawing in shades of green, brown, blue and pink. May also saw him visiting Germany for an exhibition of his work in Berlin, and for the Whitechapel show which had travelled to Hanover. Later the same month he took part in a large Gay Rights demonstration in Los Angeles with Christopher Isherwood and Don Bachardy, Jack Larson and Jim Bridges, and Nick Wilder. In June he visited Paris with Celia and Peter for the Matisse exhibition, and made a very precise line drawing of Alexis Vidal and Jean Léger's living room in the rue de Seine, the basis for an etching which he produced for the National Council for Civil Liberties in 1971. He went also in June to take the waters at Vittel; at the Grand Hotel he filled a sketch-book with crayon drawings of the terrace, the view from his window, Peter reading the paper on the balcony, Peter in the bath, Peter sketching et cetera.

In July he was in Rotterdam, where his Whitechapel show had reached the Boymans Museum. In August, after Peter had left for a holiday with his parents in California, Hockney and Mo McDermott visited another spa, this time Vichy, where he drew Mo in the Pavillon Sévigné and then took a supply of bottles of the local product to Carennac where he drew *Carennac, Howards End and Vichy Water* (see plate 95), a still life of the lunch table with a copy of E. M. Forster's novel in the foreground. Food was on his mind during this visit, for he brought back to London a sketch-book with careful crayon drawings of leeks, a courgette, red peppers, limes, a banana and a pineapple. Among the other guests at Carennac were the sculptor Anthony Caro and his wife Sheila, Godfrey Pilkington, owner of London's Piccadilly Gallery and an early admirer of Hockney's work, and Patrick Procktor, with whom he played endless games of chess (see plate 108). Hockney took Peter on a tour of eastern Europe in September, visiting Prague, Budapest and Belgrade, whose National Gallery was the last port of call for his Whitechapel exhibition. They took the waters in Karlsbad and Marienbad and, in Venice, Hockney did one of his finest line drawings of Peter which shows him leaning back in an armchair in the Hotel Regina.

There is a great contrast between the relaxed informality of *Peter, Hotel Regina, Venice* and a drawing of the dancer Rudolf Nureyev, which is dated 28 November 1970. Hockney has always chosen to portray people whom he knows, and continually resists

the idea of commissioned works: 'I have never been interested in doing portraits as commissions for the simple reason that people have self-images, and they are never satisfied.'[3] Sometimes he breaks his rule if the sitter interests him, but he is rarely satisfied with the results. His portrait drawings arise out of his relationship with the sitter, which explains why his images of Peter tend to work so well. He had never met Nureyev before, and his drawing is awkward and somehow wooden, giving little idea of the person. His drawings of famous people whom he knows (Christopher Isherwood, Stephen Spender, Cecil Beaton, Frederick Ashton, Richard Hamilton, Billy Wilder) are usually highly successful in marrying brilliant technique with personal insight. He would later have problems with commissioned drawings of John Gielgud (see page 185), Henry Moore, William Burroughs, J. B. Priestley and Isaiah Berlin, yet he overcame the problems when asked in October 1968 to draw W. H. Auden, whom he had never met.

Hockney had read Auden when at college and he had quoted from his work in *The Fourth Love Painting* of 1961. Auden's friends and collaborators, Christopher Isherwood and Stephen Spender, had often talked to Hockney about him so that, when he was asked to draw Auden by Peter Heyworth, music critic for the *Observer*, he jumped at the chance of a meeting. He took Peter and Kitaj with him and all three drew Auden sitting in a big armchair, smoking incessantly. Auden was grumpy throughout the meeting. He objected to having three visitors instead of one, and he objected to all the pornography he found at New York railway station bookstores. He struck Hockney as being rather like the headmaster of an English school. He completed three drawings in the one session, two quite effective profiles that make the poet look rather like a frog, and one – a front view – which he thought terrible and tore up later (see page 185). Hockney felt Auden had little visual feeling, and yet he often quotes his lines from 'Letter to Lord Byron': 'To me art's subject is the human clay/landscape but a background to a torso;/All Cézanne's apples I would give away/For a small Goya or a Daumier.' Hockney commented in his autobiography: 'I think they're marvellous lines, and very sympathetic . . . I know Cézanne's apples are very special, but if you substitute "all Don Judd's boxes I would give away, or for that matter all Hockney's pools, for a small Goya or a Daumier" it has more meaning. I'm sure that's what he really meant.'[4]

Towards the end of 1970 Hockney was approached by Sir David Webster, General Administrator of the Royal Opera House, Covent Garden, for a commemorative portrait on his retirement. At first, reluctantly, Hockney offered to do a drawing, since he was an opera lover himself. The Opera House, however, wanted a painting, and after deciding that perhaps he ought to try one such commission in his life, Hockney agreed to go ahead. The result was one of his most difficult and least satisfactory projects. He could not find a suitable setting in Webster's own house off Harley Street, and a watercolour sketch dated January 1971 shows the final solution: Webster sits on a chair by the glass

table with its vase of tulips in David's studio in Powis Terrace. Another sketch, in coloured pencils and dated February 1971, shows Webster asleep with added colour notes including 'eyes grey-blue'. One great problem was that the sitter could not stay awake; he was ill, in fact dying, at the time. With the help of photographs, Hockney started work on the painting in March, knowing that it had to be ready by the end of April. This deadline, together with his total lack of involvement in the picture, caused immense worries and, very unusually, he had to lock himself in the studio with no visitors allowed and to work eighteen hours a day. Webster was delighted with the finished painting, but it is a very artificial pose and the cantilevered chair does not look satisfactory. The acrylic surface is not attractive. Hockney heartily dislikes the painting.

The year 1971 began normally enough, with Hockney and Peter spending a week in Paris, which was fast becoming one of Hockney's favourite cities. But their friends were aware of a growing tension in the relationship. They had lived together for four years, and Peter in particular was feeling dissatisfied and a little bored. The age difference could no longer be ignored and Peter was beginning to experience the need for some independence from Hockney, both as a person and as an artist. He had begun to spend more and more time in the studio which Ann Upton had let him use in her Colville Square flat in Notting Hill Gate after her husband Mike had moved out. In Paris, Hockney and Peter stayed with their friends Jean Léger and Alexis Vidal in the rue de Seine, and here Hockney met Joe Macdonald, an intelligent and attractive male model from New York. His career in Paris was beginning to take off, and he and Hockney were soon to become close friends.

Back in London, Hockney became very involved with the National Portrait Gallery exhibition in February of *Mr and Mrs Clark and Percy* and the associated photographs and drawings which attracted crowds of people who had never visited the gallery before. He also made nude drawings of Richard Neville (see page 184) and his co-defendants in the *Oz* magazine obscenity trial at the Old Bailey for an auction to raise money for their defence. The following month, when he was already experiencing difficulties with the Webster portrait, he felt the need for further travel, so he took Peter and Celia to Morocco for two weeks. She was having difficulties with Ossie and needed a break, and her inclusion in the party helped Hockney and Peter with their problems as well. On 1 March they travelled to Marrakesh where Hockney made numerous sketches in coloured crayon of the bazaar and the exotic grounds of the Mamounia Hotel. He was excited and inspired by his first experience of Morocco: 'The moment we arrived at the hotel – we had a bedroom with this beautiful balcony and view – I immediately thought it would make a wonderful picture. So I deliberately set up Peter in poses so that I could take photographs and make drawings. The scene in life is full of romantic allusions: Peter on a balcony,

gazing at a luscious garden and listening to the evening noises of Marrakesh.'[5] On their way back they visited Tangier and they stopped in Madrid to see the Velázquez paintings in the Prado Museum. But it was the Goyas with their wonderful range, from the early colourful tapestry designs to the late terrifying Black Paintings, which really excited Hockney.

In London, he returned to work on the Webster portrait, but he also began a more congenial painting, *Sur la terrasse*. This shows Peter standing on the Hotel Mamounia balcony looking out over the gardens. It is based very closely on a colour photograph and a coloured crayon drawing, although Hockney also had George Chinnery's painting *The Balcony, Macao* in mind. The cool greens and blues of Hockney's picture make it an atmospheric image of the romance surrounding his experience of a Marrakesh evening in which the back view of Peter in his tight white trousers plays an important part. It is ironic that while Hockney was painting the picture, Peter was meeting and falling in love with Eric Boman, a Swedish boy who was studying photography and design at the Royal College.

There is irony too in the fact that, at this same moment, the conversion work to expand and improve the flat at 17 Powis Terrace for Hockney and Peter was coming to a successful conclusion. Peter had never felt comfortable in such a small living and working environment. This had been ideal for a single man, straight out of art college in 1962, but by 1970 it had outlived its usefulness. Hockney was now a famous person who loved entertaining: it was not unusual for there to be forty people to tea on a Saturday afternoon. He was becoming part of an international set, and he took great pleasure in making endless videos of his guests, who ranged from writers and artists to pop stars. One whole videotape was devoted to Mick and Bianca Jagger, but the novelty eventually wore off and Hockney gave the equipment away.

Peter had made a great effort as soon as he arrived to improve the flat by buying furniture and antiques, just as he had worked on Hockney's appearance and persuaded him to buy his clothes from Tommy Nutter in Savile Row. In 1970, Hockney acquired the lease of the nextdoor flat from the tobacco and sweet wholesaler who owned the house, and asked a young architect who had just finished his training at the Architectural Association, Tchaik Chassay, to design a new environment covering the whole of the first floor. Hockney had known Chassay's wife Melissa when she was Tony Richardson's girlfriend at Le Nid du Duc. Chassay was very clever and also extraordinarily attractive: whenever Hockney and Patrick Procktor and Ossie Clark told everyone how lovely he was, he would go bright scarlet with embarrassment. To reduce inconvenience, the new half of the flat was built quite separately. Chassay had designed a large dining area for which Hockney bought an enormous wooden refectory table and fourteen chairs in Paris. The library was panelled with cedar of Lebanon so that one had the impression of walking

into a cigar box. Hockney took a special interest in the new bathroom, for which he wanted deep blue tiles, a circular shower area and lots of strategically placed mirrors so that beautiful bodies could be seen from all angles. The builders completed the job and broke through the wall joining the two flats towards the end of March when *Sur la terrasse* was on the easel in the studio and Peter was consolidating his new relationship with Eric Boman.

The building work in the flat exacerbated the difficulties between Hockney and Peter, so Hockney decided to go to America for three weeks on his own. In New York he spent a few days with Kitaj and he met the photographer Robert Mapplethorpe, whose work he greatly admired. He drew Mapplethorpe's portrait (see plate 131) in exchange for a male nude photograph. Feeling the call of California, he flew to Los Angeles to stay with Nick Wilder, who introduced him to his friend Arthur Lambert, a New York banker. Lambert had a Hollywood home at Hedges Place near Sunset Boulevard where he lived with a talented young artist named Larry Stanton. At the top of the house was a big room where lively parties were held for the most beautiful gay boys of Los Angeles. Hockney loved the atmosphere and the scenery of these occasions. He became a close friend of Larry Stanton and encouraged him in his work.

One of the boys who frequented the house was Paul Miranda, a slim and attractive blonde, who especially caught Hockney's eye and who was the subject of many drawings during the visit (see page 108). On one occasion Don Bachardy and Hockney were drawing Miranda at the same time when Hockney tore up his drawing and left the room. Don retrieved the two halves of the page and later glued them together. When Hockney saw the framed drawing the following year, he said: 'It's really not bad at all, is it?' and congratulated Bachardy for rescuing it. Another of Hockney's favourite models was a boy called Michael Diapetz: Arthur Lambert made a film of him photographing Diapetz in first a red jockstrap and then a black one. The house in Hedges Place was truly a voyeur's paradise.

Hockney returned to Powis Terrace in mid-April to be greeted with a bombshell: 'I wanted to go to California for some adventure. The day I came back, three weeks later, Peter said he was going to Paris, which I thought was a bit odd. And then I realized he was having an affair with someone else. At first I was a bit hurt, and then I thought, well, there's nothing I can do about it, really. After all, I'd just been to California to release myself, as it were. And I thought, it's probably temporary; can't always expect the magic of something to go on and on.'[6] Peter went to Paris with Eric to visit Picasso's daughter Paloma while Hockney, in some distress, finished his Webster portrait and continued work on *Sur la terrasse*. And, at that moment, he received a visit from a film-maker called Jack Hazan.

In 1970 someone had given Hazan the catalogue of Hockney's Whitechapel exhibition, and he had decided immediately: 'This artist is going to be huge. I must make a film about him. I must find out what lies behind these extraordinary pictures.'[7] He was not able to interest Hockney in the idea but, nevertheless, he went to Rotterdam and filmed the Whitechapel show before the paintings were dispersed. Hazan had made a film previously on the artist Keith Grant, but he was dissatisfied with the usual format of an art film. He wanted to use irony and humour to explore the world of a contemporary artist, and he knew that Hockney was the ideal subject. He felt that his not being gay was a positive advantage, as there would be no danger of his making a consciously 'gay' film. At this crucial moment in Hockney's life, in April 1971, Hazan arrived at Powis Terrace and explained his plan. Hockney remembered later: 'He had said he wanted to make a film and I'd refused him, as usual. And as usual he hadn't believed me. He'd come back, saying "Can I just do this little thing?" That's how his whole film was made – "I just need this one last shot."'[8] Thus came into being the film *A Bigger Splash*.

On and off, over the next two years, Hazan followed and filmed Hockney and his friends in various parts of the world. In May 1971 Hockney took Peter to Le Nid du Duc in an attempt to rekindle some of the magic of their relationship. They enjoyed the company of the other guests – the veteran photographer Jacques-Henri Lartigue and the artists Nikki de San Phalle and Jean Tinguely – and they swam and lazed by the pool in the warm sunshine. Hockney did some beautiful crayon drawings, including a view of a white rose in a glass vase on the window-sill, and he also took many photographs of the swimming pool and the nearby beach. But the atmosphere was tense, and at times they would only communicate with each other through Tony Richardson.

Hockney took his parents to the Lake District for a holiday in June and then returned to London to complete *Sur la terrasse*. A visit to Carennac in the company of Ossie and Celia Clark, Mo McDermott and Maurice Payne had already been planned for August and Hockney invited his friends George Lawson and Wayne Sleep to join them. He had visited the Royal Ballet with Lindy Dufferin in 1967 and had been introduced to Wayne Sleep, one of its star performers. They had become friends and Hockney had later introduced Sleep to George Lawson whom he had met through Kasmin. Lawson was an antiquarian bookseller with a colourful past. After leaving college he had holidayed in the Aran Islands off the west coast of Ireland. The Clerk of Works of the new water supply scheme had been dismissed a short time before and, when Lawson arrived on the ferry, he had been mistaken for his replacement. He stayed for two years, although without qualifications for the job, solving problems with logic and completing the project on time. He had then travelled to London to await a bequest from his late uncle who had left a considerable sum to a giraffe at Edinburgh Zoo, which Lawson would inherit after its

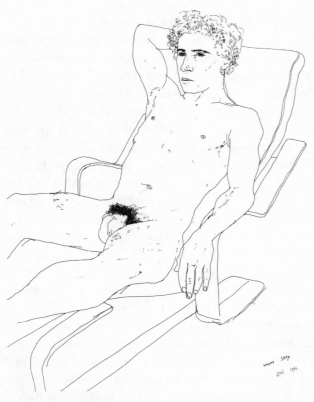

Wayne Sleep, 1971

death. The party took the morning ferry from Southampton to Cherbourg on 30 July and drove down in a convoy of three cars to the Dordogne for what Peter was later to describe as 'the summer of High Strikes Drama'.[9]

The holiday started well. Hockney had asked Maurice to bring some copper-plates, and he made etchings of Maurice and Mo sitting in chairs as well as a very effective one of Mo naked and asleep in a flower-patterned beach chair. Hockney and Peter drove to the Gorge du Tarn and took a boat trip through the underground grotto at the Gouffre de Padirac. They visited the spa at nearby Miers where Hockney took a photograph of a simple little French shop that caught his eye and which later became the subject of a painting, as well as an etching published by the *Observer* in London. With Mo they took the waters at Alvignac up in the hills and, on George Lawson's birthday, 9 August, everyone went on a trip to Rocamadour, an extraordinary place of pilgrimage built on a sheer rockface. The following week Peter suggested a visit to Barcelona and Hockney readily agreed. They visited the Museum of Modern Art and Hockney especially loved the Picasso Museum.

But things were getting difficult between them and they drove to nearby Cadaqués to stay with Richard Hamilton. By now they were having violent arguments. On 20 August they visited Mark Lancaster who was spending August in an apartment belonging to Marcel Duchamp's widow in Cadaqués. Unknown to Hockney, one of Mark's guests was Eric Boman. Mark had met Eric with Peter at the opening of Cecil Beaton's exhibition at the National Portrait Gallery earlier in the summer, and he had invited him to Cadaqués. The reason for Peter's suggestion of a visit to Spain was thus made clear.

Jonathan Guinness MP and his wife Sue, who had a holiday home outside Cadaqués, had arranged a picnic on a boat for the following day and invited Hockney and Peter to join Mark and Eric and the other fifty guests. An outing with a lot of English people he did not know was the last thing Hockney had come to Spain for, and he tried to persuade Peter to return with him to Carennac. Peter preferred to stay for the picnic, and a terrible row developed which involved everyone. Mark tried to persuade Hockney to stay but, instead, he stormed off in a sulk, leaving Peter and Eric to have a lovely time together on the outing and then to stay at the apartment to recover on 22 August.

While Hockney and Peter were in Spain, Jack Hazan had arrived to stay in the village of Carennac. He hoped to be able to do some filming but was greeted by torrential rain and flooding. While waiting for Hockney's return, he took some film of Mo and Ossie camping it up in their best French. On his way back to Carennac Hockney met up with George Lawson and Wayne Sleep at Perpignan where they all stayed in the Grand Hotel. This was in a state of some disorder, having been hit by an earthquake the day before. Hockney drove next day to Carennac, got out of his car and burst into tears. Seeing Jack Hazan waiting to film him was the last straw: he could only say: 'Just leave, please, Jack; I'm having a terrible time.'[10] Hazan packed his bags and left.

Hockney's first reaction on returning to Carennac was to want to apologize to Peter. Mark Lancaster had no telephone, so he put a call through to Richard Hamilton who promised to pass the message on. Hockney's next decision was to drive back to Cadaqués, in order to make it up with Peter and perhaps persuade him to return to Carennac. Ossie was about to drive his big blue Bentley to the Riviera to stay with Mick Jagger, so he said: 'We'll all keep you company. Mo can come with me and you can drive Maurice, and if we leave in the morning we'll make it in a day.'[11] So they left on the morning of 23 August, had lunch at the Grand Hotel in Perpignan, crossed the border where Ossie caused a sensation by alighting from his Bentley in high-heels and a long chiffon scarf, and finally reached Cadaqués that evening. They arrived unannounced at Mark's flat, where they found Eric with Peter, who was dressed in a smart sailor suit. Hockney begged him not to leave him, but Peter merely said: 'I thought you understood. I don't want you here. Please go back to France.'[12] Hockney protested: 'I've just driven back, I'm not going to leave now: I'm going to stay a day, I'm going to rest, I've been driving back and forth.'[13]

So he and Ossie and Mo and Maurice went to stay with Richard Hamilton for a couple of days. Hamilton was quite amused by all the drama: 'The border police must know you very well, David, and the Grand Hotel at Perpignan.'[14] Maurice had brought some copper-plates, so Hockney occupied himself with doing an etching of Hamilton sitting in a chair and smoking a cigar. On 25 August, he drove back to Carennac with Maurice and Mo, and then returned to London. On 28 August, Ossie drove Peter and Eric to Biot, near Nice, where they stayed with Mick Jagger and Marsha Hunt. Peter then travelled to Israel for Yom Kippur with his parents, followed by a holiday together in Greece. Mark was glad to see the backs of all of them. His holiday had been ruined.

When Peter returned to London from Greece he announced that he was going to live in his studio in Ann Upton's flat in Colville Square. He was never to move back into Powis Terrace. The effect on Hockney was catastrophic: 'It was very traumatic for me, I'd never been through anything like that. I was miserable, very, very unhappy. Occasionally I got on the verge of panic, that I was alone, and I started taking Valium. I'd never taken pills of any kind. The Valium helped a bit . . . It was very lonely: I was incredibly lonely.'[15] He could not accept that Peter had left him, and he continued to hope for his return even after Peter had moved into a flat of his own in Colville Terrace, at the bottom of Powis Terrace, in January 1972. Their friends tried not to take sides, but few were surprised by the break-up of the relationship. Peter recalled recently: 'David had built up a fantasy through his physique magazines of blonde Californian athletes. I was not blonde and not particularly athletic. I was an aspiring artist and I had a mind of my own. I was *not* the embodiment of his fantasy at all. I found it difficult to develop as an artist and as a person while living with him. We had wonderful times and I don't regret any of it, but the relationship could not have lasted for ever.'[16] His role had been that of an erotic object, to be cherished, celebrated in pictures, and shown off proudly to friends and visitors. It was difficult for him to guard his independence and impossible to develop his own talents. The price for living with such an exciting and extraordinary person as Hockney was too high. Eric Boman was a young and ambitious photographer trying for success in London, and he and Peter were able to encourage each other as their relationship grew. Hockney was then, and has remained, married to his work. Nothing comes before his art, no one has more importance.

Characteristically, at this difficult time, Hockney found salvation in his work. Throughout September and October he worked for fourteen or fifteen hours a day; he rarely went out, except for a quick visit to Paris with Kitaj to see the Balthus exhibition. During this period he drew closer to Celia Birtwell, for he found it easier to confide in a woman, and in their many hours together in the studio he made several drawings of her. He had been offered a show of new paintings at the André Emmerich Gallery in New York in May

1972, and during the two months following his return from France and Spain, he completed seven paintings. Three were on his favourite theme of the swimming pool, but these were inspired by the south of France rather than California. The water is painted in a more naturalistic way than had been the case earlier; for this he used the technique of stained acrylic paint on unprimed canvas. The more naturalistic treatment of water is especially clear in *Deep and Wet Water*, as well as in *Pool and Steps, Le Nid du Duc*, which shows Peter's white T-shirt and sandals on the edge of the pool where he had left them before jumping into the water. Both these images are based on photographs taken earlier in the summer, but the concentration on Peter's absence in the latter picture is symptomatic of Hockney's state of mind.

Hockney prefers to play down such significance in his work: he sees *Still Life on a Glass Table* (also painted at this time) as a straightforward rendering of glass objects which had accumulated over the years. Yet most of the objects chosen to be depicted with such loving care were the fruits of Peter's collecting expeditions, and underneath the table is a dark and ominous shadow. Others in the series are simple images empty of people, based once again on photographs taken during the summer: these include *Beach Umbrella* and *French Shop*. The third pool painting is *Rubber Ring Floating in a Swimming Pool*, a direct transcription of an almost abstract photograph that reminded him of Max Ernst. Hockney planned to complete the new series of pool paintings with *Pool with Two Figures*, a portrait of Peter looking at a figure swimming underwater, later to be given the title *Portrait of an Artist*, and he began work on this picture in late October.

On 21 October, Mark Lancaster went to tea with Hockney at Powis Terrace. Hockney was still in a terrible mood and Mark suggested he should go away for a while. Hockney said he might go back to California, to which Mark replied: 'No, you'll associate everything with Peter. Try somewhere you've never visited before. What about Japan?'[17] The next day Hockney telephoned him and said: 'I've decided to go to Japan. I leave in two weeks time. Will you come with me?'[18] Mark jumped at the idea of a four-week trip to the Far East with all expenses paid. They met in San Francisco on 10 November, after Hockney had spent a few days in Los Angeles seeking sympathy from Christopher Isherwood and Don Bachardy. A pen-and-ink drawing inscribed 'Mark, St Francis Hotel, San Francisco. Nov. 11th 1971' is the first of many images which came from this extensive trip. It shows Mark asleep in bed. Throughout the holiday the two artists shared a room, and Mark had the same experience as Hockney's other travelling companions, that of being awoken by the sound of his pen as he wrote a letter or worked on a drawing having got up at six o'clock. This explains why Hockney has made so many drawings of his friends asleep; it is a time too when models are less troublesome.

As always, Hockney had worked out the itinerary of the holiday with meticulous care.

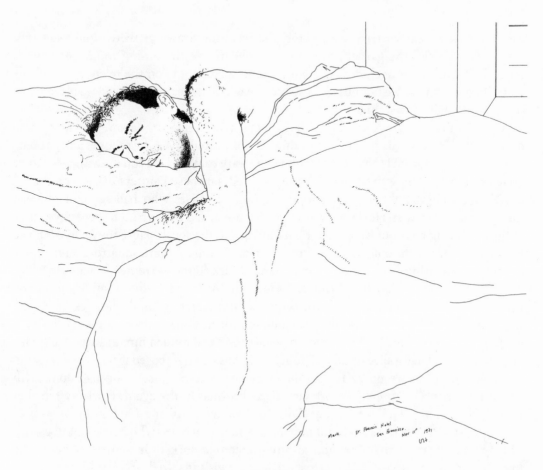

Mark, St Francis Hotel, San Francisco, 1971

These trips are known among his friends as 'Whizz Tours', and Mr Whizz is always in charge. Two days were spent at the Royal Hawaiian Hotel on Waikiki Beach in Honolulu. Here Hockney had a shock. Mark would usually stay out late at night and return when Hockney was already asleep, throwing his clothes on to a chair before going to bed. Hockney awoke on the first morning of the holiday to be greeted with the sight of one of Peter's favourite shirts. By coincidence, Mark had brought an identical one with him. Hockney immediately took a photograph and later drew the shirt on a stool in Japan. A few days later he did a similar drawing of his own suit and tie on a chair and, on his return to London, he did an oil painting entitled *Chair and Shirt* of Mark's shirt in Honolulu. The parallel with Van Gogh's symbolic empty chairs is no coincidence; at this time he was becoming more and more interested in the Dutchman's work.

The holiday was an exercise in therapy, and Mark had to accept that he was a stand-in

for Peter. As on earlier trips with Peter, the resulting drawings were almost entirely confined to hotels: the garden, the foyer, the bedroom, the dining room, often with Hockney's companion included. Hockney would spend hours on the telephone to Peter and, when visiting some famous sight, which he would never draw, he would often sigh: 'Peter would have loved this.'[19]

After Honolulu, Hockney and Mark spent two weeks in Japan. Hockney was disappointed by the ugliness of the buildings in Tokyo, but loved the temples and gardens of Kyoto, which formed the subject of one of his rare coloured crayon drawings not to be done in a hotel. They visited an exhibition entitled 'Japanese Painters in the Traditional Style' and were delighted by the sophistication of artists who had ignored modern European art. As usual, Hockney wanted to visit a spa, and the two men spent a few days at the hot spring resort of Beppu on the Inland Sea to the south. Here they stayed in the Suginoi Hotel, a traditional Japanese inn, and Hockney drew Mark squatting on the floor at breakfast wearing his yukata, an experience Mark found extremely uncomfortable. They visited a Shinto phallic shrine and Hockney made a drawing of an island in the Inland Sea. This distinctive landmark, with its natural arch through the rock, had been the subject of a painting done the previous month in London from a postcard which Kasmin had given him. He loved the image because it reminded him of Monet and also because it looked like a slice of cake. The painting was a self-imposed test to see if Japan in reality would measure up to his confident preconceptions, just as he had done with *Domestic Scene, Los Angeles* before visiting California. In the event, Hockney felt that Japan had let him down in a way that California had certainly not. One thing he enjoyed was being stared at in the street, not because the Japanese knew who he was, but because of his blonde hair, rugby shirt and different-coloured socks. On returning home, he found Japan more interesting in retrospect, and his visit inspired later paintings.

Hockney has never shown any great interest in money, but he enjoys being able to stay at the best hotels. In Tokyo he had chosen the Imperial; his next port of call was the Mandarin Hotel in Hong Kong, where he did a fine ink drawing of Mark sitting in an armchair. They went next to the Bella Vista in Macao. After a couple of days on the island of Bali, they reached the Oriental Hotel in Bangkok on 1 December. As well as visiting the extraordinary temples with their exotic Buddhas, Hockney and Mark were taken by a resident Englishman to one of the famous bars where young Thai boys entertain gay visitors. They chose two boys and, to the owner's astonishment, Hockney asked them to make love while he drew them. This resulted in more giggling than love-making. Mark befriended a young boy and Hockney did a strong pen-and-ink drawing of him in the nude which the boy then signed in Thai script.

From Bangkok they flew on to Rangoon, where they stayed at the famous Strand Hotel, a lovely old relic from the days of the British Empire. Hockney did a series of

drawings of Mark in his best suit sitting in the dining room, where a violinist and a pianist played for the pleasure of five visitors trying to eat the terrible canned food. Hockney had planned to stop next in Bombay and New Delhi, but the war between India and Pakistan made this impossible and, after a delay in Rangoon, they had to fly back to Bangkok and on via Beirut to Istanbul, their last port of call. Here it rained the whole time and they both felt they had had enough of foreign parts for a while. Nonetheless they called in at Rome on their way back, which Hockney enjoyed showing to Mark who had never been there before.

They returned to London on 12 December after a trip that had been a great success, given the difficult circumstances. Hockney had filled a couple of his fourteen-by-seventeen-inch sketch-books with pen-and-ink and coloured crayon drawings, which were shown at Kasmin's gallery in London and the Emmerich Gallery in New York the following year. Two paintings resulted from the holiday; they were begun immediately on his return and finished in 1972. *Mount Fuji* is a view of the snow-capped volcano and its reflection in Lake Hakone painted in the acrylic stain method which gives it the flatness of a Japanese print by Hokusai, an impression conveyed also by the two flowers in a bamboo vase in the foreground. It is one of Hockney's most obviously pretty images, which perhaps explains why it now hangs in New York's Metropolitan Museum of Art. *Japanese Rain on Canvas*, on the other hand, is an almost abstract design inspired by the fascination with rain in Japanese art. It was painted in thin washes of colour which were quite literally rained upon from a watering can.

At the beginning of 1972, Hockney returned to work on *Portrait of an Artist (Pool with Two Figures)* (see plate 111). He had begun this, the last of his pool paintings, the previous October. The subject had been suggested, in true surrealist fashion, by the accidental juxtaposition of two photographs on Hockney's studio floor. One was of a figure swimming underwater, which he had taken in 1966 in Hollywood, and the other was of a boy looking intently at something on the ground. Hockney liked the idea that the boy was looking at the swimmer, and the chance of painting two figures in contrasting styles, one conventional and the other distorted by water, appealed to him immensely. His choice of Peter as the standing figure, and his decision to call the painting *Portrait of an Artist* instead of merely 'Pool with Two Figures' demonstrated that the picture was to have special meaning at this crucial period. The May deadline for the New York show at the Emmerich Gallery served to concentrate his attention.

His tortured progress on this difficult painting was catalogued on film by Jack Hazan. Hockney felt guilty about having sent him packing when he found him at Carennac on his return from Cadaqués, so when Hazan contacted him again in October, he agreed to some co-operation. Hazan asked to film him taking a shower in his brand new bathroom,

and Hockney, muttering 'I think you're mad, Jack,' went ahead. In the film, he walks into his bathroom, takes off his underpants quite unself-consciously, examines himself in the mirror and then takes a shower. The event was not without its comical side as Hazan had to strip off himself and join Hockney in the shower to film the sequence with a waterproof camera.

From then on, Hazan would visit the studio frequently to do a little filming. So it came about that he recorded the progress of *Portrait of an Artist*. The underwater figure was painted first, in thin acrylic washes to emphasize the wetness, and then the rest of the canvas was coated with gesso. This meant that the basic composition and the positioning of the pool in relation to the standing figure could not be altered, even though Hockney realized that something was seriously wrong with the picture. He tried different backgrounds, from distant mountains to a brick wall, then a glass wall and, finally, mountains again. The bloated figure in the pool, with its baggy trunks, looked like a corpse, and the perspective of the corner of the pool was incorrect. In early April he decided to start again on a new canvas, even though the exhibition was only weeks away. Kasmin was horrified, but Hockney was quite confident that he had solved the problems and could finish the picture in two weeks. However, he needed further photographs of the scene, so he made a quick trip to Le Nid du Duc. Peter was filming with Jack Hazan in California, so Hockney took Mo as his stand-in, and a young photographer called John St Clair as the swimmer. With his new Pentax camera with automatic exposure, Hockney took literally hundreds of photographs of St Clair swimming underwater in different light conditions and with different water surfaces, and of Mo standing by the pool at different times of day wearing Peter's pink jacket. For their pains, each was given a drawing of himself. After two days they returned to London and Hockney took all the film directly to the processing laboratory to save time.

Although he had done sketches at Le Nid du Duc, he found the photographs more useful, and he covered the wall of the studio with them. But the photographs of Mo were not ideal so he took Peter, who had returned from California, to Kensington Gardens and photographed him in the same light conditions, in the same position and wearing the same pink jacket. Jack Hazan filmed this session. Hockney had initially refused to allow him to film the new version of the painting as time was at such a premium, but he had changed his mind when Hazan offered to lend him his pure daylight lighting equipment, which would enable him to paint through the night. So Hazan was able to record the final two-week period in the long creation of the painting.

The pool and the swimmer were completed first. The acrylic stain technique was used for the water, as well as dancing white lines recalling the first Californian experiments. The background of mountains followed, with the 1970 Le Nid du Duc painting *The Valley* being used for reference. Much of the pool surround was painted by Mo, who was

also having to spray the canvas continually with water to prevent the acrylic from drying too fast. Peter was painted last: his outline is seen as a white blank in the otherwise complete picture in Hazan's film, which also shows Mo projecting a composite photograph of Peter in Kensington Gardens onto a large sheet of cardboard so that Hockney can draw round the outline. In this way a life-size image of Peter was painted, and Hockney copied this onto the canvas. He and Mo had worked on the painting eighteen hours a day for two weeks, and it was completed and varnished on the day of the deadline. The following morning they began rolling it at six o'clock and it was taken to the airport at eight-thirty. Hockney remembers it as an exhilarating experience: 'I must admit I loved working on that picture, working with such intensity; it was marvellous doing it, really thrilling.'[20]

At the Emmerich Gallery exhibition in New York in May, among a strong selection that included *Sur la terrasse, Pool and Steps, Le Nid du Duc, Still Life on a Glass Table, Chair and Shirt* and seven other paintings, *Portrait of an Artist (Pool with Two Figures)* stood out as a major work. Given the problems, both technical and psychological, which beset its gestation, this was a real achievement. Though based on photographs, there is enough invention in the picture to counterbalance the naturalism that was becoming a problem elsewhere in Hockney's work. In retrospect, however, he is not entirely happy with the picture: 'It seems a little stiff. Basically I was trying to depict a clear space like Piero della Francesca. I love the space in his paintings, it's beautiful. But I can't paint in his way. Later I found other ways to do it.'[21] The Emmerich exhibition, which also featured fourteen drawings including many from the Far Eastern tour, was a critical success and every item was sold.

Hockney was in New York for the Emmerich show; he had taken Mo, who had contributed so much to *Portrait of an Artist*. Together they visited many parts of eastern America until then unknown to Hockney: Miami, Atlantic City, Philadelphia. In New York they stayed with Henry Geldzahler, and Hockney did a crayon drawing entitled *Henry, Seventh Avenue* which shows him relaxing in an armchair wearing a flowery shirt and smoking his favourite cigar. Hockney gave it to Geldzahler, who later reported that the artist thought of it as his best portrait of his friend.[22] Geldzahler gave the drawing to the Metropolitan Museum of Art in New York in 1980 when he retired from his position there as Curator of Twentieth Century Art. During the same visit, Hockney produced one of his most popular etchings, *Panama Hat*. Geldzahler had asked him to contribute a print for the Phoenix House charity fund along with Joseph Cornell, Adolph Gottlieb and Jim Rosenquist. Hockney offered a portrait of Geldzahler, but this was rejected because he was organizing the fund. The resulting print shows his hat, jacket, pipe and glass for iced coffee on a chair, a portrait of Geldzahler without Geldzahler, recalling the similar evocation of Peter entitled *Chair and Shirt*. These are both very

affecting images which make deliberate reference to Van Gogh's two paintings, *Yellow Chair with Pipe and Tobacco* and *Gauguin's Chair with Candle and Book*.

On his return to London, Hockney started work on another ten-foot by seven-foot double portrait, this time of his friends George Lawson and Wayne Sleep. Since Lawson is a keen amateur musician and Sleep is a dancer, Hockney saw music as the link between them. He made sketches in their Wigmore Place flat, where he noticed that Lawson's favourite seat was his three-legged stool in front of his clavichord. A large squared-up gouache dated 7 August shows the basic composition: Wayne stands in the doorway, watching George who is seated at the clavichord, looking out of the window. Hockney worked fast on the canvas, which Kasmin wanted for his last exhibition in December before closing his gallery and dealing privately. By October it seemed to be finished. Hockney was trying to paint the figures more naturalistically than in any of his previous portraits; and he was concentrating on the London light as it filtered across the picture, illuminating first Wayne and then George until it faded towards the right-hand side. George could be seen to be playing one note, A Flat, and that was at one point to be the title, a double reference to the musical theme and to the scene of the picture. The player of a clavichord has complete control of the pitch; Hockney was perhaps making a comment on the relationship here, as with his other double portraits. I remember visiting him in late October, when he told me, to my surprise, that the painting was a failure. He was already becoming dissatisfied with acrylic paint, and felt the need to re-do large areas of the picture. George moved his clavichord and stool into Hockney's studio and posed for many hours but, finally, Hockney decided that the problems of naturalism had defeated him for the moment, and he would not allow Kasmin to show the picture.

Hockney spent two weeks of July with Geldzahler in Calvi on the island of Corsica. Geldzahler took his young friend Nicky Rae, a Royal College of Art fashion student from Glasgow, and Hockney took a French boy named Thierry. On the way they stopped at the spa of Baden-Baden to take the waters which, so Hockney announced solemnly, 'cure one of homosexuality for half an hour'.[23] At Calvi they stayed in the Grand Hotel. Hockney had his new leather drawing-case with him, which looked like a briefcase and had been specially made to his specifications in London. He was therefore well prepared and, as usual, his drawings concentrated almost without exception on his companions and the hotel, rather than on the local sights. He made careful line drawings of Thierry in his underpants and elaborate coloured crayon drawings of Nick Rae and Geldzahler. *View, Grand Hotel, Calvi* is really a study of Hockney's bedroom window with its long curtains and balcony railings, reminiscent of a similar scene he had drawn many times in Jean Léger's flat in Paris, and the view of Calvi outside the window is only vaguely suggested. The nearest he came to drawing the resort was an image of one solitary

umbrella on the beach. As at Carennac in 1970, he spent many hours drawing vegetables. He would very carefully place a group of green beans or carrots on a sheet of paper. Geldzahler had to write notes in French for the maid: 'Please do not disarrange the string beans; they are in the process of being drawn.[24]

The group stopped in Nice on the way back, and Hockney paid visits to Frank Lloyd at Antibes and Larry Rubin at Plan de la Tour, occasions which caused mixed feelings. Lloyd, of Marlborough Fine Art, had turned Hockney down in 1961; Rubin, of Knoedler's Gallery in Paris, had been an early admirer and was a partner of Kasmin. A few days were also spent taking the waters at Vichy where David drew his friends in the Pavillon Sevigné and under the umbrellas in the beautiful gardens. On his return he completed two small canvases from photographs taken on the trip: *Two Deckchairs, Calvi* shows the façade of an ordinary French house with two deckchairs leaning against the wall, and was conceived as a deliberate comment on the minimalist sculptures of Robert Morris and Barry Flanagan; *Hotel Garden, Vichy* is a study of two chairs and a table under an umbrella in the bright sunshine.

In September Hockney took Ossie Clark to Munich for the Olympic Games. He has never been a sports enthusiast, but he had been asked to design an Olympic Games poster and had chosen to depict a diver in close-up entering the water of the pool. The swimming events attracted him most of all at Munich, and he took numerous photographs of Mark Spitz and the other contestants. Ossie spent a great deal of time watching the games on television with Mick Jagger, and flew back to London early, leaving Hockney behind, so that he was still there at the time of the terrorist shootings in the Olympic village.

Kasmin's closing show of Hockney's work in December was a very small affair compared with the earlier Emmerich show. Without *George Lawson and Wayne Sleep*, it could only muster *Two Deckchairs, Calvi, Hotel Garden, Vichy, Japanese Rain on Canvas* and *Cubistic Sculpture with Shadow*, an attempt to relate the three-dimensionality of a Gonzalez sculpture to its two-dimensional shadow. There were also many drawings, some from the summer trip, some of Peter, whom Hockney was continuing to see, and some of Celia Birtwell, who was providing solid support as he tried to adjust to living alone. The exhibition also included affectionate portraits in pen and ink of his parents, his mother sitting in her favourite armchair at home in Bradford, and looking less comfortable in his studio, his father reading the paper at home and lounging on his sofa, as always wearing two watches.

At the end of the year Hockney made some beautiful coloured crayon drawings of Celia in clothes designed by Ossie using her fabrics. By now they were a very successful

fashion team with their own retail outlet, Quorum Dress Shop on the King's Road in Chelsea. They were featured in fashionable magazines and colour supplements, and they made clothes for the young aristocracy as well as Mick and Bianca Jagger. Hockney made a drawing of Bianca Jagger wearing an Ossie Clark coat in November. Ossie and Celia's fashion shows were spectacular events, and Jack Hazan caught the atmosphere of razzle-dazzle when he filmed 'Quorum Presents Black Magic' at the Royal Court Theatre in May 1971 for *A Bigger Splash*.

In January 1973 Hockney left London for Los Angeles. Ken Tyler and Sid Felsen of Gemini Press had suggested he might do a new series of lithographs as a follow-up to 'A Hollywood Collection' which he had made for them in 1965. Since then he had concentrated on etching for his major graphic projects such as Cavafy (1966) and Grimm (1969), and the idea of returning to California to work on lithography appealed to him. He settled into his favourite hotel, the Château Marmont in Hollywood, and his friend Joe Macdonald came from New York to spend some time with him. Hockney's recent visit to Japan had given him a real interest in Japanese wood-block prints, as he had demonstrated with *Mount Fuji* and *Japanese Rain on Canvas* of 1972. The invitation from Tyler and Felsen offered him a perfect opportunity to further explore the graphic possibilities of Japanese art, and he decided on the subject of the weather since so many Japanese print-makers had used this as the theme of their work. He made trial runs with two studies of lightning and *Ten Palm Trees in Mist*, which is strongly suggestive of Los Angeles in the smog, and then he started on the six images of the series: *Rain, Sun, Wind, Lightning, Mist* and *Snow*. First he drew *Rain*, which was a variant of the painting *Japanese Rain on Canvas*; then followed *Sun*, which was based on a photograph of the blue shutters in Christopher Isherwood's house, with the addition of highly stylized rays of golden light. *Snow* was the most obviously Japanese image in the series, and *Wind* the most humorous with the conceit of four of the other prints being blown into the air past a streetsign for Melrose Avenue, home of Gemini Press. They are pleasing decorative images which work well as lithographs, but do not seem to stretch Hockney's abilities in the same way as his best etchings.

Celia and Ossie's relationship was going through a difficult period at this time. In February Hockney rented a house on the beach in nearby Malibu so that Celia and her two children could come and stay for a holiday. The two months that followed were a happy period: for Hockney it was like having a family of his own. He continued to work at Gemini, where he produced three large lithographic portraits of Celia, the most assured being *Celia, 8365 Melrose Avenue* which depicts her in one of her printed fabric

designs sitting in front of his image of *Snow*. This was soon followed by *The Master Printer of Los Angeles*, a full-length lithograph of Ken Tyler which features Hockney's own image of *Rain*. He also produced lithographs of chairs in his Malibu house, a little portrait of Henry Geldzahler, and a vase of blue irises beside a copy of Flaubert's novel *Bouvard and Pécuchet*. Thus ended three months of sustained print-making to begin a new year of graphic work in which he was to complete no paintings at all.

Towards the end of March, Ossie flew to Los Angeles to take his wife and the children home; Hockney then spent a lot of his time with Nick Wilder and his young lover Gregory Evans. Wilder was by now acting as Hockney's Californian dealer, and Hockney was considering a new double portrait, this time of Nick and Gregory. He took photographs of them in their apartment on Larabee Drive and produced a coloured crayon drawing which shows them in front of the huge window of their living room giving on to a garden with elaborate palm trees which he made to look like an aquarium. He was attracted to the idea of painting another *contre-jour*, this time capturing the light of southern California instead of London, but the plan was never carried out. He was by now less enthusiastic about double portraits and, in any case, Gregory was about to end his relationship with Nick to go and live in Paris.

Hockney left Los Angeles for New York on 8 April. Earlier the same day, he had been driving with Leslie Caron to visit the film director Jean Renoir when he heard, on his car radio, of the death of Picasso. It was sad news, for he much admired Picasso's work. He passed on the news to Jean Renoir, who commented: 'What an un-Picasso thing to do.'[25] The big news in New York, however, was not the death of Picasso but the breaking of the Watergate scandal, and Hockney returned to London rather regretful at leaving when America was becoming so exciting.

The Powis Terrace flat was beautiful after all Tchaik Chassay's work on it, but it was lonely and it was full of memories of Peter. Tchaik and Melissa Chassay were spending Easter on the Greek Island of Lindos and they invited both Hockney and Peter to join them. Hockney was relieved not to have to stay in London, and also delighted that Peter had accepted the invitation as well. They enjoyed their holiday in the sun together, riding donkeys down to the beach or sketching side by side in the local museum. After the initial break, relations between them had been very strained for over a year, but now they were more at ease with each other. Peter was still very happy with Eric Boman, but Hockney had not got over the shock of losing him and, instead of returning to live in Powis Terrace, he decided to spend a while in Paris. He had often stayed with friends Jean Léger and Alexis Vidal in the rue de Seine, so he decided to take a room in the Hôtel de Nice in the nearby rue des Beaux-Arts. Gregory was living in the rue de Dragon not far away, and he and Hockney spent a lot of time together visiting the Paris museums. They often

went to dinner at Yves Navarre's flat near the Arc de Triomphe, where they met many Parisian artists and writers.

In June, Joe Macdonald came to Paris from America and they went touring together. They visited the spas at Vichy and Vittel, sitting in white dressing-gowns in the traditional wicker chairs, sipping the waters with the elderly and listening to the local musicians. By now Hockney was an expert on the different spa waters of Europe. They travelled on to Geneva for a few days in Switzerland, only to be surprised by Jack Hazan wanting to do 'a little more filming'. Hazan used a hand-held camera and no extra lights to film them talking in their hotel room about Hockney's sadness at losing Peter: 'I've done some good drawings of Peter. I always mean to keep stuff but then I let it all go and later regret it. I shall keep all the drawings of my mother. I'll get rid of all my drawings of Peter.' Hazan was to use this conversation to open and close his film *A Bigger Splash*, making everything in between a flashback from June 1973.

Hockney and Geldzahler had arranged to rent the art critic Mario Amaya's villa at Sant 'Andrea in Caprile near Lucca for the summer, so Geldzahler flew to Paris and they travelled to Italy together at the beginning of August. The Casa Santini, where Hockney had stayed with Peter and Patrick Procktor in July 1967, was an old traditional Italian farmhouse with a long, covered terrace overlooking the open countryside; he saw it as his own Château de Carennac. He invited friends to drop in for a few days; those who accepted included Mo McDermott, Julia Hodgkin and her son Sam, and Don Cribb, a photographer from Los Angeles. Hockney made many coloured drawings of Geldzahler, more than he had ever done before at one time. He also drew the other guests, the municipal swimming pool at Lucca with a boy in a stripy costume and a dramatic splash by the diving board, and a rather poignant image of his little bedroom mirror festooned with a colourful array of his ties. As usual, it was these personal scenes that he recorded, rather than the historic sights, although he did make one drawing of a lonely column standing in the middle of nowhere, and on a visit to Florence he drew Michelangelo's *David*, inscribing the drawing 'David by David'.

The catalogue of Hockney's 1970 Whitechapel Gallery exhibition had mentioned in the bibliography that a book on him by Henry Geldzahler was in preparation. Geldzahler had done little more than make some notes. With the help of Paul Cornwall-Jones, Nikos Stangos, who had translated the Cavafy poems for David in 1966 and was now working for Penguin Books in London, had organized a slide-show of Hockney's work and recorded his comments in conversation with Geldzahler. There was certainly a demand for a book on Hockney and so Geldzahler and Hockney spent much of their time in Lucca discussing the form such a book might take. However, their efforts were interrupted by the sudden arrival of Kasmin, in a state of some agitation, having driven almost non-stop from the Dordogne with two London friends.

75

76

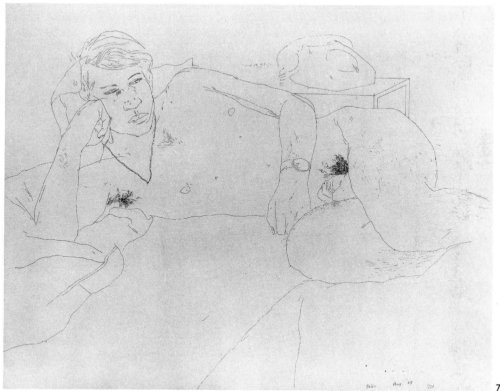

77

75 Peter Schlesinger, c. 1974
76 David and Peter with Janet Deuters' baby, Chingford, 1967
77 Peter, 1968

78

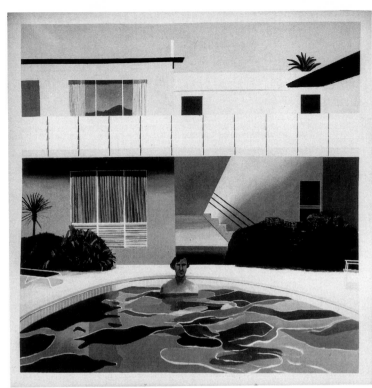

79

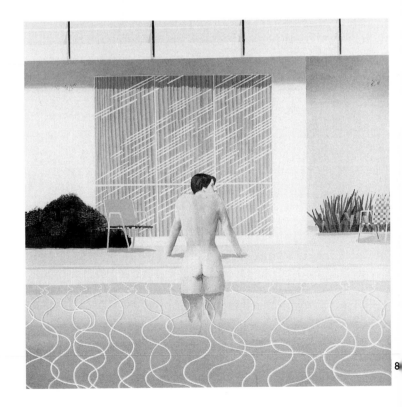

80

78 Nick Wilder's apartment and pool,
Larabee Drive, West Hollywood, 1978

79 *Portrait of Nick Wilder*, 1966

80 *Peter Getting Out of Nick's Pool*, 1966

Hockney wrote of his arrival in Los Angeles:
'As I flew over San Bernadino and looked
down and saw the swimming pools and the
houses and everything and the sun, I was
more thrilled than I've ever been arriving at
any other city, including New York.'
Californian swimming pools have become
his trademark. He was fascinated by the
reflections on the surface and experimented
with different ways of depicting them.

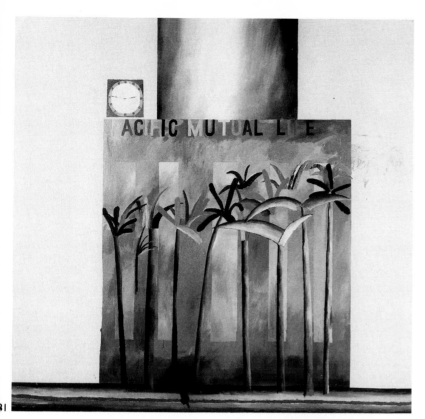

82

81 *Building, Pershing Square, Los Angeles*, 1964

82 Pershing Square, Los Angeles, 1978

83 David Hockney with *A Neat Lawn*, 1967

Hockney was attracted to Pershing Square because John Rechy's novel *City of Night* described it as the centre of a sleazy underworld of gay bars and cruising parks. But it was the everyday style of Californian functional architecture that caught his attention.

84

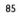

85

86

84 *The Room, Tarzana,* 1967

85 Macy's advertisement for bedspread, 1967

86 *Mademoiselle O'Murphy,* by François Boucher, 1752

Whereas the majority of Hockney's Californian paintings are arrangements of verticals and horizontals (84) is a much more complicated design with its spatial relationships governed by intersecting diagonals. This careful use of geometry gives it a perspective depth in contrast to the flatness of the previous images. Initial inspiration came from a newspaper advertisement, but Hockney added his new lover Peter Schlesinger as the all-important focal point. The pose recalls Boucher.

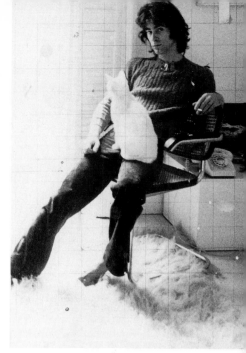

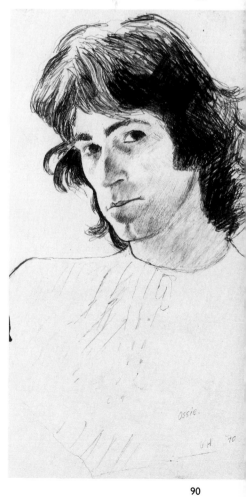

87 *Mr and Mrs Clark and Percy*, 1970/1

88 Ossie Clark at home, photographed by David Hockney, 1970

89 Study for *Mr and Mrs Clark and Percy*, 1970

90 *Ossie Clark*, 1970

91

92

93

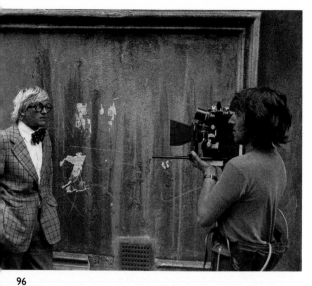

96

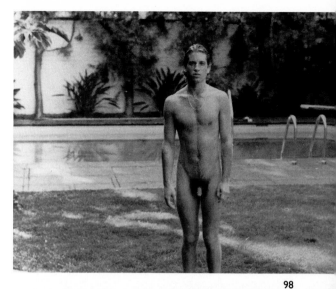

98

97

99

91 David Hockney at Carennac, 1971

92 David Hockney and Peter Schlesinger, France, 1967

93 (left to right) Mo McDermott, David Hockney, Peter Schlesinger, Carennac, 1971

94 *Breakfast, Carennac,* 1967

95 *Carennac, Howards End and Vichy Water,* 1970

96 Jack Hazan filming David Hockney for *A Bigger Splash,* 1972

97 (left to right) Peter Schlesinger, David Hockney, Celia Birtwell (still from *A Bigger Splash*), 1972

98 Peter by the pool (still from *A Bigger Splash*), 1972

99 Four boys (still from *A Bigger Splash*), 1972

100 Peter Schlesinger and friend (still from *A Bigger Splash*), 1972

100

101

102

103

101 Eugene Lambe, Lucca, August 1973

102 David Hockney drawing Eugene Lambe, Lucca, August 1973

103 David Hockney completing his drawing of Eugene Lambe, Lucca, August 1973

104 *Dr Eugen Lamb* (sic), Lucca, August 1973

In August 1973, Hockney rented a villa near Lucca in Italy for the summer. He saw it as his own Château de Carennac and invited his friends to join him. He made many drawings including a portrait of George Lawson's eccentric friend Eugene Lambe, which has become one of his most reproduced works. Perversely he mis-spelt both Lambe's names in his inscription.

Kasmin had travelled to Balme, where he had recently bought a property near Carennac, with John Prizeman, the architect who had remodelled his new premises when he closed his Bond Street gallery. Jane Kasmin and their children were spending the summer at Balme with Eugene Lambe who was doing maintenance work on the house, a converted herb-store. Lambe was an Irish lecturer in Philosophy at Dublin University who had dropped out of academic life after a nervous breakdown and had become a general handyman. George Lawson had met him in Ireland and brought him to London where he had settled in a flat in the same building as George and Wayne Sleep in Long Acre. With his long red hair and beard, and the strong Irish accent in which he recounted a succession of witty tales, he had established himself as a real character. Kasmin had gone drinking at a village fête with John Prizeman and Eugene Lambe the day after he arrived, and this, together with some recent philandering, had resulted in a violent row with his wife Jane. After much smashing of windows and hurling of insults, Kasmin had fled from the wreckage of his marriage with Prizeman and Lambe at three in the morning. He had driven his BMW at speeds of up to 140 miles per hour, and after one short stop at Sète, the three had gained the sanctuary of the Casa Santini.

After his recent experience with Peter, Hockney felt perfectly ready to offer Kasmin a shoulder to cry on. All work on the book came to a halt as the group went travelling. They spent a while in Pisa, where Hockney photographed everyone in front of the leaning tower, and then they paid a visit to Princess Beatrice Monte and her husband Baron Gregor von Rezzori, the author of the autobiographical novel *Memoirs of an Anti-Semite*. She was the owner of the Galleria dell'Ariete in Milan and had given Hockney a one-man show in 1966. She lived in the Villa Reale at Marlia, south of Florence, with enormous numbers of pug dogs to whom she was in the habit of serving San Pellegrino water. Diaghilev and Nijinsky had been previous visitors, and the house was full of photographs of them. Here Hockney made careful crayon drawings of Geldzahler and Don Cribb sitting in white wicker chairs. Back in the Casa Santini, John Prizeman took a sequence of photographs of Hockney photographing and then drawing Eugene Lambe on the terrace: Hockney made two striking coloured crayon drawings of Lambe in his blue smock and trousers and the large straw hat which he had bought him in the market at Lucca (see plates 101, 102, 103, 104). Prizeman recalled later: 'I watched him doing the big, finished drawing, sitting in front of Eugene, staring at him intently. He started at the top of the blank page, slowly filling in Eugene's hat, and working down the page like unrolling a curtain.'[26] Perversely, Hockney inscribed the drawing 'Dr Eugen Lamb', giving him an academic distinction he did not possess and spelling both his names incorrectly.

While he was in Italy, arrangements were being finalized for Hockney to draw the writer J. B. Priestley. The first approach had come in a letter from John Thompson, the

Director of the Bradford City Art Gallery, in which he mentioned that Priestley would be receiving the freedom of the city shortly, and that a portrait of the author by Hockney would fill a large gap in the museum's representation of contemporary art. Characteristically, Hockney ignored the museum's request until Thompson asked his brother Paul Hockney, in his capacity as a Bradford City Councillor, to intervene. Hockney refused any suggestion of a painting but agreed to do a drawing, and so, in late July, Thompson wrote to Priestley proposing the idea.

Thompson pointed out that the museum already owned interesting portraits of distinguished people with Bradford connections (Delius by James Gunn, a self-portrait by Sir William Rothenstein and a James Barraclough portrait of Priestley himself) and that it would like to have a portrait by the latest Bradford artist to achieve international fame. Hockney had already painted David Webster, Christopher Isherwood and Ossie Clark; would Priestley agree to being drawn by him in September? The writer replied encouragingly, but he was not clear whether he would be expected to pay for the drawing. Thompson immediately assured Priestley that there would be no cost to him; indeed he was hoping that Hockney would present the drawing to the museum as a gift, as eventually happened. Complicated arrangements were then made as to the date and place of a sitting which would be convenient for both parties and finally, on 22 August, Hockney sent Thompson a picture postcard of the thermal baths at Lucca suggesting he could do the drawing on 14 September in London. Thompson then had to deal tactfully with a press agency who were planning to send a reporter and photographer around to record the meeting.

Hockney spent the morning of 14 September at Priestley's flat in the Albany. He was, as always, apprehensive about drawing someone he did not know, and when asked later how he got on with Priestley, merely remarked: 'Well, he just sat there looking big.'[27] He completed three Rapidograph drawings of Priestley sitting in an armchair and looking big. In two, he sucks on his pipe and looks rather grumpy, recalling the earlier drawings of Auden, but in the third he has put down his pipe and he is smiling at the artist (see page 185). This rather conventional image was chosen for the museum, although Hockney prefers the other drawings. Given the circumstances, the drawings are surprisingly successful in capturing the author; far more so than a drawing of Henry Moore at the Café Royal of June 1972. The situation was the same: famous Bradford artist persuaded to draw another famous Yorkshireman he had never met before, but on this occasion the drawing completely failed to convey the character and talent of the sculptor, as Hockney is the first to admit.

CHAPTER SEVEN

PARIS 1973–1974

Towards the end of September 1973 Hockney returned to Paris. He had enjoyed the couple of months he had spent there earlier in the year, and now decided to spend much longer in the city. His friend Tony Richardson had recently bought a Paris apartment with the money earned from making *The Charge of the Light Brigade* in France, and now offered to lease it to Hockney. The apartment was in the cour de Rohan, just off the passage de Commerce, one of the lovely old pedestrian streets in the Latin Quarter (see plates 124, 125). It was in a beautiful historic building, once the palace of the Bishops of Rohan, in a quiet private courtyard with a large living room over the archway forming the entrance, giving views on both sides. Jean Léger and Alexis Vidal were two minutes away in the rue de Seine and Gregory Evans was nearby in the rue du Dragon. It was an easy walk across the Pont Neuf to the Louvre. Hockney was absolutely delighted. This was to be his home for the next two years.

The Latin Quarter is well known for its colourful local characters, and Hockney fitted in very well. In his panama hat, rugby shirt, red braces, bow tie, cricket blazer, baggy pinstripe trousers, and different-coloured socks, he would take his breakfast at the Café Flore or the St Claude on the boulevard St Germain and then have his evening meal at the Brasserie Lipp or La Coupole. In November he made a marvellously atmospheric drawing of Henry Geldzahler with his coffee and cigar at La Coupole being drawn by an artist named Sasha Rubinstein, a very entertaining and amusing man who used to charge fifty francs for a five-minute portrait (see page 134). Hockney thought he could always fall back on that way of earning a living in his old age, if necessary. One of the locals he soon got to know was Lila di Nobilis, a theatre designer who had worked for Tony Richardson on *The Charge of the Light Brigade*. She was a rather eccentric recluse who had a tiny garret in the rue de Verneuil and refused to use the telephone. She was a Marquise but always gave her money away; she lived with lots of cats but only one tea cup. Her unvaried diet was soup and beans. She had worked with Zeffirelli at the Paris Opéra on *Così Fan Tutte* but spent most of her time teaching children to draw by means of an old-fashioned *camera obscura*. Hockney said to her: 'Oh it's lovely. Do let me try it,' but she replied 'Oh no, you don't need it, you can draw already.'[1]

Lila di Nobilis was the subject of a large and highly finished crayon drawing in October, the first of a series of such images. Hockney was invited to meet Man Ray and

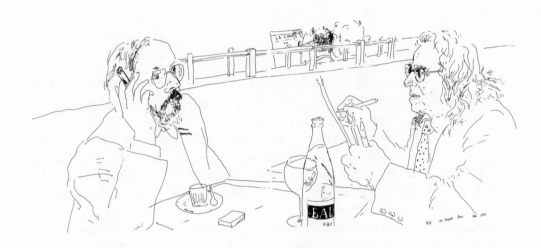

Henry Geldzahler at La Coupole, Paris, 1973

leapt at the chance of drawing him because he was very sympathetic to his work. He found him a wonderful old man, fascinating to talk to, and he drew him sitting in his studio in a red jacket and black beret with a picture behind him and a chessboard at his side (see page 185). It made him regret not having had the chance to draw Picasso. However, he did take the opportunity at this time to draw his old friend Andy Warhol, who was visiting Paris. This drawing was sold at Sotheby's in New York on 2 May 1988, after Warhol's death (see plate 123), for $330,000, an auction price record for a Hockney drawing. Warhol returned the compliment by taking numerous photographs of Hockney which were the basis for his *Portrait of David Hockney* painted later the same year (see plate 126). In November Hockney made a precise and very affectionate drawing of his close friend Jean Léger at the cour de Rohan, clutching his arms in characteristic fashion, and this was followed in December by an equally careful drawing of Kasmin sitting in the same chair. The series continued with portraits of Jacques de Bascher de Beaumarchais, a handsome aristocrat and friend of the fashion designer Karl Lagerfeld, and Yves-Marie Hervé, a young student of Art History at the Ecole du Louvre who was Hockney's lover while he was living in Paris (see plate 122). He made crayon portraits of his mother and his father, when they visited him in January 1974, which are among his finest drawings of his parents. But by far the majority of drawings during this period are of Celia Birtwell. She made many visits to Paris, and Hockney drew her again and again, in a black slip and

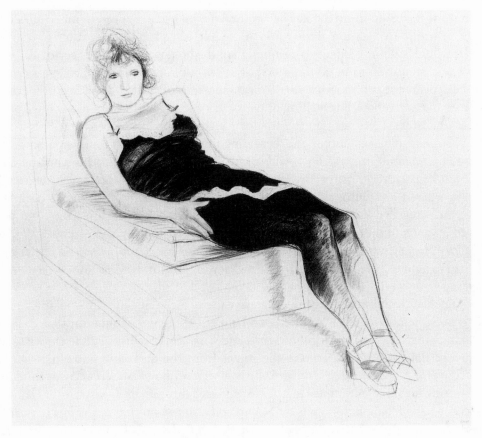

Celia in Black Negligée, 1973

in various dresses of her own design. These images tend to idealize her in a way that Hockney very rarely idealizes men. Apart from his mother, Celia has played the most important female role in his life. The relationship has also had great significance for Celia, especially during this Paris period. She recalled later: 'The only time it came near to being a sexual thing was when I went to Paris and he did drawings of me in negligées. It was like something was going on, but it was quite remote. I think he likes a woman's understanding. He can talk to me about things. In the French drawings, when we were very close, there was something going on between us which I think he portrayed through those drawings. He said to me that this was his way of expressing how he felt about me.'[2]

Throughout 1973 Hockney had been concentrating on graphic work, from the 'Weather' series of lithographs in California to the Italian and French drawings. He had also been experimenting with etching techniques. When I had recorded an interview

with him for inclusion in my book *The Erotic Arts*, he had promised to make an erotic etching for the limited edition of the book, to join a screen-print done by Allen Jones. We agreed it would be a more explicit continuation of the homosexual Cavafy series of 1966. When I was finally asked to go to Petersburg Press in Portobello Road to approve the print, I discovered that he had forgotten the dimensions of the book and had produced a very large and marvellous line etching of two boys making love in front of a framed print of a vase of flowers. I was hesitant to turn down an original Hockney etching, but, to my relief, he agreed to make another one, repeating the image but on a much smaller scale. This was then bound into the book and made a telling contrast with the very hetero-sexual, multi-coloured print by Allen Jones. The image later obtained a degree of notoriety when it was (automatically) included in the exhibition of Hockney's complete prints which travelled the British Isles in 1979–80. In certain museums, the print was removed by order of the local authorities on grounds of obscenity; at Liverpool's Walker Art Gallery one of the curators, Marco Livingstone, who later wrote a book on Hockney's work, had to fight to have it included for public viewing, and at the Glasgow Art Gallery it was placed so discreetly that many people never saw it at all.

Hockney had always mistrusted the excessive use of technique in print-making but, in London in September of 1973, he tried experiments in the use of aquatint that enabled him to draw directly with a brush onto the plate with acid. Maurice Payne showed him how to use Polycell glue to protect the brush from the acid long enough to create interesting effects. Recently in California he had been reading Flaubert and was thinking of illustrating his story 'A Simple Heart'. He produced three images, portraits of Flaubert and George Sand from photographs by Nadar, and also *My mother at the age of twenty (from a photograph) as a study for Félicité in 'A Simple Heart' of Gustave Flaubert*. He was delighted with the resulting watercolour effect.

He had been asked to contribute an etching in memory of Picasso to a portfolio being published by Propyläen Verlag of Berlin, and so, when he arrived in Paris, he went to the workshop of Aldo Crommelynck, who had been Picasso's etcher for twenty years. Crommelynck showed Hockney the proper technique for using the sugar lift which was Picasso's method of obtaining aquatint, and Hockney put this information to use by making two etchings which are dedicated to Picasso. The first is *The Student: Homage to Picasso*, in which he, with a portfolio of work under his arm, humbly approaches his hero who is represented by his sculptured head on a pedestal. The image is inspired by *The Sculptor's Studio* from Picasso's 'Vollard Suite' of 1933, in which Picasso had depicted himself as the artist who is always aware of the impossibility of achieving his highest ambitions. In Hockney's second and rather more exciting print, *Artist and Model*, he sits opposite Picasso at a table by a window. It is a witty and highly individual interpretation of the title of so many of Picasso's own images; Hockney's subservient role in the

An Erotic Etching, 1972/3

confrontation is stressed by the fact that he is naked while Picasso is clothed. The two figures are drawn in different techniques, Picasso in the new direct style using a brush and the sugar lift, Hockney in the traditional method of hardground etching. It seems probable that Hockney had been looking at another image from the 'Vollard Suite', in which Picasso drew himself in simple outline conversing at table with Rembrandt who was depicted in extraordinary detail.

Hockney was still keen to pursue his plan of illustrating Flaubert's 'A Simple Heart', and produced five more etchings in Paris before deciding that other ideas had priority. Crommelynck had suggested he try coloured etching using a new technique he had discovered which enabled the artist to retain the spontaneity of the medium. Hockney experimented by drawing Gregory Evans from life straight onto the plate in red and blue. He was delighted with the result, which looked deceptively like a lithograph. (Gregory was rather less delighted; the speed of the technique had captured him looking thoroughly depressed and with his hair in disarray, the result of being asked to model early in the morning after a late night out.) Hockney went on to produce coloured etchings of godetias and marguerites, to practise the new technique, and then turned back to Picasso: Simplified Faces (1974) is a coloured etching arising from a series of drawings

of heads constructed out of geometric forms: Cézanne's cube, cylinder and sphere seen through the eyes of Picasso. This was soon followed by *Cubistic Studies*, a drawing of constructed heads derived from Picasso's cut-out and folded metal sculptures of the 1950s.

Hockney's contact with Crommelynck and first-hand information about Picasso's techniques brought home to him the sheer breadth of the artist's achievement. His two *hommages* were sincerely meant tributes. In an interview with Pierre Restany in Paris in July 1974, he gave a hint of the importance that Picasso's work was to have on his own development in the direction of a new freedom from the extremes of naturalism: 'I would tend to think that a great twentieth-century artist, such as Picasso, would use that kind of freedom as regards form, going from one style to another, exactly as he wished. That implies a very extended scale, and a very great one. I am not saying my work has such a range, far from it, but I believe in the freedom of action which derives from the liberties you take as regards form.'[3] There are hints of the way ahead in a curious print entitled *Showing Maurice the Sugar Lift* of 1974, which displays a confusing variety of styles and techniques. Quite unrelated images are depicted in hardground, softground, drypoint and sugar aquatint, and a geometric figure in the upper right-hand corner would later reappear in the painting *Invented Man Revealing Still Life* of early 1975. *Showing Maurice the Sugar Lift* was originally intended simply as a demonstration piece, to show Maurice Payne how Crommelynck had perfected the sugar lift method. Only when friends expressed their fascination with the image did Hockney agree to publish it; Maurice was a little offended, fearing that people might think he did not know what the sugar lift method was.

Although the Picasso-inspired prints and drawings raised issues which would be of great importance later, during late 1973 and 1974 Hockney was also still preoccupied with naturalism in his paintings. He had decided, on arriving in Paris, to begin painting in oils again after nearly ten years of using acrylic paints, but the interval had been a long one and the first Paris paintings, based on drawings from the summer trip to Italy, were abandoned because he tried to use oil like acrylic. Then he decided to try another double portrait. Shirley Goldfarb and her husband Gregory Masurovsky were American artists who had lived in Paris for twenty years. She used to go to the Café Flore, where Hockney first met her, at 6 pm every day, always wearing a black cashmere sweater, black leather slacks, black high-heeled shoes and heavy mascara, and accompanied by her little Yorkshire terrier. She would engage tourists in conversation and allow them to buy her drinks, and she was ever on the look-out for a party invitation. Gregory and she would usually have dinner at La Coupole because their apartment was so tiny. They each had their own little room which served as studio and living space, and they lived more or less separate lives. Hockney saw the subject for a painting here, and made many drawings of

their flat. There was no room to paint the picture there, and they posed for many hours in the cour de Rohan studio. The painting shows Gregory sitting on his bed at his work table in his tiny compartment and Shirley sitting on a chair in her work space next door, with her abstract pointillist painting on the wall and her dog in front of her. Hockney has had to remove the whole of one wall in order to reveal their little flat. As usual, he has concentrated on trying to portray a relationship, but the resulting image, which at four-foot by seven-foot is considerably smaller than the earlier double portraits, is rather static and lifeless, even though he by now felt happier working in oil paint.

Hockney settled into a routine quite quickly in Paris. He would get up early and draw, then go out for breakfast and spend the morning at the Louvre or some other museum, often in the company of friends. It was his habit to work in his studio in the afternoon, and Gregory would arrive at 4 pm for tea and to run errands and make phone calls. He would always dine out. He took Mo to the Louvre to look at the Jacques-Louis David paintings, and with Jean Léger he would always pay a visit to the works by Ingres. Jean once asked Hockney if he could draw as well as Ingres; Hockney replied that he could not but would, nevertheless, have a try. The result was the November 1973 drawing of Jean clutching his arms. His most constant companions on these museum visits were Yves-Marie Hervé and Gregory Evans, and he always took Kitaj to the Louvre when he came to Paris. Kitaj once photographed him admiring a drawing by Seurat, and a crayon drawing by Hockney entitled *Il pleut sur le Pont des Arts*, of Yves-Marie walking across the Pont des Arts to the Louvre in the pouring rain, shows a strong influence from Seurat. Yves-Marie recalls that Hockney was planning a painting which would sum up the romance of Paris, and made him pose on the bridge in the rain for endless photographs. The drawing, together with a small oil entitled *Yves-Marie in the Rain* (see plate 122), shows the intended composition, but the painting which followed was never finished.

Hockney's second and third completed paintings of Paris demonstrate a modified use of Seurat's pointillist technique. Both these pictures were inspired by a visit to the Pavillon de Flore at the Louvre where French drawings from the Metropolitan Museum, New York, were on show. *Two Vases in the Louvre* is a view of the courtyard through a window; *Contre-jour in the French Style – Against the Day dans le Style Français* shows a window with a blind half-lowered and a glimpse of the formal Tuileries Gardens beyond. As soon as Hockney saw these views he recognized them as wonderfully French subjects, took some photographs and then made drawings. Each became first a painting, and then a coloured etching. He felt that *Two Vases in the Louvre* needed a figure in the foreground, so he tried to photograph Yves-Marie in the exact spot in the museum. This brought objections from the attendants; he photographed his friend outside and tried to superimpose the cut-out image onto the painting. But the result was unsatisfactory and

he abandoned the idea. Hockney used the pointillist technique because it was an obviously French style of painting, and he hoped it would help him become accustomed to oil paint again. He also relished the challenge of pitting himself against artists better-known than himself, not just Seurat but also Degas, Matisse, Bonnard and Vuillard, all of whom had painted similar subjects. His adoption of the pointillist technique works especially well in *Contre-jour in the French Style* with its subtle light effects, and the use of oil paint allowed him the opportunity to loosen his brushwork after the tightness of his naturalism in acrylic.

In February 1974, while working on the new double portrait and the two Louvre paintings, he had a phone call from Jack Hazan. His film *A Bigger Splash* was now finished; would Hockney like to come and see it? He returned to London and saw the film in a private viewing theatre. What he saw was a mainly factual, but partly fictionalized story of his break-up with Peter and its effect on him, his work and his friends. He later recalled in his autobiography: 'When I saw it I was stunned and shattered, partly because it was like living through the . . . there is something very real about it; despite all one's criticism of the film, there's a lot of truth in it, and I was utterly shattered; I had no idea.'[4] Hazan remembers that day and the aftermath: 'David was shaking. He was devastated. He said to me: "It's too heavy, Jack. It's just too heavy. We can't have that." I told him he should not have been so casual and dismissive about my film, because then he would have realized what I was trying to do. I heard nothing from David for two weeks, although there were rumours of lawsuits and Kasmin was said to be ready to offer £20,000 for the negative to prevent it being shown. I realized I had brought back to him all the problems of the break with Peter which he thought was over. I was upset that he was upset. I knew the film was not an act of cruelty. I had never once lied to him. He had to face the situation. And I considered I had put as much emphasis on his work as his life – I had sought to show how painful art can be to the artist, and I had shown his ultimate achievement.'[5]

Hockney had been totally unprepared for this exposé of his private life: 'We were always joking about him and his film. He'd become a joke, Jack, really. We thought his film was going to be a twenty-five minute blurred film with bad sound, that it would be on at the Academy Cinema with a Polish version of Shakespeare. We never expected it to be two and a half hours of weeping music.'[6] Ossie went to see the film and told him: 'You know David, you can't ignore this film, it's truer than the truth.'[7] Hockney returned to London to see it a second time with Shirley Goldfarb, who was a keen cinema-goer. She thought it was wonderful and the best film she had ever seen about an artist creating pictures. Claes Oldenburg saw it and congratulated Hazan on a brilliant film about art. Hockney then decided that it would be wrong to stop the film, whatever his personal misgivings might be, and so he signed a release for Hazan.

Hockney spent Easter 1974 with Yves-Marie at Le Nid du Duc. They visited the Léger Museum at Biot and also the Château de Castille where he made a spirited pen-and-ink drawing of Douglas Cooper with some of his Picasso paintings and also drew Yves-Marie in crayon reading a book by Jean Cocteau. *A Bigger Splash* had been chosen as the only British film at the nearby Cannes Film Festival, and Tony Richardson remembers how Hockney adamantly refused to attend the performance, telling everyone how he had been conned by Jack Hazan. Michael York and Michael Caine, also guests of Richardson, both saw the film and expressed great enthusiasm, as did the reviewers of *The Times* and the *Guardian*. Back in Paris, Hazan visited Hockney to invite him to a special public viewing of the film as part of a season of Cannes Festival films. Seeing his latest double portrait on the easel, he said 'You see, David, that's what you do all the time; look at what you're doing to them.' Hockney replied: 'I see your point; if Shirley and Gregory say "We don't like that picture," I'm not going to destroy it, if I like it.'[8]

A Bigger Splash (see plates 96, 97, 98, 99, 100) opens in June 1973 with Hockney entertaining Joe Macdonald in Geneva while Mo in London expresses his sadness at the events which have broken up the happy life of David, Peter, Ossie, Celia and himself. The film then becomes a flashback. The good times are seen as Hockney attends Ossie's fashion-show with Peter and Celia, but then Mo tells us that it's all over, Peter is leaving David. Peter reluctantly returns to Hockney's studio to pose for *Sur la terrasse*, while Kasmin bemoans the fact that he has no pictures to sell to the waiting clients. Celia gives Hockney emotional support while Peter works on his paintings in his new flat, and makes love with a boyfriend. Hockney starts the first version of his large portrait of Peter, *Portrait of an Artist (Pool with Two Figures)*, but finds work on it very difficult, and is seen cutting a canvas to pieces. He discusses with Henry the possibility of moving to New York, and visits Patrick Procktor's Redfern Gallery exhibition while Mo complains that the new painting of Peter is not progressing. Hockney goes to have a close look at his earlier picture *The Room, Manchester Street* with Patrick. Then, while taking a shower, he has visions of Peter and his beautiful young friends swimming naked in a Hollywood pool. In his studio he works on the second version of *Portrait of an Artist*, using photographs taken in the south of France. At a drag party he asks Peter to model for the picture, and next day photographs him in the park. With Mo's help he then completes the painting. Kasmin once more berates Hockney for not producing enough work; Hockney then sits by Henry who is having a bath and tells him amusing stories about his father. He visits Celia but she will not let him in as Peter is with her, so he cuddles up to Larry Stanton on the sofa for some sympathy. In his mind he sees Peter swimming in the nude, and visiting first Betty Freeman and then Nick and Gregory in Los Angeles. In New York with Mo, Hockney looks at his recent paintings at the Emmerich Gallery and then disappears after a strange meeting with Henry. Celia is desperately worried and phones

Ossie who calls in at the Tate Gallery to look at the portrait of himself and Celia. Mo returns alone to London where Kasmin is closing down his gallery. Back in 1973, Hockney tells Joe that he will keep all drawings of his mother but get rid of all his drawings of Peter.

Jack Hazan made his film under difficult circumstances, never knowing for certain whether he would have an end product because of the lack of co-operation. He made two other films during the three years he worked on *A Bigger Splash*, and only after six months' editing with his partner David Mingay did he realize he had achieved something. The final version is a new kind of film about art because it is thought out as a true-life drama rather than a documentary. He was fortunate to have appeared when he did because, although he had started filming in 1970 before the break-up, the events of 1971 meant that, suddenly, a story had fallen into his lap. The film is essentially a drama, a high proportion being fact and some being fiction. Although the actors are real characters, it is not *cinema verité*, except for Ossie's fashion-show and Andrew Logan's Alternative Miss World drag party, because it is consciously planned and acted out. It is based on events that actually happened, but Hazan added fictional scenes using dramatic licence in order to create a clearer story. The drama sequences are obvious inventions; Hockney did not disappear in New York but, on the contrary, took a holiday with Mo; Kasmin closed his gallery because he wanted to sell pictures privately, not because a lack of Hockney pictures put him out of business. The fiction that most angered Hockney was that he ripped up the first version of *Portrait of an Artist* out of emotional frustration, whereas he insists that the problems with the picture were purely technical. He also says: 'I cut up and destroyed the first version of the picture. I didn't slash it, as Jack Hazan says in his film. It was actually cut up quite carefully because I made a bit of it into another painting and gave it to Ossie and Celia.'[9] The press release clearly states: 'At a new low, he destroys the "Peter canvas" and his six months' work,' and this interpretation of the scene has been generally accepted. The *Observer* film critic wrote: 'In a finely directed scene which eventually justifies an ambitious operatic backing ("*Nessun Dorma*"), Hockney advances on his problematical canvas and knifes it. Hazan's camera, unable to watch, stares at the windows, a table, the flashing lights of the artist's telephone. But the tension thus released enables Hockney to make a fresh technical approach to *Peter by the Pool*.'[10] Careful viewing of the film reveals that, at the crucial moment, the first version of the painting is still on the easel. Hockney is actually shown cutting up a quite different canvas.

On one level, the film can be seen as a documentary on Hockney's painting, his working techniques and, particularly, the painful progression of *Portrait of an Artist*. However, its subsequent popularity owes more to the fact that it presents a revealing story of two years in the life of a famous artist. It has touches of humour: Kasmin

continually regretting the lack of paintings for him to sell and Hockney's complete lack of concern; Geldzahler and Patrick Procktor each aping their portraits; Hockney asking Procktor where he painted his view of the Grand Canal in Venice, only to be told 'in the basement of my house in Manchester Street'. There is beautiful camera work in the slow-motion dream sequences involving Peter in Los Angeles. But the wailing music by Patrick Gowers is a continual irritation and Mo's often repeated dirge, 'When love goes wrong, there's more than two people that suffer,' is merely annoying.

Mo co-operated with Hazan throughout the filming, but feels in retrospect: 'I don't think I came out well, although I did exactly what Jack asked. In fact except for David, the film makes us all look terrible.'[11] Ossie had a rather smaller role, and feels that the film is sympathetic and accurate.[12] Celia, on the other hand, is very unhappy about her involvement: 'I felt flattered to be asked to take part, but I think Jack led us on, took us all for a ride, and made a lot of money out of us. He saw the value of exaggerating the emotional angle, of embroidering what really happened. He used me as a crazy link between David and Peter. He got me to do things I didn't want to do. I played into his hands. Ossie refused to do much, and Peter asked for payment. Mo and I got nothing, yet we did not come out of the film well. We were made to look like real wimps. I was horrified. I don't think it did my career as a fabric designer any good at all.'[13] Peter sees the film as well-made fiction: 'I'm playing a role, a walking sculpture, an erotic object. Jack was very fair to me, he told me exactly what he wanted, and I agreed because I loved the idea of being in a movie, although I really wanted to get away from the whole episode. Jack wanted me to make love to Eric in the bedroom scene, but I said no, it must be someone I don't know, otherwise I can't do it. It was not easy – the guy was actually straight, not gay. The first time it didn't work at all and we kept arguing about what we should be doing. We didn't even take our trousers off. The second time we got into it, when it was filmed, and I think it went well. Jack wanted us to go a little further, but I didn't want it to become pornography. We were paid £100 each: others in the film were a bit annoyed since no one else was paid. Jack also paid for me to fly to California for the pool sequences. I asked some friends – Gregory Evans, Jimmy Swinea, Mark Lippscombe – to be in the film and they all jumped at the chance. We were all a bit nervous of being in the nude at first but we got used to it and enjoyed it. But my parents weren't too happy.'[14]

Hockney comes out of the film well because he is the hub and everyone else merely spokes in his wheel. No one has identity except insofar as they relate to him. He is shown to be human, vulnerable, rather innocent and very talented. In retrospect, he takes a philosophical view: 'I joke about the film. I try and ignore it. I'll talk about it with people, but on the whole I ignore it. In fairness to it, in many ways it's a remarkable film; I don't think it could be repeated, because to repeat it you'd have to find innocent people. If Jack

Hazan showed me that film, and then said: Now I'd like to make a film about you, can I? I'd say Fuck off. Anybody would, I think. The people in the film were completely innocent, not realizing how it was being done; Jack didn't realize either, although he at least knew what the photography was going to be like. But I think the film will always be shown, because there are good things in it, and you've to take them along with the bad.'[15]

Hazan never set out to make a gay film and does not see *A Bigger Splash* as such, but it has become regular viewing at gay film festivals all over the world and is discussed in books on gay cinema such as Richard Dyer's *Gays and Film*.[16] It makes no attempt to explain or defend the gayness of its characters, it merely accepts it, and it suggests that the break-up of a gay relationship can be just as catastrophic as that of a straight one. It could be said that the love-making and the pool scenes pander to gay audiences, but these episodes are successfully integrated into the film. However, the reaction of some of the gay press was hardly favourable: 'Oh for a gay who is a dustman and not an interior decorator, a greengrocer and not a designer of women's clothing!'[17] 'The heart of its confusion is a shirking or simple unawareness of what it means to be gay in this world, yes even if you're as rich as David Hockney and his friends.'[18]

The gay content of the film caused great problems of distribution. *A Bigger Splash* was at first banned for four months in Paris, and in America Customs initially only allowed it in for one screening at the New York Film Festival, declaring it to be 'disgusting and immoral'. The London Film Festival announced it as their opening attraction until the Director of the British Film Institute described its homosexuality as repellent and unsuitable for such a prestigious occasion; instead it was shown on the closing night. Eventually it did very good business in London, Paris and New York and, in addition to being chosen for the Cannes, New York and London film festivals, it won prizes at the Locarno and Chicago festivals. Alexander Walker closed his review of the film by writing: 'The guarded waters close again over the "splash" [the affair] has made, leaving a surface as smooth as any Hockney painted. But we have felt the turbulence underneath – an effect as rare in the cinema as it is powerful.'[19]

Soon after Hockney moved to Paris in 1973, the British Council approached him about a large exhibition of his work which they proposed to mount at the Venice Biennale. He was not particularly keen to have another such show so soon after the Whitechapel exhibition in London in 1970, but said they could go ahead if they wished. A while later, they came back and said that the Biennale had been cancelled, but the show could perhaps be transferred somewhere else. He immediately suggested Paris since he was living there but had hardly exhibited there at all. So it was that a major exhibition of his work took place at the Musée des Arts Decoratifs in the Louvre from October to December 1974. Thirty paintings were on show, compared with forty-five at the Whitechapel exhibition,

but the emphasis was on recent work and half the paintings dated from post 1970. These included *Mr and Mrs Clark and Percy; Sir David Webster; Pool and Steps, Le Nid du Duc; Portrait of an Artist (Pool with Two Figures)*, and the three Paris paintings. There was a far better representation of drawings, 105 instead of forty-eight, but no prints. The exhibition was a huge success, causing great interest in the press and producing high attendance figures. For Hockney himself it was a useful opportunity to take stock of his progress since the Whitechapel show. In particular, it enabled him to see both the strengths and the limitations of his naturalistic style, and it was to lead to a new freedom in his painting. The catalogue contained an introduction by Stephen Spender which placed Hockney in the alternative tradition of English painting and poetry, a great original in the line of descent from William Blake. Also included was an interview between Hockney and Pierre Restany, in which he says: 'I need constant stimuli of all kinds, visual and others, that is why I travel a lot and enjoy working in lots of different places . . . In the paintings and drawings I've done here there is much more of Paris than there is of London in all I've been able to do in London. The reason is simple: it's easier for me to get the necessary detachment in Paris because I don't understand much of the French character or the language. But on the other hand I know how to use my eyes and I like the sensation of detachment I can experience in Paris and which stimulates my work.' Asked by Restany whether he intended to stay longer in Paris, he replied: 'Oh sure. Paris is very exciting for me, for plenty of reasons. First since as I said, I have started to paint Paris. It's much more difficult painting Paris than painting Los Angeles. No one or hardly anyone has painted Los Angeles. Whereas Paris has been painted by so many people. By very talented artists, much greater than I am. Also I want to take up the challenge, because it's worth the trouble and I like to make life difficult for myself. If you want to paint anything worthwhile you shouldn't be afraid of stepping up the pressure. That suits me. I'll stay.'[20]

Gregory. Palatine
Roma
Dec 1974
n+

CHAPTER EIGHT

EUROPE, AMERICA
AND AUSTRALASIA 1974–1977

During the early summer of 1974, when he was having battles with his tight drawing style and the increasing naturalism of his first Paris paintings, Hockney received a telephone call from John Cox, Director of Production at the Glyndebourne Festival Opera in Sussex. Would he design a new production of Stravinsky's opera *The Rake's Progress*? The idea of working in a completely new field had obvious attractions at this difficult time, but the very limited experience of designing *Ubu Roi* in 1966 hardly seemed sufficient for him to take on such a task as was now being offered. However, he was prepared to travel to Glyndebourne for further discussion with Cox, who convinced him that he could overcome the technical problems and adapt his methods to the requirements of an opera. Hockney could not resist the challenge and agreed to produce his designs for costumes and scenery by Christmas 1974.

John Cox had seen the 1966 production of *Ubu Roi* and was confident that Hockney could design something much more ambitious. He knew the 'Rake's Progress' etchings of 1961–63, and when the Stravinsky opera was chosen for Glyndebourne, he immediately thought of inviting Hockney to design it. The first Glyndebourne production of the work in the fifties had been entrusted to Osbert Lancaster, whose designs had complemented the social commentaries of Hogarth, and the management suggested the political cartoonist Gerald Scarfe for the new version. Cox thought this would result in a very acid flavour, preferring the benign humanity he sensed in Hockney's work, and his view won the day.

For Hockney the collaboration was to prove crucial, opening a new chapter in his career, and leading to other operatic commissions which were to introduce his work to a completely new audience around the world. It was not, however, a matter of entering into a foreign environment. Ever since his father had taken him and his brother John to see the Carl Rosa Opera Company's production of Puccini's *La Bohème* at the Bradford Alhambra in the late forties, Hockney had been a devotee of opera. By 1974 he had seen more operas than most people knew existed, and he would often listen to opera on his car stereo. Having accepted the commission to design *The Rake's Progress*, he resolved to put all his energies into achieving a successful result and justifying the confidence shown

Gregory Thinking in the Palatine, 1974

by John Cox. He had told Cox at an early stage: 'I suppose, if you're asking me, you're wanting something a bit out of the ordinary!'[1] and he was determined to create just that.

Hockney immediately set about researching into the background of the work. Stravinsky had long wanted to write an English language opera, and Hogarth's 'Rake's Progress' paintings, which he saw in an exhibition in Chicago in 1947, prompted the choice of subject. With his librettists W. H. Auden and Chester Kallman he worked out a plot, 'a three-act moral fable, to be based on the "Rake's Progress" series,' in which Tom Rakewell sells his soul to the devil and abandons his sweetheart Anne Trulove in order to experience the delights of London, only to end up in the madhouse. They took great liberties with Hogarth, including only the brothel and Bedlam scenes from his series, and adding new characters such as Nick Shadow (the devil), Baba the Turk (a bearded lady whom Tom marries), and Mr Sellem (a strange auctioneer). They created a twentieth-century pastiche of the eighteenth century both in the libretto and in the Mozart-flavoured music, and so Hockney decided he must try to give the eighteenth-century setting of the opera a twentieth-century look.

In September 1974 John Cox visited him in Paris to see his initial design ideas for the opera. In October, after the opening of his Louvre exhibition, Hockney left Paris for a suite at the Château Marmont Hotel in Hollywood; Stravinsky had composed the opera in Los Angeles, and Hockney took with him the original recording of the work which the composer had directed himself. He asked Mo McDermott to come with him; Mo had previously worked for a stage designer in London, and he advised Hockney that he would obtain better results if he made scale models of each set instead of merely producing drawings. Together they made miniature images of every scene of the opera, which Hockney conceived as three-dimensional drawings inspired by the Hogarth originals. By Christmas he was able to show 70 per cent of the necessary work to John Cox in London. Cox later recalled: 'I was absolutely delighted. I had not been thinking in terms of Hogarth myself, I had kept an open mind. I had expected a twentieth-century setting for the opera, whereas David had set it in the eighteenth century but succeeded in giving it the feel of the present day.'[2] Hockney had not been inspired by Anne Trulove, so he had made her into a rather dull schoolmistress. Cox wanted this changed. 'I told David, "The audience has to weep for Tom, because he has lost Anne, and so she must be made worth losing."'[3] On the other hand, he had responded well to the more exciting characters, the bearded lady, the brothel keeper and the wild auctioneer. And he had so liked Nick Shadow that he had used a cut-out photograph of an attractive young man for him, to which he had added mascara and fashionable stubble.

Hockney's designs for *The Rake's Progress* (see plates 136, 137, 139) were based on Hogarth's engravings and not his painted series. One of his first decisions was to make the engraver's cross-hatching technique the theme of his designs, both for the scenery

and for the costumes. At first he thought of limiting everything to black and white, to imitate the engravings, but then decided that Hogarth would have used colours if he had known how. He bought best-quality German inks – red, blue, green and black – and drew everything in miniature on his model using the cross-hatching technique. When he presented this idea to the staff at Glyndebourne, they were not convinced that it would work, so he made test-pieces of cross-hatchings and hung them up on the stage. Some looked like a solid colour, others like a chessboard. Eventually he found the exact scale which looked right from the auditorium.

Most of his costume designs were taken directly from Hogarth's 'Rake's Progress' etchings or paintings, but some of the settings came from other Hogarth sources: the brothel is based on an engraving entitled *The Lottery* and the graveyard scene owes its inspiration to a plate from the 'Industry and Idleness' series. The scene of Bedlam, one of the opera's high points, has walls covered with graffiti which were inspired by details from Hogarth's *Bedlam* and also his 'Invasion' series, to which Hockney added the initials of Auden, Kallman and Stravinsky, among other idiosyncratic scribblings. His original idea was to have six lunatics standing in boxes at the back of the stage, but John Cox suggested putting the entire chorus in boxes: 'This was the happiest collaborative coup of all, for I hated the prospect of the singers doing their own thing in that awful Actors' Studio way of representing madness of all kinds (e.g. *Marat-Sade* and *We Come to the River*). This way we could use the chorus as figments of Tom's diseased imagination.'[4] The final scene shows Tom and Anne in a last embrace in front of the boxes containing the chorus who are dressed in black with grotesque white masks based on Hogarth's *Analysis of Beauty*; it makes a stunning visual climax to the opera.

The first performance of the Cox-Hockney production of *The Rake's Progress* was given on 21 June 1975. As usual at Glyndebourne, the opera started at 5.30 pm, with an interval of seventy-five minutes for picnic dinners on the lawn. With his usual sense of occasion, Hockney invited his friend Peter Langan to provide an open-air banquet for his friends to enjoy during the interval. Langan had formerly earned his living as a petrol salesman with a big expense-account, and found that he enjoyed lunching his customers more than selling them oil. He went into partnership with an architect friend and opened a restaurant called Odins in London in 1972 which became a great success. Hockney, who loves good food, became a regular patron; he drew Langan standing under an umbrella as an illustration for the menu. When Langan's Bistro opened later the same year, he drew him in the restaurant for the new menu. Next Langan, in partnership with the actor Michael Caine, opened Langan's Brasserie, a smart restaurant in the French style modelled on La Coupole in Paris. This time Hockney's menu design was a coloured crayon drawing of Peter Langan, Michael Caine and their chef Richard Shepherd eating their lunch among the palm trees of the restaurant. So successful was it that the menus

Peter Langan, 1972 (for restaurant menu)

Neal Street Restaurant Menu, c. 1972

were continually being stolen. Hockney also designed a menu for the Neal Street Restaurant in Covent Garden, which had been opened by Kasmin and Terence Conran as a result of their culinary achievements each summer at Carennac. The original drawing of a table laid for dinner includes Hockney's favourite meal in his original spelling: 'Beluga Caviare, Watercress Soup, Truite au bleu, Chateaubriands sauce Bearnaise, Mange tout, Haricots vert, Cheese, Creme brulee, no coffee (it is a killer), Gerwertztraminer, Chateau Lafitte, Chateau Yquem.' Hockney also assured himself of good meals elsewhere: he designed menus for Mr Chow's restaurant and for *Ma Maison* in Los Angeles, and for *La Chaumière* in Paris.

For *The Rake's Progress* banquet, Langan set up a long table by the lake at Glyndebourne and piled it high with delectable food served by a fleet of bronzed Spanish waiters (see plate 138, 140). There was a great deal left at the end of the interval, so Hockney invited the entire company, performers, musicians and stage-hands, to finish the banquet after the final curtain. Improvized lighting was set up on the lawn for music and dancing as the early morning mist began to rise off the surface of the lake. The

Glyndebourne production proved to be an enormous success, and later travelled all over the world. On the opening night John Cox whispered to Hockney 'Shall we do *The Magic Flute* next?' Hockney whispered back, 'I'll think about it.'[5]

Towards the end of 1974, when *The Rake's Progress* designs were well underway, Hockney was invited to lunch in Paris by Yves Navarre, who told him of a commission he had received from Roland Petit for the libretto of a new ballet to music by Marius Constant. He wanted Hockney to listen to the story in silence and then say whether he would like to do the designs. He had taken his inspiration from a Roman gravestone in the museum of Antibes which commemorated Septentrion, a boy in the local theatre. His epitaph was *'saltavit et placuit'* (he danced and he pleased). Navarre's story was set on the beach at Antibes in contemporary times. A group of fashionable people in evening dress, including a pair of young lovers, an old lady covered with jewellery, a powerful businessman and a film star are lounging about in a state of complete boredom when a beautiful young man appears out of the sea. He begins to dance in an erotic and narcissistic way, and seduces each of the characters in turn. But far from joining him in his world of pleasure, they all reject him and return to their state of boredom. In desperation, Septentrion kills himself; no one takes any notice.

Navarre remembers Hockney's immediate reaction: 'David said it was marvellous and he would love to do some designs. He'd start right away. He empathized with Septentrion as epitomizing the loneliness of the true artist, who won't compromise. He felt this very strongly and later wrote a little piece about it for the theatre programme.'[6] Hockney made sketches for the costumes and the backdrop. He set the scene in front of a house with little balconies and green shutters which recalled *Two Deckchairs, Calvi*; in the first sketch a deckchair was, in fact, included. At one side were neat little sculpted hedges and trees, and at the other side he added a swimming pool (reminiscent of *Portrait of an Artist*) from which Septentrion would emerge. Another addition was a large and colourful sculpture by Léger standing behind the pool. He had seen the piece at the Léger Museum at Biot earlier in 1974 and, as he explained: 'Léger is for me the perfect model of the artist whom nothing and no one has been able to corrupt.'[7] Hockney made a finished crayon drawing and then supervised its transference by scene-painters in Paris onto two backdrops, one for day and one for night. He also travelled down to Provence for the dress-rehearsal and first performance of *Septentrion* by Roland Petit's Ballets de Marseille in May 1975. He took all this trouble for minimal payment because the story appealed to him so strongly. In the theatre programme he wrote: 'Every artist is alone . . . Ambition makes his life more and more difficult. He enters into competition with the present and the past of his art. He feels more and more alone, and under attack, but this can at the same time stimulate him.'[8]

Since the break-up of his relationship with Peter Schlesinger, Hockney had felt

especially lonely. In Paris he became aware of a deepening in his friendship with Gregory Evans (see plate 144), the former lover of Nick Wilder: 'We met about 1970, and he came to live in Paris in 1973 when I did, and from then on, slowly, we got closer and closer, and about 1974 I realized I was very keen on him – there was something marvellous about him, his manner. I mean, he can be a literalist like I am, playing with words in conversations – having games – which I like, and so we grew together.'[9] In December Hockney took Gregory to Rome. It was his first visit to Italy, and Hockney loved showing him the sights: the young men and, especially, the historical buildings and museums. Typically, his photographs and drawings from the trip concentrate on his friend, rather than the places they visited together. There are two fine pen-and-ink drawings of Gregory seated, one with his head resting on his arm inscribed 'Roma 1974', the other in a long overcoat among broken columns inscribed 'Gregory, Palatine, Roma Dec. 1974' (see page 146). Hockney gave the latter the title *Gregory Thinking in the Palatine*; it seems likely that he was alluding to a drawing made by Henry Fuseli in the Roman Forum in about 1780, *The Artist Moved by the Magnitude of Antique Fragments*,[10] which also shows a figure seated among the remains of Ancient Rome. Hockney's title could thus be his tongue-in-cheek recognition of the eighteenth-century determination to be overwhelmed by antiquity.

The two line drawings of Gregory in Rome were included in a small exhibition of Hockney's graphic work at the Bernard Gallery in Paris in April 1975. As well as a dozen etchings and lithographs, there were about thirty drawings in coloured crayon, the medium he favoured while living in Paris. From 1973 were drawings of Celia Birtwell, Man Ray and Jacques de Bascher de Beaumarchais; from 1974, Yves-Marie Hervé, Douglas Cooper, the study for the proposed portrait of Nick and Gregory, and various drawings of Hockney's parents on visits to Paris. Also on show were more recent drawings dating from early 1975: a series of Celia lying on a bed, nude and semi-nude, the first such images Hockney had drawn of her; a series of Geldzahler including the first nude drawings of him; a full-length nude study of Gregory which is one of the model's own favourites (see plate 145); and drawings of Hockney's friends Nicky Rae, Carlos and Randy. Some of these were very tight, academic drawings which took a week, the longest he had ever spent on one drawing: 'They were done as an exercise, a necessary exercise I think, in order to be able to draw freely . . . they give you enormous confidence and then, when you come to use two or three lines, you know what you're doing, you know more what you're looking at, and you know how to deal with it. So they're done just for that really . . . You see, these were the most naturalistic . . . and I think actually it was these that confused me and yet I kept thinking it was "Ossie and Celia" [*Mr and Mrs Clark and Percy*].'[11]

Hockney had been unhappy about the restrictions of naturalism for some time. His

work for the Glyndebourne *Rake's Progress* had given him a new enthusiasm in his search for alternative directions. In 1975 he finally abandoned any idea of completing the double portrait *George Lawson and Wayne Sleep* which he had begun back in 1972: 'The reason I abandoned it was because of all the problems I began to find in naturalism, and they took me a long time to sort out. In a way, I spent a long time on pictures that I later grew to hate a bit – I was wasting my time there.'[12] To identify the problems was one thing, but to find a solution was an enormous task. 'I found moving away from [naturalism] harder than moving away from anything else.'[13]

He felt that the way forward could be via another double portrait, but one treated in quite a different way. In 1972 he had told me: 'I've more or less given up painting portraits of pairs, but the more I think about it, the more I'm sure that I'd like to paint my parents. It's a very traditional thing to do, I know, painting one's parents, but I think it could be a lot more than just that. Their predicament, their lack of fulfilment, the desperate not-knowing what they could have had out of life. And their relationship with me. I think it could be OK.'[14] Ever since his mother had entered hospital for an operation in 1973, he had been planning such a picture. As he told Marco Livingstone: 'My father could go to the hospital every day for a few hours, but he wasn't used to sitting and talking to her for a few hours every day at home. He'd be doing something, my mother would be doing something else. It was then I noticed that people communicate in other ways, it's not always just talking, especially people who know each other well. They'd been married forty-five years, and if you've been living with somebody forty-five years, you know a lot about the face, the little actions, what they mean, you know how to interpret them. I think it was then I decided there was a subject there I somehow wanted to try and deal with.'[15] In March 1975, when his parents were visiting Paris and on other occasions, he made preparatory drawings (see plates 152, 153) and took photographs and then began painting *My Parents and Myself* from life (see plate 150). As a new departure he chose a square six-foot by six-foot canvas and, instead of placing the figures in a clearly defined setting, he portrayed them sitting on either side of a green trolley containing items from his studio, but against a completely blank background of bare canvas. On the trolley stood a vase of yellow tulips and a mirror which reflected his own image, and on the bare canvas he drew a large red triangle to reinforce the concept of a mutually dependent three-way relationship.

The result did not satisfy Hockney: 'After about three weeks it was all quite fresh – I should have just left it like that. But it looked too much like earlier work, it looked as though I've gone back a bit and don't know quite what to do. So I was never truly satisfied, nor was I satisfied with it as a portrait of them, it wasn't quite right. So I had to struggle on.'[16] First he repainted his self-portrait in the mirror so that it was less central, then he altered the chairs from tubular steel to wood and formed a stage for his parents

and the trolley. Finally, he painted over the plain background to create a wall in front of which ran a rail with two blue curtains looped over it. This device was borrowed from Fra Angelico's *Dream of the Deacon Justinian*; it served to underline the theatricality of the scene in a similar manner to the curtain paintings of 1963. But Hockney was still not satisfied that the painting worked successfully. The first stage of the image is recorded in the last illustration of his autobiography which was dictated in summer 1975. The second stage can be seen in photographs he took of his parents with the picture in his studio in London at the end of 1975. Then he abandoned it.

Hockney felt a very real need to make a success of such an important subject, and so in 1977 he returned to the idea with a painting entitled *My Parents* (see plate 151). Once more it was a six-foot square canvas, and once more Mr and Mrs Hockney are sitting on either side of the green trolley. But his reflection in the mirror has been replaced with a glimpse of Piero della Francesca's *Baptism*, one of his favourite paintings, a reproduction of which he always keeps on his studio wall. Next to it can be seen a corner of the final stage of *My Parents and Myself* with Fra Angelico's curtain draped over its rail. He had found it impossible to retain his own image successfully in the painting: 'I thought it didn't work. I couldn't get it to work. I mean I am very clumsy at times.'[17] On the trolley can be seen a book on the eighteenth-century French painter Chardin whose intimate scenes of domestic life are alluded to in the painting. There is now a clearly defined setting of a floor with a rug, as well as a wall behind the figures. The biggest change is in the sitters themselves: Laura Hockney is alert and responsive as she looks at David, whereas Kenneth Hockney prefers to concentrate his attention on a book which he holds in his lap. The result is much more relaxed and natural than the stiffness of *My Parents and Myself*, the colour is much stronger, the handling of the oil paint more assured. He was especially pleased that his sister Margaret, a stern judge, felt that the picture was an accurate portrayal. However he told me recently that he now feels a little dissatisfied with it: 'I think the painting of my father is very good – he was always in his own world. But I'm less pleased with the portrait of my mother. I'm not sure that I have caught the relationship totally. I've often thought of doing another.'[18]

My Parents is certainly more successful than the 1975 picture, where Hockney was so desperately trying to find a way out of naturalism. By 1977 he was quite ready to work in a more naturalistic manner if the subject required it, and he was pleased that the Tate Gallery later chose this very personal image to expand their holdings of his work.

A sign of Hockney's determination to move away from naturalism in 1975 is a small painting entitled *Invented Man Revealing Still Life*. The central figure is derived from his Picasso-inspired experiments of 1973 and follows closely the geometric figure in the top right-hand corner of *Showing Maurice the Sugar Lift* of 1974. The picture contains strong contrasts of illusionistic painting and near abstraction, and recalls the stylistic

freedom of the works of the early 1960s. A direct reference to the curtain paintings of 1963 is made once more with the same Fra Angelico detail employed in *My Parents and Myself*: here the invented man pulls back the curtains to reveal the still life of white tulips in a blue vase.

The theatricality of *Invented Man* owes something to Hockney's parallel work for *The Rake's Progress*, but the only painting that resulted directly from the opera was *Kerby (After Hogarth) Useful Knowledge* of 1975, now in New York's Museum of Modern Art. This was inspired by Hogarth's frontispiece to *Dr Brook Taylor's Method of Perspective Made Easy* published in 1754 by Joshua Kirby (who Hockney mistakenly recalled as John Kerby). Hogarth's satire on the misuse of perspective amused Hockney greatly, and he very much enjoyed transcribing it into paint, using the techniques of his stage sets for Glyndebourne to create the image of a river scene in which impossible things happen and completing the whole picture in under a week. It was only nine years later that he realized, with hindsight, how important this painting had been in helping him to move away from naturalism and a search for consistency towards experimentation with the nature of depiction through a study of reverse perspective.

My Parents and Myself, Invented Man Revealing Still Life and *Kerby* occupied Hockney from March throughout the rest of 1975, with interruptions for *Septentrion* in May and *The Rake's Progress* in June. In August, he gave himself a holiday at The Pines on Fire Island near New York. His banker friend Arthur Lambert had a house there which he loved to fill with visitors each summer (see plates 134, 135). It was an American Carennac, but with a big difference; The Pines is a gay seaside resort, and every summer its beaches are packed with beautiful male bodies. Hockney is not a keen swimmer or sunbather, but the beaches provided ideal material for his camera, and he filled one whole album with photographs of beautiful bronzed young men taken during August 1975. These included Lambert's protégé, the young artist Larry Stanton (see plates 132, 133), and Hockney's friend, the famous model Joe Macdonald, both of whom had appeared in the film *A Bigger Splash*. As in his Los Angeles house, so here at Fire Island, Lambert loved to surround himself with beautiful boys. Hockney had a wonderful time. His friends Henry Geldzahler and Don Cribb were also Lambert's guests. There were afternoon tea dances on the beach, and evenings would often be spent at Gino's Bar which teenage boys could patronize as no alcohol was served. As usual, Hockney spent much of his time drawing: he produced careful pen-and-ink portraits of Henry (see page 156) and Joe, quick crayon sketches of boys on the terrace of the house, and highly polished drawings in coloured crayon of Don and of a friend of his from New York called Robert. Twice he drew Joe Macdonald's lover Larry Slanz lying nude on Lambert's sofa, first in

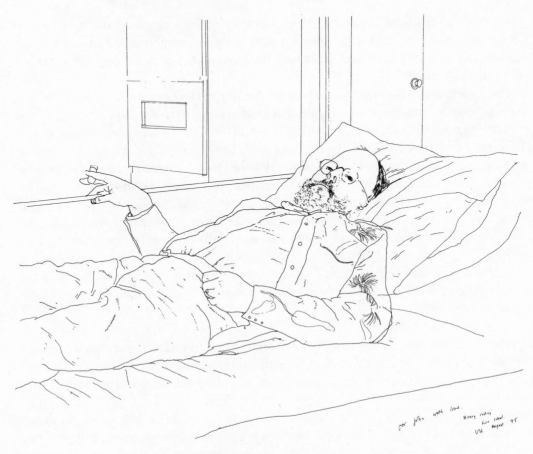

Henry Resting, Fire Island, 1975

pen and ink and then in coloured crayon, which was unusual as it is his custom to use only one medium per session.

During 1975 Hockney showed an especial interest in making nude images of his friends. Early in the year, the Bernard Gallery exhibition in Paris had included nude drawings of Celia, Henry, Randy and Gregory. He had been very keen to draw Yves-Marie nude but his friend always demurred: 'I said no in Paris because I was shy and felt vulnerable, and I considered myself much too thin compared with the voluptuous drawings of Celia. Then I said no in London because it was much too cold to pose without clothes.'[19] Throughout the year he produced many nude drawings of Gregory, and at the beginning of November he took a series of Polaroid photographs of Gregory, Mark Lippscombe and himself in his bathroom at the cour de Rohan. In the flat Gregory had found a bag full of

men's sportswear from a Hollywood shop, so he and Mark tried on the jockstraps and running shorts: 'They keep putting it on, taking it off, so I start taking the pictures. It's very sexy, a nice little bum with the stars and stripes across it.'[20] There were also nude photographs of Gregory and Mark in the bath, and of Hockney and Mark sitting on the side of the bath with their arms round each other. No flashlight was used, as he wanted Caravaggio's flesh-colouring in the pictures. He also wanted the flesh to shine, and so the three of them were continually jumping in and out of the bath to obtain the right effect. A selection of these Polaroids was published in *Playguy*, an English gay magazine, in January 1976. The editor had gone to interview Hockney and found him sticking the pictures into his latest album, so he asked if he might reproduce a few. Hockney agreed, thinking they would come out as tiny blurred images. In fact, four of them were reproduced full page, in colour, to his surprise, including two of him. He was rather pleased. 'One of them, I thought, was very flattering to me, where I've got my little arm round his waist. We're sat nude on the bath looking up. *He's* got a marvellous body but I thought *I* didn't look too bad; I didn't mind them printing it actually, I was quite flattered. I look very young . . . The photos reproduced very well . . . It was a fun afternoon actually!'[21]

Since his Royal College days Hockney has never been reticent about his homosexuality. It was typical of him that he should not object to a gay magazine publishing his photographs, although he must have known it would cause controversy. In 1968 he had taken a stand against officialdom by demanding the return of some American male nudist magazines which had been confiscated from him by the British Customs and, by the seventies, he was a Vice-President of the Campaign for Homosexual Equality in London. When the Incognito gay bookshop in Earls Court was raided by the police in June 1976, a phone call brought him quickly round to the shop to confront the officers. He told *Gay News* at the time: 'When people become aware of oppression, they should do something about it. Censorship is quite bad here and nobody complains . . . What censorship does is inhibit a whole area of activity that people should be able to examine for themselves, which is our right and duty. Gay people should protest about their publications being confiscated and prosecuted because it is blatant discrimination and the more people that complain, the more the police will have second thoughts.'[22] The *Guardian* was one of many Fleet Street newspapers that reported his demonstration and solidarity with the shop: 'I protest at the distinction between eroticism as high art which can be published, and eroticism as low art which can be raided by the police. Inspector Higgins says the police have acted in a civilized way. I don't think this is a tolerant or civilized act. I think it stinks.'[23]

1975 was in many ways a crucial year for Hockney. *The Rake's Progress* at Glyndebourne marked a new departure in his career; paintings such as *Kerby* pointed the

way to a new direction for his painting; it was the year when he finally produced his autobiography. Henry Geldzahler's proposed book (mentioned in the Whitechapel exhibition catalogue of 1970) never materialized, nor did the collaborative effort which he and Hockney had discussed at Lucca in the summer of 1973. Nikos Stangos, who had conceived the idea for a book, was working now for the publishers Thames and Hudson, and he was determined to find a way out of the *impasse*. In the late summer he decided that the solution lay in a tape recorder, so he invited Hockney to his flat in London, stocked his refrigerator with bottles of white wine, and told him forcefully: 'The book with Geldzahler will never be done. There's a real demand for a book. Let's do it together, all at one go, and let's do it *now*.'[24] Hockney agreed, and spent the next three days a virtual captive on a Victorian chaise-longue, telling Stangos details of his life and, more especially, the circumstances of his various paintings and engravings as he remembered them. The wine flowed freely; there were no meal breaks; the scene was like that of an extended psychoanalytical session. Stangos had prepared a large pile of reproductions and a long list of questions, and Hockney allowed his thoughts to flow freely, sometimes drifting off to sleep in mid-session. At the end of three days he returned to Paris.

Stangos now had twenty-five hours of taped conversations which produced five hundred pages of transcript. He wanted a narrative, so he erased all his questions, included some material from other sources, edited out more than half of the typescript, and was left with about 80,000 words. This he sent to Hockney in Paris. He remembers the reaction vividly: 'David was shocked. He hadn't expected a narrative account at all. He felt it was rather revealing, perhaps embarrassing, maybe even harmful to himself. And he wondered if anyone would be interested. It was like *A Bigger Splash* all over again – he said he hadn't realized what had been going on. All I had done was to organize his words into a narrative, taking as my model Benvenuto Cellini who dictated his bragging account of his deeds to his assistant as he didn't have time to write it all down himself. But I felt I had managed to keep the charm of David's own style.'[25] Stangos convinced him that the book would do him no harm, and it was published with a rather analytical introduction by Henry Geldzahler in 1976. Thames and Hudson's print run was only 3,000 copies, to the disgust of Nikos, but all were sold before publication and a further run of twenty thousand copies was ordered to catch up with demand.[26] Although some criticisms were made – that the book was too oral, repetitive, and uninteresting – most reviews were favourable, and it has continued to sell. Some critics were over-eager to praise the book; Nicholas Phillipson described it in *The Times Literary Supplement* as: 'The most remarkable autobiographical work any artist, scientist or man of letters of his generation has written.'[27]

Hockney begins his book with a warning: 'It is very good advice to believe only what an artist does, rather than what he says about his work.'[28] Then follows a very brief

account of his life and art training before leaving Bradford, and a slightly fuller description of his time at the Royal College of Art. The rest of the book is a chronological survey of his subsequent work, full of insight and humour but reading at times rather like the commentary to a slide-show. Thus details of his life that do not result in art works tend to be ignored. It also at times exhibits the fallability and selectivity of human memory. The last illustration is *My Parents and Myself* as it looked towards the end of 1975, and the last work discussed is *Homage to Michelangelo*, a two-colour etching that was commissioned for a German portfolio in celebration of the 500th anniversary of Michelangelo's birth. Hockney shows two views of Vera Russell, a well-known figure in the London art world, who was in Paris working with Samuel Beckett and Jasper Johns on the book *Foirades/Fizzles*.[29] She is walking past a wall on which are inscribed the words 'In the room the women come and go, talking of Michelangelo', among sketches of his Sistine Chapel nudes. Hockney chose the lines from T. S. Eliot's 'The Love Song of J. Alfred Prufrock', as the most famous modern literary reference to the artist, and Vera seemed to him to be the sort of woman who *would* talk of Michelangelo.

Hockney and Stangos had the problem of how to end the autobiography of an artist who was only thirty-eight. They chose humour: 'When I was talking about it to Jasper Johns, he told me about a scene in *The Maltese Falcon* where a man says to the detective, What does it mean, "In the room the women come and go, talking of Michelangelo"? And the detective says; It probably means he doesn't know much about women. Pretty good. I like that.'[30]

Hockney finished talking into Stangos' tape recorder in the late summer of 1975 and returned to a Paris that was no longer as exciting as it had seemed two years earlier. He had never mastered the language, and now he found he was growing increasingly deaf, which made understanding French people almost impossible. He has told me that he had never had an ear for languages: 'Visual people in my experience are not very good at languages unless they are born in a place where they are forced to speak two or three. The trouble with French for me is the pitch it's spoken at. I don't understand German either, but it's more guttural and I can recognize certain words and sentences. My ear can't hear where French words begin and end, it all seems to blur into one sound. I mean I do try but I just can't hear it. And I refuse to try one of those language courses where they immerse you in boiling oil and don't let you out until you speak French. Someone said the other day, it must be terrible not to be able to communicate with the French. I said, What do you mean, I've had two exhibitions here, isn't that communicating?'[31] Another problem was that his address had become well known: 'Too many people came to see me. I was too central, people dropped in all the time. For the first year, nobody came, I would meet them in cafés. But later I realized it was impossible to get any work done. I suddenly thought, well, this is no good, I'm off. Within three days I had packed up and left Paris.'[32]

Yves Navarre went to say goodbye on 6 November, and Hockney drew his portrait, fulfilling an earlier promise, oblivious to the removal men scurrying around him. The following day he was gone.

Hockney's permanent base was still 17 Powis Terrace, but he had not felt it was his home ever since Peter Schlesinger had moved out. Tchaik Chassay's remodelling had created a beautiful first-floor flat which David no longer wanted. Earlier in 1975 he had sold the flat to Tchaik and Melissa and bought a small apartment on the top floor of the house. Tchaik had taken the roof off and inserted steel girders to create a studio, and David moved in on his return from Paris. It was a light, airy space and David liked it very much, but nevertheless, he still felt sad in Powis Terrace and, after Christmas in Bradford, he was on the move again.

Gregory Evans was in New York in January 1976, so Hockney joined him there. Sid Felsen of Gemini Press had invited him to do a new series of lithographs in Los Angeles, so he and Gregory decided to spend two weeks driving slowly across the continent. Nothing was booked in advance; they simply consulted their Rand McNally guide-book each afternoon to find a hotel with a good dining room. Some days they had to make do with the most basic facilities (Howard Johnson Motel, New Orleans; Sunday Inn, Houston), but at other times they made exciting discoveries. In Arkansas, they found the Arlington Hotel in Hot Springs, a ghost town that had enjoyed fame as a spa in the twenties. The hotel was a little dilapidated, but had the marvellous atmosphere of a bygone age. Hockney and Gregory enjoyed the steambaths where elderly men in white uniforms pummelled their muscles to relax them after their travels. After dinner they joined the formally-dressed residents for card games. As usual Hockney had his sketch-pads with him, and he made some quite elaborate coloured crayon drawings of the hotel: the terrace with its blue wicker chairs; his suitcase with shirt and tie on the floor of his bedroom.

Another happy surprise was the Biltmore Hotel in Phoenix, Arizona, which had been designed by Frank Lloyd Wright in the twenties. Many brightly-coloured crayon drawings date from their stay here in early February, including a general view of the hotel with palm trees, plus a large blue pot filling the foreground. Three views of the swimming pool concentrate on the reflections of palm trees, red chairs and blue tiles in the water, creating shapes on the surface that recall the experiments of the mid-sixties (see plate 116). There are also pen-and-ink drawings of Gregory in the lounge, at dinner and asleep in bed. Like Mark Lancaster on the Far Eastern tour of 1971, he would often awake to the sound of Hockney's pen as he drew yet another sleeping figure. Hockney would have been out already to buy the newspapers and have some breakfast. Henry Geldzahler has described the experience of travelling with Hockney: 'Like David Smith

and very few other artists I've ever known, David would just get up and start working. If everybody is asleep, he draws them sleeping, and if he's alone, he draws his luggage lying on the floor. He'll work until he drops and then think that he's sick for a day and then he's well again.'[33]

In Los Angeles the couple stayed in a penthouse at the Château Marmont Hotel where Hockney continued to make drawings of Gregory. One of the most unusual from this period shows him in the dentist's chair having a tooth drilled; it seemed impossible for Gregory to escape Hockney's inquisitive eye. He was also the subject of one of the first lithographs in a series entitled 'Friends' produced for Gemini in the spring of 1976.[34] These large two-and-a-half by three-and-a-half feet images were drawn directly onto the stone using traditional techniques; they depicted the subjects, seated full-length, in meticulous detail, recalling the very similar portraits of Celia Birtwell and Ken Tyler which Hockney had made for Gemini in 1973. His other sitters were Joe Macdonald, Mo McDermott, Nick Wilder, Henry Geldzahler and Sid Felsen as well as more recent friends, the actress Brooke Hopper and the film-director Billy Wilder. A further series of smaller head-and-shoulders images included Peter Schlesinger, Don Cribb and the author Michael Crichton, and there was a double portrait of Christopher Isherwood and Don Bachardy which imitated their 1968 painting but reversed their positions, so that this time Don was looking at Christopher. Though pleasant enough, these images of Hockney's friends seem a retrograde step when compared with the experimental graphic work he had undertaken with Crommelynck in Paris in 1973 and 1974, and, in reality, fulfill the roles of academic demonstration pieces. As he told me, 'I did them as exercises, I wasn't that interested in what they would look like. Hardly anyone draws from life any more, hardly anyone can, for that matter. It always improves my work. It's exactly what Picasso and Matisse used to do.'[35]

A further series of 'Friends' drawn for Gemini in early summer 1976 seems to prove Hockney's point, for these lithographs of Henry, Gregory and Maurice Payne are refreshingly loose and free in technique. *Gregory with Gym Socks* and *Gregory Reclining* are spontaneous nude drawings which show a very direct response to his physique. *Henry with Bald Patch* and *Henry with Cigar* are drawn on aluminium plates with a diluted type of lithographic ink known as tusche and show an expressive economy of means inspired by Chinese brush drawings which Hockney had seen a short time before at the British Museum. He described one of them to me at the time: 'It's one of the most beautiful drawings I have ever seen, just simply a snail, but it took my breath away. It's so simple, you can see it's all done at one go. And yet that artist must have known exactly how much ink he needed on his brush. He knew exactly what a snail looks like, and how it moves, and leaves its trail, and that's what he shows us. It's exquisite! Go and look at it!'[36]

The film-director Billy Wilder, whose portrait figured in the 'Friends' series, had been an admirer and collector of Hockney's work for some time before meeting him at a Hollywood dinner party in the early seventies. He told me recently: 'We got along exceedingly well. It would have been a pleasure to meet him even without knowing that he was one of the important artists of our time. He is much better-read than I ever will be, and he knows all about movies and the theatre. He is a great connoisseur of good music. He tells a good joke and is clever at imitations. Any Hollywood hostess is honoured to have him at her party – they fight for him because he brings life. He's become a superstar. He and I talk about everything from movies to politics. The conversation jumps from Mrs Thatcher to Sylvester Stallone in one split-second. I am flattered that he always says *Sunset Boulevard* and *Some Like it Hot* are two of his favourite movies, but we don't usually talk about my movies or his pictures. There's too much else to talk about, but the great thing is he's always interesting, and if he has got nothing to say he just keeps his mouth shut. It's fascinating how a working-class Englishman has become so much a part of our community. If you only have one friend and it is Hockney, you are not lost in this world. So try and make it Hockney!'[37]

Gregory left Los Angeles in March for New York on his way back to Paris. In New York he had a telephone call from Hockney inviting him to visit Australia, and he jumped at the chance. The National Gallery in Melbourne was holding a big exhibition of Hockney's graphic work in April, and it was a good excuse to visit his brothers Philip and John who had settled in Australia. He and Gregory also visited New Zealand and spent a while on the island of Bora Bora north of Tahiti where Hockney made colourful crayon drawings of houses among the exotic flowers and palm trees and took many photographs for his albums. Gregory went on to Paris and Hockney returned to Los Angeles to continue his work for Gemini Press.

In the summer he returned to Arthur Lambert's house on Fire Island. There he made a very detailed crayon drawing of Larry Stanton wearing a colourful baseball jacket. He worked his way down the page from the head but never managed to finish the lower sleeves and hands. He inscribed it 'for Arthur (I'll finish it later) with much love and thanks from David'. Henry Geldzahler and Christopher Isherwood were there, and Stanton filmed Hockney painting small portraits of each of them. Hockney also made two paintings of his bedroom in Lambert's house. Geldzahler had brought a book of poems by Wallace Stevens, and he persuaded Hockney to read the long poem entitled 'The Man with the Blue Guitar' of 1936. Taking as his starting-point Picasso's 1903 painting *The Old Guitarist*, which he saw at the first Picasso museum exhibition in America in 1936, Stevens weaves an allusive and musical text around the theme of the interplay between reality and imagination. Given Hockney's love of Picasso, it is not surprising that he felt drawn to the poem, but his excitement went further: 'I found the

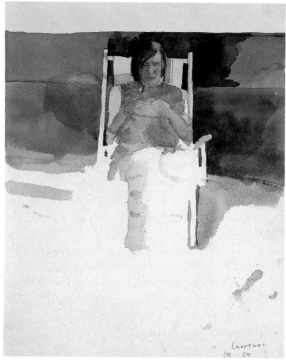

105 *Howard Hodgkin*, 1967

106 *Ianthe Cornwall-Jones*, 1967

107 Hockney with Howard Hodgkin, Carennac 1967

108 Hockney with Patrick Procktor, Carennac 1970

The Château de Carennac, overlooking the river Dordogne in central France, was the scene of many idyllic holidays for Hockney and his friends. They would play *boules* in the garden, swim in the river or visit the open-air markets. Hockney would practise his hobby of photography or play endless games of chess with Patrick Procktor. He tried watercolours, Procktor's favourite technique, for (105) and (106), but was not satisfied and gave his paints to his friend.

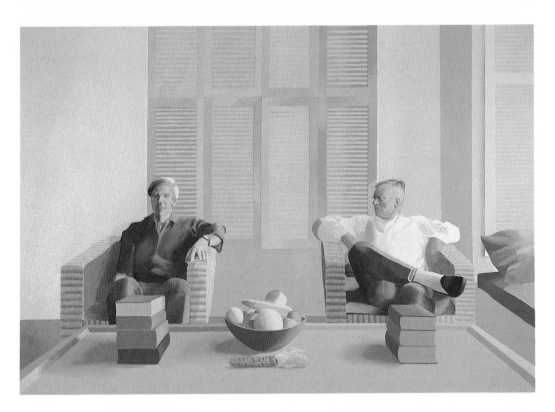

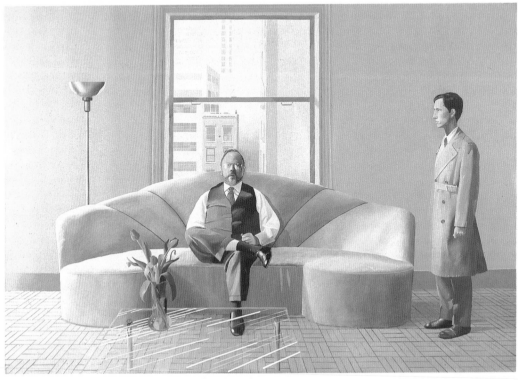

109 *Christopher Isherwood and Don Bachardy, 1968*
110 *Henry Geldzahler and Christopher Scott, 1968/9*

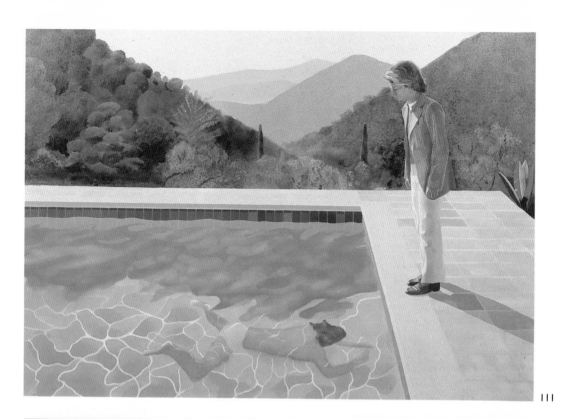

111

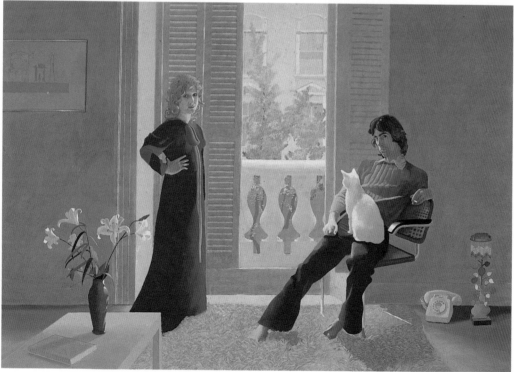

112

111 *Portrait of an Artist (Pool with Two Figures),* 1972
112 *Mr and Mrs Clark and Percy,* 1970/1

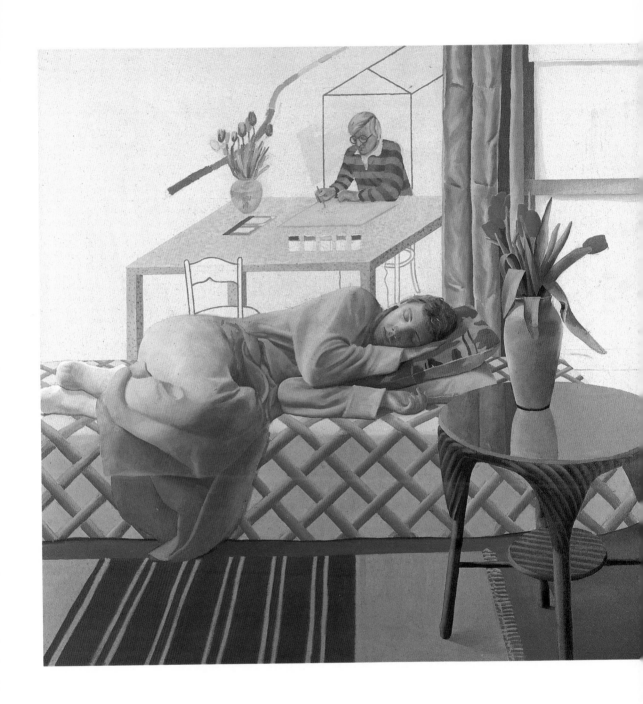

113 *Model with Unfinished Self-Portrait*, 1977

Hockney plays with reality and illusion as he tries to move away from naturalism in this painting of himself with his new lover, Gregory Evans.

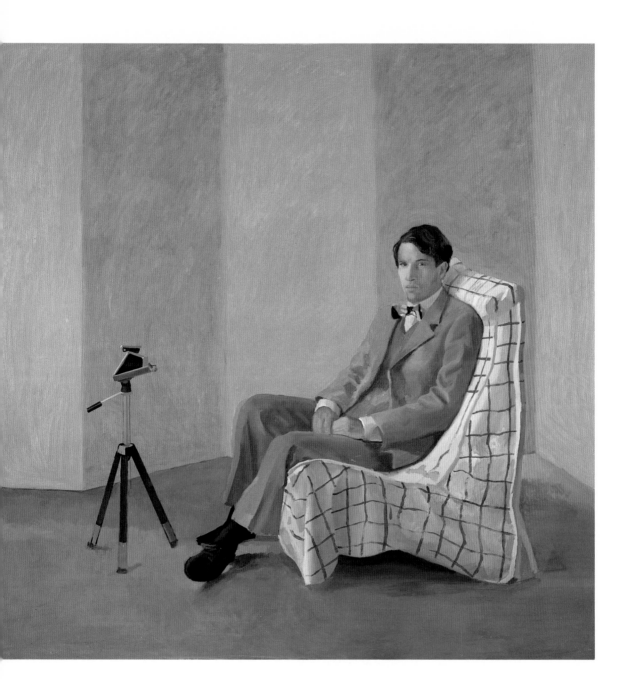

114 *Peter Schlesinger with Polaroid Camera*, 1977

Hockney criticizes a modernist aesthetic which rejects emotional involvement. (114) was an exercise in bold colour but also served to keep him in touch with his former lover, Peter Schlesinger.

115

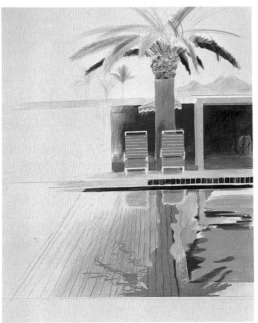

116

115 *Pool with Reflection of Trees and Sky,* 1978
116 *Palm Reflected in Pool, Arizona,* 1976
117 *Divine,* 1979
118 Hockney painting *Mulholland Drive,* 1980

During the later 1970s Hockney's determination to abandon naturalism led him to experiment with expressive colour and simplified form. He often concentrated on the ever-changing reflections in water. His discovery of a new acrylic paint designed for film animation, which produced very intense and vivid colours, enabled him to paint the drag artist Divine and the enormous canvas *Mulholland Drive.*

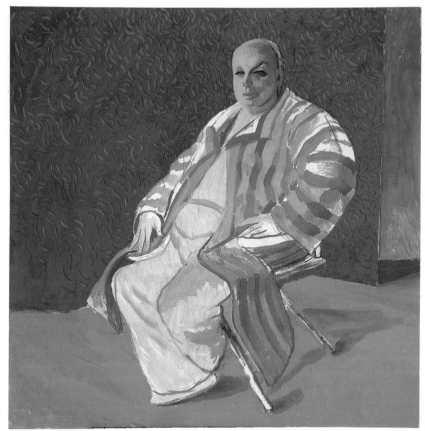

117

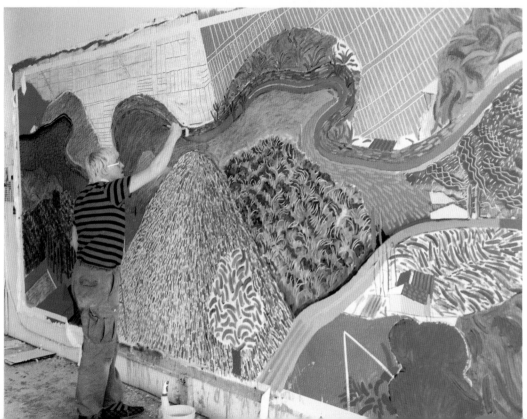

118

119

Harlequin.

120

121

119 *Ravel's Garden with Night Glow*, 1980
120 *Harlequin*, 1980
121 *Punchinello On and Off Stage*, 1980

poem totally inspiring. I got deeply involved in it. When I first read it I wasn't sure what it was about, like all poems like that, but I loved the rhythms in it and some of the imagery, just the choice of words is marvellous.'[38] He read it aloud and savoured the music of the words and began to sense something important: 'It seemed to express something I felt about my own work at the time.'[39] He made a series of ten drawings in coloured inks which showed a great debt to Picasso, including *Things as they are above a Blue Guitar* and *Running Colours with Brick Mountain*. Back in London, he painted some small canvases inspired by the poem, but these proved to be unsatisfactory and he decided to make a set of coloured etchings instead. In this way he could use the new process Crommelynck had taught him, in itself a further link with Picasso.

Stevens' poem opens with a challenge to the guitarist:

> They said, 'You have a blue guitar,
> You do not play things as they are.'
> The man replied, 'Things as they are
> Are changed upon the blue guitar.'

Hockney realized that Stevens was using the guitar as a symbol of the imagination, and so the importance of the artist's freedom of imaginative response to reality and illusion became the theme of his engravings. The full title he gave them was *The Blue Guitar, etchings by David Hockney who was inspired by Wallace Stevens who was inspired by Pablo Picasso*, and they were published both as a portfolio and a book in spring 1977. In his introductory note he says: 'The etchings themselves were not conceived as literal illustrations of the poem but as an interpretation of its themes in visual terms. Like the poem, they are about transformations within art as well as the relation between reality and the imagination, so these are pictures within pictures and different styles of representation juxtaposed and reflected and dissolved within the same frame.' The disparate images are not easy to read as interpretations of the poet's themes, but what holds them together is the continual reference to the example of Picasso. Hockney used Stevens' assertion that all art feeds on art by playing visual games with images taken from Picasso and from the summer drawings. The etching *Figures with Still Life* shows a man measured up for perspective watching a cubist woman playing a mandolin. The man was taken from a photograph of Chico Marx and the woman from a Picasso painting of 1909. Both figures are just as real or unreal as each other. In *Etching is the Subject*, a pen draws Gregory and leaves blobs of ink behind. The pen and the portrait are illusions but the blobs are real. *What is this Picasso?* has a realistic curtain drawn back to reveal a stylized head which copies Picasso's 1937 portrait of Dora Maar. And in *A Picture of Ourselves*, a woman copied from a classical sculpture in a plate from Picasso's 'Vollard

Suite' of 1933 contemplates two images of herself, one a surrealist sculpture from another Vollard plate and the other a bestial image in a mirror derived from Picasso's *Two Nudes on a Beach* of 1937. While not achieving the fluency and consistency of the Cavafy or Grimm etchings, *The Blue Guitar* is nevertheless a fascinating attempt to demonstrate the power of the imagination to question the world of appearances.

In January 1977, while still working on the etchings, Hockney began two large paintings which also relate to the Stevens poem. The first, *Self-Portrait with Blue Guitar*, was not planned but began spontaneously, using images from his recent work. Hockney depicts himself sitting at a table, which is painted in the pointillist style of the Louvre paintings of 1974, at work on *The Blue Guitar*. A vase of tulips is beside him, as is a long blue curtain. He is surrounded by images from his Stevens etchings: the red-and-blue line disappearing in perspective is from *It Picks its Way*, and next to it is the 1937 head of Dora Maar by Picasso which appears in *What is this Picasso?* Like *Invented Man Revealing Still Life* of 1975 which it resembles in many ways, *Self-Portrait with Blue Guitar* shows Hockney moving away from the shortcomings of naturalism and stressing the power of the imagination. In this way it relates directly to the 'Blue Guitar' series of etchings. The second painting, *Model with Unfinished Self-Portrait* (see plate 113), also relates to the etchings, this time in terms of the interplay between reality and illusion. It was planned more deliberately than the *Self-Portrait*, and at first glance appears to represent a figure sleeping on a couch in front of Hockney who works at his table. But the title tells us differently, for the real model is lying in front of the incomplete *Self-Portrait with Blue Guitar*. The model is painted in a naturalistic style contrasting with the artificiality of the canvas behind him, but the point of the game is to demonstrate that no part of the image is real, all is illusion. The point is reinforced in a series of colour photographs which Hockney took in the studio showing the progression of each of the two paintings, complete with model and props.

These two canvases were painted in a studio flat in Pembroke Studios, Kensington, which Hockney had obtained from the Petersburg Press since he did not feel comfortable on the top floor of 17 Powis Terrace. The model was Gregory Evans, who was visiting him at the time from Los Angeles. It was one modelling assignment which he found perfectly congenial, as he told me: 'David would wake me at 8 am, I would then put on his bright-blue dressing-gown, go downstairs to the studio, lie on the couch and go back to sleep again. When I woke up he was very good, he allowed me breaks for cigarettes and tea and we would go out to a pub for lunch. By 4 pm we would have to stop as people would always drop in for tea. We would eat out unless he could persuade me to cook dinner, and he would always sit and look at the painting for some time before coming to bed. The picture seemed to take a long time – when he draws me it is always so quick, and the drawings teach me things about myself I didn't know.'[40] Gregory had to visit Paris

before the painting was completed, and Hockney immediately asked Peter Schlesinger to take his place. Some of his photographs show Peter in the blue dressing-gown lying in front of the painting showing Gregory in the blue dressing-gown lying in front of the painting of Hockney.

The use of Gregory and Peter as models made sense because they were near at hand and also reliable. But the fact that both also played vital roles in Hockney's private life was an important factor. Personal emotion has been a motivating force throughout his career, and he has on various occasions expressed his contempt for a Modernist aesthetic which rejects such involvement. In an interview in the *Guardian* in 1975 he described some of the Tate Gallery's new acquisitions as reminding him of the Emperor's new clothes: 'There were some pieces of sculpture by David Tremlett, just cassettes in rows. It was quite beautiful to look at, but no more so than a record-shop window. And I was stood on the grille on the floor, so I said to Richard Morphet [of the Tate Gallery], "And who did this?" It was just as interesting for the eye . . . and Richard said, "Oh David, you're terrible, you're joking, at times you're almost philistine." And I said, "Well then, what's the difference, tell me what's the difference?" And he said, "That is art because an artist made it," which I thought was a shabby intellectual argument. I mean, anybody can say he's an artist. My mother could say she's an artist, you're not going to exhibit her knitting.'[41]

The January/February 1977 issue of *The New Review* included the text of a conversation between Hockney and Kitaj in which they made a united stand in calling for a return to figurative art in opposition to what they considered the peripheral concerns of Modernism. Hockney and Kitaj had remained close friends since college days when Kitaj had been influential in moving Hockney away from abstraction. Hockney drew him twice at this time, once in coloured crayon, reading a book in his study, a design for the cover of *Studio International* magazine for November 1974, and again in 1975, in pen and ink, sitting on a bench outside the Academy of Arts in Vienna (see plates 128, 130). They had a mutual admiration for each other's talents: Kitaj wrote in 1976: 'Hockney is the most intelligent, thoughtful, meticulous and tireless draughtsman in the world.' This was in the catalogue of an exhibition he arranged and chose for the Arts Council entitled 'The Human Clay', after Auden's phrase which Hockney often quotes, 'To me, Art's subject is the human clay.'[42] It was a polemical exhibition designed to focus attention on figurative art. Kitaj wrote: 'Don't listen to fools who say either that pictures of people can be of no consequence or that painting is finished. There is much to be done . . . No one can promise that a love of mankind will promote a great art, but the need feels saintly, and new, and somehow poetic to me, and we shall see.'[43]

Kitaj's words brought him much criticism, but Hockney applauded them; the conversation printed in *The New Review* reiterated and followed up many of Kitaj's

points. For instance, Hockney said: 'The art of making a picture is not much to do with a lot of Modernist ideas now. They might be "art". I wouldn't even bother going into the arguments. After all, making a picture is a wide enough interest. It's not a narrow specialization by any means. I happen to think most of the other claims for things being art are a little mad . . . And remember this: it is always figures that look at pictures. It's nothing else. There's always a little bit of mirror somewhere. You don't get *Red and Blue Number Three* looking at *Blue and Brown Number Four*.'[44] The case for a return to figurative art was well made, but predictably their stand was misinterpreted: their detractors put them down as irrelevant reactionaries and their supporters claimed them as agents for the destruction of modern art. The greatest controversy, however, centred on the cover of the magazine which, instead of the usual publicity shot, depicted the two artists in the nude, genitals and all. This was the result of a dare from Peter Langan, who invited them to lay themselves bare to the world and to his Polaroid camera. Hockney was highly amused by the row: 'It was amazing, there were objections to it, and all our discussions inside was of how figurative art meant more than abstraction. And there's other people saying 'Oh! you're all wrong,' yet they're complaining about the cover. Our whole point was made. Amazing!'[45]

In April 1977 Hockney went to India with Kasmin, who had always been fascinated by the subcontinent and went there every year, usually with Howard Hodgkin. Hockney had wanted to go ever since his visit with Mark Lancaster on their Far Eastern tour had been prevented by political circumstances. Kasmin and Hockney went as tourists and saw the sights. Amongst the few drawings Hockney made on the trip are a pen-and-ink sketch of Kasmin lying on his bed reading the Udaipur guide-book and a coloured crayon drawing of his own jacket, Panama hat, sketch-book and drawing-case on a chair in his room at the Taj Hotel in Bombay.

Throughout the rest of the year he drew continuously. There are many pen-and-ink drawings of Gregory Evans dated 1977, also of Joe Macdonald, Maurice Payne and, especially, of his mother and father. These related to the painting *My Parents*, the second attempt at this subject. There is an unusual crayon drawing of Wayne Sleep without a head, concentrating instead on his bright red singlet and blue shorts. And there are coloured crayon drawings of Marinka Watts, a friend of Ann Upton, who also modelled for Kitaj. Many of these are nude drawings: apart from Celia Birtwell, Marinka Watts is the only woman Hockney has drawn nude since leaving college. He also made drawings of Peter Schlesinger; Peter had taken Gregory's place for *Model with Unfinished Self-Portrait* and, in the summer, when Hockney moved back from Pembroke Studios to the top floor of Powis Terrace, he began a new five-foot-square painting, *Peter Schlesinger with Polaroid Camera* (see plate 114). Peter is shown sitting in an easy chair

looking directly at the viewer; a camera sits on a tripod beside him. There is a plain bluish background and deeper blue carpet, and Peter wears a purple suit. He spent a week sitting in the chair. Hockney told me at the time that the picture was merely an experiment in bold colour for which Peter happened to be on hand. It seemed to me, however, that the picture was also a convenient way of keeping in touch with Peter, for Hockney clearly still thought a great deal about him, even though they had been separated for nearly six years. Peter was to move to New York for a new life with Eric Boman the following year. The bold colour and sparse setting for the portrait of Peter were characteristic also of *My Parents* which Hockney painted this same summer.

Henry Geldzahler arrived to stay at Powis Terrace in July and Hockney decided to start a painting of him as well. The first idea, as seen in a crayon sketch, was for a scene with bright red-and-white curtains drawn back to reveal him seated and looking at some little pictures on a table. Then Hockney decided to show him standing in profile looking at reproductions of favourite paintings in the National Gallery, hence the title of the six-foot-square painting, *Looking at Pictures on a Screen*. Through the medium of Geldzahler, the spectator is invited to concentrate on the works of four masters of figurative art, Vermeer, Piero della Francesca, Van Gogh and Degas. Thus the picture is in line with Hockney's opinions expressed in the conversation with Kitaj in *The New Review*. He was delighted when the National Gallery chose to exhibit it in 1981 together with the four paintings it reproduces. He wrote a little booklet to accompany the exhibition in which he spoke about his love for these four paintings and the real value of reproductions of great works of art.[46] All four included in the picture are particular favourites, but Piero's *Baptism* is especially important to him and he takes the reproduction with him whenever he moves from one studio to another. He once told me: 'I'd love to own the painting – I'd look at it every day for an hour. The only pictures I have to look at for an hour are my own, and they're not really worth it.'[47]

Van Gogh was becoming more and more significant to him; the warm yellows and oranges of Geldzahler's portrait are proof of this. He had already begun to use strong colour in *Model with Unfinished Self-Portrait*, *Peter Schlesinger with Polaroid Camera* and *My Parents*. Recently he had told me: 'Van Gogh interests me more and more, and I think he gets better the more I look at him. Instead of Cézanne why don't we see Van Gogh as the source of modern art, an art concerned with the figure and with colour) leading on to Matisse and Picasso. You can tell how good Van Gogh is, because his paintings are so familiar and yet you never get bored with them.'[48]

In the summer, the Arts Council's annual exhibition of contemporary British art was held at the Hayward Gallery in London. The organizers were Michael Compton of the Tate Gallery, the painter Howard Hodgkin and the sculptor William Turnbull. The

artists whose work was on show included Peter Blake, Ron Kitaj, Howard Hodgkin, Stuart Brisley, Bob Law and Hockney. Each artist had a little room of his own. Hockney's paintings were *My Parents*, *Self-Portrait with the Blue Guitar*, and *Model with Unfinished Self-Portrait*. The television pundit Fyfe Robertson made a programme for the BBC about the exhibition from the point of view of the man in the street and, in view of the remarks in *The New Review*, he invited Hockney to join him. The two men were shown walking through the Hayward Gallery commenting on the exhibits. When Robertson made cruel jokes about Bob Law's plain black abstracts and Stuart Brisley's dangerous performance pieces, Hockney concurred in belittling these as artistic achievements. Robertson had a large personal following and the programme was watched by millions of people who agreed with his views. As a result, the Arts Council was pilloried for putting on such a show, and a public forum was held in the Hayward Gallery in the presence of Compton, Robertson and Hockney. Crowds poured in and the discussion had to be relayed to those outside. Compton made a blistering attack on Robertson, who left the gallery in tears; the painter John Hoyland strongly criticized Hockney's role in the affair, and many other people accused him of philistinism. He defended his position but it was clear that certain members of the art community could only accept his criticisms in a serious journal and not on a popular television programme.

Hockney continued his attack in an interview with the critic Peter Fuller which was published in *Art Monthly*: 'People want meaning in life. That's a desperate need, and images can help . . . Unfortunately, there is within modern art a contempt for people. You can read it in criticism now: the idea that ordinary people are ignorant, art isn't for them, you need a visually sophisticated group etc. This is all hogwash as far as I am concerned. That's why the Arts Council is devoted to certain kinds of art; they see it as a continuous struggle. They'll accuse Fyfe Robertson of philistinism, and shelter behind that – which is cheap. I think he has to be answered: there's a real case there.'[49] Remarks like these caused many people in the art world to consider that Hockney, who in this year of 1977 had reached the age of forty, had undergone the transition from bright young star of the avant-garde to middle-aged reactionary. Part of the problem was that he was becoming more and more popular as an artist, with the general public as well as among those with a particular interest in art, and popularity in the art world usually brings mistrust. He was quite clear in his own mind then, and indeed has remained so ever since, about the real value of popularity: 'I do want to make a picture that has meaning for a lot of people. I think the idea of making pictures for twenty-five people in the art world is crazy and ridiculous. It should be stopped; in some way it should be pointed out that it can't go on.'[50]

In August Hockney and Gregory went to Balme to stay with Jane Kasmin, who was

spending her last summer there with her sons Paul and Aaron and Howard Hodgkin's son Sam before Kasmin sold the house. Hockney made a trip to Albi to see the Toulouse-Lautrec Museum for the first time. On his return he painted pastel portraits of Paul and Aaron, but he decided they were too 'chocolate-boxy' and so tore them up. Most of the time he spent in the garden listening to Mozart's *The Magic Flute* which he played on his car stereo, since there was no tape player at the house. At the first night of *The Rake's Progress*, John Cox had invited him to design his 1978 production of the Mozart opera, and he had finally accepted. Hockney would lie on the grass trying to follow the score, in spite of the fact that he could not read a note of music.

CHAPTER NINE

NEW YORK AND LOS ANGELES 1977–1980

After their French holiday, when Gregory Evans left to stay with a friend in Spain for four months, Hockney felt he could not face the autumn alone at Powis Terrace. He decided to travel to New York, where he rented an apartment at 30 Sutton Place South, and here he worked on his designs for *The Magic Flute* with Maurice Payne. He was thus on hand for the opening at the Emmerich Gallery in October of his exhibition of recent work which included *My Parents, Self-Portrait with Blue Guitar, Model with Unfinished Self-Portrait* and *Looking at Pictures on a Screen* (which he had finished on arrival in New York), as well as drawings of his parents, Maurice Payne, Marinka Watts, and *Wayne's Singlet*, and the *Blue Guitar* etchings. It was his first New York show since 1972, and the first to be organized by Nathan Kolodner, who has handled his work and generally looked after his professional concerns ever since. The show was an enormous success with buyers and the public, and everything sold. Most critics were enthusiastic, although Hilton Kramer of the *New York Times*, while conceding that the work was entertaining, clever, accomplished, versatile, prolific and impressive, nevertheless judged it hollow, superficial, reactionary and lightweight: 'a kind of nineteenth-century salon art refurbished from the stock room of modernism.'[1]

At Balme, Hockney had listened for hours on end to the music of *The Magic Flute* because it was the music that attracted him to the opera, unlike *The Rake's Progress*, to which he had been drawn by Auden's and Kallman's libretto. But, whereas the Stravinsky led him quickly to Hogarth, Mozart's opera provided no such easy solution. From Schinkel in the nineteenth century to Chagall and Kokoschka in more recent times, great designers have been inspired by Mozart's music to interpret the rather confusing libretto of Schikaneder. This they have done in very personal ways. Hockney took his cue from the purity of the music, which he felt could best be captured with designs 'in focus, no haze, not too many shadows, reduce chiaroscuro.'[2] He realized that since the opera was made up of many very short scenes, the changes would need to be quick. He decided that flat painted scenery was more practicable than three-dimensional sets. He saw *The Magic Flute* as a journey from darkness to light as the lovers, Tamino and Pamina, endure various trials and tribulations with the help of the bird-catcher Papageno before gaining spiritual enlightenment.

The opera was written, as popular entertainment, at the end of the eighteenth century;

it was set in ancient Egypt, which was seen in a very naïve manner. Hockney therefore decided to use imagery from a variety of sources and periods to evoke a simplified and imaginative Egypt (see plates 141, 142, 143). On the one hand, he used his own observations from his journey to Egypt in 1963, referring directly to his painting *Great Pyramid at Giza with Broken Head from Thebes,* as well as a visit in early 1978 to refresh his memory which resulted in crayon drawings and a painting entitled *Café in Luxor.* On the other hand, he took inspiration from the Renaissance view of Egypt in early Italian paintings. The mountainous landscape of the opening scene is strongly indebted to Giotto's *Flight into Egypt* at Padua, and the monster that attacks Tamino is a variant of the one depicted in Uccello's *St George and the Dragon.* The Egyptian collection at New York's Metropolitan Museum provided him with the pair of seated, jackal-headed deities that appear in one scene, and the museum's monumental staircase was used for the very dramatic great hall. Hockney painted his brightly coloured designs in gouache for his large model of the Glyndebourne stage on a scale of one to twelve, creating no fewer than thirteen different sets. He found that by cutting openings in the drops he could achieve the illusion of depth. Thus the great staircase is flanked by columns in the foreground and opens on to the sky at the back; yet only a few feet separate each drop.

Owing to other commitments John Cox was not able to view Hockney's designs or discuss the ideas behind them until comparatively late. He was very impressed with Hockney's research into eighteenth-century Egyptology, Masonic rituals and traditional pantomime, but he saw great problems in transferring the designs to Glyndebourne's stage. For one thing, there were only thirty-six drops available; Hockney needed more. The scenery for *The Marriage of Figaro* would have to be stored at the back of the stage at the same time as the sets for *The Magic Flute.* And, since painted flats had long gone out of fashion, there would be great difficulties to be overcome in successfully lighting Hockney's designs. There were also disagreements over the costume designs, which Hockney himself did not consider satisfactory. However, the problems were eventually solved after many long rehearsals. Norman Stevens sat in on one, and was horrified to hear John Cox complaining about Hockney's shortcomings. Hockney had later to explain to him that, in the theatre, the director is boss of his team.

I remember travelling down to Glyndebourne for one of the rehearsals in May. We had lunch in the staff canteen where no one seemed to find it strange that Hockney was wearing a cream-coloured suit, red and white football shirt, bedroom slippers with odd socks, and white flat cap. He was very happy with the results of listening to Mozart's glorious music for nine months, even though his fee of £1,400 seemed to him a little ungenerous. He had enjoyed the experience much more than working on *The Rake's Progress,* where he had not found the music very inspiring: 'I think I've been able to capture the elements of fantasy and humour in Mozart's music, and some knowledge of

Egypt has certainly helped. But we have had to spend a long time on the lighting – I suppose if I'd been trained in this work I'd have known how difficult it was going to be to light my designs. But in that case I would probably not have dared to be quite so adventurous. The only advantage would have been to know the short-cuts. One thing I feel sure of is that the experience of working with such bold colours and simple, clear-cut designs is going to affect my painting when I go back to California after the opera is finished.'[3]

The Magic Flute offers any designer the opportunity for stunning *coups de théâtre*, and Hockney rose to the occasion. In Act I the appearance of the evil Queen of the Night is announced with a crescendo and a clap of thunder; Hockney's Giotto-inspired boulder opens on the darkened stage to reveal the Queen in front of a star-studded black sky which is lit so that the mountains, on their gauze backdrop, are made invisible. The lighting of Act II symbolizes the progression from the darkness of superstition to the blazing glory of enlightenment. Hockney's ideas for the trials by fire and water were especially brilliant: his stylized, flickering tongues of flame and splashing waterfalls (the latter taken from a menthol cigarette advertisement) looked very convincing, under his careful lighting, as Tamino and Pamina walked behind the fire and the water. Changing the sets in a matter of twenty-five seconds for these very short scenes was an astonishing feat (on the part of the stage-hands). When the lovers, with the help of the magic flute, survive the trials and reach a higher level of life in Sarastro's priestly order, the stage is transformed into a radiating sunburst which concludes the opera on a stunning visual note.

John Cox found this second collaboration with Hockney exhilarating but also a little frustrating. He later told me: 'We were able to meet less often, which didn't help. The result was probably less satisfactory in theatrical terms than *The Rake's Progress*, in spite of the beauty of David's pictures. The main problem was that the small scale of Glyndebourne's stage frustrated many plans for the technical realization of the designs, and the modern lighting was not able to cope too well with such traditional backdrops. The costumes were a curious hybrid of styles and in the wrong fabrics, because David did them after the model with his designs had gone to the scene-painters. It's ironic that the whole production worked better when we took it to La Scala, Milan, where the enormous stage and more sophisticated lighting enabled the dramatic purpose of David's designs to be more successfully realized. *The Magic Flute* is a multifarious work, and David was absolutely right to decide that the only unity you can give it is the unity of diversity.'[4]

Press reaction to the Glyndebourne production of *The Magic Flute* was highly favourable. In the *Guardian*, Philip Hope-Wallace described it as 'one of the most successful and strikingly different I could ever have imagined . . . the real champion of the evening is David Hockney who in scene after scene catches the true pictorial effect

wanted by this piece.'[5] And Robert Henderson in the *Daily Telegraph* recounted how 'time and time again . . . a spontaneous burst of applause greeted the magical sequence of stage designs created by David Hockney. Irritating as such applause can often be, momentarily masking the music, it was justified, an instinctive response to a brilliantly devised series of stage pictures that are not only fascinating in themselves, but which precisely reflect the intermingling of ceremony and pantomime from which the opera derives its unique spirit.'[6]

Hockney had decided that, once *The Magic Flute* was finished, he would return to America. He had had enough of England. He hated the drinking laws and the lack of sunshine. His recent experiences as a critic of much modern art had led him to decide that the English people were 'visually ignorant, unaware and philistine'.[7] And he had been stung by a few criticisms of his *Magic Flute* designs: that they were pastiches of Art Deco or self-indulgent references to his own earlier works.[8] He put his top-floor flat at Powis Terrace on the market, thus severing a link which went back to his arrival in the tiny, first-floor flat downstairs in 1962. He kept Pembroke Studios as a *pied-à-terre* where he could work during visits to London but, essentially, he had made the decision to move to Los Angeles. When he discovered that he had lost his driving licence and would therefore be unable to drive in the city of automobiles, he decided to break his journey to California in New York and stay with Henry Geldzahler and Arthur Lambert, in the house they had bought on West 9th Street while awaiting the arrival of a new licence. He reached New York in August. Ken Tyler, with whom he had worked successfully on lithographs at Gemini in Los Angeles, had moved to Bedford Village, just outside New York, and had often asked him to go and make some prints in his new workshop. He had even sent Hockney a bronze apple to remind him of New York. Hockney drove out to see him, to explain that he was on his way to paint alone for two years in Los Angeles after all his theatre collaborations. Ken took the opportunity to show him some recent works made with paper pulp by Kenneth Noland and Ellsworth Kelly; Hockney had to agree that they were 'stunningly beautiful'.[9] He allowed himself to be persuaded to stay for three days to try out the new technique; as a result he spent forty-five days with Ken Tyler.

Ken knew that once he had caught Hockney's attention he could keep him in Bedford Village: he cannot resist innovation: 'I love new mediums and this was something I had never seen or used before. I think mediums can turn you on, they can excite you: they always let you do something in a different way, or if you are forced to simplify it, to make it bold because it is too finicky. I like that.'[10] The process involves pouring liquid coloured-paper pulp into metal moulds and, later, putting the resulting design into a high pressure hydraulic press, thus producing a unique image which is not a coloured surface but part of the actual fabric of the paper. As Hockney had immediately realized, this involved abandoning careful drawing in favour of bold colour and simplified design. His

recent work for *The Magic Flute* stood him in good stead as he made his first experiments. He tried a series of 'Sunflowers' in honour of Van Gogh. Then he had the brilliant idea of concentrating on water. The process itself was a messy one, involving buckets of water and rubber aprons. In Ken's swimming pool he had a perfect subject for the new technique near at hand. He took dozens of Polaroid colour photographs of the water surface at different times of day and in differing weather conditions, sometimes with Gregory Evans diving in or swimming underwater, and these resulted in a series of twenty-nine 'Paper Pools' dating from August to October 1978 (see plate 115).

The 'Paper Pools' show a diversity extraordinary in such a seemingly limited project. There are basically three views of the pool with diving-board, plus one showing just the steps leading into the water, and three different images of Gregory in the pool. The diversity comes from the treatment of each image, with changes in time of day, weather effects and even the season. Hockney loved the physical involvement with his materials, kneading the pulp so as to create startling colour effects with an almost sensuous tactile quality in the finished product. Like Claude Monet at Giverny, he was able to analyse changing light-patterns on water, following on from the experiments he had made in a more traditional manner in his early Californian paintings. And like Matisse's late *papiers collés*, many of Hockney's 'Paper Pools' approach abstraction in their boldness of colour and simplicity of design. The basic format is six panels mounted together, making an image measuring six-foot by seven-foot. The three 'Divers', which show Gregory making a splash as he goes under the water, have twelve panels and are fifteen feet long. In scale as well as design, they inevitably recall Monet and Matisse, and it is a mark of Hockney's achievement that they would not look out of place with comparable examples by either.

There were long periods during the making of 'Paper Pools' when Hockney was not involved, so he drew Ken Tyler and his assistant, Lindsay Green, at their work. Ken had suggested Hockney take photographs of the process, but he had replied: 'If Van Gogh were here he'd draw [you],'[11] and the drawings were made in reed pen, echoing the boldness of the paper pulp process and responding to Van Gogh's own drawing style. Hockney had already tried this technique in a moving image of his mother drawn on 18 February 1978. His father had just died after a short period in hospital, and the drawing captures the bleakness of the moment in a very direct manner.

In retrospect, Hockney was delighted he had been seduced by Ken into staying at Bedford Village: 'Working with someone who has an awful lot of energy is very thrilling. With Ken Tyler nothing was impossible. If I said, could we, he said, yes, yes, yes it can be done. Now I'm going to paint all about figures; I'm not going to paint about swimming pools; I've done enough now.'[12]

He was now determined to continue his journey to California and concentrate on

painting. He was momentarily tempted by the arrival in New York of John Cox with the suggestion that they collaborate once more, this time on Rossini's *Barber of Seville* for Glyndebourne; he made some preliminary studies before rejecting the plan. So, in October, he finally reached Los Angeles. He had made an agreement whereby Maurice Payne became his full-time studio assistant once he left London in August; Maurice had rented a house for him on Miller Drive above Sunset Boulevard in Hollywood as well as a studio in an abandoned furniture store on Santa Monica Boulevard. Since then Maurice had been kicking his heels, waiting for Hockney to finish 'Paper Pools' and reach California. Hockney's intention had been to concentrate for a period on painting, and after the detour to Ken Tyler's workshop he was more determined than ever. When he arrived, he settled into the apartment and felt pleased to be back in Los Angeles. Besides Maurice, Mo McDermott and his wife Lisa had come to live there as well. Nick Wilder, Christopher Isherwood and Don Bachardy, Betty Freeman, Billy Wilder, Jack Larson and Jim Bridges were all in town, and he spent time with all of them. But the last time he had lived in Los Angeles he had been with Peter Schlesinger. Now he was alone; Gregory Evans had stayed behind in New York.

In the new studio, he started work on an enormous canvas, twenty feet wide, which Maurice had stretched and primed. The intention was to create an image of Los Angeles street life to signal his return. He walked up and down Santa Monica Boulevard, taking candid photographs with his miniature Pentax Auto 110 camera which enabled him to catch people unawares. He also drove around the neighbouring streets, which convinced him that a project such as he had in mind dictated a very large canvas. He told me: 'It's not like Europe where the buildings are made to be seen on foot. Here in Los Angeles, the architecture is all designed to be looked at from a car moving at fifteen miles per hour.[13] He made various coloured crayon and acrylic studies of the buildings opposite his studio, concentrating on a car-lot with its colourful bunting; these gave him the background for his painting which he called *Santa Monica Boulevard*. Various people are seen on the street, in front of a car-lot with a bright red car for sale under the bunting, a very plain shop with blue blinds covering its large windows, and the entrance to an apartment. A bronzed young man, in tight shorts, leans against a lamp-post; a man in blue jeans and a T-shirt lounges in a doorway, and another man hitches a lift. All three would be immediately recognized in Los Angeles as male hustlers. Two women with shopping bags walk past the car showroom by a palm tree. A delivery van is parked at the end of the buildings. It is, in fact, a typical Los Angeles street scene; it also represents Hockney's first multi-figure composition. He stuck photographs of passers-by to the canvas and worked directly from these as well as from friends such as Don Cribb whom he posed in the studio. This method of working seemed to him the only way of maintaining control of such a large composition, but it created a stiff and rather lifeless image which he finally

abandoned two years later. He seemed to have forgotten the freedom of *The Magic Flute* and 'Paper Pools'; he was trying to paint in a manner which he had outgrown.

In one way, however, *Santa Monica Boulevard* looks forward. Hockney had discovered a new variety of acrylic paint (designed for film animation) whose colours were more intense and vivid. The range of blues and reds in the painting show his delight in the new possibilities this suggested. Another picture of late 1978, *Japanese House and Tree*, is almost abstract in its simplified image of the architecture painted in these new acrylic colours, and the tree and the clouds in the sky are formed simply by curving strokes of paint. This attempt at using abstract colour is seen at its most radical in a small canvas which he eventually called *Experimental Canyon Painting*. Begun as a test of the new acrylic colours, this shows what Hockney called 'French marks', lines and arabesques of colour that recall early Fauvist paintings by Matisse and Dufy, as well as suggestions of Kandinsky and Mondrian abstractions.

In February 1979, Hockney returned to London for the exhibition of his 'Paper Pools'. He had first shown them at the Emmerich Gallery in New York, and since he had not exhibited in London for eight years he decided that the only other exhibition of the complete set would be in London. Kasmin had opened another gallery in Bond Street, but it was far too small for these images, so Hockney approached Vera Russell, whom he had previously depicted in *Homage to Michelangelo*. She had been running the Artists' Market for seven years in Covent Garden's Warehouse Gallery, a kind of artists' co-operative where original work sold for very reasonable prices. Vera had just heard that the rent was to be increased to £8,000 a year, and the Arts Council had turned down her request for a £27,000 a year grant on the grounds that it was a commercial gallery. Therefore she had reluctantly decided to close the Market. Hockney was very sad to hear this, as he greatly admired Vera's efforts to make original art affordable to the less well-off, so he offered her his 'Paper Pools' as her closing show. It was a memorable event. The pictures looked stunning when hung together in the large spaces of the gallery, and attendance figures were excellent. Collectors and dealers flew in from America and the continent with their cheque books ready, and all the pictures sold rapidly. The critics were intrigued by his new technique and very impressed by his achievement.

At this time the Tate Gallery still possessed only two examples of Hockney's work, *The First Marriage* of 1963 and *Mr and Mrs Clark and Percy* of 1971. They were offered one of the double-sized 'Paper Pools' showing Gregory Evans diving into the water for £6000, but they were not interested, so it went to Bradford City Art Gallery instead. In 1968 Kasmin had offered the Tate *The Room, Tarzana* and *A Bigger Splash* for £800 each and, in 1969, *Christopher Isherwood and Don Bacardy* for £1,200. All were turned down.

They finally bought *A Bigger Splash* fifteen years later for £60,000. *Christopher Isherwood and Don Bachardy* was sold in New York in 1985 for $570,000 and *The Room, Tarzana* was sold at Christie's in London for £286,000 in December 1987. Hockney felt, with justification, that the two Tate holdings were hardly representative of nearly twenty years' work. He knew that his portrait of Ossie and Celia was one of the Tate's most popular pictures. So he did a little research into the Tate's acquisitions policy while he was in London. He discovered that, in 1970, they were given thirteen works by William Turnbull and then bought three more. He also found that they had been buying works by Robyn Denny regularly, and owned sixteen by 1979. In fact, modern British abstract art was clearly much in favour with the Director, Norman Reid, whereas figurative artists such as Kitaj, Uglow, Lowry, Jones, Procktor, Phillips and Oxtoby were not thought to be of real interest. So he determined to make a public attack on the Tate's acquisitions policy.

On 4 March 1979, the *Observer* published an article entitled: '"No Joy at the Tate" by David Hockney – one of our leading painters talks candidly to Miriam Gross about official British attitudes to modern art.' Hockney criticized Reid's concern with buying British abstract rather than figurative art and the secrecy which surrounded all such decisions. He also pointed out that the collection which so proudly displayed Carl André's *Bricks* contained no single example of American realist art of the twentieth century; yet Reid had recently turned down the offer of a painting by Edward Hopper. He declared his conviction that 'art can be full of joy', and went on, 'my criticism of the Tate's present attitude is that it is so narrow, so biased in favour of joyless and soulless and theoretical art. In taking this narrow view, they are also being extremely arrogant. It is a view they are trying to impose on the public. They are saying this is what art has been like in this country for the past fifteen years. This is what is significant and we are going to tell you about it. But it is not Norman Reid's job to decide what is "significant". That is something which will be decided in the future . . . We do not know who the true avant-garde are in 1979. That will be clear in the year 2000.' Hockney had been to see Reid and had been profoundly depressed by the experience. He told me at the time that he found him a mean-spirited man with no real feeling for paintings of the visible world. He felt Reid was a weakling who was not adequate for the job, and yet he had been Director for sixteen years, having beaten a much better candidate, Professor Lawrence Gowing of the Slade School of Art, who had been considered too unconventional. Hockney recalled with gusto how one day, when the Slade had no model, Gowing stripped off and posed for the students himself. He could not see Reid doing that.

In the interests of fairness, the following week the *Observer* published Reid's reply to Hockney's criticisms. It was immediately clear that Reid had seen the article as a personal attack: 'I am glad that I announced my intention some months ago to leave the Tate at the

end of this year, or it might have been thought that David Hockney's whiff of grapeshot had finally done the trick.' He pointed out that his policy was, within the financial restraints imposed on him, to buy works of quality, which over sixteen years had included examples by Gainsborough, Stubbs, Brancusi, Léger, Mondrian, Braque, Dali, Ernst and Malevich. He had also bought contemporary British figurative art by Bacon, Freud, Kitaj and Coldstream but admitted that '[my] taste and predilections shape the collection, and it may well be that during the last fifteen years my particular love of abstract art has placed the main growth there . . . I feel sure that the intensity of experience offered by a collection built up along lines of personal conviction is a benefit which outweighs the advantages a purely representative collection would give.' The two articles attracted considerable attention and controversy. Needless to say, Hockney was not impressed with Reid's reply. He has a suspicion that his views were taken into account when Professor Alan Bowness was chosen to succeed Norman Reid. Bowness has a feeling for figurative art and has been responsible for adding Hockney's *Man Taking Shower in Beverly Hills* (1964), *A Bigger Splash* (1967) and *My Parents* (1977) to the Tate's collection.

On the way back to Los Angeles, Hockney stopped once more at Ken Tyler's studio outside New York, where he completed a series of coloured lithographs of a diving-board and swimming pool which he had started while making 'Paper Pools' the year before. He also produced an astonishingly free print of swimmers in a pool entitled *Afternoon Swimming*, and very animated lithographs on aluminium of Joe Macdonald, Henry Geldzahler, Ann Upton, and Byron Upton her son.[14] These images all have a spontaneity which goes far beyond the tight academic precision of the 'Friends' series of 1976.

Back in Los Angeles, he began a period of intense activity. In April and May he made a series of lithographs at Gemini which depict Celia Birtwell and Ann Upton. These ten images show the influence of School of Paris print-makers such as Bonnard, Vuillard and Toulouse-Lautrec (the intimate scenes of Ann combing her hair and putting on lipstick) and Matisse and Dufy (the images of Celia amused, inquiring, elegant and weary). There is a real freedom of technique here, and in the extra image of Jerry Sohn. Jerry was a friend of Alexis Vidal and had just returned from Paris to work for Sam Francis. He greatly admired Hockney's work and had written offering his services as studio assistant. Hockney was so pleased to hear from a stranger who wanted to do something for him, rather than the other way round, that he gave him a job. Maurice Payne was not finding it easy to run Hockney's studio and organize his business affairs. They tended to argue until, finally, Hockney told him: 'Your ego is as big as mine. It's time we parted.'[15] Maurice left for New York, where he later worked for Jasper Johns, Jim Dine, Claes

Oldenburg, Roy Lichtenstein and Francesco Clemente. But Hockney and he have remained on close terms and have continued to work together from time to time.

In April, Hockney began a long series of paintings, over twenty, on small and medium-sized canvases, which were to occupy him for the rest of the year and into 1980. *Santa Monica Boulevard* was still unfinished in his studio, but now he was more interested in the new pictures. Colour was his main preoccupation, following on from 'Paper Pools' and his discovery of the new acrylic paints. And he made a further study of the works of Van Gogh. In late April he flew to Amsterdam to record a short talk on Van Gogh's *Café at Night* for the BBC television series *One Hundred Great Paintings*; he even considered visiting Arles in the south of France to look for the café until he discovered that it no longer existed. In a long and interesting interview at the time with Charles Ingham, a post-graduate student at the University of Essex, he said that *Santa Monica Boulevard* was the beginning of a new phase for him for, like Rembrandt and Titian, his work would get looser as he grew older. Looseness of technique and speed of execution were, he felt, signs of confidence: 'I now realize sometimes I've been labouring over things, therefore not being expressive enough . . . The drawings rarely get laboured because they're always done with some speed. And I think they're fresher than the paintings. Although it's harder to paint. Now, what I always longed to do was to be able to paint like I can draw; most artists would tell you that, they would all like to paint like they can draw. But in California I'm beginning to find the way.'[16]

Two of the first paintings in the new series are of Ann Upton. One is a double portrait with her teenage son Byron, who was tragically killed in an accident on the London underground a year or two later. The second shows her looking into a mirror and combing her hair. The painting is a vivid splash of green and blue, set off by the bright pink of the box on which the mirror sits. On the table next to the mirror is a vase of red, white and yellow gladioli, and on the wall to Anne's right can be seen part of the unfinished *Canyon Painting* with its abstract brushstrokes. However, Hockney was not happy with this painting and, in order to create a tighter, more compact composition, he fixed two lines of masking tape on either side of Ann and asked Jerry Sohn to trim the canvas into three parts. The central section was later sold as *Ann Upton Combing her Hair*, and this five-foot by two-and-a-half foot canvas is very similar in composition to one of the lithographs of the same date, *A Lot More of Ann Combing her Hair*. The original form of the painting can be seen in photographs taken in Hockney's studio in April 1979, where it stands next to a painting of Peter Schlesinger sitting beside a table and reaching for a bottle and a glass.

This picture of Peter has never left the studio and is untitled. The figure of Peter recalls Van Gogh's drawings of a peasant at a table at St Rémy dating from 1889,[17] and the painting uses strong yellows, which immediately suggests that Hockney had Van Gogh

in mind. Peter recalls that Hockney asked him to pose for him once again when he was visiting his parents in April 1979. 'The bottle and the glass were empty.'[18] Hockney does not allow the picture to be reproduced or exhibited; when I asked him about it, he merely replied: 'It's rather sad, that picture.'[19] It is the last image he has made of the great love of his life.

Among other paintings produced during this period in 1979 are small portraits of Paul Cornwall-Jones, Vera Russell, Ken Tyler, David's brother Paul, and David's doctor Leon Banks, as well as a larger unfinished image of Kasmin seated at a table, entitled *Kas reading 'Professor Seagull'*. The latter is painted on archival cardboard, and the free handling of the paint is expressive in the Van Gogh manner. A double portrait of Henry Geldzahler and his new lover, Raymond Foye, relaxing in a corner of the studio, is also painted very freely on cardboard. A five-foot-square canvas of the same couple, entitled *The Conversation*, is modelled entirely in terms of colour. Henry wears a red T-shirt and dark blue trousers, Raymond has a bright blue shirt with yellow tie and pink jeans, and they are shown against a dark green carpet and a folding screen in shades of yellow. Another colourful double portrait was painted of Yves-Marie Hervé from Paris and his friend Johnny Reinhold, a diamond dealer and cousin of Henry Geldzahler. Yves-Marie was shown standing to the left of the picture, looking at Johnny who was seated to the right. A large fern stood between them. This painting caused Hockney a great deal of trouble. He first painted out the fern, though clear traces of it were left visible, and then he once more resorted to cutting the canvas. The left-hand side was later sold as *A Boy Named Yves-Marie*; the image of Reinhold has remained in Hockney's studio.

In the summer of 1979, Don Bachardy was drawing Divine, the drag artist and star of the cult underground films made by John Waters including *Pink Flamingos* and *Female Trouble*. Divine told Don of his great desire to meet Hockney, and so Don took him to his studio. Divine and Hockney became good friends. They enjoyed each other's sense of humour, and Hockney was delighted to find someone new and exciting to paint. He produced two canvases of Divine seated in the studio, one of which was never completed. The other painting shows the drag star wearing white trousers and a long pink and blue striped jacket (see plate 117). Don visited the studio while it was being painted and found Hockney rather exasperated as Divine had fallen asleep after smoking a joint. In fact this was a daily occurrence and Hockney found the only solution was to provide endless plates of hash brown potatoes to keep Divine awake. His picture is one of the most successful in this series, and the expressive and spontaneous brushwork recalls Hockney's remark about wanting to paint in the same way that he can draw. There is a real saturation of colour, the whole being based on a range of reds and blues set against the white of the trousers. The stripes of the jacket and the background of deep blue with pink 'French

marks' gives the painting a surface patterning which clearly owes a great deal to the example of Matisse, although the image is also indebted to Van Gogh's seated portraits of 1888 such as *The Zouave, Postman Roulin* and, especially, *Madame Roulin* with its decorative background.[20]

In 1981, the art critic Gene Baro, who had been an early supporter of Hockney's work, included *Divine* in the prestigious Carnegie Institute International Exhibition at Pittsburgh. The President of the Institute was Richard Mellon Scaife, a famous art collector and a supporter of right-wing politicians such as Richard Nixon. He walked through the show with Baro and, to everyone's astonishment, he chose the Hockney painting as his favourite. He then bought it and presented it to the Institute as a gift.

Divine was Hockney's contribution to an exhibition of current British art at the L.A. Louver Gallery in Venice, a borough of Los Angeles, in October 1979. The Director, Peter Goulds, was British and had been friendly with Hockney since opening his gallery in 1976. Nick Wilder had decided he would close his gallery at the end of 1979, and Peter Goulds was in the process of taking his place as Hockney's Californian dealer. This was the fulfilment of a dream which had started when, as a student of mine, he had sat entranced through Hockney's lecture at Coventry College of Art in early 1970. The October exhibition included works by Bacon, Kitaj, Freud, Blake and Hodgkin, with the emphasis very strongly on figurative art. Peter Blake and Howard Hodgkin decided to travel to Los Angeles for the show, and Hockney invited them to stay with him. He had recently moved to a house on Montcalm Avenue up in the Hollywood hills which, as a matter of course, had its own swimming pool. Peter and Howard spent happy hours soaking up the sun by the pool, and each drew the other in the house and in the garden. Hockney did three wash drawings of Peter, and Peter made a drawing of breakfast cereal packets by a bookcase displaying books on Picasso and Balthus. He inscribed it 'First morning in L.A. at David Hockney's house – hangover – the pen is drawing by itself. Howard and David are at the bank. Los Angeles. Oct. 23rd '79. Peter Blake'. He also started a painting of the three friends when he returned to England, which became *The Meeting, or 'Have a nice day, Mr. Hockney'* (see plate 146), based on Courbet's *Bonjour, Monsieur Courbet*. Peter and Howard are shown greeting Hockney on the beach promenade at Venice, against a background of roller-skaters and palm trees. Howard also later made *David Hockney in Hollywood*, an oil painting, and *David's Pool*, an etching, colourful abstract images which were inspired by the visit. Each had painted Hockney previously. Howard's *David Hockney drawing* (1968–70) is an oil painting on wood in which Hockney's blonde hair marks him out from the abstract design. Peter began *Portrait of David Hockney in a Hollywood-Spanish Interior* in 1965 and is still working on it. Hockney is shown sitting beneath balloons and streamers in front of an enlarged male pin-up, an image of a media celebrity and party-goer.

While lazing in the Californian sunshine by Hockney's pool, Howard Hodgkin jotted down his experiences in his diary; he described drinks and dinner parties with Christopher Isherwood, Don Bachardy, Paul Cornwall-Jones, Vera Russell, Mo McDermott, Peter Goulds, Nick Wilder, John Pope-Hennessy, Billy Wilder and Divine. Of Hockney's house he wrote: 'An instant home, the kidney-shaped pool seen through Kotah palms shimmers in the moonlight. Felt soothed and melancholy . . . Back to sit where I am, beside the pool. The sun shines, there is a smell of vegetation, and from behind the shrubs you can hear the discreet sound of some necessary equipment, perhaps a heater for the pool, which is kept at 90 degrees . . . The sun is bright so that the blue pool and transparent yellow umbrella are strictly art. As is the garden, full of trees that must have arrived in middle age and ground cover so elaborate that even the grass, when you look closely, isn't; just some miniature kind of creeping clover; the house so simple and austere, looks almost too perfectly like David's paintings.' He gave vivid descriptions of being driven in Hockney's little car to Palm Springs, Disneyland, the promenade at Venice, and 'then to the Back Lot, described by Peter as a semi-gay disco. Huge, brilliantly stroboscopically lit, and as clean and wholesome as a nursery school. Everyone of all ages looked as if they lived on cornflakes. The spectacle was mesmerizing but unerotic.' On the final day, the three of them had lunch with Billy Wilder at Ma Maison: 'French restaurant so authentic it hurts. Sauternes (very good) and delicious food. Billy says he is out of the business . . . that Sam Goldwyn said if people don't want to see your picture you can't stop them . . . then a long story about how he suggested the Life of Nijinsky as the answer to *Gone with the Wind* and having taken Goldwyn through it all with homosexuality, passion and madness till he ends in a Swiss asylum thinking he's a horse, against mounting doubts says, "If you want a happy ending have him win the Kentucky Derby." We are sitting outside the men's room and Jack Lemmon comes up to say hello and tells us he is going to "shake the dew off his lily".'[21]

In September 1978, while creating his 'Paper Pools' with Ken Tyler, Hockney had received a letter from John Dexter, Director of Production at New York's Metropolitan Opera. Dexter wanted to interest him in the idea of designing a triple bill of short, early twentieth-century French works: Erik Satie's ballet *Parade* and the operas *Les Mamelles de Tirésias* by Poulenc and *L'Enfant et les Sortilèges* by Ravel. Hockney did not reply until later in the autumn, although the connections with the world of Matisse and Picasso intrigued him, and he invited Dexter to Los Angeles to discuss his ideas further. Hockney had decided to take a long break from collaborative theatre work after *The Magic Flute* of 1978, but Dexter was able to persuade him otherwise.

John Dexter came, like Hockney, from northern England. He had seen *Ubu Roi* in 1966, and had been impressed by Hockney's designs, although he had felt they were too

flat and needed more depth. He had also attended *The Rake's Progress* and *The Magic Flute* at Glyndebourne, and he felt sure that Hockney designs would greatly enrich his proposed triple bill for New York in 1981. He later told me that he had chosen the three works deliberately: 'They were all conceived during the First World War when the Germans were at the gates of Paris and yet there was this extraordinary artistic activity in the city. Perhaps the threat to French culture provided the spur. Satie, Poulenc and Ravel were all aware of the futility and horror of war, and Apollinaire, who wrote the play *Les Mamelles de Tirésias*, had been wounded in the trenches. I wanted the evening to have an anti-war theme but with irony and tenderness not horror. In particular, I told David at the time that I wanted us to show how wildly and weirdly the arts survived in a time of world chaos.'[22]

Hockney was very sympathetic to the ideas behind the triple bill, and began to send rough sketches to Dexter in the summer of 1979. At the same time he wrote to Gregory Evans, who was then living in New York, asking him to move to Los Angeles and become his full-time assistant, to arrange his social life and to help with the work for the triple bill. Gregory accepted, and one of his first achievements was to find the house in Montcalm Avenue up in the hills where they moved in together later that summer. Gregory's job was to run the house, answer the telephone, do the cooking and help with the triple bill designs which were produced there, while Jerry Sohn looked after the studio in town where Hockney was still working intermittently on *Santa Monica Boulevard* and *Experimental Canyon Painting* as well as other canvases. It was the start of a happy period for Hockney, who had grown increasingly fond of Gregory.

John Dexter originally planned his evening of French music to begin with *Les Mamelles de Tirésias*, so Hockney's first designs were for this opera. It begins with the theatre manager explaining that the piece is light and amusing but, nevertheless, has the serious task of pointing out the need to repopulate France after the sufferings of war. It takes place in Zanzibar, an imaginary village on the French Riviera, where Thérèse is fed up with the drudgery of being a woman, and, in her determination to serve the Republic, forces her husband to change sex with her so that she becomes Tirésias. In the farce that ensues, her husband produces 40,000 children and fights off the advances of a policeman. Then the couple decide to reverse the sex-change and carry on as they were. Hockney made a rather Cubist design for the buildings of the village, with free-standing picture postcards for the background. However, Dexter found this too complicated and instead Hockney designed a series of colourful backdrops for the village square with its bar and café, plus a view of the harbour beyond which was painted in the lyrical manner of Dufy. For his costumes, he took plain, simple shapes and colours from designs by Paul Poiret which were of the right period. He also used earlier ideas of his own: the policeman was

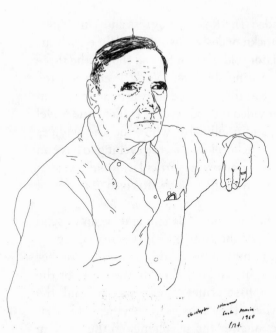

Christopher Isherwood, 1968

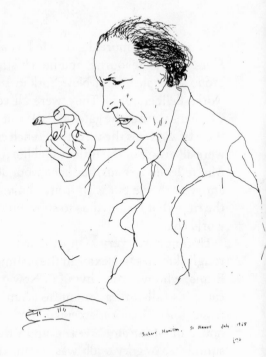

Richard Hamilton, 1968

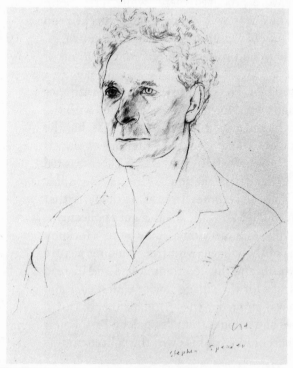

Stephen Spender, 1969

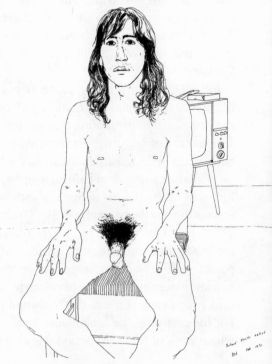

Richard Neville, 1971

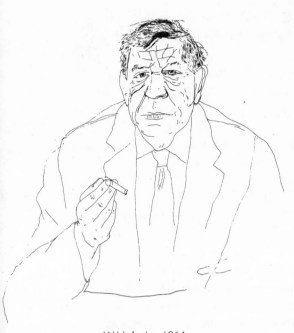

W.H. Auden, 1964

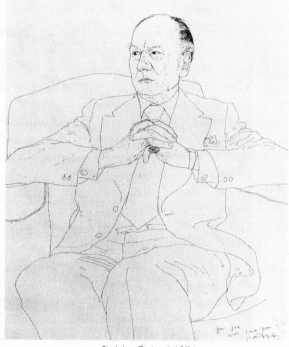

Sir John Gielgud, 1974

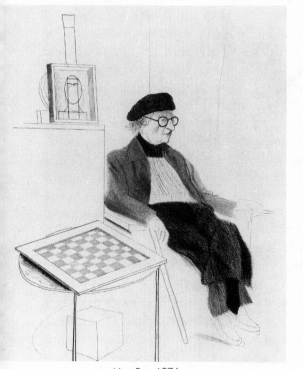

Man Ray, 1974

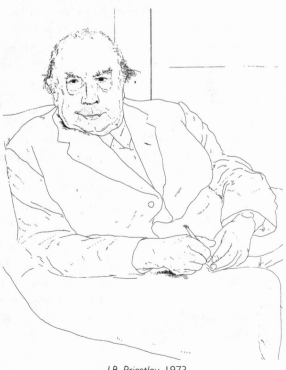

J.B. Priestley, 1973

anticipated in his amusing crayon drawing *Colonial Governor* of 1962, and Thérèse/ Tirésias recalls his other bearded lady, Baba the Turk in *The Rake's Progress*.

Next to be designed was Ravel's *L'Enfant et les Sortilèges*. Dexter had earlier planned a production in Paris with Manuel Rosenthal, who had been a student and friend of Ravel, and who remembered how disappointed Ravel had been with the unimaginative designs of the first production in 1925. Although Dexter's plans came to nothing, he remembered Rosenthal describing how Ravel used to love getting down on all fours to play with children. Hockney adored the music, the inspiration for which had been a story by Colette in which a naughty schoolboy refuses to do his homework and rips up his books, smashes the crockery, tears the wallpaper and is cruel to his cat. When he falls asleep, the objects come to life and confront him with his misdeeds. *L'Enfant et les Sortilèges* was Hockney's favourite of the three pieces: 'Colette's little story brought out the child in Ravel, which wasn't too difficult, and his music brought it out in me, which wasn't difficult either.'[23] Dexter and Hockney decided to base the production around the scale and point of view of the child. The two scenes, the boy's room in a Normandy farmhouse and the garden outside, were thus designed in exaggerated perspective to heighten the boy's troubled fantasies. Hockney had the brilliant idea of creating two-foot high building blocks which would first spell Maurice Ravel's name and then, when turned around, would become chairs, books and a fireplace. A further turn reveals sums which announce the arrival of the professor of arithmetic. The blocks would be moved about by the children's chorus dressed as puncinellos in bottle green, inspired by drawings by Tiepolo which Hockney saw in an exhibition of Italian eighteenth-century art at New York's Frick Collection. These images so appealed to him that he dressed the soloists of *L'Enfant* and the stage-hands in the same costumes. He also created a giant tea pot and cup which danced together, flames which jumped from the fireplace to menace the boy until attacked by ashes, two enormous cats who fought and then made love to each other, and shepherds and shepherdesses from the torn wallpaper who danced and sang together.

The evening's most dramatic moment comes when the boy's room dissolves into a vast and mysterious garden dominated by an enormous blue tree. The source of the tree was a black and white photograph of Peter Schlesinger and Joe Macdonald on the banks of the Nile which Hockney had taken in 1978 while researching for *The Magic Flute*. But it was David's use of colour in this scene, for which he was clearly indebted to Matisse, that so stunned audiences for the triple bill. As he said: 'When you see that colour, with the blue light on the huge mass of the tree foliage, I think you physically take the colour into your body as you take in the music. You can do this in the theatre in a way you can't do it in the cinema, because the cinema is not quite about colour, it's about light. But where there's physical colour, pigment, it's a different matter, isn't it? A physical colour is a physical thrill.'[24] He designed this scene in luminous paint so that when, at the end, after being

attacked by the insects he has damaged, the boy shows kindness to an injured squirrel and so redeems himself, the tree suddenly changes to a vibrant glowing red as the music reaches a crescendo. Dexter had invited Manuel Rosenthal to conduct the triple bill, and Rosenthal was sure Ravel would have loved Hockney's vision of his opera: 'The *éclat*, sharpness and mystery of his sets and costumes underscore Ravel's music. Hockney misses nothing: using the colour red for the trees is an idea that marvellously illustrates the fantastic quality Ravel wanted to achieve in a garden populated by the child's numerous dreams.'[25]

Dexter originally envisaged the ballet *Parade* as the intervening piece between the two operas. However, Hockney had a better idea: 'I suggested to John that we treat it as a little overture to what would follow. That seemed a good idea, because in French *parade* does not mean a parade. It means a sideshow with a barker in front of a curtain trying to get people into the theatre – a very old technique that is still used in travelling theatres, carnivals and fairgrounds. That way, I thought, there were all sorts of things we could do with it.'[26] The original production of *Parade* in 1917 was an influential collaboration between Satie (composer), Picasso (designer), Cocteau (librettist), Massine (choreographer), Diaghilev (producer), and Apollinaire (who wrote the programme notes). Cocteau's story contained many little episodes involving a host of sideshow characters, and Picasso's backdrop was a rather traditional painting of a circus with harlequins, clowns and a winged horse. At one point, Hockney intended to dominate the stage with a representation of Picasso's image in an unfinished state, so that it could be painted onstage during the performance of the ballet as an act of homage to Hockney's favourite twentieth-century artist. Other sketches show Paris in 1917 with the Eiffel Tower copied from a painting by Robert Delaunay. Finally he decided on a simple red sideshow curtain in the middle of the stage, behind which could be seen parts of the scenery of the rest of the evening's entertainment. In front of the curtain would appear the characters of *Parade* – the fairground barker, the Chinese conjuror, the acrobats, the horse, the manager and Harlequin, all based on Picasso's original designs. The curtain could be drawn back to introduce characters from the two operas, so that *Parade* served as an overture to the evening, with the stage-manager and the bearded lady from *Les Mamelles de Tirésias*, and the pair of cats and the tea pot and cup from *L'Enfant et les Sortilèges*.

At this point, Rudolf Nureyev was invited to choreograph *Parade*. The Board of the Metropolitan Opera were insistent that a star name was essential for the risky experiment of a triple bill of little-known music, for they did not feel that David Hockney was sufficiently well-known in the world of the theatre. Hockney and John Dexter had already worked out their ideas and were not happy about this late development. Nureyev arrived with a clear conception of his own about *Parade*: he wanted to rework the ballet

around the creation of the original 1917 production and the quarrels between the artistic personalities involved. His ideas were good, but unfortunately they did not fit into the already established general plan of the evening. Total disagreement resulted in an *impasse*, until one day when Hockney and Nureyev had a blazing row about the trivial matter of how many tables would fit on the stage. They had met before, in 1970, when Hockney photographed and drew Nureyev in Richmond, but without establishing any kind of rapport at all. The clash of temperaments and viewpoints could not be overcome and Nureyev left the project.

Having established *Parade* as the introductory piece of the triple bill, Dexter and Hockney had to decide how to relate it to the theme of war. Hockney designed the first set as a battlefield with barbed-wire, French *tricolore* flags and searchlights. The plan was that a soldier would remove his gasmask and uniform and reveal himself as Picasso's Harlequin from the original production. He would then lead a little boy to safety, and place him at the front of the stage to observe the introduction of the characters from behind the red curtain. The same boy would re-enter the events of the evening as the main character of *L'Enfant et les Sortilèges*. Another marvellous link was provided by Hockney's building blocks: these could be carried onstage by the soldiers to spell out the name of Erik Satie and then, after *Parade*, they could be rearranged as 'Francis Poulenc', before becoming 'Maurice Ravel', the boy's furniture and, finally, Professor Arithmetic's wrong sums. The barbed-wire theme was also carried through the evening, becoming part of the backdrops of Zanzibar in *Les Mamelles de Tirésias* and making a final appearance after the magical garden of *L'Enfant et les Sortilèges* fades from view when Harlequin reappears to embrace the child. Thus Dexter's original conception was carried through the evening: 'The possibility of war surrounds us all the time and particularly threatens the lives of our children. By using a child and a harlequin at the beginning of *Parade* and at the end of *L'Enfant*, I hoped to make the point that the only sanity for our children is in the arts – music, painting, literature.'[27]

The first night of the triple bill in New York, on 20 February 1981, was a huge success. Hockney refused to go on stage for a curtain call but, when the lights went up, he was seen in his white suit in the front stalls accompanied by Divine in full drag, and the whole house joined in a spontaneous burst of cheering applause. The press reviews were equally enthusiastic: 'In the enchanted garden at the end of the opera the entire universe is transformed by childlike wonder. To this conception, David Hockney rises with the mastery of a born theatrical genius.'[28] Those who worried that it would prove impossible to interest audiences in early twentieth-century French opera were proven wrong and, for this, credit was largely due to Hockney. Dexter, like John Cox before him, found collaborating with Hockney a memorable experience. He told me recently that he is looking forward eagerly to working with Hockney again: 'David is a first-class theatre

designer, there is no doubt about that. Although trained as a painter, he has known the theatre and the opera from his early days, and this has helped him a great deal. Of course he also benefited from working with good technical people at the Met. He's not easy to persuade into something like this, you have to grab him with a good dramatic idea. We were very direct with each other while working together, and we never stopped laughing!'[29]

On Hockney's birthday, 9 July 1980, I visited him in Pembroke Studios, Kensington. I had been out of contact with him for a while and, to my astonishment, I found the walls covered with extraordinary paintings. He was amused by my surprise: 'I saw the Picasso retrospective at the Museum of Modern Art in New York last month – a fantastic experience. He didn't spend months on one picture, he was constantly open to new ideas and inspiration which he put into his painting immediately. I came to London feeling that I must just work and work, paint and paint. I must catch his spontaneity. I'm painting a new picture every few days, plundering Picasso and Matisse, and loving every moment.'[30] The work for the triple bill was more or less finished, but I recognized one of the paintings as a free copy of Picasso's original *Parade* backdrop (*Parade Curtain after Picasso*). There was also a picture of Picasso's Harlequin doing a handstand (*Harlequin*) (see plate 120) and a five-foot-square canvas of the whole stage with the composers' names around the proscenium arch, Harlequin doing his handstand in a spotlight in front of a red curtain, and the conductor and orchestra in the foreground (*The Set for 'Parade'*). Hockney also showed me a luminously glowing image of the garden in *L'Enfant* (*Ravel's Garden with Invisible Pulchinellas*) and a painting of the set for *Mamelles* with the bearded woman, the policeman on a toy horse and other characters (*Mamelles de Tirésias*). When I returned towards the end of the month, I saw another painting of the garden (*Ravel's Garden with Night Glow*) (see plate 119), a costumed dwarf in front of the stage (*Punchinello On and Off Stage*) (see plate 121) and two pictures relating to early ideas for *Parade* (*Study for 'Parade' with Eiffel Tower* and *'Parade' with Unfinished Backdrop*). All these paintings showed a very spontaneous oil technique and bright, saturated colours, capturing an extraordinary sense of pleasure and excitement in image-making.

Hockney painted sixteen canvases relating to the world of opera and ballet during that July and August. When I visited him later, he showed me a four-foot by six-foot canvas of a stage with two dancers who were recognizable as such, even though composed in a very schematized manner. This had been painted at the start of the whole series, and was based on a drawing made three years earlier for Wayne Sleep's one-man show at the Adelphi Theatre in London in November 1977. Hockney called it *Two Dancers*, and it led to the most abstract images of this sequence of paintings, *Waltz* inspired by Ravel's ballet

La Valse of 1919, and *Dancer*. These were stage scenes showing a single figure that was entirely composed of the 'French marks' with which Hockney had experimented in his Nichols Canyon paintings in Los Angeles the previous autumn. They were almost abstract variations on Matisse's *La Dance* of 1909, and the nearest David had come to complete abstraction since his first year at the Royal College. This series was the immediate result not only of visiting the Picasso show but also of working on the triple bill, and his enthusiasm for this latest theatrical collaboration was obvious from a performance I attended in his studio on 20 July. He had a complicated theatre model complete with fly gallery and lighting system. As he played the music on his stereo tape recorder, he changed the sets, switched on the appropriate lighting, sang the various roles, hummed the choruses and occasionally danced around the room in his excitement. It was a privileged preview of the actual performance. Those not lucky enough to attend either Hockney's studio or the Metropolitan Opera in New York had a chance of seeing the more than 100 crayon and gouache studies as well as the related oil paintings in exhibitions in New York, London and Paris during 1981.

The excitement of painting so many colourful images relating to the triple bill for New York inspired Hockney to move forward from *Santa Monica Boulevard* when he returned to Los Angeles in autumn 1980. He had felt previously that this painting had started a new phase in his imagery of California. In terms of the use of new acrylic colours it had certainly opened up his work, but as far as design and execution was concerned, it was too rooted in his past naturalism. *Japanese House and Tree* of autumn 1978 had shown a move towards an almost abstract stylization of the image, and *Experimental Canyon Painting*, which was started at the same time, eventually developed into an astonishingly free arrangement of colour-marks inspired by the landscape of the Hollywood hills. Hockney told Marco Livingstone in 1980: 'Until I finished it, I didn't treat it seriously. Then I made it into a picture. Then it took nearly a year before I did the next thing from it, partly because I was working on other things. Meanwhile I kept going back to the *Santa Monica Boulevard* painting, working in a way that I'd already broken actually, and not realizing it.'[31] The 'next thing from it' was *Nichols Canyon Road and Hollywood Boulevard*, a watercolour of 1979 which led to a small painting, *Nichols Canyon Road*, and, finally, a seven-foot by five-foot canvas, *Nichols Canyon*, which was completed when Hockney returned to Los Angeles in autumn 1980, at the end of a very fertile summer.

Gregory Evans described Hockney's state of mind on his return: 'He was really excited, free of the jam created by *Santa Monica Boulevard*. He was turned on by the idea of producing a series of images of Los Angeles viewed in a new way altogether, and he worked really fast that autumn.'[32] Nichols Canyon Road snakes up from Hollywood

Boulevard into the hills where Hockney was now living, and the paintings show the road winding past neat white houses and exotic palm trees towards the high horizon. The landscape is portrayed in a mass of bright saturated colour – blue, green, red, pink, orange and yellow, giving the impression of a map of the area complete with labelling: 'Nichols Cyn Rd'. The image attempts to portray the actual experience of driving down and up a constantly twisting road, for this was his daily journey from his home to his studio: 'Suddenly Los Angeles is wiggly lines and I didn't realize it. When I lived in the flat part of LA, everything seemed like straight lines and cubes, but since I went to live in the hills and I drive down every day, I'm always driving down wiggly lines.'[33]

Hockney also painted a six-foot-square canvas of *Outpost Drive, Hollywood*, a road high up in the hills between his house and the Hollywood Bowl. This concentrated on the hills themselves and looked even more like a map. It was a preparatory work for what was to be his largest new view of Los Angeles. One day in mid October, he said to his assistant Jerry Sohn: 'Let's get rid of *Santa Monica Boulevard* right now.'[34] On the same wall, and directly on top of it, Sohn stapled and then gessoed another seven-foot high and twenty-foot long canvas which was to become *Mulholland Drive* (see plate 118). Hockney was now feeling really inspired, and he worked on the new painting continuously for the next three weeks, completing it by the middle of November. Mulholland Drive meanders along the top of the Hollywood hills, and the road is shown at the top of the vast canvas, passing neat little houses with their gardens of tropical trees and then doubling back into the foreground past electricity pylons, tennis courts and a swimming pool whose blue surface is alive with dancing white lines. This exuberant painting is a splash of bright sunshine which contains almost every colour of the spectrum. The rough surface has been constantly reworked, and the techniques vary from areas of flat glowing colour to sections made up of spontaneous rhythmic brushstrokes. The central mountain made up of red and blue calligraphic marks caused some trouble: the whole area was scraped away with alcohol and a spatula by Jerry, covering him from head to foot in clinging acrylic, before being repainted by Hockney. Beyond the road at the top of the canvas can be seen a view of the San Fernando Valley communities of Burbank and Studio City, portrayed as map-grids, which is just how they appear from the hills. These were copied from Jerry's car map book of Los Angeles, and the lines were made by scoring through the top layer of paint with a palette-knife to reveal the colour beneath. The painting gives a vast panoramic view of the district of Los Angeles where Hockney lives, and succeeds in allowing the viewer's eye to roam around the scene much as a car would explore the area.

Mulholland Drive was the centrepiece of a wall of new Hockney paintings including *Experimental Canyon Painting*, *Nichols Canyon* and *Divine* which were shown at the Royal Academy's exhibition, 'A New Spirit in Painting', in January 1981. This was a

polemical exhibition of recent painting from Europe and America designed to demonstrate a reaction against Minimalism and Conceptual Art and towards figuration and subjective experience. Hockney, therefore, fitted in perfectly, having been voicing such concerns for some years. Nevertheless, his new paintings came as a considerable shock to his admirers and critics in London whose most recent view of his work had been 'Travels with Pen, Pencil and Ink', a mammoth show of 155 drawings and prints from 1962–1979 which had reached the Tate Gallery in July 1980 after touring America and Canada. This had brought out the superlatives: in *The Times*, Bernard Levin used words like 'astounding', 'remarkable', 'infallible', 'inexhaustible' and 'captivating', and described Hockney as 'the English genius – I really do not think the noun is unjustified', and 'surely the greatest of living English artists'.[35] Reactions to his *new* work were rather less effusive: according to Marina Vaizey in the *Sunday Times*, *Mulholland Drive* was 'demented needlework',[36] although William Feaver of the *Observer* described it as 'a drop-scenic landscape made up of dozens of shorthand pictorial markings', and 'a *tour-de-force* crammed with back references and daring short-cuts.'[37] In the company of all the leading figurative artists of the day, from Bacon to Warhol, Hockney's work was singled out for comment by most of the critics. In *The Times*, John Russell Taylor wrote that his 'very large, very brightly coloured, boldly conventionalized Los Angeles landscapes do mark a promising new departure and confirm Hockney's continuing ability to break out of the constrictions his familiar manner might seem to impose.'[38] Hockney himself was quite clear in his mind that these 1980 paintings constituted 'a promising new departure'. He told me that Christmas: 'I know everyone wants me to paint pictures like *Mr and Mrs Clark and Percy* or *A Bigger Splash,* but they are not the mainstream of my work. I think they were good pictures, but in retrospect it will be seen that they were an aberration in my career. The true line of development leads from the Royal College and early sixties paintings to *Mulholland Drive.*[39]

After the Royal Academy Exhibition he asked the Emmerich Gallery to sell *Mulholland Drive.* Nathan Kolodner had difficulty showing it to clients owing to its size. It was kept rolled-up, and had to be unrolled and stapled to the wall to be seen. He knew that the proper home for the painting was the Los Angeles County Museum, which possessed no examples of Hockney's work at all. Maurice Tuchman of the museum staff told him that the asking price of $250,000 was way beyond his budget, so Kolodner persuaded Richard Sherewood, President of the Board of Trustees, to come and see it. He was soon convinced that the museum must have it and he managed to raise the necessary funds. *Mulholland Drive* is today one of the centrepieces of the Los Angeles County Museum's new extension.

The paintings of autumn 1980 are a new vision of southern California and constitute a

reaffirmation of Hockney's love affair with Los Angeles, which continues to this day. He spoke about this to an American journalist that November, as he was finishing *Mulholland Drive*: 'I think it's an acquired taste. The longer you stay here the more fascinating it becomes to you. I think visually it's a stunning city. Wherever you drive it's interesting . . . It's the exact opposite of Bradford. There it's always dark, it's always raining, the buildings are black, the climate is cold. So when you come to Los Angeles, by comparison it looks like a sunny paradise . . . People are more physical here because in the sun you're more aware of your own body. You wear less clothing, therefore you make the body look nice. In a cold place like Bradford you hardly see anybody without their clothes on. I find myself more and more interested in the idea of going to the sun. You should enjoy the sun and you should run around in it, constantly. Human beings are more joyful in the sun.'[40]

CHAPTER TEN

AMERICA AND CHINA 1980–1983

In mid-November 1980, when Hockney was in New York for technical rehearsals of *Parade* at the Metropolitan Opera, John Dexter asked him if he would like to design another triple bill, this time three works by Stravinsky: *Le Sacre du Printemps*, *Le Rossignol* and *Oedipus Rex*. The production was scheduled for December 1981, which gave very little time, but Hockney was fascinated by the challenge and accepted. He was staying at the Mayflower Hotel on Central Park West, which was very convenient for the Lincoln Center, home of the Metropolitan Opera, and Maurice Payne agreed to lend him his studio in New York where he could work on the designs. John Dexter had a house in New Jersey across the Hudson River from Manhattan, and Hockney spent many days there discussing basic approaches to the project.

The Stravinsky triple bill had one great advantage over the *Parade* evening: the in-built unity of one composer's work. It was intended as a celebration of the hundredth anniversary of Stravinsky's birth. Dexter and Hockney agreed that it should be an evening of ritual: the primitivism of *Sacre*, the protocol of *Rossignol*'s Chinese court, the pre-ordained fate of the king in *Oedipus*. This led to the adoption of two visual themes that would run through the three performances: the mask and the circle. The Metropolitan Opera wanted a ballet to start the evening, as with *Parade*, but arguments ensued as to whether it was practicable for an opera company to mount such an ambitious piece as *Le Sacre du Printemps*. Meanwhile Hockney and Dexter went ahead with the designs of the two vocal items. Early on in their collaboration Hockney sent Dexter a letter giving preliminary ideas for *Rossignol* and *Oedipus*, each designed in the form of a circle, with a note written beside them asking if he thought such schemes would work. The shape of the theatre itself, as well as the concept of these pieces as rituals, suggested a homage to the circle, and all Hockney's designs were based on that plan, something with which John thoroughly concurred: 'The intellectual, emotional and musical strength you feel coming from Stravinsky was the first thing we tried to express visually and the circle was the natural basic form. Listening to his music, you're aware of the danger, you're aware of the risk and you're aware of his perpetual challenge to the audience.'[1] Hockney, too, felt inspired by Stravinsky's music, much more so than he had in 1974 when he designed *The Rake's Progress*.

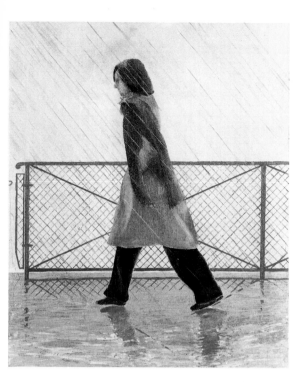

124

125

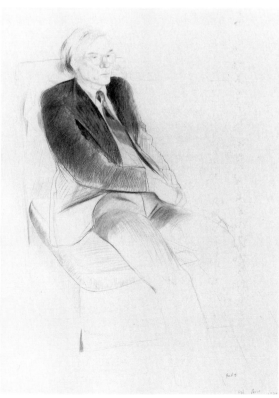

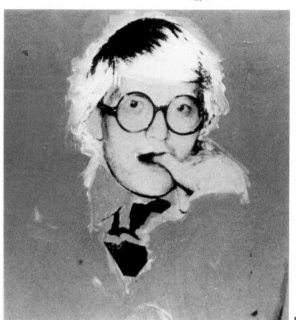

126

122 *Yves-Marie in the Rain*, 1973/4

123 *Andy Warhol*, 1974

124 Passage de Commerce, Paris, 1987

125 Cour de Rohan, Paris, 1987

126 *David Hockney*, by Andy Warhol, 1974

From 1973–75 Hockney lived in Paris where Andy Warhol came to visit him.

127

128

129

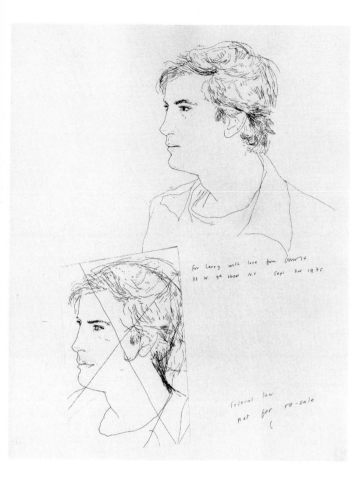

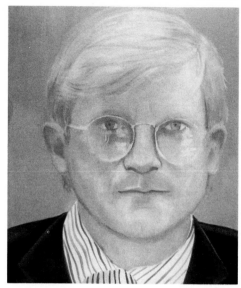

133

134

127 *David Hockney at Berkeley*, by R.B. Kitaj, 1968

128 David Hockney drawing R.B. Kitaj in Vienna, 1975

129 *David Hockney at Fire Island*, by Robert Mapplethorpe, 1976

130 *Ron Kitaj outside the Akademie der Künste, Vienna*, 1975

131 *Robert Mapplethorpe*, 1971

132 *Larry Stanton*, 1975

133 *David Hockney*, by Larry Stanton, 1975

134 (left to right) Arthur Lambert, David Hockney and Larry Stanton, Fire Island, 1975

135 Henry Geldzahler and David Hockney on Fire Island, 1975

135

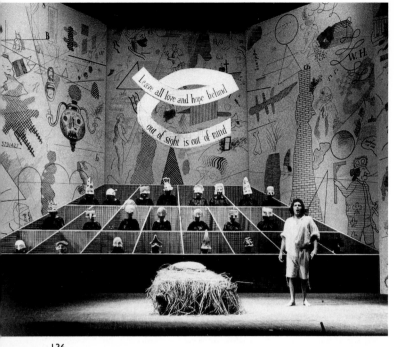

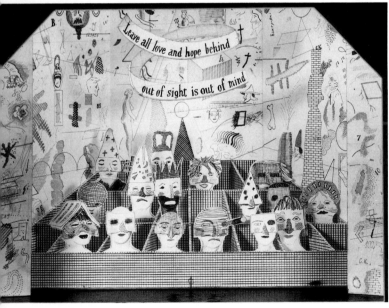

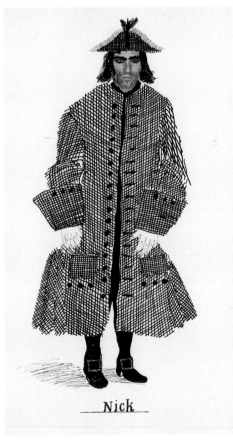

136 Bedlam scene from *The Rake's Progress*, Glyndebourne
Festival Opera, June 1975

137 Bedlam, model for *The Rake's Progress*, 1975

138 Celia Birtwell and David Hockney at the first night of *The
Rake's Progress*, Glyndebourne, June 1975

139 Nick, costume design for *The Rake's Progress*, 1975

40

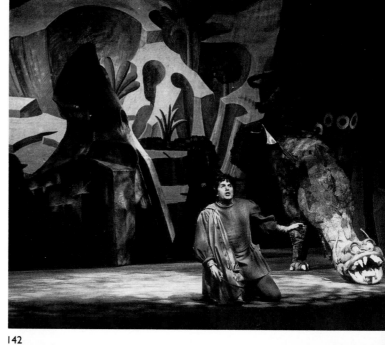

142

I

143

140 Peter Langan's banquet for the first night of *The Magic Flute*, Glyndebourne, May 1978

141 Papageno, costume design for *The Magic Flute*, 1978

142 Act I of *The Magic Flute*, Glyndebourne, May 1978

143 Act II of *The Magic Flute*, Glyndebourne, May 1978

144

14

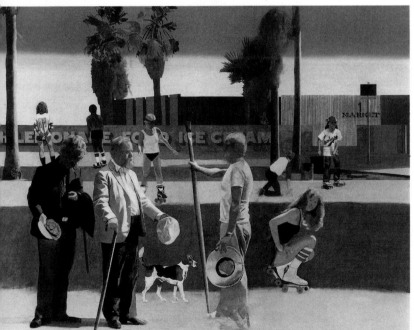

146

144 Gregory Evans in Hockney's studio in
Los Angeles, April 1982

145 *Gregory Standing Naked*, 1975

146 *The Meeting, or 'Have a Nice Day, Mr
Hockney'*, by Peter Blake, 1980–3

Hockney had known Gregory Evans for
some time before they became lovers in
Paris in 1975. Howard Hodgkin and Peter
Blake visited Los Angeles for an exhibition
of British art in 1979, and on his return
Blake began a large painting inspired by
Courbet's *Bonjour Monsieur Courbet*. He
depicted himself and Hodgkin greeting
Hockney by the beach in Venice, a suburb
of Los Angeles.

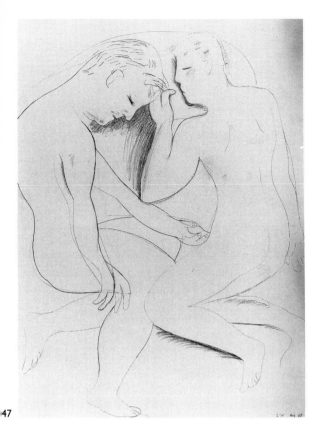

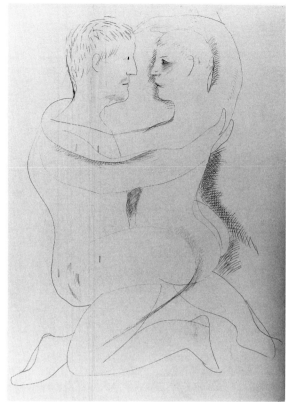

147 *Waking Up V*, 1983

148 *Waking Up VII*, 1983

149 David Hockney drawing in his studio with Ian Falconer, Los Angeles, 1982

Hockney met Ian Falconer in 1980. Two years later Falconer moved to Los Angeles to live with Hockney and become his pupil. It was not an easy relationship, but Hockney celebrated it with a series of seven Picasso-esque line drawings in 1983. These show Hockney waking Falconer from a nightmare and making love to him. They are very honest drawings with no attempt to idealize such an unequal relationship.

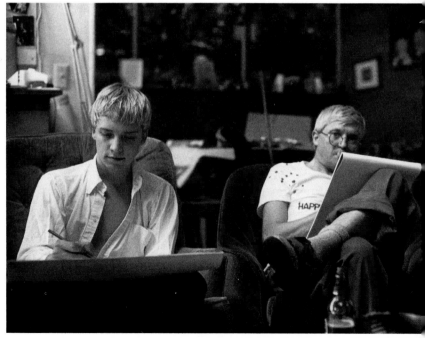

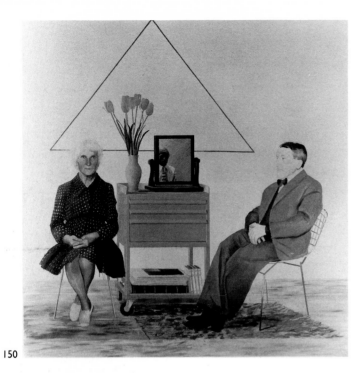

150

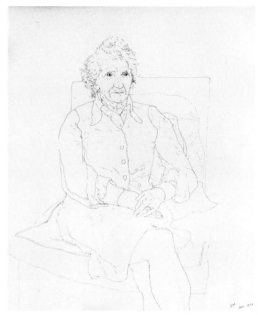

15

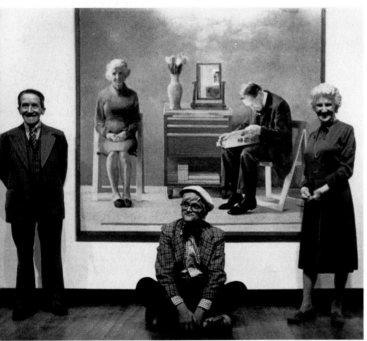

151

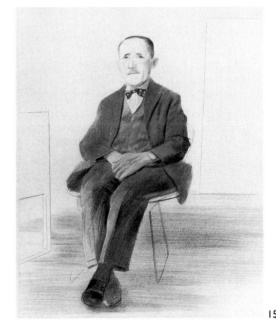

15

150 *My Parents and Myself*, 1975

151 David Hockney with his father and mother and
My Parents, Hayward Gallery, London, 1977

152 *My Mother*, 1974

153 *My Father*, 1976

Sacre, which opened the programme, caused Hockney and Dexter the most problems. At first they interpreted the ritual of the sacrifice of a virgin in terms of near-naked savages heavily painted in the manner of African natives and wearing tribal masks. Then research showed them that the highly controversial first performance in 1913 had been set in pagan Russia and had been designed to show a fertility ritual which replaced the desolation of winter with a great surge of the creative power of spring. So Hockney designed primitive costumes in heavy, coarse material with no sophistication at all, and masks that were painted directly onto the faces. The drop-curtain included Stravinsky's name and date of birth superimposed on a large circle divided into three colours: green for *Sacre*, blue for *Rossignol* and red for *Oedipus*. The set for *Sacre* was a large disc painted to resemble a stark northern landscape, but which could also symbolize the cosmos. The colours were designed to alter according to the lighting, so that the disc was cold and blue at the beginning and changed to a glowing red at the time of the sacrifice that brought a renewal of life in spring.

The mood of *Rossignol* was in total contrast to that of *Sacre*, and, for the transition between one opera and another, the segmented circle reappeared until the opera materialized in a shimmer of blue light. *Rossignol* is a Hans Andersen fairy tale about a nightingale which is befriended by a fisherman and then invited to sing for the Emperor of China in his palace. A gift of a golden mechanical nightingale arrives from the Emperor of Japan. The court prefers this prettier bird, whereupon the real one flies away. The mechanical nightingale eventually breaks down, and the Emperor sickens until the real one returns and sings him back to health. Hockney wanted to communicate the moral that truth is superior to artifice by stressing the ceremonial character of the court in contrast to the carefree life of the fisherman and the nightingale. The shimmering music suggested the delicacy of Chinese blue and white porcelain, and he based his designs on the collections of the Victoria and Albert Museum in London and of Chatsworth in Derbyshire. He created a large blue and white disc which rested at the back of the sharply-raked stage and served as both the sea and the floor of the palace. Trees, mountains and architecture could be flown down to create the necessary settings for the action. The emperor and his courtiers wore elaborate blue and white robes and their faces were painted to resemble the characters of classical Chinese opera. The chorus, who acted as attendants at the court, carried painted masks on long poles. Everything was blue and white, except for the red and gold costumes of the Japanese ambassadors and the gaudy mechanical nightingale.

Dexter wanted to stress the ballet in *Rossignol*, as a link with *Sacre*, and he invited Sir Frederick Ashton to join the team as choreographer. Ashton accepted on condition that Anthony Dowell and Natalia Makarova should dance the parts of the fisherman and the real nightingale. Dowell had met Hockney at Covent Garden with Wayne Sleep and had

long wanted to work in a production designed by him. For the fisherman, Hockney created a Chinese coolie outfit complete with hat. The nightingale wore a skin-tight leotard with simple marks to suggest feathers. His only problem was to design a tree concealing a platform at exactly the right height so that the nightingale could fly out of the branches and into the fisherman's arms.

The segmented circle once more provided the link with the third component of the performance, the oratorio *Oedipus Rex*. At first, this seemed to offer Hockney few opportunities to exercise his imagination, for Jean Cocteau's Latin text for *Oedipus*, which was based on the Sophocles original, was designed for narrator, soloists and chorus with no action whatever. Ashton suggested that Anthony Dowell should take the part of the narrator, and Hockney and Dexter involved Dowell in all their discussions. Hockney decided to present *Oedipus* as a heroic tableau, and he created a giant circle to unite stage and auditorium as one vast Greek theatre. At the back of the stage was a monolithic column in stripes of gold, and other columns were projected in lines of light onto the proscenium arch, repeating the gold paint on the front of the balconies and boxes of the theatre. The stage consisted of a large red circle which matched the colour of the theatre's carpets. The music began in darkness, with a single spotlight on the narrator who sat on a throne just above the orchestra. Then the whole stage was illuminated with strong, unvarying light. The chorus in dinner jackets stood in two lines in front of the stage on which sat the soloists, also in dinner jackets. Behind each soloist stood an attendant holding an extraordinary white mask which the singer wore when performing. The back of the stage was decorated with different masks which were copied from eighteenth-century drawings of Pompeii. The use of masks was inspired by descriptions of Greek drama where they were used so that various facial expressions could be seen from the back of the amphitheatre.

From seemingly unpromising material, Hockney created a powerful visual setting for this presentation of the story of Oedipus, who blinds himself to atone for unknowingly killing his father and marrying his own mother. It formed a stunning climax to the evening. At the centre was Anthony Dowell, declaiming his lines like an oracle speaking for the gods. The role was a great challenge for a dancer; it meant literally stepping into another world. He told me recently that he found it a terrifying ordeal to have only the few minutes of the interval to take off his elaborate *Rossignol* make-up, change, shower, re-arrange his hair, put on his dinner suit and quite different make-up, and make the mental switch from movement to voice projection. 'But after the initial discussions, I did what I was asked to do. I knew I could do it. And David knew exactly what he wanted. It was very difficult to budge him once he had made up his mind. He did everything with a marvellous sense of humour. And although his designs were stunning, one didn't feel overpowered by them when performing. There was an exciting feel to the whole project,

I was thrilled to be involved. It was certainly the most exciting collaborative venture I've ever been involved in.'[2]

As with the *Parade* triple bill earlier in the year, press reaction to the December premier of the Stravinsky celebration was almost unanimously enthusiastic. Critics recognized that Hockney was now an established figure in the world of theatre design: 'More than Dexter's, this is Hockney's show. How could anyone go wrong with a *Rossignol* that so bewitchingly captures the blue-porcelain fragility suggested by Andersen in the original story? The gorgeous drop-curtain, redolent with watery symbolism, that billows down from the flies whenever the fisherman steps forward to propound a tender morality; those delightfully grotesque Chinese death-masks that suddenly reverse to show expressions of joy as the cured Emperor rises to greet his subjects – magical effects.'[3]

In mid-May of 1981, Hockney flew to China for three weeks. As an inveterate traveller he had visited Japan, Hong Kong, Burma and India, but this was his first experience of China. The trip was suggested by Nikos Stangos of Thames and Hudson, who wanted to produce a book of Hockney's drawings and photographs of a country unknown to him. Stangos also interested Stephen Spender in the project, considering him to be a useful companion for recording the experiences of the trip; he had long been interested in Communist ideology and had known Hockney since before the Cavafy project of 1966. It was difficult to find a time when both Hockney and Spender were available, but finally May 1981 was chosen as appropriate, since Hockney was then still working out his ideas for *Le Rossignol*. Hockney invited Gregory Evans to go on the trip, and the three of them joined a party of American tourists in Hong Kong for the flight to Peking.

Hockney's first image of China was a schematic crayon drawing on the long, straight road from the airport to the centre of Peking, bordered by trees and apartment blocks and inhabited by numerous bicycles. It almost resembled a straightened-out *Nichols Canyon Road* without the exoticism of colour and foliage. More often he used watercolour, not his favourite medium but appropriate for an artist in China. His watercolour sketches of Peking include the view from his hotel window of the Avenue of Perpetual Peace, and two views of the vast and empty Tian An Men Square with the golden Gate of Heavenly Peace, the Monument to the People's Heroes and the long red walls of the Forbidden City with the Imperial Palace. These are spontaneous reactions to new sights and mark a departure from his usual habit when travelling of drawing hotels and companions rather than scenery. This was largely because the trip was being sponsored by Thames and Hudson, who would expect suitable images for the proposed book. As the visit progressed, however, Hockney found less and less time for drawing in a crowded

schedule, and so concentrated on photography. When he did sit down to draw, he often found himself surrounded by fascinated Chinese, and would end up giving the drawing to a new admirer.

The three visitors were treated rather differently from other members of the group. Arrangements had been made for them to meet the British Ambassador and British Council Representative, and they were also taken to the Central Academy of Fine Arts to talk to some staff and students and to see their rather old-fashioned work in the style of Socialist Realism. They were taken to the various tourist spots: the terracotta soldiers in the burial mound at Sian, the Ming tombs, the Great Wall, as well as to temples, opera houses, farming communes and meetings of artists and poets. Hockney took many rolls of film, and at least three images were later used in *Le Rossignol*, whose music he listened to incessantly on his Walkman: the *ch'i lin* or legendary griffin, at the Ming tombs, the grotesque masks of the Canton Opera, and the fantastic shapes of the Kweilin Mountains. The book that appeared a year later, *China Diary*, was Stephen Spender's account of the trip, incorporating Hockney's images and reactions to China as well as rather less illuminating details from history texts and guide-books.[4] The account comes alive when it records details such as Chinese people staring at Spender's large feet and politely concealing their smiles, and the English lady they met in Shanghai who recalled, 'Last time I was here in 1930, would you believe it, I had several portmanteaux and they were carried into the hotel by five coolies.'[5] Hockney noticed interesting little details about China: the clothing stores which seem to belong in the thirties; in spite of official puritanism, the extensive demand for pornography; the killing by the Chinese of almost all the birds in the country, but, since 1959, the planting of thirty-two million trees.

China Diary makes it clear that there were two high points for Hockney during the trip. He fell under the spell of the sensational craggy landscapes of the Kweilin Mountains which the friends saw from a boat on the River Li. He tried to capture his feeling of exhilaration in photographs and in a series of bold and colourful Chinese-inspired watercolours. And in a village near Kweilin he met an eight-year-old child prodigy artist who had already produced 9,000 paintings. At first the boy was very suspicious of the visitors, but as soon as Hockney started drawing with him, his eyes lit up and he would not let go of Hockney's hand. Hockney was very impressed by the boy's abilities, and they communicated easily without knowing one word of each other's language. Hockney said in the book: 'He is absolutely an artist, the most interesting painter we have yet seen in China . . . It was a rare, wonderful day which we will not forget.'[6]

In 1981, Gemini Press published a series of new lithographs by Hockney. Most depicted

Celia: in a director's chair, in a polkadot skirt, in an armchair, with a green plant, reclining on a bed. These are very freely drawn images which show a strong debt to Matisse. One print is a portrait of Hockney's younger brother, John, who was in California on a visit from his home in Australia. It was the first time Hockney had drawn John since their schooldays, and he used the image as an experiment with Coda Crapot grease crayons, which dissolve in water, giving the lithograph the look of a watercolour. Hockney tried various tricks such as sprinkling salt on the plate, which attracts grease and leaves a spotty surface, applying a nylon stocking to produce a rubbed effect, and using a razorblade to sharpen the lines. Sid Felsen describes Hockney as having 'a natural ability to look and to learn. He picks things up very fast, and leaves other people behind. It's a combination of inquisitiveness and intelligence, plus a lot of imagination. Very few artists can do it. His lack of technical training has probably helped him, for a narrow training can shut down your thinking. He now has an enormous knowledge of processes and techniques. Among all our stable of American artists, Johns, Rauschenberg, Stella, Lichtenstein, Claes Oldenburg and Sam Francis, it is Hockney's works which are the most popular.'[7]

One of the new prints was a portrait of the author William Burroughs. Sid Felsen had wanted Hockney to draw Burroughs and so had introduced them at the Gemini studios. Hockney had enjoyed meeting him but as usual had found it very difficult to produce a satisfactory drawing after one meeting. The same had been the case the previous year when Stephen Spender introduced him to Sir Isaiah Berlin at Oxford. All Souls College wanted a Hockney drawing of the Professor for their collection, and he was entertained to lunch at high table, which he found quite amusing. He produced twenty drawings during a week, and enjoyed conversation with Professor Berlin, but, as on such occasions with Auden, Priestley and Moore, he did not feel very satisfied with the results.

Hockney had grown to feel very comfortable in the Montcalm Avenue home he had rented in 1979. He had found a degree of privacy, for it was too far from the centre of the city for people to drop in unannounced. He loved the sunshine and the clear light and he loved having his own swimming pool. The house had been built in the 1950s; it had previously belonged to the actor Anthony Perkins and, in 1982, it was put up for sale; Hockney had to make a decision either to buy it or move out. He felt that his residence in California was sufficiently permanent for him to purchase the house, and he celebrated by painting the bottom of his pool an azure colour with darker blue 'French marks' at regular intervals. He completed the job with a bold 'D.H. 82' in the middle of the pool. The natural colour of the brick wall snaking around the pool did not provide as strong a colour contrast as he wanted, so he asked his London milkman, who happened to be visiting at the time, to paint it a vivid red and white. The terrace outside the living room

above the pool Hockney painted a bold ultramarine and the exterior walls a pale pink; the effect was completed with strong red blinds in the windows. It was as if he saw his home as his own personal theatre set, and was designing it to complement *L'Enfant et les Sortilèges*.

The enormous living room, with kitchen and dining area, took up half the house and served as his studio as well. He had three triangular skylights installed in the ceiling and, together with the wall of glass giving onto the terrace, this ensured that the room was flooded with the maximum of Californian sunshine. Proudly displayed above the dining table was his father's painting of Laurel and Hardy, which Hockney always takes with him when he moves house. He once told me: 'It's a really beautiful picture. It's a bit crude, not very sophisticated, yet it has real feeling which transcends any technical limitations. I think it's the obvious empathy with the couple. He loved them. He painted them often, and if anyone who came to our house said they liked Laurel and Hardy, he'd go and get one of the pictures and give it to them.'[8] Other acquisitions of personal importance included a rug by Ann Upton, a table designed by Stephen Buckley, and large wooden animals made by Mo McDermott. Above his bed hung Picasso's *Artist and Model* of 1965. He had seen the little painting on sale at Claude Bernard's Gallery in Paris at the time of the 1980 Picasso exhibition at the Museum of Modern Art and had fallen in love with it. The price was $135,000 and, in spite of the fact that he could easily afford it, his rather puritanical background prevented him from spending so much money on a gift for himself. Nathan Kolodner later heard of the problem and immediately saw the solution. *Nichols Canyon* and *The Conversation* were still in the studio, as Hockney did not want to sell them. Nathan persuaded him to do a swop: the Emmerich Gallery bought the Picasso for him and in return he gave them his two paintings.

The Picasso shows the artist beside his easel gazing intently at a nude woman lying on a bed. Hockney told me: 'I loved the way it so obviously concerns looking and thinking about drawing and painting. It's one of a series of thirty-two painted in a couple of weeks in 1965. They were a revelation to me, so inventive, every one is different. It's an age-old theme, the artist and his model, something most artists have to deal with, certainly I do, but only a master could have done this. Picasso was eighty-four, and it shows he didn't decline at all at the end of his life. I gave a little lecture the other day at the Los Angeles County Museum, I called it "Major Paintings of the Sixties". The audience was a little surprised when I started by saying that the most important art of the sixties was produced in two weeks in March 1965 in the south of France. When I explained I meant Picasso's thirty-two pictures of "Artist and Model" they were even more surprised. But I was right – those paintings were more enriching than anything else being done at the time.'[9]

Hockney's Picasso is prominently displayed in a sequence of colour photographs of the house and pool which was published in *Architectural Digest* in 1983.[10] His father's painting of Laurel and Hardy is featured in a triptych called *Hollywood Hills House* which he had painted from memory in London during the Christmas of 1980 to cheer himself up amidst the London fog and ice. The left-hand panel shows the studio before the alterations, with the sets for *Mamelles* and *L'Enfant* in the middle of the floor. The other two panels are a Matisse-like arrangement of brightly coloured shapes suggesting the terrace in its original colour of dark red, a giant palm tree, and the pool with its brick surround bathed in golden rays of sunshine. At the beginning of 1982 when he was buying the house, Hockney painted a series of three large and colour-ful gouaches, all entitled *House, Palm and Pool*, which were inspired by the central and right-hand panels of the earlier picture but which show the new colour schemes of his home. He also started a large double portrait of his brother Paul and his wife Jean who were visiting from Bradford. They were shown seated in the studio-living room with a view of part of the terrace behind them, but the painting was never completed. The reason for this was that a new interest was about to transform his work: creative photography.

Hockney had, by early 1982, filled about 120 volumes of his photographic albums, but they were, in his view, scrap-books of travel memories plus ideas for paintings, nothing more than that. In 1981 Ileana Sonnabend, a New York art dealer, looked through the albums and published a portfolio of twenty photographs, beautifully printed in Paris, which were sold, to Hockney's consternation, for $400 a print. Then the Pompidou Centre, the Paris Museum of Modern Art, asked if they could hold an exhibition of Hockney photography. He was very reticent about the idea, but finally allowed Alain Sayag of the Pompidou staff to come and choose some examples from the albums in January 1982. During this stay they argued for hours about the merits of photography: 'My main argument was that a photograph could not be looked at for a long time. It has nothing to do with the subject-matter. I first noticed this with erotic photographs, trying to find them lively: you can't. Life is precisely what they don't have, or rather, time, lived time.'[11] Since the negatives of the photographs chosen by Sayag could not immediately be found, Hockney bought boxes of Polaroid SX-70 film and made instant copies to be used for reference in Paris. He was left with several packs of unused film and, in order to convince himself of the limitations of conventional photography, he experimented by taking a host of shots of the interior and exterior of his house. Recalling his three-panel painting *Hollywood Hills House* of 1980, he began in the studio, then walked onto the balcony and finally out to the pool. As he progressed, he arranged the images side by side on a table, building up a rectangular panel consisting of three lines of

ten Polaroids. The result, he felt, conveyed the actual experience of walking through the house and into the garden. He glued the thirty photographs onto a board and inscribed across the borders of the lower images: 'My house, Montcalm Avenue, Los Angeles, Friday February 26th 1982. D.H.'

Hockney felt instinctively that this casual experiment was to have important consequences for his work. 'From that first day, I was exhilarated. First of all, I immediately realized I'd conquered my problem with time in photography. It takes time to see these pictures – you can look at them for a long time, they invite that sort of looking. But more importantly, I realized that this sort of picture came closer to how we actually see, which is to say, not all-at-once but rather in discrete, separated glimpses which we then build up into our continuous experience of the world.'[12]

In his albums there are various earlier examples of collaged photographs, the earliest being from 1967 when he and Peter Schlesinger photographed each other on a park bench in Paris; Hockney then joined the two pictures so that they appeared to be sitting on the bench together. Other images composed of more than one photograph include his father in his workroom in Bradford (1969), Rudolf Nureyev in Richmond (1970), Peter Schlesinger posing in Hyde Park for *Portrait of an Artist* (1972) and a ten-photograph image of the swimming pool at the Munich Olympic Games (1972). These were composite close-ups designed to avoid the distortions of a wide-angled lens. The Polaroid 'joiner', as he christened it, had a far more serious purpose. Nearer in effect was a sequence of eight photographs of Henry Geldzahler taken in a park in Germany during the summer of 1981. While taking the photographs Hockney noticed two boys leaning over a bridge in the background: 'I thought one of the boys had a very nice bum, with his blue jeans on.'[13] Using his zoom lens he focused on the boys over Henry's shoulder, and as the sequence progresses, Henry turns to have a look as well.

During the week following the first Polaroid experiment, he made eight more joiners, concentrating his attention on people rather than objects or views. The largest is a grid of sixty-three Polaroids building up a double portrait of Christopher Isherwood and Don Bachardy. They are shown against the wall of the studio to which are pinned two of the recent gouache paintings of the house and garden. Isherwood is seated, enjoying a glass of wine, while Don Bachardy stands looking down affectionately at him. Isherwood's head is captured in one Polaroid while Bachardy's takes up five, expressing the movement of his glance. Hockney explained: 'At first they were both looking at me, but as the minutes passed, I noticed that Don spent more and more time gazing down at Christopher with that fond, caring look that so characterizes their relationship.'[14] 'So I altered the picture to include this, re-photographing parts of Don when he thought I'd done that bit. In this way I got a more interesting picture, altering it as I went along. I

thought, you're halfway through the picture and you can still alter it! This is not like an ordinary photograph. It's really about drawing.'[15] It took him over two hours to make the collage, choosing one notional vantage point and then moving throughout the field of vision taking close-ups through the fixed-focus lens of the Polaroid camera. As he took each shot, he would lay it carefully on the floor to develop while he pounced on the next detail. Isherwood thought he was behaving like some mad scientist, but was fascinated to see how the enterprise finally turned out. Hockney felt he had really captured the essence of the relationship of these two important friends whom he so admired and envied.

In early March, Nathan Kolodner in New York received a telephone call from Hockney: 'I've discovered something really important with photography, you must come and see me now.'[16] Kolodner obligingly flew to Los Angeles on 10 March and stayed up half the night looking through the new work. He was very excited and immediately suggested a show of the Polaroids at the Emmerich Gallery later in the year. On 11 March Hockney made a joiner of Kolodner swimming in his pool. The Polaroids were taken very close to the surface, so that he seems almost to fill the whole pool: one breast-stroke movement takes him from one end to the other. On 31 March Hockney followed this with a much larger joiner of Gregory swimming in the pool. The 120 Polaroids were taken from further away, so that the naked form of Gregory appears about thirty times throughout the wide expanse of the joiner, making the pool of Olympic proportions. Hockney saw this as his version of a Tiepolo ceiling with Gregory as a multitude of erotic angels ascending into the deep blue sky. He later made two more joiners of the pool, one in bright sunlight and the other in a shower of rain. It was an ideal subject, with its pattern of French marks on the bottom, and these photographs were the latest in a long line of images showing his fascination with light on the surface of swimming pools.

Hockney made more than 140 joiners between the end of February and early May 1982. Many were portraits of friends – Nick Wilder, Kasmin, Gregory Evans, Jerry Sohn, Celia Birtwell and her children Albert and George, Stephen Spender, Henry Geldzahler, Billy Wilder and his wife Audrey. On a visit to London in May he added David Graves, Ann Upton, Vera Russell, Patrick Procktor, and highly effective double portraits of George Lawson and Wayne Sleep, and of Paul Kasmin and Jasper Conran, sons of his two friends (see plate 154). This latter pair stand in front of the painting *Ravel's Garden with Night Glow*, and their blue jeans and shirts almost merge into the twilight blue of the picture. There is also a clever study of the photographer Bill Brandt and his wife looking at their Polaroids placed on the floor, as they are taken. Brandt suggested Hockney should include himself, and so he substituted Polaroids of his own face in the finished version. In all these images, he felt he was approaching something as

exciting and potentially fruitful as Picasso's Cubism, and two joiners were deliberate pastiches of a Cubist still life with guitar and other objects. He saw Cubism as having brought about the destruction of a fixed way of looking at the world, and as having led not to abstraction but to a different view of reality. In a lecture at the Victoria and Albert Museum in London in 1983 he said that with conventional photography 'You're simply looking through a window. Cubism is a much more involved form of vision. It's a better way of depicting reality, and I think it's a truer way. It's harder for us to see because it seems to contradict what we believe to be true. People complain when they see a portrait by Picasso where for instance someone has three eyes. They say: "But people don't have three eyes!" It's much simpler than that. It's not that the person had three eyes, it's that one of the eyes was seen twice. This reads the same way in my photographs.'[17]

In London, in the summer of 1982, Hockney began a large painting entitled *Four Friends* which shows the immediate effects of his Polaroid experiments. The picture consists of eight separate canvases, each one depicting the upper or lower half of one of the four figures. Each figure is seated but with a different background, and they all have either multiple limbs or facial features. The panels were painted very fast and left in an incomplete state, and the picture has never been exhibited. But it taught him how to use his new ideas in his painting. Although clearly indebted to Picasso, there also seems to be more than a hint of Soutine's large seated portraits, with their distorted features and concentration on the hands, particularly his *Woman in Red* of *circa* 1923.[18] Hockney had written an essay on Soutine while at college in Bradford, and in an interview published in early 1983 he talked admiringly of Soutine's 'marvellous portraits'.[19] For the subjects of *Four Friends* he chose those who happened to be near at hand. They included Celia Birtwell, David Graves, Stephen Buckley and a new friend he had brought with him to London, Ian Falconer.

Hockney had met Ian Falconer at Henry Geldzahler's apartment in New York while rehearsing the *Parade* triple bill at the end of 1980. Ian was a friend of Henry's lover Raymond Foye, and had just started a course in Fine Art at the Otis Parsons School of Design. He was nineteen and was very excited by the glamour surrounding the great David Hockney. For his part, Hockney immediately fell for the charms of this attractive and highly intelligent boyish blonde, and a relationship developed. At first Hockney felt rejuvenated and was happy to take Ian to fashionable nightclubs like Studio 54 and dance the night away. New York nightlife had never really appealed to him, however: it was the world of Andy Warhol and there was no room for rivalry, friendly or otherwise. He much preferred the social life of Los Angeles, and had returned there in early 1981 to work on prints at Gemini Press and to prepare his designs for the Stravinsky triple bill. In spite of his closeness to Gregory, he had nevertheless missed Ian's company, and had

persuaded him to move to the sister college of Otis Parsons in Los Angeles at the beginning of 1982, when Gregory was away. However, Ian found that the college taught little more than cottage crafts and quit, declaring that he needed no other teacher than David Hockney (see plate 149). So it was that he appears in some of the very first Polaroid joiners, such as *Ian with Self-Portrait* (2 March 1982) and *Ian and Me Watching a Fred Astaire Movie on Television* (6 March 1982).

After the burst of Polaroid activity in May 1982, Hockney and Ian left London for Paris where Alain Sayag was trying to put his photographic exhibition together. Raymond Foye joined them from New York to edit the catalogue, and the three of them stayed for a while in Jean Léger's apartment in the rue de Seine. The result was chaos: the apartment was small, and neither Hockney nor Ian was a tidy person. The living room was soon knee-deep in discarded clothing, and when a French radio interviewer called to speak to Hockney he recoiled in horror. The three therefore moved to a nearby hotel. Raymond's position was a delicate one, for he could see that Hockney was trying hard to forge a closer relationship with Ian, at this time without much success. Ian would want to spend the night dancing in the clubs and meeting other young gays. Hockney would be left at the hotel with Raymond who would then witness the rows next morning as Ian teased Hockney with tales of the previous night's sexual exploits. Hockney felt Ian was being cruel to him, yet he had to try to take into account the fact that Ian was very disturbed that his father was dying of cancer at that time.

The Emmerich Gallery in New York showed the Polaroid joiners in an exhibition appropriately called 'Drawing with a Camera' in June. The show then travelled to Los Angeles and London. It was decided at the start that none of the pieces would be for sale, as their durability was open to question owing to the nature of the Polaroid process, and this has remained the policy. Very few critics reviewed the exhibitions initially, since there was some uncertainty as to whether the images came under the heading of 'art' or 'photography'. Revealingly, it was the prestigious New York photographic magazine *Aperture* which took the plunge: 'The visual pleasure here is a sensuous exploration of surfaces. The artist moves around the room, approaching the object of desire, embracing it at a distance as the shutter clicks and the electronic motor purrs, then retreating and moving on to the next. The composite image is reconstructed from a composite of sensory experiences, of surfaces seen and collected. The wholly mundane compendium of objects in the room assumes the dimensions of a spectacle . . . The grid is a rational structure for an exercise in intoxicating sensuality. The drab and insignificant become the singular and radiant . . . David Hockney is a painter who happens to take pictures from time to time. Now, it seems, he is becoming a painter who is a photographer as well.'[20]

In London there was less reticence: in the *Sunday Times*, Marina Vaizey described the joiners as 'captivating explorations of the mosaic of form',[21] and John Russell Taylor wrote in *The Times* that the images were 'unmistakable Hockney: yet another refutation of the detractors who insist that Hockney is just a clever technician with a pencil. The quality and individuality of his vision set him apart from an army of imitators; and they have seldom been so sharply, nakedly in evidence as here.'[22] Other critics were less happy and questioned the originality of Hockney's conceptions. It is true that artists Gilbert and George had mounted photographs together in a series of photo-installation pieces between 1972 and 1974 such as *Raining Gin* and *Dark Shadow*,[23] but the technique and the effect were quite different. Andy Warhol had made a jokey Polaroid collage of a nude woman for the German edition of *Playboy* magazine in August 1974, but a more significant precursor was the Belgian photographer Stefan de Jaeger. He had been exhibiting 'Polaroid paintings', large-scale portrait and landscape composites including up to 700 snapshots, in Brussels and Paris since 1979, and he was so angry when he saw the Hockney joiners in a magazine that he visited the Emmerich Gallery to accuse Hockney of plagiarism. Hockney denied ever having seen de Jaeger's work. It is certainly not unusual for artists to hit upon new techniques at the same time. In any case, de Jaeger's images tend to be portraits against plain backgrounds which depend for their effects on the patterning of clothing and other textures, and they are imbued with symbolic meaning, whereas Hockney's joiners relate to the psychology of perception.[24] One artist well known for his Polaroid experiments is the American Lucas Samaras, but his 'autopolaroids' of the late seventies were transformations of individual photographs, and it was only in 1983 and 1984 that he began to make collaged photo-pieces.[25]

In early July, Hockney and Ian were in Paris for the opening of the Pompidou Centre's exhibition of photographs which concentrated on the wealth of material in the albums but came right up to date with some Polaroid pieces. They returned to London, where Hockney worked on the painting *Four Friends* and also completed a full-length, seated portrait of David Graves deriving from his section of the other painting. It was entitled *David Graves in Harlequin Shirt* and this time consisted of three joined canvases. The whole image was over ten feet high. The painting continues Hockney's Polaroid experiments and has a strong Picasso flavour, with its four hands and three feet and with both sides of the face depicted together. Especially effective is the patterning created by the colourful shirt, but the enormous painting as a whole does not exhibit the degree of confidence one could expect from a fully-resolved idea. At the same time Hockney made his last Polaroid joiners, including one of Henry Moore resulting from a visit to the sculptor's studio at Much Hadham on 23 July (see plate 155). Moore

was fascinated by Hockney's photographic ideas, and Hockney was in turn intrigued to see Moore's hands: 'I thought his hands were quite marvellous, and he tends himself to draw marvellous hands, so I put in a lot of his hands.'[26] The concentration of seven depictions of hands in the joiner of the sculptor seated in his studio gives the image a special relevance to the sitter, and makes the result a far more successful evocation of Henry Moore than the drawings Hockney had made at the Café Royal in 1972.

In August Hockney took Gregory to stay with their friend Dagny Corcoran at her summer house on the island of Martha's Vineyard off Cape Cod, Massachusetts. After all the photographic activity of the previous months, he decided to leave his Polaroid SX-70 behind, and took with him a sketch-book instead. In 1985 he agreed to have an exact facsimile of the sketch-book published as *Martha's Vineyard and Other Places*.[27] Hockney always makes drawings on his trips; the large exhibition of 1978–80 entitled 'Travels with Pen, Pencil and Ink' demonstrated the wealth of material that results. The Martha's Vineyard sketch-book is different in that it contains quick sketches and simple doodles as well as more finished images, and these were not originally intended for sale or for publication. Most of the pages, therefore, seem very slight as examples of Hockney's skill, yet the whole book offers an interesting opportunity of watching him at work. The images range from a copy of an Ingres and a drawing of Hockney's left hand holding his pens, to quick sketches of Gregory having his hair cut, Henry Geldzahler *à la Picasso* smoking a cigar and Ann Upton as voluptuous as a Renoir. Hockney makes colourful crayon drawings of his bedroom and views of the island with the deep blue sea, as well as careful pen-and-ink studies of a table with telephone and tea pot complete with Lipton's tea-bag label, and a pile of books representing his reading material for the holiday. In two places he has left a portrait unfinished and closed the book, leaving smudges on the opposite page which he has later, in fine surrealist fashion, incorporated into an expanded image. In his introductory note to the facsimile, he cites the Moroccan sketch-books of Delacroix as good reasons for finding interest in such seemingly ephemeral activities as holiday sketching.

At Martha's Vineyard Hockney had his little Pentax 110 camera, but he hardly used it except to take a sequence of ten views around his bedroom. On his return to California he had the film developed and then stuck the photographs on a board to make a more or less continuous image. It was not as striking as his Polaroid joiners, but he felt that the lack of the grid formed by the white surrounds of each Polaroid photograph was a positive advantage. He began to realize that the grid created a window, and yet he had been trying to destroy the whole concept of window vision, the idea of an image being a view through a window. And the Polaroid pieces took time, for he had to wait for each snap

to develop. With his Pentax he could take photographs as fast as he could release the shutter, and its zoom lens enabled him to take close-up details of far more extensive scenes.

In order to experiment with the new camera, Hockney drove through California, Utah and Arizona in September, taking literally thousands of shots of scenes such as the Yosemite Valley, Zion Canyon and the Grand Canyon. On his return, he had the films developed at Benny's Speed Cleaning and One-Hour Processing Shop, and then began fitting the shots together, ignoring the polite notice from the developers pointing out all the basic mistakes he had made. He made a collage of *The Grand Canyon from North Rim Lodge* consisting of four rows of six snaps which gave the impression of having consecutively focused on each part of the scene, pausing only to press the shutter. The resulting image was once more a rectangle but without the white grid lines. This was too predictable and conventional, so he made another one of *The Grand Canyon Looking North* consisting of over 150 shots arranged in a broad curve which echoed the sensation of looking round the scene. The photographs were placed so that they overlapped in most places, thus building up a much less regular pattern. The resulting image is enormous, and has an extraordinary vividness and clarity that recalls Flemish fifteenth-century altarpieces. This is because every constituent part of the image is in focus, unlike a conventional photograph where certain areas are bound to be out of focus. Hockney felt that this new technique of making what he called 'photo-collages' was a breakthrough: 'I realized I'd found a way to show the grandeur and genuine awesomeness of these landscapes that I'd always felt, but which photography, it seemed to me, had never been able to show.'[28]

Other photo-collages resulting from this autumn trip included dramatic views of Yosemite Valley, the Merced River, and an amusing image entitled *You make the picture, Zion Canyon, Utah*. In the background are the towering rocks and their tree-covered lower slopes, and in the foreground is a tourist sign which reads 'The Great White Throne challenges photographers, amateurs and professionals alike. Changing light and shadow change the mountain's mood, and the pictures you can get. Let your imagination guide your lens. Remember that your camera only records what it's pointed at – you make the picture.' Below it can be seen yellow Kodak boxes and used spools of film, and at the bottom of the picture appear Hockney's feet. Thus he indicates his own presence – 'I am making the picture' – but he is also in the picture; so the picture conveys the physical experience of the scene rather than merely the look of the scene. From now on, he would frequently include his feet or his hand or his shadow in the photo-collages.

These images may have the clarity of Van Eyck but, for Hockney, they were a further experimentation with the ideas of Cubism and drew on his longstanding interest in

Chinese painting. Recently he had read George Rowley's *The Principles of Chinese Painting*, in which he writes of 'the supreme creation of Chinese genius – the landscape scroll', and goes on: 'We restricted space to a single vista as though seen through an open door; they suggested the unlimited space of nature as though they had stepped through that door and had known the sudden breathtaking experience of space extending in every direction and infinitely into the sky.'[29] Hockney felt, with reason, that his landscape photo-collages were a movement in this exciting direction.

During the next nine months Hockney travelled to London, Bradford, New York, Minneapolis and Japan, and in each place he continued to take thousands of individual photographs. During that period he made about 200 collages, many consisting of well over a hundred shots. As with the Polaroid joiners, he often concentrated his attention on people. In Bradford in November he photographed his mother in the rain among the graves in ruined Bolton Abbey, where she and his father had done their courting in 1926. The resulting collage is a moving and atmospheric image of an elderly lady among emblems of mortality. In January 1983 he took Ian Falconer for his first view of Yorkshire, and made collages of him among the ruins of both Bolton Abbey and Fountains Abbey, as well as outside Ponden Hall where his college friend Rod Taylor lived in the original for Thrushcross Grange of *Wuthering Heights*. The bleakness and gloom of these images, together with his view of the craggy rocks of Gordale Scar, seem out of character, but in November 1982 he explained in a BBC radio interview: 'I've always thought that while I love the sun and I love the Mediterranean aspect of California, I also do like Gothic gloom in a way and I've a weakness for it and I assume that's Bradford in a sense. Bradford makes me think of fairy tales, Grimm's fairy tales – that's the Gothic gloom side and when you think of all that neo-Gothic architecture of northern England or even the ruined abbeys of Yorkshire and so on, that's the side obviously, isn't it? I can always remember as a child on rainy days how black they were then, and you know, it's rather an affectionate image.'[30]

In London he made collages of Sir Frederick Ashton, Norman Stevens, David Graves, Celia Birtwell and her two boys plus the cats Blanche and Percy, and a complicated image of Ian washing his hair in the bath. I well remember visiting Pembroke Studios one day to find him crouching on the floor beside a large sheet of grey cardboard. David Graves had just come back from the local chemist's shop with the latest batch of photographs of the interior of the studio, and Hockney was checking whether his memory had served him well since he had had to work without the advantage of the immediacy of the Polaroids. He very rapidly fitted the new photographs into the collage, rejecting a few but including the majority, all the time giving me a running commentary on how anyone could do the same with a little imagination, since it did not require expensive equipment or

specialist knowledge. In New York for a repeat of his *Parade* triple bill, he photographed John Dexter rehearsing *Les Mamelles de Tirésias* in the Metropolitan Opera House, and an ice-skater in convoluted movement for a 1984 Winter Olympics poster. Movement was an interesting challenge in the collages: *Raymond Foye Looking at Brooklyn* shows Raymond in profile looking out of a window on the right, and on the left we see the back of his head and the view he is looking at. One of the most complicated collages is a view of the Brooklyn Bridge, an eight-foot-tall vertical image which concentrates on the intricate spiderweb patterns of the cables and the sharp textures of the planks of wood which make up the floor. This startling creation took two weeks to assemble.

From the same visit dates a collage of Hockney's close friend Joe Macdonald in his apartment. He stands among his Hockney souvenirs, a *Parade* poster, a 'Paper Pool' and a lithograph of him and a friend. Beside him is a drawing with the inscription 'Dearest Joe, get well soon.' Joe was to die tragically a few weeks later of AIDS, a disease which was also to kill other close friends of Hockney including Jean Léger, Alexis Vidal and Larry Stanton. He contributed an essay to a posthumous book on Larry's paintings and drawings.[31]

When Hockney had photographed Sir Frederick Ashton in January at Pembroke Studios, they were meeting to discuss a further theatrical collaboration. Ashton had choreographed Stravinsky's *Le Rossignol* for the Hockney/Dexter triple bill in 1981, and he had invited Hockney to design a backdrop for *Varii Capricci*, a ballet he had created to music by Sir William Walton for the Royal Ballet's appearance in April at the Metropolitan Opera House as part of the 'Britain Salutes New York' festival. Ashton had first collaborated with Walton in the creation of *Façade* with Edith Sitwell in 1931. *Varii Capricci* had been written for the guitarist Julian Bream in 1972, but later orchestrated, and Ashton had asked Walton to expand it for the Royal Ballet in 1982. It was Walton's last project before his death early in 1983, and the performance of Ashton's ballet was dedicated to his memory. Hockney was delighted to contribute since he was a friend of both Ashton and Walton. Ashton suggested a backdrop which would evoke Walton's garden on the island of Ischia, 'a tropical paradise packed with rare ferns, camellias, exotic trees, and a luxurious swimming pool from which the idle guest has a perfect view of sea, sky or Vesuvius'.[32] It was a perfect subject for Hockney; his design depicted a deep blue swimming pool recalling his set for *Septentrion* of 1975, but this time bordered with palm trees and vividly-coloured flowers, with cypress trees to the left and an elegant house exterior to the right, all set against an orange sky. Ossie Clark had been brought into the project, and designed rather fluttery costumes in pastel shades for the wealthy lady (Antoinette Sibley) and her friends, and a smart black and white outfit including dark glasses and greased black

hair for the gigolo (Anthony Dowell) who has a sexual flirtation with her and then mysteriously disappears. Hockney's backdrop perfectly catches the atmosphere of the piece, which was an enormous success in New York, a success repeated later in the year at Covent Garden.

David Over Exposed
Hayward 1983

Gerald Scarfe

CHAPTER ELEVEN

AMERICA, JAPAN AND MEXICO 1983–1985

In February 1983, Hockney travelled with Gregory Evans to Japan to speak at a conference about the uses of paper in art. The visit resulted in some of the most ambitious of all his photo-collages. *The Giant Buddha, Nara* is a very large image of the interior of the temple containing the seated Buddha and its companion. The viewer's eye is led into the temple by Hockney's shoe in the immediate foreground, and then in various directions along the textured paving stones, with their patina of age, until it reaches one of the many enormous pillars of red wood which rise up to the intricate matrix of the ceiling. It constitutes a deceptively simple rendition of a complicated three-dimensional space. In *Gregory Watching the Snow Fall*, Hockney's bare feet next to *A History of Haiku* introduce us into his hotel bedroom, where Gregory lies in bed looking up at him and then out at the snow-covered garden with its ornate stone lanterns. The image demonstrates that these collages can be touchingly intimate, even though they are more usually dramatic. As a further experiment with movement, Hockney made *Walking in the Zen Garden at the Ryoanji Temple, Kyoto*; his alternately red and black socks border the garden in the immediate foreground, above which stretch vertical strips of individual shots of the pebbles right up to the boundary wall of the garden at the top of the collage. The shots were taken from the different stages of the walk along the edge of the garden, and the well-over-160 individual photographs of pebbles were a real headache to assemble. The most ambitious of the Japanese collages is *Luncheon at the British Embassy, Tokyo*, a four-foot by seven-foot depiction of real space and real time. Ten people sit round a polished wooden table on which Hockney's place-card and two rolls of film indicate his presence. It shows various stages of conversation between the diners, who include Paul Cornwall-Jones and Gregory, as well as the Ambassador and his wife, and their multiple images are skilfully integrated into the collage. From the rich patterns of the carpet to the ornate cornice of the ceiling, a complete image of the room is built up, even though there are large gaps in the collage. As the eye roams around the table, it catches sight of a servant in the far right-hand corner who has just brought in the wine. No wide-angled, static photograph could have even approximated the experience conveyed by this collage.

Back in Los Angeles, Hockney felt he had nearly exhausted the new idea, but he made four more collages. *Ian Drawing Ann* is a fascinating image of Ian Falconer crouching on

David Over Exposed, Hayward, by Gerald Scarfe, 1983

the floor of Hockney's studio, concentrating intently on the paper in front of him and looking up every now and then at Ann Upton who sits opposite him making a colourful rug. Photo-collages of the Grand Canyon and of Gregory in Japan are included in the background. Another image shows theatre director Bob Holman talking to Christopher Isherwood and Don Bachardy in their Santa Monica house. He had invited Hockney to make some designs for a W. H. Auden play, *Paid on Both Sides*, which was to be performed in New York in May, and he is shown discussing Hockney's sketches with Isherwood, who had collaborated with Auden. *Fredda bringing Ann and Me a Cup of Tea* is a highly complex image resulting from a British television interview for the *South Bank Show*, where Hockney was asked to make a collage on camera. The television crew can be seen crouching in one corner of his garden (where the interview took place), mistakenly thinking they are out of sight, and a letter is included in the collage in which the film developers apologize for ruining one of the rolls of film, a nice conceptual touch.

The last of the series of photo-collages is *The Hawaiian Wedding* of May 1983. David Graves was by now helping Hockney assemble the photo-collages, and he and Ann Upton decided to marry. Hockney insisted they should do it in style, to provide the occasion for a spectacular collage, and he arranged that they should travel with him and Ian to Hawaii. On 20 May the four of them took a boat to an island grotto where the rather kitsch ceremony took place. The official performing the ceremony was somewhat taken aback to find that the proceedings seemed merely an excuse for an elaborate photographic session. The resulting collage is the largest and most complicated of the whole series; it consists of an irregularly shaped frieze six-foot high by six-yards long, and represents a narrative account, with the boat trip depicted on the left-hand side, complete with serenading musicians, the walk to the grotto in the centre and the ceremony itself on the right-hand side. Inevitably, Hockney did not have time to take as many photographs as he needed, and so he has drawn a few extra details on the collage in coloured crayon. The resulting image is too fragmentary and confusing to be a complete success.

At the beginning of 1983 he decided to show his photo-collages at the Emmerich Gallery and to allow editions to be made for sale. The Polaroid joiners had been necessarily unique pieces, but since the collages were made from conventional negative film, there would be no problems in making exact duplicates. At a meeting in March in Los Angeles, Paul Cornwall-Jones, as Hockney's publisher and business manager, agreed with the dealers Nathan Kolodner and Peter Goulds that there would be no more than nine in each edition, and that the market could only bear prices of between $1,500 and $10,000 according to size. David Graves was in charge of production, and he set up a workshop in the Santa Monica Boulevard studio, with about ten assistants. Graves' training as an architect and his previous work as an interior designer meant that he was used to

complicated projects, but he found this a real challenge. It had been decided to produce editions of just forty-two of the photo-collages, and each one had been re-photographed and pasted in a master note-book for reference. The relevant negatives for each collage had to be found and identified, and then multiple copies of every separate photograph had to be made so that an assistant could begin the extremely complicated task of making a duplicate copy of Hockney's original collage. Every day he would visit the studio and inspect the progress of the work. If he was satisfied with a finished panel, he would inscribe it with title and signature and it would then go to be framed.

In April Kolodner took twelve photo-collages to the Venice Art Fair to sound out the market. Dealers were very suspicious: they did not look like Hockneys, they were not originals, the colour would fade. Only five were sold. Meanwhile, to Kolodner's consternation, Paul Cornwall-Jones had increased both the edition numbers and the prices. He then sold a number of the collages to each of Hockney's dealers at the very high discount of 50 per cent. This brought him almost immediately half a million dollars. Unknown to anyone, Petersburg Press was in financial difficulties and the money was to keep the firm afloat.

In May the Emmerich Gallery showed the collages under the title 'New Work with a Camera'. At the same time, exhibitions were held in Los Angeles, Chicago, Tokyo and at Kasmin's new gallery in Cork Street, London. There was resistance everywhere to buying the work. By now Hockney had applied a hand-stamp to each image which read: 'Not recommended for investment. Buy for pleasure only.' Critical reception was mixed, as had been the case the previous year with the Polaroid pieces. The British photographer David Bailey described the work as 'nothing but rubbish, unoriginal and executed without any real understanding of what's going on',[1] but Henri Cartier-Bresson wrote to Hockney from Paris to say how wonderful they were. In *Arts Magazine* (New York), Jon R. Friedman wrote: 'The ordinariness of Hockney's materials and the accessibility of his procedures shouldn't distract us from the originality of his conception and the subtle beauty of his results.'[2] Colin Ford, Keeper of Britain's National Museum of Photography, declared: 'I believe he is the first to have mastered the crucial element of time. It makes his photographs unique, just as Cubist paintings are. Indeed, they help one understand Cubism . . . I believe that Hockney has made an important contribution to the art of photography.'[3] And the *British Journal of Photography* described the works as 'unforgettable', 'a revelation', and 'the single most important photographic exhibition for over ten years', concluding: 'Hockney has succeeded in doing what photographers have been struggling to achieve (often without realising it, unenlightened as most of them are) for decades – namely "exploding" the confines of the photographic frame as we have come to know it.'[4] The sourest note was sounded by Stuart Morgan who wrote in *Artscribe* about Hockney's 'transition from Angry Young Man to Boring Old Fart' and

went on: 'Of late he has been trying to forget the brick wall his painting had hit by photographing it in pieces hundreds of times, sticking the bits together, calling it *Brick Wall, L.A., 1982* and then telling us how he has re-defined photography . . . In all of these, an applied style kills the subject and makes the whole business little more than a technical exercise.'[5]

After *Hawaiian Wedding* of May 1983, Hockney decided to stop his photographic experiments; he had achieved what he wanted, a form of photography which reproduced the natural dynamics of looking. He had been asked to collaborate in making an exhibition of his work for the stage, to be held in Minneapolis in November. But in June of 1984 he returned to photography to make two more collages, *Desk, London*, an opened-out view with some of his favourite books including Cosima Wagner's *Diaries*, *The Complete Letters of Vincent van Gogh* and an album of Picasso's works; and *Nude, London* (see plate 156). This latter image was the result of a commission from film director Nicolas Roeg for a pin-up of Theresa Russell, who was playing Marilyn Monroe in *Insignificance*. Hockney decided it was only worth doing the job if he made it a really different sort of pin-up; thus the girl's body is fragmented so that one sees the front, back and side views at the same time. The contortions of her body are tantalizing: she sprawls on a pink silk sheet, eyes firmly on the viewer and tongue between her lips. Unlike a typical calendar girl, whom the eye takes in at one go, Hockney's pin-up requires the viewer to make a slow and careful examination of every part of her body. He discussed this in a 1984 video interview for the Archives of American Art at the Smithsonian Institution: 'Only erotic photographs inspire you immediately to look for more than thirty seconds, and my pin-up requires you to look very slowly, you are forced to move over every inch of her body which makes it more interesting, more erotic. It was the most complicated photo-collage I had attempted, because I wanted to push my ideas further. Every one of the 170 photographs was taken from a different position. It was really just like drawing – I could do whatever I wanted.'

After the Emmerich show of photo-collages in May 1983, Nathan Kolodner was in Switzerland on vacation when he received news that Paul Cornwall-Jones and the Petersburg Press had gone bankrupt. He immediately contacted Hockney and flew to London. None of the money from the sale of the collages had reached Hockney, and he was owed a great deal in addition. His capital was all tied up in property and investments and he had little ready money to pay bills and staff salaries, so he was obliged to sell to the Emmerich Gallery a great deal of work he had wanted to keep. While Cornwall-Jones was acting as Hockney's business manager and publisher, the Petersburg Press was expanding enormously on the proceeds, without him being aware of what was happening. When friends had warned him in the past that undue advantage was being taken of him, he had

taken no notice at all, preferring to continue with his work. Yet he was bitter at what had happened, and ever since 1983 he has retained full control of his business affairs. At the time of the bankruptcy, Gregory Evans took over some of Cornwall-Jones' responsibilities, and David Graves left the Petersburg Press to become Hockney's full-time assistant. Cornwall-Jones has had no further involvement in his affairs. He told me recently that he thinks Hockney never fully understood the problems under which he had to work: 'I acted as his business manager for six years, and my company the Petersburg Press kept offices in London and New York to enable us to work for him and to service him. He needed people to do things for him and he needed a constant income, without the pressure to produce work for sale. We diverted our energies into looking after him without being fully paid for our time and energy. I instituted a series of dealers all over the world to whom his work is syndicated. David has a big ego and he needs people to help him who understand him and are sympathetic to his foibles. I set up a structure which is still in place, and I taught him how to run his empire.'[6]

When Hockney bought his Montcalm Avenue house, it had a paddle tennis court in addition to the swimming pool. He badly needed more room for work, so he employed an architect to design a large studio with ceiling panels to give him a good north light. The new studio was built on the site of the paddle tennis court and was completed in July 1983, just in time for him to work on his November theatre show for the Walker Art Center in Minneapolis. Hockney had agreed to the show back in 1980, but only now had he begun to consider how it would look. He was not happy to show only sketches and models, and so he decided to recreate some of the sets, which would then be shipped to Minneapolis, in his new studio. It was an enormous task, for which he had the help of Jerry Sohn, Ian Falconer, David Graves and Mo McDermott as well as Ron Elliott, a technician from the Walker Art Center. First, he painted five large panels for *Les Mamelles de Tirésias*, and then hit on the witty idea of creating the characters of the opera on about thirty small canvases. On these, he painted hats, heads, torsos, legs et cetera, so that all sorts of male and female combinations were possible, much in the manner of the surrealist game of *cadavre exquis*, which was in perfect keeping with the role-reversals of the main characters. For the Bedlam scene of *The Rake's Progress*, he painted yards of canvas with graffiti and cartoon drawings and then designed a series of masks in Styrofoam coated with plaster of Paris for the madmen. These were sent to Minneapolis, where they were mounted on poles wrapped in grey cloth and set in the boxes of the original design for Glyndebourne.

Next to be recreated was *The Magic Flute*. Hockney stapled an enormous canvas, forty-foot long and ten-foot high to the studio wall and painted the desert scene with long-handled brushes in bright sparkling colours. The result is his largest single painting. The animals and the figure of Tamino were made out of Gatorfoam in flat,

interlocking planes inspired by the recent photo-collages, representing Hockney's first sculptures, and the same inspiration lay behind his new version of *Le Rossignol*. He painted dozens of little canvases in shades of blue and white, and fitted them into a complicated arrangement so that the viewer would see the story unfold as he walked past. He later made a photo-collage of the piece entitled *Walking Past Le Rossignol*. After this, he recreated the Norman farmhouse interior of *L'Enfant et les Sortilèges* with the shepherds and shepherdesses materializing out of the wallpaper, the princess in multiple images stepping out of her fairy-tale book and walking across the stage, and a big black cat lying beside the glowing fire formed by building blocks.

Hockney moved to Minneapolis to complete the last two sets. The auction scene from *The Rake's Progress* was quite faithful to the Glyndebourne original, with alligators and Egyptian mummies cut out of Gatorfoam suspended from the ceiling and Hogarthian characters of the same material populating the stage. For *Le Sacre du Printemps* he painted a large canvas with primitively-dressed figures dancing around an abstract circle which would lie flat on the floor, and suspended behind and above it a large disc reproducing the design of trees and mountains from the New York production. This was to be placed in a black enclosure and lit by a slow-moving theatrical colour-wheel to bring about the change from the deadness of winter to the the rebirth of spring. Only one job remained: to create the garden of *L'Enfant* which would be entered through the already completed Norman farmhouse. Hockney was determined to give visitors to the exhibition the same thrill of excitement which the magical appearance of the garden caused in the theatre. He created a room with plywood walls covered with canvas on which he painted blue and red trees, clouds, rolling hills, pink dragonflies, black moths and bats and green frogs. The floor was covered with green carpet, and in the centre stood a giant red tree with blue foliage. The luminous paint was made to glow by clever use of the gallery lighting. Once inside, visitors could sit and listen to Ravel's beautiful music as they admired the magic garden all around them. It was the high point of the exhibition.

'Hockney Paints the Stage' had developed into a new art work. The show, with the seven painted environments as well as sketches and models and a few earlier paintings relating to theatrical devices, toured the world from 1983 to 1985, visiting Mexico, Toronto, Chicago, San Francisco, Texas and finally London. After the initial opening in Minneapolis in November 1983, Hockney travelled to London for a show at the Hayward Gallery of his photographic work. This differed from the Pompidou exhibition of the previous year, for instead of featuring individual snapshots, Hockney's albums were represented by whole pages, and sometimes double-page spreads, in order to introduce the theme of linked images. The show also included twenty-seven Polaroid joiners and forty-eight photo-collages, and ended with *The Hawaiian Wedding* as well as a series of drawings of the event. To coincide with the exhibition, he gave a lecture illustrated with

slides of his new photographic work at the Victoria and Albert Museum. The *Sunday Times* published an amusing and affectionate caricature of Hockney the photographer by Gerald Scarfe (see page 212).

Also in the busy month of November, Hockney was represented in an exhibition in London called 'The Male Nude – a Modern View'. An art consultant, François de Louville, had invited some fifty contemporary artists to submit works on the theme of the male nude in order to explore both the erotic and the aesthetic possibilities of the subject. Hockney sent nine drawings and in Edward Lucie-Smith's introduction to the resulting book, he is singled out as the most important contemporary artist to concern himself with the sexual realities of this subject. Lucie-Smith writes that 'Hockney's elegance and wit brought acceptability to aspects of sex considered almost unmentionable, and certainly universally rejected as subject-matter for serious art,' and he goes on to say that Hockney 'is quite candid about his own homosexual feelings . . . The unique aspect of Hockney's artistic personality is his openness; his unembarrassed capacity for expressing intimate feelings in public.'[7]

The drawings Hockney submitted included seated nude studies of Ossie Clark and Ian Falconer plus a sequence of seven drawings of Ian and himself entitled 'Waking Up' (see plates 147, 148). These images show him waking Ian from a nightmare and making love to him. They are very honest drawings which concentrate on Ian's bottom and show the contrast between the older and the younger body, together with the clumsiness of the one and the reticence of the other. There is no attempt to idealize such an unequal relationship. Hockney had drawn closer to Ian during 1982 when Gregory Evans developed a severe drink problem and had to spend some weeks in a clinic. The drawings in 'Waking Up' date from August 1983 when Hockney also painted three self-portraits of himself in bed with Ian which demonstrate a lack of closeness between them.

Hockney needed emotional contact to make possible his total devotion to his work. Neither Gregory nor Ian seemed willing or able to provide him with this support, which required submission to a dominating personality together with acceptance of his romantic and largely voyeuristic sexual demands. With both young men living in the Montcalm Avenue House, Gregory in his own room and Ian in Hockney's room, friction between the two was inevitable. Ann Upton was living nearby and found herself continually involved in three-way disputes. Gregory was finding it difficult to run the house with no help from Hockney, and Ian objected to his freedom being threatened by Hockney's sense of possession. At first Ann thought Ian was using Hockney and hated him for it, but then she came to realize that he was trying to grow up and develop his own talents, which were considerable, and she grew very close to him. Far from exploiting his position, Ian chose to move out of Montcalm Avenue while still remaining very friendly with Hockney, who followed up the August images with a September/October series of

about thirty-five self-portrait charcoal drawings (see page ii), in many of which he shows, with a similar degree of honesty, his feelings of intense dejection and despair.

At the beginning of 1984 he planned two paintings which relate to the Ian drawings and the self-portraits. On one canvas he drew in charcoal an image of Ian and himself making love, but never went on to paint it. However, he completed a self-portrait on two small joined canvases which must rank as one of the most personal of such images ever painted. He shows himself crouching on a bed naked with his eyes shut and mouth open in an expression of pain. He is sporting a prominent erection which forms the central pivot of the composition. One is reminded of Dürer's nude self-portrait drawing and Egon Schiele's paintings of himself masturbating. Hockney's charcoal drawings of himself from late 1983 and his *Erotic Self-Portrait* of early 1984 are uneven works, but their degree of self-revelation is quite moving, and they provide a useful antidote to the impression formed by many of his admirers of a man with a continually sunny disposition.

At the beginning of 1984, Hockney and Gregory joined Nathan Kolodner and three of his friends for ten days on the island of Mustique. They rented the palatial residence of Colin Tennant (Lord Glenconner) for a relaxing holiday in the sunshine. Gregory's drinking was under control and, although he and Hockney were no longer lovers, they were still very close. Princess Margaret was staying nearby, and when Kolodner met her on the beach she invited the whole group to a party. She is an admirer of Hockney's work and she asked if he would draw a birthday card for her house-guest Lady Buckhurst, a great fan of his. The group brought six bottles of champagne to the party and Hockney made a coloured crayon drawing of the bottles as his birthday gift.

On his return to Los Angeles, Hockney began a series of over thirty paintings that were to occupy him until the summer. It was the first concentrated spell of painting since the *Parade* works of 1980, and a clear demonstration of the lessons he had learnt from his photographic experiments. He had foreshadowed this in September 1983 in a letter to Mark Haworth-Booth, who had organized the Hayward Gallery exhibition of his photography: 'Where this is leading me I don't know yet, but naturally I'm very excited by it and realize the possibilities it opens up.'8 The first paintings, from the end of January, were composed of separate, small canvases as in some of the theatre re-creations. A self-portrait consisted of eight sections including hair, face, shoulder, torso, hand holding the brush, legs et cetera, although when Hockney later exhibited it in London he only showed five of the parts. There was also a portrait of Ian (two sections, a large head with a small body wearing only a pair of shorts) and an eight-panel image of a

rather inebriated Peter Langan who was trying, unsuccessfully, to establish a restaurant in Los Angeles.

In February, Hockney made four paintings of the view of his house, pool and garden from his terrace. Three are loosely constructed small- and medium-sized oils painted in bright shades of blue, red, green, yellow and pink. The fourth in the series was his first major work of 1984, *Self-Portrait on the Terrace*, a seven-foot by ten-foot painting consisting of two joined canvases (see plate 158). This is a night scene, with the intense blue of the terrace and its balustrade filling the foreground, beyond which can be seen the illuminated pool set against the dark green of the garden. On the right-hand side stands the sketchily outlined but unmistakable figure of Hockney portrayed simultaneously in two positions. He looks soulfully to the right and also gazes intently across the picture-plane to the other wing of the house where the sleeping form of Gregory can be seen in his bedroom which glows with a warm pink light. The painting makes a strong and powerful impact and brings together the colour intensity of *Ravel's Garden* and the multi-faceted nature of the photographic experiments, as well as bearing witness to Hockney's fondness for his house and garden and his deep attachment to his companion of ten years, Gregory Evans.

Hockney's admiration for Picasso had not abated, and in March he made a series of eight charcoal drawings of his assistant Jerry Sohn in order to demonstrate the continuing potential of Cubist methods of portraiture. The first four were drawn from life; they were pinned up on the studio wall and then joined by each of the others as they were made in progression, moving further and further from a naturalistic image. He then repeated the experiment by making six charcoal drawings of a French student named Pierre St Jean who had paid a visit in the course of writing a thesis on Hockney's work. It was a pleasant surprise for him to find himself immortalized by the subject of his studies. Hockney later spoke to Marco Livingstone about how he had tried to use the lessons he had learnt from Picasso: 'It took me a long time to realise that the way Picasso can draw, where you see the front and back of the figure, is not distorted, it isn't a distortion at all. Well, when you realize that, you begin to realize how in a way more real it is, you want to get involved. But it's not easy, actually, what Picasso did. That whole idea is not easy, but in a sense that's what I'm going towards, because it's more real.'[9]

Hockney now decided that the time had come to plan some large-scale paintings which would use the lessons learnt from his study of Picasso and his photographic experiments. He began by making gouache studies at the Echo Park home of Mo McDermott and his wife Lisa. These little drawings show very simplified views of the house with its terrace and the panorama of buildings and landscape beyond. They led to a five-foot by three-and-three-quarter foot gouache of the terrace with its exotic cactus plants and the Cubist houses in the distance, and then a double-size gouache version with the interior of

the house to the left and the terrace to the right. Finally, in April, he painted a five-foot by sixteen-and-three-quarter foot gouache in two panels entitled *A Visit with Mo and Lisa, Echo Park, Los Angeles*. The left-hand side gives glimpses into the living room, bedroom and kitchen of the house, together with the steps leading down to the garden. On the right-hand side is the terrace with its view of Cubist houses and pink trees set against a vivid blue sky. The figures of Mo and Lisa are made up of unpainted areas of the white paper against the yellow of the terrace, giving the feeling of a Matisse *papier collé*. The colours are bright throughout the painting, but they are thinly textured owing to the use of gouache, and the enormous image looks rather disjointed and decorative.

While working on the image of Mo and Lisa, Hockney was already planning his next large picture, *A Visit with Christopher and Don, Santa Monica Canyon* (see plate 157). This is on two canvases and measures six-foot high and twenty-foot wide. Once again he began by making gouache sketches on the spot, but the painting was planned and executed to be read as an unfolding visit to Chris and Don's house, and gains dramatically from the basic structure. The primary influence was now from Chinese landscape scrolls, allied to the continuing interest in Cubism. Hockney was also trying to put into practice the theory of reverse perspective. He considered that the rules of Western Renaissance perspective put the experience of space into a straitjacket in which it was seen from a single fixed point of view which served only to limit it. Chinese landscapes and Picasso's Cubism, on the other hand, suggested ways of depicting the unlimited space of nature through reversing the laws of scientific perspective. He had already tried to use such an idea with his photo-collages.

The painting is designed to be read from right to left in the oriental manner, and to lead the viewer to the house in the manner of Chinese landscape scrolls, examples of which he had seen at the Musée Guimet on a quick trip to Paris in March. The yellow strip which leads into the picture at top right is Adelaide Drive, Santa Monica. One stops by the palm tree at the number-plate 45, and walks down the drive to where two cars are parked, then through the gate and down the steps to the house, just as a visitor would have to do in real life. Behind is the view from the house of Santa Monica Canyon, with the big yellow building on the bluff and the expanse of deep blue sea. One enters the living room with its two chairs and table which are familiar from the double portrait of 1968, and through the window one sees the view of the canyon again. Then one can either go left to Don's studio where he is making a drawing beside the window with the same canyon view, or walk to the right, through the dining room with its circular table and same view, the bedroom with its double bed, television set in reverse perspective and, once more, its view of the canyon, and finally to Chris typing in his study with Hockney's painting of the canyon view above the desk.

The painting took three months and caused Hockney many problems. He found that

right-angles tended to stop the progress of the eye through the journey, and had to make many changes to remove those he had included. The two figures stood out too prominently from the composition, drawing the eye immediately, so he had to repaint them as transparent images. And some form of central fulcrum was required, which explains the placing of the circular table. The result is an image that forces the viewer to look for more than a cursory twenty seconds, in order to reconstruct its spaces. It is a great improvement on *A Visit with Mo and Lisa*: it is painted in oils, which give its glowing colours a more dense and saturated effect than gouache, and it has a much more carefully planned structure. The repeated images of the canyon view serve to unify a seemingly disparate and potentially confusing subject. It can be said to be one of Hockney's major achievements of the early eighties.

Hockney made many other paintings during the very productive spring and summer of 1984. There were four portraits of Celia Birtwell as well as four portraits of Christopher Isherwood: he is wearing glasses, without glasses (see plate 159), typing and wearing a long blue dressing-gown. There were also double portraits of David and Ann Graves, and of Patrick Procktor and his son Nicholas who were visiting from London. But more significant was a three-foot by ten-foot oil painting on two canvases, *Hotel Romano Angeles, Acatlan*, resulting from a visit to Mexico for the showing of 'Hockney Paints the Stage'. Hockney and Gregory and David Graves were driving through the country to Oaxaca when their car broke down in the town of Acatlan and they had to spend a night at the hotel. Hockney fell in love with its courtyard garden and made some sketches which led to the large oil painting. The garden, with its curious brick well and exotic trees and plants, is viewed from inside the covered terrace, but the scene is opened out in reverse perspective so that the straight lines of the terrace have become curved as the eye scans the scene. This has caused the parallel lines of the red roof-beams to fan out and converge on the centre of the picture. For this painting he designed and executed a frame decorated with hieroglyphic patterns reflecting the colours of the picture. Another work from this visit was *Gregory Asleep*, a painting consisting of five sections, two of the face plus one of a shoulder and a blank canvas, all placed on the floor in front of a large canvas with an outline drawing of the terrace and courtyard.

This same summer Ken Tyler told Hockney of a new process for making lithographs he had found, called continuous tone lithography, or the Mylar technique. This involved drawing on sheets of frosted acetate which could be proofed very quickly. He had bound these acetate sheets into a sketch-book which made portable the whole process of preparing lithographs. Hockney was fired with enthusiasm for the new process, and decided that the Mexican hotel provided the ideal testing ground. So, in September, he travelled back to Acatlan with Ken and Gregory for a week, and spent the whole time

drawing in Ken's sketch-book. The technique involved drawing on each sheet in one colour, but since the sheets were transparent, the artist could form an idea of the finished lithograph by looking at the superimposed sheets in the sketch-book. At the end of the week, Hockney and Gregory returned to California and Ken went to Bedford Village outside New York to work on proofing the designs.

In October Hockney was in New York for the opening of an Emmerich Gallery exhibition of his new work. The large paintings were all on show as well as preliminary studies, and there were portraits of Celia, the multi-canvas images of David Graves, Gregory Evans and Peter Langan and the last two photo-collages, *Nude* and *Desk*. Critical reaction to the exhibition was mixed, but it was a huge success with collectors, and almost $2 million changed hands, which was quite extraordinary for the work of a living artist. *Self-Portrait on the Terrace* and *A Visit with Mo and Lisa* sold for $250,000 each, and a small portrait, *Celia with her Foot on a Chair*, made $50,000. *A Visit with Christopher and Don* was not for sale, as Hockney wished to keep it. Fifteen photo-collages were sold, signalling a turnabout from the earlier problems in finding buyers for the photographic experiments. For Hockney it was a welcome sign that André Emmerich and Nathan Kolodner could be relied upon after the *débâcle* of the Petersburg Press bankruptcy.

After the opening of the show, he went to stay at Ken Tyler's studio to begin work on a new set of lithographs arising from the Mexican visit. Ken had proofed the colour separations made at the hotel and Hockney experimented with two views, one very similar to the earlier oil painting and the other showing the hotel seen from the garden. The Mylar technique allowed for multi-layered colours, and Hockney's proofs of his new lithographs included up to twenty-eight different colour-printings. He also made acetate drawings of his mother, Celia, Ken, and his Pembroke studio in London and left them all for Ken to proof. While in New York, he met a new challenge by agreeing to act in a public performance of a play by his beloved Picasso, *Desire Caught by the Tail*. Picasso's mistress Françoise Gilot put up the money and the play was directed by Françoise Kourilsky of the Ubu Theatre. The performance was given at the Guggenheim Museum, in aid of charity, with the participation of figures from the arts such as Larry Rivers and Philippine de Rothschild. The parts were read, and Hockney's Bradford accent was almost incomprehensible to much of the audience. It was a curious evening, and like so many similar events, it was more of a financial than an artistic success.

Hockney spent Christmas with his family, as is his custom. On this occasion he made some paintings of his mother and a double portrait, in three parts, of his sister Margaret and her friend Ken Wathey. But as with the summer paintings of Patrick and Nicholas Procktor and David and Ann Graves, he was not satisfied with the results and has never

exhibited them. At the end of December he travelled to Paris with Celia to attend a party in honour of his friend Jean Léger. Jean had been hospitalized, suffering from AIDS, and could only leave the hospital for one night. Hockney and Celia did their best to cheer him up. Jean died three weeks later.

In February 1985, Hockney and Gregory joined Nathan Kolodner in Mustique once again. They spent two weeks in the sunshine, with Hockney reading extensively about physics and the psychology of perception. The photographer Lord Lichfield, Princess Margaret's cousin and neighbour on the island, was organizing the annual cricket match of Englishmen against the local inhabitants and asked Hockney to join his team. He is no sportsman, but gamely he agreed. The sight of Hockney playing cricket brought tears to the eyes! It was, however, a less happy stay than the previous year, for there was now clear tension between Hockney and Gregory. Their relationship was being soured by Gregory's return to heavy drinking, resulting in much anger and hostility. In spite of this, Hockney filled a sketch-book with colourful drawings of the island, including a sequence showing the table on their terrace laid out for afternoon tea.

On his return from Mustique, Hockney moved into Ken Tyler's studio accommodation in order to complete work on his new lithographs. Ken had proofed all the acetate drawings made the previous autumn, and Hockney spent the next four months reworking the proofs and making further drawings. An immediate project was to devise an image which would epitomize the Mustique holiday, and he decided to make a large four-panel screen. He had originally intended his 'Paper Pools' of 1978 to be framed as screens, but this had proved impracticable. Yet his growing interest in oriental art had reminded him of the fascination exerted by a screen. He used his Mustique sketch-book as a basis and chose to concentrate on the images of afternoon tea on the terrace. He designed a four-panel screen seven-foot high by eleven-foot wide, and then worked on four tall rectangular designs, each composed of two sheets of paper, which would build an image of the terrace in Mustique framed by columns on either side and by oriental arches along the top. A table with tea pot and cups and four wicker chairs are depicted in reverse perspective in the foreground, against a complicated colour arrangement of tiles, and in the distance can be seen palm trees and the sea with towering cliffs.

Hockney reworked the design many times over the next two years, altering the framing arches to take into account the reverse perspective of the scene and refining the patterns and textures of various elements in the composition. This process was facilitated by the Mylar technique, which merely required him to redraw one or more of the acetate separations. In 1987 he was finally satisfied with the screen, which he called *Caribbean Tea Time*, and an edition of thirty-eight was produced. So great was the interest that most were sold before they were made. It was an ambitious project which, in the end, had necessitated 100 different colour-printings. The Moorish shapes of the roof in the final

version recall Matisse's Moroccan paintings, and the overall effect of the screen suggests one of Matisse's large-scale *papiers collés*. Hockney had told Ken he wanted to make a 'nice screen showing the warmth of the island',[10] and the result dances with colour and light.

While working on the screen, Hockney was also completing his lithographs of Pembroke Studio and the Mexican hotel. *Conversation in the Studio* had been finished the previous autumn as a test-piece: a very simple image with two chairs representing the conversation, and a frame painted by him to suggest that the image went beyond it. The reverse perspective chairs appear in all the Pembroke Studio prints including *Pembroke Studio Interior*, a ten-colour image composed almost entirely of lines rather than areas of colour, with the collage of the desk on an easel in the background, and once more a painted frame. The most complicated of this series is *Walking Past Two Chairs*, which required twenty-one printings. Here, the reversed perspective chairs and table with vase of flowers are carried onto the hand-painted frame which is itself sculpted to Hockney's design, in order to continue the image in reverse perspective. He coined the description 'Moving Focus Prints' for these new lithographs, and referred to them in terms of 'fractals', a new mathematical term for reductive, identical images of larger physical objects. In theory, rearranged fractals will always reflect the essentials of the original image. Hockney wrote in 1987: 'With a fractal, you look in and in and in, and it always goes on being a fractal. The edges of things become blurred, and that seems a good thing. Getting rid of borders seems a good thing. It's a way towards a greater awareness of unity.'[11]

He also completed six lithographs inspired by the Mexican hotel. *Hotel Acatlan: First Day* more or less repeats the two-canvas oil painting of 1984 but with greatly intensified colours, the result of twenty-four separate printings. *Hotel Acatlan: Second Day* is a view of the hotel as seen from the garden, with the arched brick well in the foreground. The third in this series of two-sheet, two-and-a-half-foot by six-foot images is *Hotel Acatlan: Two Weeks Later*. This returns to the original view from the terrace, but from a higher viewpoint, so that the whole of the garden can be seen with the well in the centre, and the terrace is made to appear to extend all around it in a circle. The reverse perspective works more successfully here, with the red roof-beams creating jagged shapes which break up the order and symmetry of the first version. The same progression can be followed in three smaller lithographs, *Views of Hotel Well, I, II*, and *III*, each with a hand-painted frame. *Hotel Acatlan: Two Weeks Later* served as the model for *A Walk Around the Hotel Courtyard, Acatlan*, an oil painting on two canvases measuring six-foot by twenty-foot, not far short of the dimensions of *Mulholland Drive*. The scene is clarified by the central column of the terrace being moved off-centre, thus revealing the well which becomes the fulcrum of the whole composition. And the title is appropriate,

154 *Paul Kasmin and Jasper Conran, 1982*

Henry Moore. Much Hadham. 23rd July 1982 CH.

155 *Henry Moore, 1982*

156 *Nude, London, 1984*

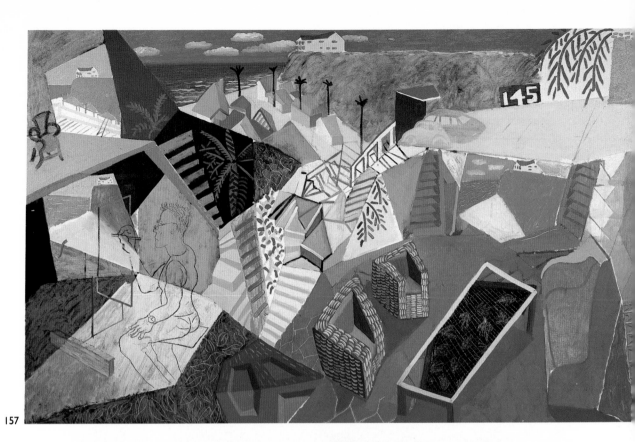

157

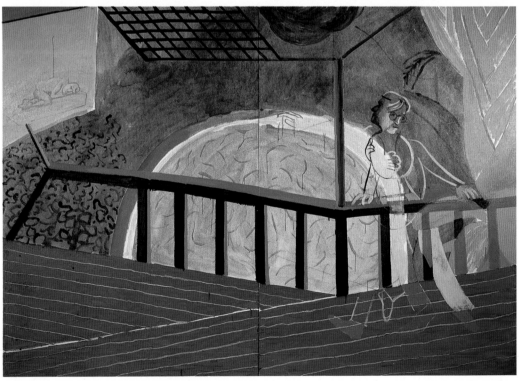

158

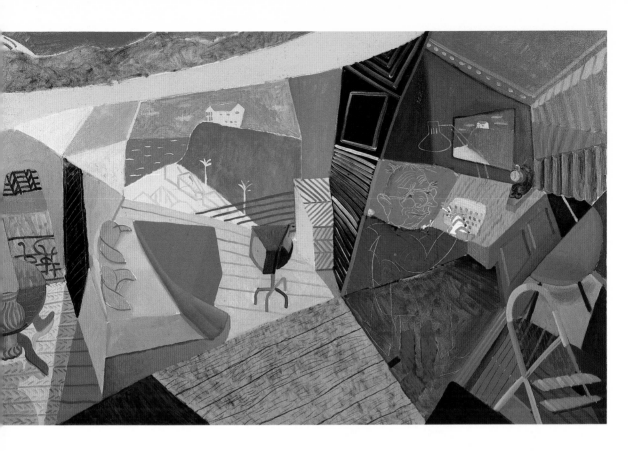

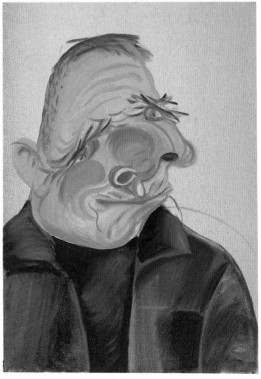

157 *A Visit with Christopher and Don, Santa Monica Canyon*, 1984

158 *Self-Portrait on the Terrace*, 1984

159 *Christopher without Glasses*, 1984

Hockney's photographic experiments led to a concentrated spell of painting in 1984 which also showed his continuing admiration for Picasso and his new discovery of Chinese scrolls.

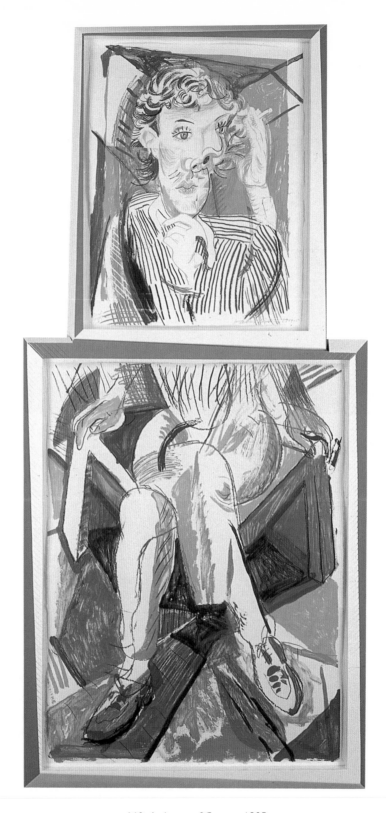

160 *An Image of Gregory,* 1985

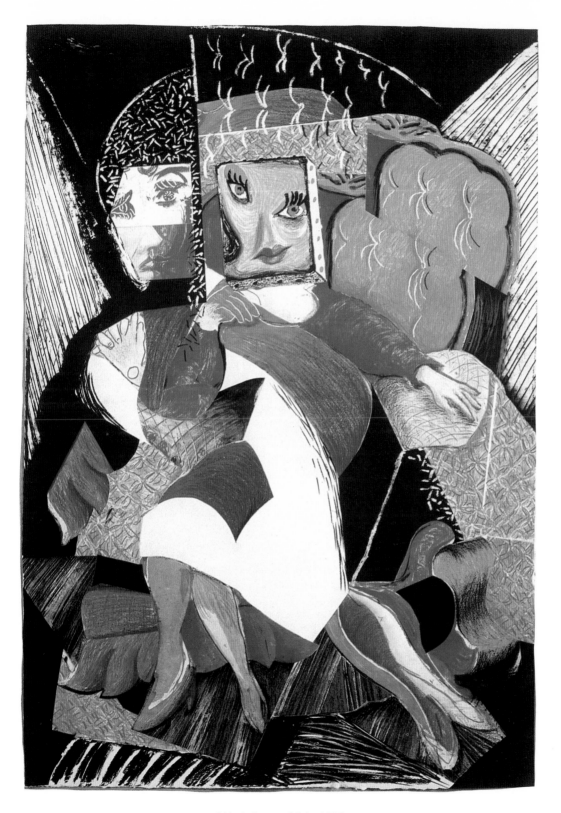

161 *An Image of Celia*, 1985

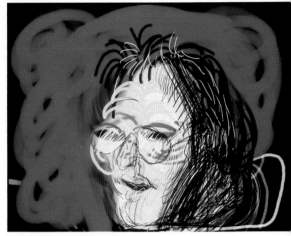

162

164

165

162 *Quantel Paintbox number 5*, 1985
163 *Quantel Paintbox number 4*, 1985
164 *Peace on Earth*, 1986
165 *A Bounce for Bradford*, 1987

In recent years Hockney has been using the latest technology to reach a wider audience. His work with computer (162 & 163) produced glowing images, literally painting with light. His experiments with an office copier led to (164) and (165), web-offset lithographs on newsprint from his colour separations and print specifications.

for as in a Chinese scroll, the eye is made literally to walk around in the picture plane.

Hockney was also working on large lithographs of Gregory and Celia during this fruitful period. *An Image of Gregory* (see plate 160) is a life-size colour print on two sheets which are framed separately in a two-part white and grey lacquered frame which Hockney designed and painted. It interlocks across the centre, dividing the upper body from its lower half. Gregory's face is portrayed in Cubist style, and each hand is shown in two positions. He sits on a stool which is seen in reverse perspective, and his crossed legs wind around each other in a fashion characteristic of a tall, slim person. It makes for a powerful image of Gregory and, as in the best Picasso Cubist portraits, he is clearly identifiable as the sitter.

When Celia came to visit him in New York in 1985, Hockney made a half-length lithograph portrait of her with her hands folded behind her head entitled *Red Celia* which owed a great deal to Matisse's Fauvism. He then planned a much more ambitious full-length portrait, of which the first attempt was *An Image of Celia, State I*, a seventeen-colour lithograph of 1986 which shows her in two positions seated in a padded armchair against a decorative wallpaper and carpet. He felt that this was still too realistic, and so in *An Image of Celia, State II* he removed sections of the design, added a collage of the face from *Red Celia* and gave the print an irregularly-shaped plain white frame. This still did not satisfy him, and so he produced the final version, *An Image of Celia* (see plate 161), a thirty-five colour lithograph/collage/screen-print using elements from the two preliminary studies and adding a collaged print of a small canvas in which her heavily made-up eyes and rosebud mouth seem to float in a rubber mask. For this he designed a moulded and hand-painted frame which continues the colours and shapes of the design. The portraits of Celia are striking images, but confusing and unsatisfactory when compared with the two-part portrayal of Gregory.

Ken Tyler had succeeded in capturing Hockney's attention with the new Mylar technique, just as he had done in 1978 with the paper pulp process. He knows Hockney loves new challenges. He told me at the time of completing work on the *Caribbean Tea Time* screen that, of all the artists with whom he works, Hockney has the most courage: 'He gets bored with easy techniques. He likes to move on, to investigate something new. Others may prefer an easy path but he is prepared to take a risk and he has the energy and talent to do it. He will put the same energy into print-making as into painting, he has total commitment to what he is doing. He is a consummate draughtsman rather than a great painter, and is at his best at print-making. In fact he is changing the course of print-making.'[12]

CHAPTER TWELVE

LOS ANGELES 1985–1988

In July 1985, those prints that were completed, together with *A Walk Around the Hotel Courtyard, Acatlan* were exhibited at Kasmin's gallery in London under the title 'Wider Perspectives are Needed Now', and then were shown again at Emmerich's gallery in December. A selection of sixteen were issued in editions of between forty-five and ninety-eight and these, together with trial proofs of unissued prints plus preparatory drawings and a hand-coloured working proof of *Caribbean Tea Time*, were exhibited at the Tate Gallery in March 1986 as 'Moving Focus Prints'. Hockney wrote in a catalogue note: 'There is a principle in Chinese painting called "moving focus". It acknowledges the spectator's moving eye and body. For this reason the Chinese would not have needed Cubism . . . Most of these prints try to utilize this idea in some form. When the body is felt to move, the depiction of space is changed from a static "hollowing out" to a more dynamic, restless one – closer, I think to our experience of it.'[1] The later prints were then shown at Kasmin's gallery in August 1986 as 'Still Lives and Interiors', and a selection of the Tyler lithographs plus earlier photographic work was exhibited in San Francisco at the Erika Meyerovich Gallery in January 1987 as 'Moving Focus: Graphics, Drawings, Photo-collages', with a well-illustrated catalogue including an introductory note by Marco Livingstone.

Critical reaction to the new prints was somewhat muted wherever they were shown. Critics were still in shock from the photo-collages, and many were in a quandary about what to make of the new work. In *The Times*, Alistair Hicks wrote that '*An Image of Celia* is little more than a good pastiche of Picasso. *Red Celia* is a crude, but vivid, piece of updated Fauvism.' He considered the Mexican hotel prints 'perhaps the most successful in his endeavour to master time and space', but described the exhibition at the Tate Gallery as 'full of sideshows but [lacking] any convincing direction.' He concluded: 'Too many of Hockney's recent works are emotionally flat and are little credit to an artist of his standing. There are many other British painters providing a more positive lead.'[2]

While Kasmin was showing the new prints in London in July 1985, Hockney was in Arles in the south of France. He always enjoyed visiting the countryside loved by Van Gogh, but on this occasion he was there by invitation of the prestigious Rencontres Internationales de la Photographie to give a lecture on his photographic experiments. Every summer the town of Arles is host to famous photographers from around the world,

and that year the British Council sent an exhibition of Hockney joiners and photo-collages. Hockney was the star attraction, and his talk was entitled *'On a besoin de plus grands perspectives'* (Wider perspectives are needed now). It was delivered, of necessity, in English. While in Arles, he was approached by the photographic editor of Paris *Vogue*. In the past he had invited various figures from the arts to do a feature in the magazine: Miró, Dali, Zeffirelli. Would Hockney like to do the same? It was an interesting challenge, and after insisting on a totally free hand with his forty-two pages, he agreed to submit his art work by 10 October for the December/January issue. He welcomed the opportunity to develop his current ideas about perspective and reach a wider audience. On his return to Los Angeles, he pinned forty-two blank sheets of paper to his studio walls and began to plan his layout.

He decided to take as his theme the concept of movement and how reverse perspective enables the viewer to enter the picture-plane. He wrote his commentaries in longhand to be reproduced directly on to the page, in French, complete with numerous corrections. Under his photo-collage *Walking Past Le Rossignol* he wrote about the principles of Chinese painting and described how he had made the collage, and then added: 'Movement is life. Absence of movement is death.' Opposite a crossed-out drawing of a chair in conventional perspective replaced by an image of the same chair in reverse perspective, he wrote a piece called 'The Perspective Lesson' in which he suggested that rules of perspective had become necessary to enable Renaissance artists to depict the static, actionless death by crucifixion of Jesus Christ, and to communicate his suffering. Modern photography had copied this way of seeing the world as motionless and viewed through a hole. Opposite a photo-collage of his mother's face he declared that fixed images emphasize our separation from each other, whereas images involving movement bring us together and show us a world of enchantment. To amplify his ideas he included earlier work, the lithographs *An Image of Gregory* and *Hotel Acatlan: First Day*, plus a series of new photo-collages made especially for *Vogue*. These included Mo and Lisa McDermott and Jerry Sohn at Echo Park; a Hollywood hitch-hiker; and views of his terrace both with and without bright sunshine and shadows. All were reproduced right up to the edge of the page. As this was for a French magazine, he also made photo-collages of the Luxembourg Gardens and Place Furstenberg in Paris. The latter is particularly successful in allowing the spectator the sensation of moving around amongst the trees and buildings. At the time, he pointed out to me the complications of making such a picture and showed me the numerous different positions from which he had taken many of the over 200 snaps in the collage in order to create a more accurate transposition of reality.

For the cover of French *Vogue*, Hockney painted a small canvas of Celia's face which he later used in the lithograph *An Image of Celia*. He told me that he emphasized her

mascara and lipstick because cover-girls are always heavily made-up, but that he deliberately painted her in a Picasso style so that the magazine would stand out on the news-kiosks. He also told me that he was absolutely delighted to see how the feature had turned out. 'I am reaching a much wider audience than the readership of *Arts Review* or *Artscribe*. There's nothing wrong in being associated with a magazine like *Vogue* whose accent is on fashion and commercialism. They will sell 120,000 copies, half of them abroad, and each will be seen by more than one person. I'm reaching a quarter of a million people with my ideas: how many people read the art criticism magazines? Anyway, I'm not that concerned with art world criticism and opinion of my work. I know I'm keeping Modernism alive with my ideas about seeing and depicting. One has to look to Picasso who changed our way of looking for us. I went to Francis Bacon's recent show – powerful images but hardly revolutionary, he hasn't changed our view of reality. Picasso always described his works as experiments, and so are mine. Photography is today's medium but without movement it has no reality. I really feel my recent work including *Vogue* is more successful in giving the appearance of reality. If we think conventional perspective is reality, we ignore Cubism's revolution and have made no progress since the Renaissance. These are important issues which relate to current concepts of reality in the material universe. In quantum physics and mathematics, scientists no longer see everything as objectively clear and obvious. Measurement implies the presence of the measurer just as photography implies the presence of the photographer. Why shouldn't art be in the vanguard of exploration? Art can change the world!'[3]

The *Vogue* project and the Mylar prints were part of Hockney's fascination with using the technology of the day to reach his audience, and so it was only a matter of time before he would turn his hand to computers. In December 1985 he was approached by Michael Deakin with an invitation to try out the Quantel Paintbox. Deakin, of Griffin Productions, who had known Hockney since working at Editions Alecto, was keen to interest a leading artist in the possibilities of the new computerized technology so as to attract others to join a project for a series of television films. Hockney jumped at the chance and spent eight hours with the Paintbox before Christmas. It had been developed two years earlier for use with television graphics, to make weather maps, title sequences et cetera. Hockney immediately saw great possibilities for making pictures and ignored the technical tricks used for television work. Sitting in front of a plain work-surface with an electronic pen, he traced images which appeared simultaneously on a television monitor (see plates 162 and 163). He could summon up palettes of colour and mix or alter them at will, as well as making a selection from a range of different widths of brush or pen. He discovered that, far from being merely a tool for designing graphics, the Paintbox was a new medium which offered him the facility of literally painting with light: 'I'm painting with light on glass. The only equivalent for the amazing colours I can produce is stained

glass. Paint just can't give this intensity and almost neon glow.'[4] The television programme showed him making a view of Pembroke Studios in London, then a portrait of Francis Bacon which went wrong and changed into David Graves. Finally he produced an interior view of his studio with an exotic horse galloping in to eat a bunch of flowers. Hockney told me at the time that he was very satisfied with his first attempts and hoped to go to Japan to try out more sophisticated equipment. 'With these extraordinary colours and my perspective ideas, we can all start seeing the world in a much more interesting way.'[5] Inspired by Hockney's example, Sidney Nolan, Richard Hamilton, Howard Hodgkin and Larry Rivers were also featured in the television series *Painting With Light*, although none showed quite the exuberance and sense of excitement that came from Hockney's performance with the machine. Eighteen months later, he tried out the High Definition Quantel Paintbox which produces colour separations to be transferred into prints, and he hopes to work further with this machine.

He was in a philosophical mood in December of 1985. He had ended his *Vogue* feature with the words *'Paix sur Terre'* (Peace on Earth), and he also designed a Christmas card for the Museum of Contemporary Art at Chicago whose message read 'Peace on Earth – even though we like war, this excitement will have to be given up as we would be the last generation to experience its terrible thrill.' He had been invited to contribute to Visual Aid, a project in which almost every well-known artist in Great Britain collaborated in making a giant serigraph print to be sold in aid of Bob Geldof's Band Aid charity for the Ethiopian famine disaster. Hockney's contribution was a panel with the message 'Love conquers all, Peace on Earth'. Yet this was a period of personal unhappiness. While in Paris in early December for the Bernard Gallery's *Vogue* show, *'Images et Pensées pour une Revue'*, he visited his friend Alexis Vidal who was in hospital with AIDS. Like Jean Léger earlier in the year, Alexis was to die a few weeks after Hockney saw him. David Graves, Hockney's assistant in Los Angeles who had helped him so much over the years, most recently on the photo-collage editions and the *Vogue* layout, had decided to return to London. His wife Ann did not drive, which was a great disadvantage in Los Angeles, and both of them had grown tired of Californian life and were missing their London friends. Hockney found it difficult to accept that they were not happy living in his orbit. Ian Falconer, whom he had painted in September wearing blue jeans and red tennis shoes and watching television, was no longer living in Montcalm Avenue. Nor was Gregory Evans.

Gregory had been drinking heavily in Mustique in February when relations between him and Hockney were deteriorating. In August they visited London together for the opening of 'Hockney Paints the Stage' at the Hayward Gallery, but it was clear to their friends that Gregory now had a major drink and drugs problem, and that his psychologi-

cal distress was sapping Hockney's energy. When Hockney returned to Los Angeles to work on the *Vogue* project Gregory travelled to Italy, but, on his return to Los Angeles in the autumn, there was an emotional struggle between them which resulted in Hockney demanding that Gregory return to the clinic in which he had spent a period a few years before. Gregory stayed at the clinic until the end of November, when he insisted on moving into his own apartment, a decision Hockney could not accept. He told Gregory that if he did not live at Montcalm Avenue there was no job for him there either. And so they parted.

Hockney had never completely overcome the shock of losing Peter Schlesinger, but Gregory had become increasingly important to him and their lives were inextricably bound up together for over ten years, both emotionally and professionally. Gregory was always able to be honest and frank with him and was never overwhelmed by his fame. He was therefore able to deal successfully with the trappings of Hockney's life-style as well as providing emotional support, even throughout Hockney's relationship with Ian. He loved travelling and was an ideal companion on trips abroad. Gregory's experience recalls that of Peter: he loved and respected Hockney but found he could not continue to live in his shadow. 'My drinking was a symptom of the trouble, not its cause,' he told me recently. 'I realized that I could not submit any more. There was no room for me to grow. His idea of growth and mine were different. In his world there is no compromise, and it has to be his world. He does not realize that you have to be present to have a relationship, you have to give something of yourself. He always wanted what Christopher Isherwood had, but failed to understand that Chris was emotionally available to Don.'[6] Hockney told me of the difficulties of living with someone who has a drink problem: 'It was absolutely terrible. I didn't understand. I'd say "Why don't you just stop drinking and taking drugs, what are you doing to yourself?" Slowly I realized how serious it was, how deeply alcohol affects people. I had to put up with it. Then eventually I got him into a hospital, and he hated me for it. It was awful. A few months later he thanked me for doing it, but it took him a long time. And then he didn't want to come back. But he looks so much better now. He's a dear. In a way he means more to me than Peter, and always will. He's a wonderful person, Gregory.'[7] Hockney faced a difficult future without Gregory or Ian Falconer or David Graves. Eventually he employed Charlie Scheips from Chicago as his personal assistant, to look after his day-to-day affairs and business matters, as well as a chef to do the cooking. An old friend, Jimmy Swinea, who had appeared with Peter in the pool sequence of *A Bigger Splash*, became a studio assistant, and he could also call upon Jerry Sohn and Mo McDermott when necessary. He chose a puppy to be his loving and loved companion, the brother of Ian's dachshund, Heinz. He christened his puppy Stanley after Stan Laurel, and visitors to Montcalm Avenue in 1986 had to get used to Stanley's affectionate habit of trying to eat their ankles.

Hockney's interest in new technology, which had led him to experiment with the Quantel Paintbox, grew ever stronger throughout 1986, a year in which he produced hardly any paintings at all. One day in February, at Jerry Sohn's flat, he started to play around with a Canon Xerox machine with colour cartridges. Soon the floor was covered with sheets of paper. He had not realized what could be done with an ordinary copier; Jerry ordered him one the same day. Hockney had discovered that a copier, a printing machine that produces a different kind of printed image, offers the artist a range of new possibilities. He spent a total of seven months experimenting with his machine. He made his 'Home Made Prints' in the same way that he would make a lithograph. He drew each image or part of an image on a different sheet of paper according to its colour and then fed the sheets into the machine consecutively, sometimes repeating a stage to intensify its colour. The end-product was the result of a number of superimposed printings in a choice of standard copier colours. He aimed for an edition of sixty of each design but often did not achieve this, owing to the wastage rate through the complications of the layering process.

Hockney saw great advantages here over conventional lithography. The copier prints from paper to paper, leaving out the involved stage of working first on a zinc-plate or a stone. It prints dry, so that the whole process is immediate; and rather than ink it it uses a powder known as toner which is fixed onto the paper by a heat process, resulting in a dense and non-reflective surface. He especially loved the effect of the black: 'It seemed to me that it was the blackest and most beautiful black I had ever seen on paper. It seemed to have no reflection whatsoever, giving it a richness and mystery almost like a "void"'.[8] He did all the printing himself, dispensing with the services of master-printers, which he saw as a great and revolutionary advantage. He ended up with entirely original prints which could not be duplicated on the machine that made them without losing their complicated layers of colour, although as an experiment he made one for the cover of an entertainment guide, *L.A. Weekly*, depicting a vase of flowers by an easel set against the map of Los Angeles.[9]

These images are necessarily limited to the size of paper a copier can accommodate, although in some cases Hockney made composite images which consist of four or six sheets of paper. And the colours are limited to the range of toners available. Nevertheless, he managed to achieve a great variety through the layering process and also through the use of materials. Thus wooden tables are made by copying real pieces of wood, and *Man Reading Stendhal, July 1986* is partly composed of pages from a book. The subjects are appropriate for 'Home Made Prints': scenes of his house, trees in his garden, flowers on his tables. There is more than a hint of Braque in the still lifes and of Picasso in the figures, but a note of good-natured humour runs through the whole series: *Ian and Heinz, June 1986*, shows a leg with a red tennis shoe beside a convincing dog composed of

seven black marks; *Man Looking for His Glasses, April 1986* is a spider-like form, all arms and legs, which bends down short-sightedly and searches the floor; and *Celia with Guest, July 1986* contrasts the schematic occupant of a reverse perspective chair with the painting of Celia's face for the cover of *Vogue*. One of the most successful images is a two-panel self-portrait, immediately recognizable with its jutting chin and owl-like spectacles in reverse perspective, wittily dressed in a photocopy of his shirt (see jacket illustration). Like all the thirty-three prints exhibited in New York, Los Angeles, London, Chicago, Paris and Tokyo in December 1986, this simple self-portrait was shown in a very grand frame. The critic of the *Daily Telegraph* loved the Xeroxes: 'David Hockney is simply our jolliest artist . . . It is always fun to see what he is up to and he loves painting so much that each new exhibition bowls one over with its invention and enthusiasm. It would be very hard not to be pleased with these bold, snazzy images of flowers, fruit, tables, chairs, jugglers and an absolutely charming dachshund. All burst with high spirits . . . This is anything but a sombre exhibition, with Hockney delightfully spoofing Matisse and the late Picasso. Indeed I sometimes think Hockney has spent a fair part of his life rediscovering or revitalizing these two greatest of all twentieth-century artists.'[10] And in *The Times*, John Russell Taylor wrote: 'It has long seemed that Hockney's most important attribute was his wholly personal way of looking at things, and his most dazzling talent his ability to make us see things exactly as he sees them . . . And it is the same here.'[11]

When I visited Los Angeles to see the Xerox prints in Hockney's studio in November 1986, he showed me two large paintings standing side by side. The first was *Christopher Isherwood in Blue Dressing Gown* of 1984, and the second was a seated portrait of Henry Geldzahler reading a book completed earlier in the summer, his only painting in 1986 apart from small studies of plants and of Stanley. *Henry* reminded me of a Synthetic Cubist portrait by Picasso, built up in collage using brightly coloured textures and materials. At first only an eye, a nose and a hand were recognizable, but slowly I could make out his other features, his feet, the book he was reading. Hockney took me to the back of the studio to look at the portraits of Christopher and Henry and other pictures from a distance. There was an obvious difference in the effects they produced. He explained how he felt this happened: '*Christopher* has stayed over there while you are standing here next to me, yet you still feel as close to *Henry* as before even though the picture is also over there. It's strange, isn't it? The reason is that *Henry* occupied your space to begin with and *Christopher* did not. It's the same with those still lifes and *Stanley* – they stand out so clearly from here, yet *Ian Watching Television* of last year does not. I'll tell you why. The intensity of the tones and the bold shapes make the edges of the canvases disappear. So the picture leaps out at you. It all comes from my Xeroxes, working in layers and with collages. I am making your eyes move about, as I had started

to with the photo-collages and pictures like *A Visit with Christopher and Don* of 1984. Movement is everything. If you can make the eye move about, you make the viewer aware of the element of time, and so time and space will be interconnected. You can't have space without time. So you have to understand that physics and art are closely related. It's amazing that the art world doesn't seem to have woken up to that yet. The connection is science. Science had to deal with reality. The philosophical basis of quantum physics is that there is no such thing as a neutral viewpoint. It has to be a participatory viewpoint. So the idea that you were outside reality and could look at it objectively had to go. It did. And since they realized that, they have made great discoveries. Well, Cubism is like that – putting our bodies back into space. It's about you, you are part of it, not outside it. Science is making these discoveries now, we can't go backwards. We have to face them. Art has to face them. Science and art are coming together, that's what fascinates me.'[12]

Although Hockney produced no paintings during the latter half of 1986, the autumn was a busy time, for he visited New York where he received an award from the widely respected International Council for Photography and the honour of a show of 'Photo-collages and Composite Polaroids' at their gallery, which was a sign of official recognition of his contribution to photography. While in New York he saw his old friends Andy Warhol and Mick Jagger and proudly showed them snaps of his puppy Stanley, the light of his life. It was his last meeting with Warhol, who died in early 1987. At that time Hockney wrote a tribute in which he stressed how both he and Warhol were fascinated by technology: 'Images are in front of us all the time. The art of painting has to be connected with printing today; if not, not many people can see it. Most people know painting through printing. Warhol understood that and began to make something of it. He began to turn the media into a medium. It will take time to understand his work in the future.'[13]

In December 1986 the American magazine *Interview* published a feature on Hockney and the Xeroxes for their December 1986 issue; in the course of the conversation which appeared, he talked about holograms, trying to make Cubistic movies for television, his Paintbox experiments, and especially the 'Home Made Prints': 'There's a very subversive side to it. I enjoy that immensely, especially in that I make pretty pictures that are subversive. I love that. It's undermining the idea of reproduction, which, you have to remember, is a very accepted notion . . . Mine are somewhat pretty pictures, and I like that.'[14] To demonstrate his concept of subversion, he asked the magazine to publish an original print by him in the same issue. He provided them with the colour separations and specifications as to how to print it, and they did the rest. The result was *Peace on Earth* (see plate 164), a heat-set Web-offset lithograph on newsprint, depicting flowers in a vase with the title inscribed around them. It was clearly an original print, yet no master-printer had been involved. It was published in a very large edition, and reached

hundreds of thousands of people. It was thus a continuation of the ideas behind both the *Vogue* feature and the Xerox prints. When he showed me the proof of the *Interview* print in November, he said: 'It's art making use of technology. I'm humanizing hi-tech.'[15] He repeated this exercise in February 1987 for his local paper back home in Bradford, the *Telegraph & Argus*. They asked him to contribute to their 'Bradford's Bouncing Back' campaign which was to celebrate the city's social, cultural and business rejuvenation. Hockney sent them four large sheets of card, each containing one colour of a design, from which they made four colour printing-plates. When printed, the image became *A Bounce for Bradford* (see plate 165), a cheerful image of a rubber ball bouncing backwards and forwards across the page. In an accompanying letter he wrote: 'What happens when your presses put [the plates] together is the piece. It is, therefore, not a reproduction in the normal sense at all – the only way your image exists is on your page. There is no such thing as bad printing or poor printing. Any printing process has its own beauty that can be used.'[16]

Soon after the *Bounce for Bradford* piece appeared, Hockney was asked to submit work for the Royal Academy's annual Summer Exhibition. He had been elected to Associate Membership the previous year. He had accepted only after prolonged persuasion from the President, Roger de Grey, who had taught him at the Royal College, and from his friends Ron Kitaj, Peter Blake, Allen Jones and Norman Stevens, who were already Associate Members. Although he had once exhibited in the Summer Exhibition in 1957 as a student, he did not feel the Academy had any relevance to him. In 1986 he had agreed to show three of his Mexican hotel lithographs. Owing to the complicated and expensive printing process, and to the dealer's percentage, the prices were between £10,000 and £12,750, a fact that was adversely commented on by some critics. So, when asked to submit for the 1987 Exhibition, Hockney sent in his two recent newspaper prints *Peace on Earth* and *A Bounce for Bradford*. The issue of *Interview* had been sold out and no extra copies of their print were available, but Hockney's brother Paul was able to persuade the *Telegraph & Argus* to print a further run of 10,000 copies of *A Bounce for Bradford* in addition to their usual printing of 100,000 copies. The extra copies of the special supplement containing Hockney's print were on sale at the Royal Academy, and the catalogue entry read: '*A Bounce for Bradford* (from *Bradford Telegraph & Argus* Supplement "Bradford Bouncing Back" 1987) Web-offset litho newsprint (edition of 110,000, 18p each).'

Hockney's deliberate attempt to turn the tables on his critics was not very well received by his fellow Royal Academicians, but it obtained maximum publicity and visitors to the exhibition could be seen emerging with armfuls of original Hockney prints. The *Observer* trumpeted 'Eighteen pence – a snip for an original Hockney' and recommended that purchasers treat the image with magnesium metoxide to ensure its survival. In his

review of the show in the *Guardian*, Waldemar Januszczak singled them out for praise: 'I thoroughly enjoyed and approve of David Hockney's contribution . . . Hockney's cheeky image of a bouncing ball is actually a very ambitious attempt to challenge the usual, phoney deep space of the newspaper photograph and replace it with a new perspective system based on the experiments of Cubism. It is a work which continues his attack upon the truthfulness of photographic perspectives. Best of all, both picture and price-tag challenge the view that the artist's job is to make exclusive knick knacks for the living rooms of the well-to-do. Thus this tiny 18p print challenges the very foundations on which the Royal Academy Summer Show is built.'[17]

In Los Angeles in October 1986, Hockney had begun work on designing Wagner's *Tristan und Isolde* for Jonathan Miller's December 1987 production at the Los Angeles Music Center Opera. He had often told me that Richard Wagner was really the only composer who would tempt him back to opera design: the music excited him, and he had seen some really terrible productions. He had always felt that Wagner needed colour, as Van Gogh had written in his letters in the 1880s; yet, until now, no one had designed his operas with that in mind. I was not surprised when he showed me his plans for *Tristan* in November. He had already filled a sketch-book with ideas for each of the three acts, and had inserted Polaroid photographs of three-dimensional models resulting from these early ideas. At one end of the studio stood a large-scale model of the Los Angeles stage, on which he could try out his ideas with the help of Mo, Ian and Jimmy who were all working with him for this project. He told me that what attracted him to *Tristan und Isolde* was the music: 'It's very beautiful music, magical music. And I love Wagner's idea that an opera should bring together all the arts – poetry, painting, music. They told me they would be using the Los Angeles Philharmonic Orchestra conducted by Zubin Mehta, not just an ordinary theatre orchestra. So I thought I could meet the challenge to find colours and shapes that would respond to the music. People mistakenly think Wagner's operas have to be static. That's nonsense. I will be using painting to create space, light and colour, strong colour. I learnt how to do this with Ravel's *L'Enfant*, in the garden scene. I shall use the lighting to create the strong colour the opera needs.'[18]

When I returned to Los Angeles in February 1987, I watched a run-through of the opera in the studio. Hockney sat at a console and manipulated the lighting of his three sets on the model stage while Ian played the music on the stereo. For Act I, which takes place on board the ship in which the noble knight Tristan is bringing Princess Isolde from Ireland to marry King Marke of Cornwall, he had created an almost abstract design suggesting the prow of the ship under enormous sails which filled the upper part of the set. The only decorative elements were the ship's railings, which had a Celtic motif. As Tristan and Isolde drank the love potion, there was a dramatic change of lighting which

transformed the set. Hockney's set for Act II consisted of a forest of stylized trees outside King Marke's palace. Once again changes of lighting heralded the dramatic moments of Tristan and Isolde's love duet, King Marke's discovery of them embracing, and Tristan's fatal wounding. For the rocky courtyard of Tristan's castle in Act III, he had designed an enormous lime tree with a very plain landscape leading into the far distance. Here again, he used the lighting to create the mood of the opera's climax, when Isolde sings the *Liebestod* before falling dead upon the body of Tristan. As she started singing, the stage grew darker and darker and the whole sky became transformed into a vault of stars. On the last notes of her song, the night sky turned into a new dawn to signal the triumph of love over death.

Hockney told me afterwards that he felt he had achieved what he set out to do: 'Wagner wanted the power of sight and sound. When people told him opera was for small, sophisticated audiences, he said this denied the power of his music to go deep into everyone. It's the same with art: painting is much too powerful just to be designed for museums. My recent art works were designed to reach wide audiences, and my *Tristan* designs are enormous paintings – no museum would give me this amount of space. I'm putting the space of my painting into the real space of the theatre. I'm creating form with lighting and colour. The great scale of Wagner's *Tristan* is diminished if the designs are literal. My approach is new – the dramatically static nature of the opera will be given movement not by the singers but by means of light and colour, which will carry the hypnotic flow of the music. Wagner's greatest opera will give me the opportunity to demonstrate my ideas about perspective, space and movement on a dramatic scale.'[19]

When *Tristan und Isolde* opened in Los Angeles in December 1987, Hockney's designs were enthusiastically welcomed. On the first night, the unveiling of his almost abstract set for Act III so electrified the audience that an enormous burst of applause interrupted Zubin Mehta and the Los Angeles Philharmonic Orchestra, with the result that they had to pause and then start a second time. The automated lighting system requested by Hockney worked perfectly, and the production was immediately hailed by American and European critics as 'Hockney's *Tristan*'. In the London *Daily Telegraph*, Stephen Spender described it as 'in many respects magical. David Hockney's scenery and still more his lighting reached at times heights which were the visual equivalent to the massive power and pathos of the orchestral playing.'[20] And Gerald Larner wrote in the *Guardian* that the set for Act I 'must be one of the most beautiful and original ever inspired by a Wagner opera.' He continued: 'Hockney's vision is entirely his own and his technique absolutely new . . . [this] could prove a breakthrough in stage design.'[21]

Although most of Hockney's energies in 1987 went into his designs for *Tristan*, he was

also active in other directions. In a travelling amusement park in Vienna, called 'Luna-Luna', supervised by André Heller, to which various artists were invited to contribute, a circular pavilion was erected to a design by Hockney. It was entirely painted in red, blue and green to resemble *Ravel's Garden*. He was also turning his thoughts to painting, concentrating on portraits of friends and of his beloved Stanley as well as canvases related to his designs for *Tristan*. He also found time to paint the swimming pool of the Hollywood Roosevelt Hotel in imitation of his own, in exchange for the use of a suite for a year. In England, he offered a prize of £2,500 to the artist/photographer who submitted the most interesting image or three-dimensional construction in which the convention of one-point Western perspective was rejected. This produced so many good entries that in the end he awarded two prizes. And Cambridge University announced that it had appointed him as their Slade Professor of Fine Art for the year 1990/91, the earliest date at which he was available. He would be required to give twelve lectures.

In February 1988, a retrospective exhibition of Hockney's work opened at the Los Angeles County Museum of Art before travelling to New York and London. It contained over 150 items including paintings, graphic work, photographic experiments and theatre designs, and covered his whole career from the lithograph *Self-Portrait* of 1954 and *Portrait of My Father* of 1955 to *A Walk Around the Hotel Courtyard, Acatlan* of 1985 and his last photo-collage, *Pearblossom Highway*, of 1986, an elaborate image of a desert road disappearing into the distance. Hockney had planned the layout of the show himself, with the intention of demonstrating how his work has consistently engaged with the now-fashionable concerns about the nature of representation. The sequence of rooms bore the titles 'Flatness and Depth', 'Breaking the Frame' and 'Elusive Surfaces', and paintings, graphic works and photo-pieces were mixed together with no attempt at showing a chronological development. The only exception was the last room which recreated his studio and was filled with his most recent works, his paintings of *Tristan und Isolde*, Stanley, and various friends, presided over by the enormous *Pearblossom Highway*.

The weighty catalogue of the show reproduced most of the exhibits and included seven essays on aspects of Hockney's work (photo-collages, stage designs, influence of Picasso et cetera) by critics and by his friends Kitaj and Henry Geldzahler. At the back were twenty-three pages of coloured designs conceived by Hockney and created through the use of printing ink in the manner of the *Interview* and *Bradford Telegraph & Argus* images. The subjects included the artist's house, garden and pool in Los Angeles, as well as Stanley. The show was enthusiastically received by public and critics alike. Invitations to the private view became status-symbols and, in the first week, the exhibition was visited by an astonishing total of 16,000 people. In the gallery they were guided by Hockney himself narrating an 'acoustiguide' cassette, and in each room they were able to

sit comfortably on brightly coloured modular chairs designed for the purpose by the artist himself. Hockney was featured in every gossip column and on every radio and television station in Los Angeles, and many farther afield. In far distant London he was the subject of articles in the *Independent* and the *Sunday Times Magazine* (for the cover of which he designed a 'Home Made Print' *Self-Portrait*) as well as publications as diverse as *House and Garden, Harpers & Queen*, and *Country Life. Art and Design* magazine devoted its complete issue for February to him, with well illustrated and thought-provoking articles on various aspects of his life and work, recent interviews, and the texts of his lectures on Picasso and Perspective. In the British daily newspapers he was shown presenting a copy of the catalogue to the Duke and Duchess of York when they visited the show as part of their tour of a festival celebrating cultural ties between Los Angeles and Great Britain.

Hockney was in the news again almost immediately. He had heard of the British government's proposed legislation which would prevent local authorities' promoting homosexuality. Many sections of the arts community had already condemned Clause 28, as it had become known, because they feared it would threaten artistic freedom, since most theatres, cinemas, libraries and art galleries come under local government control. Hockney wrote to the *Sunday Times* attacking the 'meanness of spirit and smallness of imagination' in what he saw as 'Nanny England', and the 'small group of dreary unimaginative people running almost everything'.[22] The paper gave him front-page billing, since they claimed he had also issued a veiled threat to withdraw his exhibition from its planned showing at the Tate Gallery in October 1988. He later denied this, but the threat nevertheless sent shivers through the London art world, which was eagerly awaiting the autumn show. The *Guardian* devoted the whole of its leader to Hockney's intervention,[23] and its columns were filled with letters from readers supporting his criticisms. However, the tabloid newspaper the *Sun* was offended by his comments on Clause 28: 'We can get along without his paintings. In fact, he can stay away permanently.'[24]

It was pure coincidence that Hockney heard about Clause 28 soon after the opening of his exhibition, and the timing of his letter was prompted by the forthcoming vote in the House of Commons in which attempts to amend the clause were, in fact, defeated. His admirers could appreciate that his intervention was directly in line with his earlier expressions of dismay at anti-homosexual prejudice. Meanwhile the art critics were responding favourably to his retrospective. The *Los Angeles Times* declared 'there is a kind of Mozartian inner harmony about this refined, intimist Pop Classicist,'[25] and in the London *Independent*, Marina Warner called Hockney 'the painter laureate of southern California', 'a Boy Wonder, a prodigy, a wit, a naïf, Bradford's favourite son, brilliant defender of the faith in figuration' and 'one of the most skilled draughtsmen alive'.[26] The

artist's high profile in February and March of 1988 demonstrates that at the age of fifty, David Hockney is as busy and as controversial as ever.

I asked Hockney recently whether he was satisfied with his first fifty years, and what he felt about both the public adulation and the harsh criticism which he had received. He replied: 'I never look back too much, and I take no notice of critics. I'm always moving on. I've finished with photography and I've finished with theatre. I'm just going to paint now. You see, I think my best work is still to come.'[27]

CONCLUSION

On a warm autumn afternoon in November 1986, sitting in his living room overlooking the pool at his Hollywood Hills home, I asked Hockney what he thought he had achieved as he approached his fiftieth birthday. 'I consider I have got a lot to do. I never look back too much, I'm always moving on. I don't hold inquests. I keep going on as far as I can discovering things. I realize I'm out on a limb in contemporary art, I don't mind, that's fine. I have never thought I was in the main stream of Modernism. Nevertheless, I think what I do is important, actually. I don't care whether it is art or not. I love to quote Picasso: "I never made a painting as a work of art, it's all research." I could not care less what the critics say: I am quite unconcerned about what other people think.'[1]

These are impressive, even brave sentiments, although the last statement is hard to believe, for Hockney was angry at Tim Hilton's slighting review of 'Hockney Paints the Stage' in *The Times* and also hurt by Robert Hughes' description of him in *The Shock of the New* in 1980 as 'the Cole Porter of Modern Art'.

Hockney, like many highly creative people, is totally dedicated to his talent to the exclusion of all else. His work comes before everything. Nothing else has importance in his life, no one, not even a lover, can be a higher priority. He is totally self-centred, even though he can be very generous when he chooses to be. He is so used to being the centre of attention and often adulation that he takes it for granted and can behave towards people in an insensitive and often downright rude manner. He is surrounded by people, but, at the same time, essentially alone. When I asked him if he had achieved a degree of happiness with all his wealth and fame, he replied: 'I think happiness is something you just get glimpses of. That's all. And the glimpses keep you going. Then you can cope with anything. An artist has to accept himself. I like myself. I don't have any self-hatred. I enjoy my own company. I'm never bored. The only times I get terribly lonely I know there is something wrong with my thinking actually and then I get out of it. I always do. It's a kind of inner strength. In many ways I am quite self-contained.'[2]

I have mapped out Hockney's career in some detail, attempting to place his pictures in the context of his life and to demonstrate the intensely autobiographical nature of his work. He had a brilliant start to his career as the golden boy who rejuvenated British post-war art, admired in this country and abroad, praised by the critics and enjoyed by the public.

The sixties was a vibrant decade for British art, but whereas the excitement and enthusiasm which this generated did not survive the decade, David Hockney did. He entered the seventies with a well-received retrospective exhibition in London, but as the second decade of his career progressed, there were signs of faltering. He found great problems of both a technical and personal nature with *Mr and Mrs Clark and Percy* and *Portrait of an Artist*. *George Lawson and Wayne Sleep*, *Il pleut sur le Pont des Arts*, *Yves-Marie in the Rain* and *Santa Monica Boulevard* were abandoned, and *My Parents and Myself* was put aside and later re-started on a new canvas. He did not seem to be stretching himself. Instead, he was relying too easily on a strong facility for naturalistic depiction.

Just as he seemed to be losing his way, Hockney found a new lease of life in designing for Glyndebourne, and his work for the New York Metropolitan Opera brought a new energy and vibrancy to his painting at the end of the seventies. In the eighties, an interest in Picasso and Cubism led to experimentation with perspective in photography and printing, but up till now, without a great deal of success as far as his painting is concerned. This lends weight to the theory held by many people that he is more a graphic artist than a painter.

In recent years, Hockney has grown increasingly indebted to Picasso, especially on account of his continual readiness to experiment and change direction. But he would be the first to admit that he in no way measures up to Picasso's stature. Admittedly his painting career has lasted barely half as long as Picasso's. But Picasso showed a continual awareness of major issues, sometimes political, sometimes philosophical. He made powerful statements in the form of creations that could clearly be recognized as 'major works'. He provided ideas for a host of imitators as well as inspiration for many other creative artists. He changed our way of seeing the world, in common with Van Gogh, an artist also much admired by Hockney.

To say that Hockney has not yet achieved the level of attainment of Picasso or Van Gogh is not, however, to discredit him. A more appropriate comparison is perhaps with Matisse, who made no attempt to create powerful statements but who sought to communicate a joy in living and a delight in seeing, and who also changed our vision of the world. Hockney once told me: 'I have always been aware that there is a great pleasure in seeing. I tend to make things charming because that's my way, but often it's a bit of a disguise. I'm not afraid if they are pretty, I like pretty pictures. I tend to think that my view of the world is a bit oriental – I share their view of the tragic. Tragedy is a literary concept, not a visual one.'[3]

In a discussion of his favourite artists, he put Matisse high on the list: 'You cannot dislike him. He's a fantastic artist, but there are certain things he can't do that Picasso can do. Matisse couldn't paint a family with tenderness, which Picasso could do. He didn't

have the emotional range.'[4] This is an interesting comment from more than one point of view. It is a telling comparison between Picasso and Matisse, but it can be applied also to a comparison between Picasso and Hockney himself, who like Matisse displays a limited emotional range in his work. Looking back over Hockney's output to date, one is aware of the emphasis on a hedonistic view of the world at the expense of real passion. At the same time, one can see the very positive use made of irony and humour.

David Hockney is one of the most famous artists in the world today, with an exhibition of his work somewhere almost every day of the year. He has been the subject of books, television programmes and films. He has won prizes and received doctorates too numerous to list. He is displayed at Madame Tussaud's Exhibition in London and has been featured on the prestigious British radio programme *Desert Island Discs*. His paintings were used to illustrate the credits of the film *California Suite*. A street in his home town of Bradford has been named after him, as have shops and restaurants elsewhere. He has attacked the acquisitions policy of the Tate Gallery and seen his criticisms take effect. He has condemned modern art's 'decline' into Minimalism and Conceptualism and seen the New Expressionism and Figuration which he admires begin to flourish. He has influenced art schools and practising artists, advertising and photography. His works have been used as book covers, in television soap operas and as the subject of comedy sketches. He stands today as a major figure in British art of the generation between the 'Old Master' Francis Bacon and the new avant-garde. He has achieved the difficult task of moving successfully from 'avant-garde' to 'establishment' status. His lack of recent output in terms of paintings is not a measure of failure as an artist, for he has chosen to diversify his talents and has achieved great success in doing so. As he enters his second half-century with a mammoth retrospective, the signs suggest he is ready to startle and excite his public all over again. His place in the history of twentieth-century art is already assured. One question remains. He is a very good artist, a highly talented artist and an extremely intelligent artist. But only the future will show whether he is a *great* artist.

LIST OF ILLUSTRATIONS

PLATE SECTIONS

1. David Hockney as wolf cub, *c*. 1947, photograph, Laura Hockney, Bradford.
2. (clockwise from upper left) John, David and Kenneth Hockney, 1955, photograph, Laura Hockney, Bradford.
3. (clockwise from upper left) David, Margaret, Philip, Paul, Laura, Kenneth and John Hockney, 1976, photograph, Paul Hockney, Bradford.
4. *Hutton Terrace, Bradford*, 1955, watercolour and pencil, Frank Johnson, Bradford, (photo: Richard Littlewood).
5. Laura Hockney outside Hutton Terrace, Bradford, 1985, photograph, (photo: Jerry Sohn).
6. Steadman Terrace, Bradford, 1987, photograph, (photo: Peter Webb).
7. *Bolton Junction*, 1956, oil, Wakefield Educational Resource Service, Yorkshire, (photo: Richard Littlewood).
8. *Bradford*, by Derek Stafford, 1954, oil, Derek Stafford, London.
9. *Rawson Square, Bradford*, by Frank Johnson, 1955, oil, Frank Johnson, Bradford, (photo: Richard Littlewood).
10. 'My Bruffer John', *c*. 1950, pastel, Laura Hockney, Bradford, (photo: Peter Webb).
11. *Nude*, 1957, oil, Bradford Art Galleries and Museums, West Yorkshire, (photo: Richard Littlewood).
12. *Norman Stevens*, 1954, pencil and wash, Frank Johnson, Bradford, (photo: Richard Littlewood).
13. *Paul Hockney*, 1954, pencil and wash, Frank Johnson, Bradford, (photo: Richard Littlewood).
14. Hockney painting in the attic at Hutton Terrace, 1954, photograph, Laura Hockney, Bradford.
15. Hockney's early oils, Hutton Terrace, 1954, photograph, Laura Hockney, Bradford.
16. (left to right) John Loker, Norman Stevens, David Oxtoby and David Hockney playing poker, Bradford Art College, 1956, photograph, John Loker, London.
17. (left to right) David Fawcett, David Hockney, Frank Johnson and Derek Stafford, Bradford Art College, 1957, photograph, *Bradford Telegraph and Argus*.
18. (left to right) David Hockney (wearing cap), Rod Taylor, John Loker with poster, CND March, Aldermaston, 1958, photograph, John Loker, London.
19. *Sacrifice*, by Alan Davie, 1956, oil, Tate Gallery, London.
20. *For the Dear Love of Comrades*, 1960, oil, Royal College of Art, London, (photo: Jon Wright).
21. *Erection*, 1959, oil, Private Collection, (photo: Christie's).

22. *The First Love Painting*, 1960, oil, Paul Hockney, Bradford, (photo: Richard Littlewood).

23. *The Third Love Painting*, 1960, oil, Mrs George M. Butcher, Oxford, (photo: Richard Littlewood).

24. (clockwise from top left) Peter Phillips, David Hockney and Peter Crutch at the Royal College of Art, 1961, photograph, (photo: Geoff Reeve).

25. *The Bradford Mafia at the Royal College of Art* (1960) by David Oxtoby, 1976: (left to right) John Loker, Norman Stevens, David Hockney, David Oxtoby, Michael Vaughan, Douglas Binder, David Oxtoby, London, (photo: Peter Webb).

26. David Hockney in the RCA Christmas Revue, 1961, photograph, Janet Deuters, London, (photo: Ferrill Amacker).

27. *Self-portrait*, 1954, collage, Frank Johnson, Bradford, (photo: Richard Littlewood).

28. *Portrait of My Father*, 1955, oil, David Hockney, Los Angeles, (photo: Kasmin-Knoedler Gallery, London).

29. *Cat*, 1955, ceramic, Louise Hallett Gallery, London.

30. *View of Bradford from Earls Court*, 1960, oil, Private Collection, Bradford (photo: Richard Littlewood).

31. *Doll Boy*, 1960, oil, Kunsthalle, Hamburg, (photo: Waddington Galleries, London).

32. *The Cha-Cha that was Danced in the early hours of 24th March*, 1961, oil, Tony Reichardt, Australia, (photo: Kasmin-Knoedler Gallery, London).

33. *Tea Painting in an Illusionistic Style*, 1961, Private Collection, London, (photo: Kasmin-Knoedler Gallery, London).

34. *The Most Beautiful Boy in the World*, 1961, oil, Werner Boeninger, Los Angeles, (photo: Kasmin-Knoedler Gallery, London).

35. *The Last of England?* 1961, Janet Foreman, London, (photo: Michael Foreman).

36. *The Last of England* by Ford Madox Brown, 1855, oil, Birmingham Museum and Art Gallery.

37. David Hockney at Nailsworth Carnival, Gloucestershire, June 1961, photograph, (photo: Ron Fuller).

38. (left to right) Richard Bawden, David Hockney, Fred Scott and Geoff Reeve at Nailsworth Carnival, Gloucestershire, June 1961, photograph, (photo: Ron Fuller).

39. Peter Crutch with *The Cha-Cha that was Danced in the Early Hours of 24th March* in the RCA Painting School, 1961, photograph, (photo: Geoff Reeve).

40. David Hockney and Peter Crutch with *Peter C.* in the RCA Painting School, 1961, photograph, (photo: Geoff Reeve).

41. *Hero, Heroine and Villain*, 1961, watercolour and pencil, Private Collection, (photo: Waddington Galleries, London).

42. Derek Boshier and David Hockney in the RCA Painting School, 1961, photograph, (photo: Geoff Reeve).

43. David Hockney and Derek Boshier in front of *We Two Boys Together Clinging*, in the RCA Painting School, 1961, photograph, (photo: Geoff Reeve).

44. *Spinning Round*, by Jean Dubuffet, 1961, (detail), oil, Tate Gallery, London.

45. *The Most Beautiful Boy in the World* (study for *We Two Boys Together Clinging*), 1961, watercolour and ink, Private Collection, (photo: Piccadilly Gallery, London).
46. Teenagers' Room, S.S. *Canberra*, photograph, The Architectural Press, London, (photo: Bryan Heseltine).
47. Teenagers' Room, S.S. *Canberra*, photograph, The Architectural Press, London, (photo: Bryan Heseltine).
48. David Hockney and Ferrill Amacker, New York, summer 1961, photograph, Mark Berger, New York.
49. David Hockney's Diploma Show, RCA, June 1962, photograph, (photo: *Queen Magazine*).
50. Mark Berger and David Hockney, New York, summer 1961, photograph, Mark Berger, New York, (photo: Ferrill Amacker).
51. *David Hockney with Cliff Richard*, by Mark Berger, autumn 1960, oil, Mark Berger, New York, (photo: Earl Ripley).
52. *Domestic Scene, Los Angeles*, 1963, oil, Private Collection, (photo: John Webb).
53. *American Boys Showering*, 1964, pencil and crayon, Private Collection, (photo: Tradhart Ltd.).
54. *Physique Pictorial* magazine, Los Angeles, fall 1957, (photo: Athletic Model Guild, Los Angeles).
55. *Physique Pictorial* magazine, Los Angeles, January 1963, (photo: Athletic Model Guild, Los Angeles).
56. *Two Boys Aged 23 and 24*, Plate 2 of 'Fourteen Poems by C P Cavafy', 1966, Peter Webb, London, (photo: Peter Webb).
57. *He Enquired After the Quality*, Plate 3 of 'Fourteen Poems by C P Cavafy', 1966, Peter Webb, London, (photo: Peter Webb).
58. *Dale and Mo*, 1966, pencil, Peter Webb, London, (photo: Peter Webb).
59. *Those bottles should be handkerchiefs*, 1966, ink, Nikos Stangos, London, (photo: Prudence Cuming Associates).
60. David Hockney, Iowa, 1964, photograph, Tate Gallery Archives.
61. (left to right) Andy Warhol, Henry Geldzahler, David Hockney, Jeff Goodman, photographed by Dennis Hopper in New York in December 1963, Dennis Hopper, Los Angeles, (photo: Twelvetrees Press, Pasadena).
62. *Help*, 1962, oil, Private Collection, (photo: Kasmin-Knoedler Gallery, London).
63. *A Grand Procession of Dignitaries in the Semi-Egyptian Style*, 1961, oil, Edwin Janss, California, (photo: Kasmin-Knoedler Gallery, London).
64. *We Two Boys Together Clinging*, 1961, oil, Arts Council of Great Britain, (photo: Kasmin-Knoedler Gallery, London).
65. *The Fourth Love Painting*, 1961, oil, Private Collection, West Germany, (photo: Waddington Galleries, London).
66. *Teeth Cleaning, W11*, 1962, oil, Private Collection, (photo: Christie's).
67. *Play Within a Play*, 1963, oil, Joseph Haddad, Los Angeles, (photo: Kasmin-Knoedler Gallery, London).

68. *Figure in a Flat Style* (detail), 1961, oil, Dr Michael Stoffel and Dr Eleonore Stoffel, Cologne, (photo: Waddington Galleries, London).
69. *Peter C.*, 1961, oil, Manchester City Art Gallery, (photo: Kasmin-Knoedler Gallery, London).
70. *A Bigger Splash*, 1967, acrylic, Tate Gallery, London.
71. *The Room, Tarzana*, 1967, acrylic, Private Collection, (photo: Kasmin-Knoedler Gallery, London).
72. *Beverly Hills Housewife*, 1966/7, acrylic, Private Collection, Los Angeles, (photo: Kasmin-Knoedler Gallery, London).
73. *Boy About to Take a Shower*, 1964, acrylic, Private Collection, (photo: Tradhart Ltd.).
74. *Sunbather*, 1966, acrylic, Hans Neuendorf, Hamburg, (photo: Tradhart Ltd.).
75. Peter Schlesinger, *c.* 1974, photograph, Tate Gallery Archive, (photo: John Kasmin).
76. David and Peter with Janet Deuters' baby, Chingford, 1967, photograph, Janet Deuters, London.
77. *Peter*, 1968, ink, Private Collection, (photo: Marlborough Fine Art, London).
78. Nick Wilder's apartment and pool, Larabee Drive, West Hollywood, 1978, photograph, (photo: Peter Webb).
79. *Portrait of Nick Wilder*, 1966, acrylic, Fukuoka Sogo Bank, Japan, (photo: Tradhart Ltd.).
80. *Peter Getting out of Nick's Pool*, 1966, acrylic, Walker Art Gallery, Liverpool, (photo: Geoffrey Clements).
81. *Building, Pershing Square, Los Angeles*, 1964, acrylic, Paul Kantor, (photo: Geoffrey Clements).
82. Pershing Square, Los Angeles, 1978, photograph, (photo: Peter Webb).
83. David Hockney with *A Neat Lawn*, 1967, photograph, (photo: Jorge Lewinski).
84. *The Room, Tarzana*, 1967, acrylic, Private Collection, (photo: Cuming Wright Watson Associates).
85. Macy's advertisement for bedspread, 1967, *San Francisco Examiner*, (photo: Whitechapel Art Gallery, London).
86. *Mademoiselle O'Murphy*, by François Boucher, 1752, oil, Alte Pinakothek, Munich.
87. *Mr and Mrs Clark and Percy*, 1970–71, acrylic, Tate Gallery, London.
88. Ossie Clark at home, photographed by David Hockney, 1970, Tate Gallery Archive.
89. Study for *Mr and Mrs Clark and Percy*, 1970, crayon, Tate Gallery, London.
90. *Ossie Clark*, 1970, ink, Tate Gallery, London.
91. David Hockney at Carennac, 1971, photograph, (photo: Brian Young).
92. David Hockney and Peter Schlesinger, France, 1967, photograph, (photo: Jane Kasmin).
93. (left to right) Mo McDermott, David Hockney, Peter Schlesinger, Carennac, 1971, photograph, (photo: Brian Young).
94. *Breakfast, Carennac*, 1967, ink, Private Collection.
95. *Carennac, Howards End and Vichy Water*, 1970, John Kasmin, London, (photo: Tradhart Ltd.).
96. Jack Hazan filming David Hockney for *A Bigger Splash*, 1972, (photo: Jack Hazan).

97. (left to right) Peter Schlesinger, David Hockney and Celia Birtwell (still from *A Bigger Splash*), 1972, (photo: Jack Hazan).

98. Peter by the pool (still from *A Bigger Splash*), 1972, (photo: Jack Hazan).

99. Four boys (still from *A Bigger Splash*), 1972, (photo: Jack Hazan).

100. Peter Schlesinger and friend (still from *A Bigger Splash*), 1972, (photo: Jack Hazan).

101. Eugene Lambe, Lucca, August 1973, photograph, (photo: John Prizeman).

102. David Hockney drawing Eugene Lambe, Lucca, August 1973, photograph, (photo: John Prizeman).

103. David Hockney completing his drawing of Eugene Lambe, Lucca, August 1973, photograph, (photo: John Prizeman).

104. *Dr Eugen Lamb* (sic), Lucca, August 1973, crayon, Marchioness of Dufferin and Ava, London, (photo: Rodney Wright-Watson).

105. *Howard Hodgkin*, 1967, watercolour, Brian Young, London.

106. *Julia Hodgkin*, 1967, watercolour, Brian Young, London.

107. Hockney with Howard Hodgkin, Carennac, 1967, photograph, (photo: Brian Young).

108. Hockney with Patrick Procktor, Carennac, 1970, photograph, Tate Gallery Archive, (photo: John Kasmin).

109. *Christopher Isherwood and Don Bachardy*, 1968, acrylic, Gilbert de Botton, Switzerland, (photo: Kasmin-Knoedler Gallery, London).

110. *Henry Geldzahler and Christopher Scott*, 1968/9, acrylic, Abrams Family Collection, (photo: Tradhart Ltd.).

111. *Portrait of an Artist (Pool with Two Figures)*, 1972, acrylic, David Geffen, (photo: Kasmin-Knoedler Gallery, London).

112. *Mr and Mrs Clark and Percy*, 1970/1, acrylic, Tate Gallery, London.

113. *Model with Unfinished Self-Portrait*, 1977, oil, Werner Boeninger, Los Angeles, (photo: Andre Emmerich Gallery, New York).

114. *Peter Schlesinger with Polaroid Camera*, 1977, Gilbert de Botton, Switzerland, (photo: Tradhart Ltd.).

115. *Pool with Reflection of Trees and Sky*, 1978, paper pulp, Andre Emmerich Gallery, New York.

116. *Palm Reflected in Pool, Arizona*, 1976, crayon, Mrs Gardner Cowles and Charles Cowles, USA, (photo: Nick Wilder).

117. *Divine*, 1979, acrylic, Carnegie Institute of Art, Pittsburgh.

118. Hockney painting *Mulholland Drive*, 1980, (photo: Sidney B. Felsen).

119. *Ravel's Garden with Night Glow*, 1980, oil, Rita and Morris Pynoos, Los Angeles, (photo: Galerie Claude Bernard, Paris).

120. *Herlequin*, 1980, oil, David Hockney, (photo: Galerie Claude Bernard, Paris).

121. *Punchinello On and Off Stage*, 1980, oil, David Hockney, (photo: Galerie Claude Bernard, Paris).

122. *Yves-Marie in the Rain*, 1973–74, oil, David Hockney, (photo: Tradhart Ltd.).

123. *Andy Warhol*, 1974, crayon, Private Collection, (photo: Sotheby's).

124. Passage de Commerce, Paris, 1987, photograph, (photo: Peter Webb).

125. Cour de Rohan, Paris, 1987, photograph, (photo: Peter Webb).

126. *David Hockney* by Andy Warhol, 1974, screenprint, Frederick Hughes, New York.

127. *David Hockney at Berkeley* by R. B. Kitaj, 1968, oil, Marlborough Fine Art, London.

128. David Hockney drawing R. B. Kitaj in Vienna, 1975, photograph, (photo: Sandra Fisher).

129. *David Hockney at Fire Island* by Robert Mapplethorpe, 1976, photograph, Robert Mapplethorpe, New York.

130. *Ron Kitaj outside the Akademie der Künste*, Vienna, 1975, ink, Ron Kitaj, London, (photo: Prudence Cuming Associates).

131. *Robert Mapplethorpe*, 1971, ink, Robert Mapplethorpe, New York, (photo: Robert Mapplethorpe).

132. *Larry Stanton*, 1975, ink, Arthur Lambert, New York.

133. *David Hockney* by Larry Stanton, 1975, oil (destroyed), (photo: Arthur Lambert, New York).

134. (left to right) Arthur Lambert, David Hockney and Larry Stanton, Fire Island, 1975, photograph, (photo: Don Cribb).

135. Henry Geldzahler and David Hockney, Fire Island, 1975, photograph, (photo: Don Cribb).

136. Bedlam scene from *The Rake's Progress*, Glyndebourne Festival Opera, June 1975, (photo: Guy Gravett).

137. Bedlam, model for *The Rake's Progress*, 1975, ink (model), David Hockney, (photo: Tradhart Ltd.).

138. Celia Birtwell and David Hockney at the first night of *The Rake's Progress*, Glyndebourne, June 1975, photograph, (photo: Bob Marchant).

139. Nick, costume design for *The Rake's Progress*, 1975, ink and collage, David Hockney, (photo: Tradhart Ltd.).

140. Peter Langan's banquet for the first night of *The Magic Flute*, Glyndebourne, May 1978, photograph, (photo: Jane Kasmin).

141. Papageno, costume design for *The Magic Flute*, 1978, David Hockney, (photo: Tradhart Ltd.).

142. Act 1 of *The Magic Flute*, Glyndebourne, May 1978, (photo: Guy Gravett).

143. Act 2 of *The Magic Flute*, Glyndebourne, May 1978, (photo: Guy Gravett).

144. Gregory Evans in Hockney's studio in Los Angeles, April 1982, photograph, (photo: Andre Emmerich).

145. *Gregory Standing Naked*, 1975, crayon, Nick Wilder, New York, (photo: Galerie Claude Bernard, Paris).

146. *The Meeting, or 'Have a Nice Day, Mr Hockney'*, by Peter Blake, 1980–3, oil, Tate Gallery, London.

147. *Waking Up V*, 1983, pencil, David Hockney, (photo: Tradhart Ltd.).

148. *Waking Up VII*, 1983, pencil, David Hockney, (photo: Tradhart Ltd.).

149. David Hockney drawing in his studio with Ian Falconer, Los Angeles, 1982, photograph, (photo: Sidney B. Felsen).

150. *My Parents and Myself*, 1975, oil, David Hockney, (photo: Tradhart Ltd.).

151. David Hockney with his father and mother and *My Parents*, Hayward Gallery, London 1977, photograph, (photo: Ellie Angel).

152. *My Mother*, 1974, ink, David Hockney, (photo: Galerie Claude Bernard, Paris).

153. *My Father*, 1976, crayon, Paul Hockney, Bradford, (photo: Richard Littlewood).

154. *Paul Kasmin and Jasper Conran*, 1982, composite polaroid, David Hockney, (photo: Tradhart Ltd.).

155. *Henry Moore*, 1982, composite polaroid, David Hockney, (photo: Tradhart Ltd.).

156. *Nude, London*, 1984, photographic collage, David Hockney, (photo: Tradhart Ltd.).

157. *A Visit with Christopher and Don, Santa Monica Canyon*, 1984, oil, David Hockney, (photo: Andre Emmerich Gallery, New York).

158. *Self-Portrait on the Terrace*, 1984, oil, Rita and Morris Pynoos, Los Angeles, (photo: Andre Emmerich Gallery, New York).

159. *Christopher without Glasses*, 1984, oil, David Hockney, (photo: Andre Emmerich Gallery, New York).

160. *An Image of Gregory*, 1985, lithograph, Ken Tyler, New York.

161. *An Image of Celia*, 1985, lithograph, Ken Tyler, New York.

162. *Quantel Paintbox number 5*, 1985, computer drawing, (photo: Michael Deakin, London).

163. *Quantel Paintbox number 4*, 1985, computer drawing, (photo: Michael Deakin, London).

164. *Peace on Earth*, 1986, lithograph, *Interview Magazine*, New York, (photo: Peter Webb).

165. *A Bounce for Bradford*, 1987, lithograph, *Bradford Telegraph and Argus* (photo: Peter Webb).

LINE DRAWINGS

ii. Frontispiece *Self-Portrait with Tie*, 1983, charcoal, David Hockney, (photo: Tradhart Ltd.).

xiv. *Self-Portrait*, c. 1955, ink, Laura Hockney, Bradford, (photo: Peter Webb).

7. 'The Scouts Jumble Sale', c. 1952, ink, Paul Hockney, Bradford, (photo: Peter Webb).

18. *Life Drawing*, c. 1959, crayon, Royal College of Art, London, (photo: Jon Wright).

37. *Mirror, Mirror on the Wall*, 1961, etching, (photo: Tradhart Ltd.).

44. 'A Rake's Progress', Plate 3, *The Start of the Spending Spree and the Door Opening for a Blonde*, 1963, etching, Royal College of Art, London, (photo: Jon Wright).

44. 'A Rake's Progress', Plate 8a, *Bedlam*, 1963, etching, Royal College of Art, London, (photo: Jon Wright).

50. *The House of a Man Who Had Made the Journey to Mecca*, 1963, crayon, A. P. Rushton, London.

61. '14 Poems by C. P. Cavafy', Plate 6, *In an Old Book*, 1966, etching, Peter Webb, London, (photo: Peter Webb).

62. '14 Poems by C. P. Cavafy', Plate 10, *One Night*, 1966, etching, Peter Webb, London, (photo: Peter Webb).

74. '14 Poems by C. P. Cavafy', Plate 4, *To Remain*, 1966, etching, Peter Webb, London, (photo: Peter Webb).

74. '14 Poems by C. P. Cavafy', Plate 7, *The Shop Window of a Tobacco Store*, 1966, etching, Peter Webb, London, (photo: Peter Webb).

77. *Peter Schlesinger*, 1967, etching, Peter Schlesinger, New York.

79. *Peter Schlesinger* by Don Bachardy, *c.* 1970, ink and wash, Don Bachardy, Los Angeles.

79. *Peter*, 1968, ink, David Hockney, (photo: John Webb).

79. *Peter*, 1969, ink, James Kirkman, London, (photo: Prudence Cuming Associates).

85. *Charles Alan*, 1969, ink, John Torson, New York.

85. *Patrick Procktor in New York*, 1966, ink, Lionel Larner, New York, (photo: Charles Krewson, New York).

85. *David at 165 E. 81st St.*, by Patrick Procktor, 1966, ink, Lionel Larner, New York, (photo: Charles Krewson, New York).

88. *Bob, SS 'France'*, 1965, crayon, Paul Cornwall-Jones, London, (photo: Tradhart Ltd.).

88. *Mo*, 1965, crayon, Patrick Procktor, London, (photo: Peter Webb).

97. *David Hockney* by Don Bachardy, 1979, ink and wash, Don Bachardy, Los Angeles.

97. *Don Bachardy, Santa Monica*, 1966, pencil, Galerie Claude Bernard, Paris.

108. *Paul Miranda*, 1971, ink, Arthur Lambert, New York.

117. *Wayne Sleep*, 1971, ink, Private Collection, (photo: Tradhart Ltd.).

121. *Mark, St Francis Hotel, San Francisco*, 1971, ink, Mrs Kingsmill, (photo: Tradhart Ltd.).

134. *Henry Geldzahler at La Coupole, Paris*, 1973, ink, Private Collection, (photo: Rodney Wright-Watson).

135. *Celia in Black Negligée*, 1973, crayon, Galerie Claude Bernard, Paris.

137. *An Erotic Etching*, 1972/3, etching, Peter Webb, London, (photo: Peter Webb).

146. *Gregory Thinking in the Palatine*, 1974, ink, Galerie Claude Bernard, Paris.

150. Neal Street Restaurant Menu, *c.* 1972, (photo: Peter Webb).

150. *Peter Langan*, 1972 (for restaurant menu), ink, Peter Langan, London.

156. *Henry Resting, Fire Island*, 1975, ink, John Torson, New York.

184. *Richard Neville*, 1971, ink, Private Collection, (photo: Tradhart Ltd.).

184. *Richard Hamilton*, 1968, ink, Private Collection, (photo: Tradhart Ltd.).

184. *Stephen Spender*, 1969, pencil, Stephen Spender, London, (photo: Galerie Claude Bernard, Paris).

184. *Christopher Isherwood*, 1968, ink, Private Collection, (photo: Piccadilly Gallery, London).

185. *Sir John Gielgud*, 1974, ink, Emmerich Gallery, New York, (photo: Bettina Sulzer).

185. *W. H. Auden*, 1964, ink (destroyed), (photo: Tradhart Ltd.).

185. *Man Ray*, 1974, lithograph, Galerie Claude Bernard, Paris.

185. *J. B. Priestley*, 1973, ink, Bradford Art Galleries and Museums, West Yorkshire, (photo: Richard Littlewood).

212. *David Over Exposed, Hayward*, by Gerald Scarfe, 1983, Gerald Scarfe, London, (photo: Peter Webb).

Endpapers 'A Rake's Progress', Plate 1, *The Arrival*, 1963, etching, Royal College of Art, London, (photo: Jon Wright).

NOTES

CHAPTER ONE Bradford 1937–1959

1. Interview between David Hockney and Peter Webb, Los Angeles, 15 November 1986.
2. Ibid.
3. *David Hockney by David Hockney* (London, Thames and Hudson, 1976; New York, Abrams, 1977), page 30.
4. Telephone conversation between Kenneth Grose and Peter Webb, 20 January 1987.
5. *David Hockney by David Hockney*, op. cit., page 29.
6. Interview between Derek Stafford and Peter Webb, London, 31 June 1987.
7. Interview between David Hockney and Peter Webb, Los Angeles, 15 November 1986.
8. Interview between Paul Hockney and Peter Webb, Bradford, 29 January 1987.
9. *David Hockney by David Hockney*, op. cit., page 39.
10. Telephone conversation between Margaret Burton and Peter Webb, 20 March 1987.
11. *The Artist by Himself: Self-portraits from Youth to Old Age*, edited by Joan Kinneir, with introduction by David Piper (St Albans, Granada Publishing, 1980), letter of 21 October 1958, quoted on page 35.

CHAPTER TWO London 1959–1962

1. Interview between Adrian Berg and Peter Webb, London, 9 October 1986.
2. Interview between Ron Kitaj and Peter Webb, London, 8 November 1986.
3. Conversation recorded by G. F. Watson in 'A Consideration of David Hockney's Early Painting (1960–65) and its Relationship with Developments in British and American Art at That Time' (unpublished M.A. thesis, Courtauld Institute of Art, London University, 1972).
4. See 'The Quest for Fulfilment', by Ken Martin (*Observer Magazine*, London, 16 March 1969).
5. Interview between David Hockney and Peter Webb, Los Angeles, 15 November 1986.
6. *David Hockney by David Hockney*, op. cit., page 68.
7. *David Hockney*, by Marco Livingstone (London, Thames and Hudson, and New York, Holt, Rinehart & Winston, 1981), page 21.
8. Interview between David Hockney and Peter Webb, Los Angeles, 15 November 1986.
9. Conversation recorded by G. F. Watson in 'A Consideration of David Hockney's Early Painting (1960–65)', op. cit.
10. Conversation recorded by Marco Livingstone (20 February 1976) in 'Young Contemporaries at the Royal College of Art, 1959–1962: Boshier, Hockney, Jones, Kitaj, Phillips' (unpublished M.A. thesis, Courtauld Institute of Art, London University, 1976).

11. 'David Hockney talks to Keith Howes' (*Gay News*, number 100, London, August 1976), page 17.

12. *David Hockney by David Hockney*, op. cit., page 64.

13. Ibid., page 64.

14. 'Young Contemporaries', by Ray Watkinson (*Studio International*, London, February 1961).

15. Interview between Ron Kitaj and Peter Webb, London, 8 November 1986.

16. Interview between David Hockney and Peter Webb, Los Angeles, 15 November 1986.

17. Interview between John Kasmin and Peter Webb, London, 14 January 1987.

18. Quoted in 'The Pre-Raphaelites' (catalogue of exhibition at the Tate Gallery, London, 1984), page 124.

19. Conversation reported by Mark Berger in interview with Peter Webb, New York, 21 November 1986.

20. Interview between Peter Crutch and Peter Webb, London, 31 March 1987.

21. Interview between David Hockney and Peter Webb, Los Angeles, 15 November 1986.

22. Letter from David Hockney to Mark Berger, London, 28 May 1961.

23. Ibid.

24. Interview in *Town*, London, September 1962.

25. *David Hockney by David Hockney*, op. cit., page 65.

26. Letter from David Hockney to Mark Berger, London, 5 May 1961.

27. Letter from J. R. P. Moon, Registrar, Royal College of Art, London, to F. T. Coleclough, Principal, Regional College of Art, Bradford, 3 November 1961, preserved in Royal College archives.

28. *David Hockney by David Hockney*, op. cit., page 87.

29. Quoted in 'Beautiful or Interesting' (*Art & Literature*, number 5, London, Summer 1964) page 94.

30. *The Times*, London, 13 February 1962.

31. Interview between Mo McDermott and Peter Webb, Los Angeles, 14 November 1986.

32. 'David Hockney talks to Keith Howes', op. cit., page 17.

33. See 'British Painting Now', by David Sylvester, with photographs by Lord Snowdon (*The Sunday Times Magazine*, London, 2 June 1963).

CHAPTER THREE London 1962–1963

1. 'New Readers Start Here . . .', by Richard Smith (*Ark*, number 32, Summer 1962), page 38.

2. 'Clown with Vision', by Emma Yorke (*Town*, London, September 1962).

3. Letter written by David Hockney to the Tate Gallery, dated London, 15 August 1963, quoted in *Tate Gallery: Catalogue of Modern British Paintings* (London, Tate Gallery, 1965), entry on *The First Marriage* by David Hockney.

4. cf. *Physique: a Pictorial History of the Athletic Model Guild*, edited by Winston Leyland (San Francisco, Gay Sunshine Press, 1982).

5. *David Hockney by David Hockney*, op. cit., page 89.
6. Ibid., page 90.
7. David Hockney's statement to Mark Glazebrook, quoted in 'David Hockney, paintings, prints and drawings, 1960–1970' (Catalogue of exhibition at Whitechapel Gallery, London, 2 April – 3 May 1970), page 32.
8. *Observer*, London, 15 December 1963.
9. *Burlington Magazine*, London, January 1964.
10. *Sunday Telegraph*, London, 1 December 1963.
11. *The Times*, London, 17 December 1963.
12. *Sunday Times*, London, 15 December 1963.
13. cf. Chapter Two, note 33, above.
14. 'The Young Peacock Cult' (*Daily Express*, London, 3 May 1965).
15. *David Bailey's Box of Pin-Ups* (London, Macdonald, 1965).
16. *Pop as Art: A survey of the New Super-Realism*, by Mario Amaya (London, Studio Vista, 1965).
17. *Private View*, by Bryan Robertson, John Russell and Lord Snowdon (London, Nelson, 1965), pages 150 and 235.

CHAPTER FOUR America 1963–1967

1. Interview between David Hockney and Mark Glazebrook, quoted in Whitechapel Gallery catalogue, op. cit., page 11.
2. *David Hockney by David Hockney*, op. cit., page 99.
3. Ibid.
4. Ibid.
5. Ibid.
6. Ibid., page 68.
7. Interview between Christopher Isherwood and Peter Webb, Santa Monica, 15 August 1976.
8. Quoted in *David Hockney by David Hockney*, op. cit., page 98.
9. Interview between Nicholas Wilder and Peter Webb, Los Angeles, 14 August 1976.
10. *David Hockney by David Hockney*, op. cit., page 100.
11. 'David Hockney in Paris: A Conversation with Melvyn Bragg', in *The Listener*, London, 22 May 1975, page 673.
12. Ferus Gallery, Los Angeles, 1964.
13. 'David Hockney interviewed by Anthony Fawcett', in *The Face*, London, April 1983, page 34.
14. David Hockney's statement to Mark Glazebrook, quoted in Whitechapel Catalogue, op. cit., page 47.
15. *David Hockney by David Hockney*, op. cit., page 44.
16. Ibid., page 101.
17. Ibid.
18. Patrick Procktor, *Halloween*, 1966 (Private Collection, London).

19. *David Hockney by David Hockney*, op. cit., page 102.
20. Exhibition review by Edward Lucie-Smith, *Studio International*, London, January 1966, page 35.
21. *David Hockney*, by Marco Livingstone, op. cit., page 81.
22. The unused Cavafy etchings were shown in an exhibition entitled 'Hockney and Poetry' at the Michael Parkin Gallery, London, in 1982 and reproduced in the catalogue.
23. Exhibition review by Edward Lucie-Smith, *The Times*, London, August 1966.
24. Interview between Maurice Payne and Peter Webb, New York, 22 November 1986.
25. *Pharos and Pharillon*, by E. M. Forster (London, The Hogarth Press, 1923).
26. Reported in interview between Mark Lancaster and Peter Webb, Folkestone, 22 January 1987.
27. *David Hockney by David Hockney*, op. cit., page 103.
28. *The Fool on the Hill*, by Max Wall (London, Quartet Books, 1975), page 225.
29. *David Hockney*, by Marco Livingstone, op. cit., page 103.
30. Interview between Betty Freeman and Peter Webb, Los Angeles, 16 August 1976.
31. *David Hockney by David Hockney*, op. cit., page 104.
32. Ibid.
33. Ibid., page 100.
34. Reported in interview between Peter Schlesinger and Peter Webb, New York, 23 November 1986.
35. *David Hockney by David Hockney*, op. cit., page 125.
36. *David Hockney*, by Marco Livingstone, op. cit., page 108.
37. Henry Geldzahler's Introduction to *David Hockney by David Hockney*, op. cit., page 17.
38. Exhibition review by Charles Harrison, *Studio International*, London, January 1968.
39. *David Hockney*, by Marco Livingstone, op. cit., page 97.
40. Henry Geldzahler's Introduction to *David Hockney by David Hockney*, op. cit., page 15.
41. *The Englishness of English Art*, by Nikolaus Pevsner (London, Architectural Press, 1956), page 59.
42. *Emma*, by Jane Austen, 1816, Chapter 12.
43. Henry Geldzahler's Introduction to *David Hockney by David Hockney*, op. cit., pages 15 and 16.
44. *David Hockney by David Hockney*, op. cit., page 151.
45. Telephone conversation between Alan Turner and Peter Webb, 5 February 1987.
46. Interview between David Hockney and Peter Webb, Los Angeles, 14 February 1987.

CHAPTER FIVE Europe and America 1967–1970

1. *David Hockney by David Hockney*, op. cit., page 158.
2. Interview between Jane Kasmin and Peter Webb, London, 19 January 1987.
3. Interview between Patrick Procktor and Peter Webb, London, 24 September 1986.

4. *David Hockney*, by Marco Livingstone, op. cit., page 108.
5. *David Hockney by David Hockney*, op. cit., page 157.
6. Henry Geldzahler's Introduction to *David Hockney by David Hockney*, op. cit., page 19.
7. Interview between David Hockney and Peter Fuller, in *Art Monthly*, London, November 1977, page 9.
8. *David Hockney by David Hockney*, op. cit., page 159.
9. 'Hockney Paints a Portrait', by David Shapiro, in *Art News*, New York, May 1969, page 31.
10. See René Magritte's *La Chambre d'Ecoute* (1953) and *Le Tombeau des Lutteurs* (1960), illustrated in *René Magritte*, by Patrick Walderg (Brussels, André de Rache, 1965), pages 102 and 110.
11. *David Hockney*, by Marco Livingstone, op. cit., page 121.
12. Reported in interview between Nathan Kolodner and Peter Webb, New York, 20 November 1986.
13. *David Hockney*, by Marco Livingstone, op. cit., page 119.
14. *David Hockney by David Hockney*, op. cit., page 203.
15. 'An Erratic Journey', by James Burr, in *Apollo*, London, April 1970, page 311.

CHAPTER SIX Europe, America and Asia 1970–1973

1. Interview between Ossie Clark and Peter Webb, London, 7 November 1986.
2. Interview between David Hockney and Peter Webb, Los Angeles, 14 February 1987.
3. Interview between David Hockney and Peter Webb, Los Angeles, 15 November 1986.
4. *David Hockney by David Hockney*, op. cit., page 195.
5. Ibid., page 239.
6. Ibid., page 204.
7. Interview between Jack Hazan and Peter Webb, London, 18 September 1986.
8. *David Hockney by David Hockney*, op. cit., page 239.
9. Interview between Peter Schlesinger and Peter Webb, New York, 23 November 1986.
10. *David Hockney by David Hockney*, op. cit., page 240.
11. Interview between Ossie Clark and Peter Webb, London, 7 November 1986.
12. Interview between Peter Schlesinger and Peter Webb, New York, 23 November 1986.
13. *David Hockney by David Hockney*, op. cit., page 240.
14. Ibid.
15. Ibid.
16. Interview between Peter Schlesinger and Peter Webb, New York, 23 November 1986.
17. Interview between Mark Lancaster and Peter Webb, Folkestone, 22 January 1987.
18. Ibid.
19. Ibid.
20. *David Hockney by David Hockney*, op. cit., page 248.
21. Interview between David Hockney and Peter Webb, Los Angeles, 15 November 1986.

22. 'David Hockney: An Intimate View', by Henry Geldzahler, in *Print Review*, number 12, New York, 1980.

23. Ibid.

24. Ibid.

25. *David Hockney by David Hockney*, op. cit., page 288.

26. Interview between John Prizeman and Peter Webb, London, 20 February 1987.

27. Interview between David Hockney and Peter Webb, Los Angeles, 15 November 1986.

CHAPTER SEVEN Paris 1973–1974

1. Conversation reported in interview between John Richardson and Peter Webb, New York, 6 February 1987.

2. Quoted in 'The Painter and the Painted Lady', by Iain Finlayson, magazine article, source untraced.

3. 'Pierre Restany/David Hockney: a conversation in Paris', in 'David Hockney, Tableaux et Dessins, Paintings and Drawings', catalogue of exhibition at the Musée des Arts Decoratifs, Palais du Louvre, Paris, 1974, page 21.

4. *David Hockney by David Hockney*, op. cit., page 286.

5. Interview between Jack Hazan and Peter Webb, London, 18 September 1986.

6. *David Hockney by David Hockney*, op. cit., page 248.

7. Interview between Ossie Clark and Peter Webb, London, 7 November 1986.

8. *David Hockney by David Hockney*, op. cit., page 286.

9. Ibid., page 247.

10. Film review by Russell Davies, *Observer*, London, 16 March 1975.

11. Interview between Mo McDermott and Peter Webb, Los Angeles, 12 November 1986.

12. Interview between Ossie Clark and Peter Webb, London, 7 November 1986.

13. Interview between Celia Birtwell and Peter Webb, London, 5 November 1986.

14. Interview between Peter Schlesinger and Peter Webb, New York, 23 November 1986.

15. *David Hockney by David Hockney*, op. cit., page 287.

16. *Gays and Film*, by Richard Dyer, London, British Film Institute, 1980.

17. 'The Collinson Column', by Laurence Collinson, in *Quorum*, volume 2, number 10, London, 1974, page 36.

18. Film review by Andy Dussin in *Gay News*, London, November 1974, page 13.

19. 'A Small Ripple in Hockneyland', by Alexander Walker, in the *Evening Standard*, London, 10 December 1974.

20. Musée des Arts Decoratifs, catalogue, op. cit., pages 21–22.

CHAPTER EIGHT Europe, America and Australasia 1974–1977

1. Conversation recorded in *Hockney Paints the Stage*, by Martin Friedman (London, Thames and Hudson, 1983), page 77.

2. Interview between John Cox and Peter Webb, London, 19 May 1987.
3. Ibid.
4. *Hockney Paints the Stage*, op. cit., page 84.
5. Interview between John Cox and Peter Webb, London, 19 May 1987.
6. Interview between Yves Navarre and Peter Webb, Paris, 7 December 1986.
7. '*Un Solitaire*', by David Hockney, in theatre programme notes for *Septentrion*, Ballets de Marseille, 1975, page 7. (Translated from the French by the author.)
8. Ibid.
9. Interview between David Hockney and Peter Webb, Los Angeles, 15 November 1986.
10. Sometimes entitled *The Artist in Despair over the Magnitude of Antique Fragments (right hand and left foot of the Colossus of Constantine)*, collection of the Kunsthaus, Zurich, reproduced in 'Henry Fuseli 1741–1825', exhibition catalogue, Tate Gallery, London, 1975, plate 10, pages 54–55.
11. Conversation with David Hockney recorded by Charles Ingham in 'Words in Pictures: The Manifestation of Verbal Elements in the Work of Kurt Schwitters and David Hockney' (unpublished thesis, University of Essex, 1985).
12. Ibid.
13. *David Hockney by David Hockney*, op. cit., page 124.
14. Interview between David Hockney and Peter Webb, London, 6 April 1972.
15. *David Hockney*, by Marco Livingstone, op. cit., pages 181 and 183.
16. 'Words in Pictures', by Charles Ingham, op. cit.
17. Interview between David Hockney and Peter Webb, Los Angeles, 14 February 1987.
18. Ibid.
19. Interview between Yves-Marie Hervé and Peter Webb, Paris, 16 April 1988.
20. 'Words in Pictures', by Charles Ingham, op. cit.
21. Ibid.
22. 'David Hockney talks to Keith Howes', op. cit.
23. The *Guardian*, London, 26 June 1976.
24. Interview between Nikos Stangos and Peter Webb, London, 15 January 1987.
25. Ibid.
26. See *Opening Accounts and Closing Memories: Thirty Years with Thames and Hudson*, by Trevor Craker (London, Thames and Hudson, 1985), pages 165–166.
27. Book review by Nicholas Phillipson in *The Times Literary Supplement*, London, 3 December 1976, pages 1515–16.
28. *David Hockney by David Hockney*, op. cit., page 27.
29. *Foirades/Fizzles*, by Samuel Beckett, illustrated by Jasper Johns (Petersburg Press, London, 1976).
30. *David Hockney by David Hockney*, op. cit., page 295.
31. Interview between David Hockney and Peter Webb, Los Angeles, 17 February 1987.
32. Ibid.
33. 'David Hockney: An Intimate View', by Henry Geldzahler, op. cit.

34. See *18 Portraits by David Hockney* (Los Angeles, Gemini G.E.L., 1977).
35. Interview between David Hockney and Peter Webb, Los Angeles, 15 November 1986.
36. Interview between David Hockney and Peter Webb, London, 24 November 1975.
37. Interview between Billy Wilder and Peter Webb, Los Angeles, 15 February 1987.
38. 'Words in Pictures', by Charles Ingham, op. cit.
39. David Hockney quoted in *The Times Literary Supplement*, London, 21 January 1988, page 60.
40. Interview between Gregory Evans and Peter Webb, Los Angeles, 13 November 1986.
41. 'Glyndebourne à la Mode: David Hockney Talks to Michael McNay', in the *Guardian*, London, 20 June 1975.
42. 'Letter to Lord Byron', by W. H. Auden.
43. 'The Human Clay', with introduction by R. B. Kitaj, exhibition catalogue, Arts Council, London, 1976.
44. 'R. B. Kitaj and David Hockney in Conversation', in *The New Review*, volume 3, numbers 34/35, London, January/February 1977, pages 75–76.
45. 'Words in Pictures', by Charles Ingham, op. cit.
46. 'Looking at Pictures in a Book', by David Hockney, (London, The National Gallery, 1981).
47. Interview between David Hockney and Peter Webb, London, 14 April 1978.
48. Interview between David Hockney and Peter Webb, London, 20 July 1977.
49. 'An Interview with David Hockney, Part I', by Peter Fuller, in *Art Monthly*, number 12, London, November 1977, page 6.
50. 'An Interview with David Hockney, Part II', by Peter Fuller, in *Art Monthly*, number 13, London, December 1977/January 1978, page 6.

CHAPTER NINE New York and Los Angeles 1977–1980

1. Exhibition review by Hilton Kramer, in the *New York Times*, 30 October 1977.
2. Theatre programme notes to *The Magic Flute*, by David Hockney, Glyndebourne Opera Company, 1978.
3. Interview between David Hockney and Peter Webb, Glyndebourne, 18 May 1978.
4. Interview between John Cox and Peter Webb, London, 19 May 1987.
5. Opera review by Philip Hope-Wallace, in the *Guardian*, London, 29 May 1978.
6. 'Glyndebourne Opens with Hockney Spell', by Robert Henderson, in the *Daily Telegraph*, London, 30 May 1978.
7. 'Hockney at Home', by William Green, in *Vogue*, London, August 1978, page 159.
8. See 'Grand Designs', by Peter Conrad, in the *New Statesman*, London, 16 June 1978, page 823.
9. *Paper Pools* by David Hockney (London, Thames and Hudson, 1980), page 10.
10. Ibid.
11. Ibid., page 39.

12. Ibid., page 100.
13. Interview between David Hockney and Peter Webb, Los Angeles, 15 November 1986.
14. See *David Hockney: 23 Lithographs, 1978–80* (Tyler Graphics, New York, 1980).
15. Interview between Maurice Payne and Peter Webb, New York, 22 November 1986.
16. 'Words in Pictures', by Charles Ingham, op. cit.
17. See *The Works of Vincent van Gogh*, by J.-B. de la Faille (London, Weidenfeld & Nicolson, 1970) numbers F1594 verso, F1596 recto, F1601 recto, F1601 verso, illustrated on pages 544, 545 and 547.
18. Interview between Peter Schlesinger and Peter Webb, New York, 5 February 1987.
19. Interview between David Hockney and Peter Webb, Los Angeles, 17 February 1987.
20. See *The Works of Vincent van Gogh* by J.-B. de la Faille, op. cit., numbers F424, F432, F504–8, illustrated on pages 196, 201 and 224.
21. 'Peter Blake and Howard Hodgkin in California', in *Ambit*, number 83, London, 1980, pages 3–7.
22. Interview between John Dexter and Peter Webb, London, 30 May 1987.
23. Quoted in *Hockney Paints the Stage*, by Martin Friedman, op. cit., page 168.
24. Ibid., page 173.
25. Ibid., page 176.
26. Ibid., page 161.
27. Ibid., page 127.
28. 'The Met Falls Under the Hockney Spell', by Dale Harris, in the *Guardian*, London, 6 April 1981.
29. Interview between John Dexter and Peter Webb, London, 30 May 1987.
30. Interview between David Hockney and Peter Webb, London, 9 July 1980.
31. *David Hockney*, by Marco Livingstone, op. cit., page 213.
32. Interview between Gregory Evans and Peter Webb, Los Angeles, 13 November 1986.
33. 'Hockney Among the Wiggly Lines', by James D. Teel, in *After Dark*, Los Angeles, February 1981, page 48.
34. Interview between Jerry Sohn and Peter Webb, Los Angeles, 13 November 1986.
35. 'Stunning Colour, Even in Black and White', by Bernard Levin, in *The Times*, London, 15 July 1980.
36. Exhibition review by Marina Vaizey, in the *Sunday Times*, London, 18 January 1981.
37. Exhibition review by William Feaver in the *Observer*, London, 18 January 1981.
38. Exhibition review by John Russell Taylor in *The Times*, London, 16 January 1981.
39. Interview between David Hockney and Peter Webb, London, 28 December 1980.
40. 'Hockney Among the Wiggly Lines', by James D. Teel, op. cit., page 51.

CHAPTER TEN America and China 1980–1983

1. Quoted in *Hockney Paints the Stage*, by Martin Friedman, op. cit., page 137.
2. Interview between Anthony Dowell and Peter Webb, London, 2 June 1987.

3. 'Masks, Magic and Myths at the Met', by Peter G. Davis, in the *New York Magazine*, 21 December 1981, page 71.

4. *China Diary*, by Stephen Spender and David Hockney (London, Thames and Hudson, 1982).

5. Ibid., page 139.

6. Ibid., pages 172, 174 and 195.

7. Interview between Sidney Felsen and Peter Webb, Los Angeles, 16 November 1986.

8. Interview between David Hockney and Peter Webb, London, 10 February 1979.

9. Interview between David Hockney and Peter Webb, London, 15 December 1985.

10. 'Architectural Digest Visits David Hockney', by Constance W. Glenn, in *Architectural Digest*, New York, April 1983, pages 123–130.

11. Quoted in *David Hockney Cameraworks*, with essay by Lawrence Wechsler (London, Thames and Hudson, 1984), page 9.

12. Ibid., page 11.

13. *David Hockney Photographs* (London and New York, Petersburg Press, 1982), page 23.

14. Quoted in *David Hockney Cameraworks*, op. cit., page 12.

15. *David Hockney on Photography* (New York, Emmerich Gallery, 1983), page 16.

16. Interview between Nathan Kolodner and Peter Webb, New York, 20 November 1986.

17. *David Hockney on Photography*, op. cit., page 21.

18. Reproduced in *Soutine*, by Andrew Forge (London, Spring Books, 1965), plate 21.

19. 'David Hockney's Different Ways of Looking', by Milton Esterow, in *ARTnews*, New York, January 1983, page 58.

20. 'David Hockney's Photographs', by Christopher Knight, in *Aperture*, number 89, New York, 1982.

21. Exhibition review by Marina Vaizey in the *Sunday Times*, London, 11 July 1982.

22. Exhibition review by John Russell Taylor in *The Times*, London, 30 June 1982.

23. Reproduced in *Gilbert and George 1968–1980* (Municipal Van Abbemuseum, Eindhoven, Holland, 1980), pages 123 and 143.

24. See *Stefan de Jaeger, Dimensions Polaroid, 1979–1982* (Galerie Isy Brachot, Bruxelles, 1982); and 'The Case Against David Hockney', by Marcel Croes, in *The Bulletin*, Brussels, 10 September 1982, pages 10–11.

25. Examples were exhibited at the Mayor Gallery in London in 1986.

26. Lecture on 'Photography', by David Hockney, Japan, February 1983. Unpublished text supplied by courtesy of Emmerich Gallery, New York.

27. *Martha's Vineyard and Other Places: My Third Sketchbook from the Summer of 1982*, by David Hockney (London, Thames and Hudson, 1985).

28. *David Hockney on Photography*, op. cit., page 22.

29. *The Principles of Chinese Painting*, by George Rowley (New Jersey, Princeton University Press, 1959), quoted in *David Hockney on Photography*, op. cit., page 26.

30. Quoted in *The Listener*, London, 11 November 1982.

31. *Larry Stanton: Paintings and Drawings*, with essays by Arthur Lambert, Henry Geldzahler and David Hockney (New York, Twelve Trees Press, 1986).

32. Theatre programme notes for *Varii Capricci*, by Gillian Widdicombe, Covent Garden, London, July 1983.

CHAPTER ELEVEN America, Japan and Mexico 1983–1985

1. *The Times*, London, 4 November 1983.
2. 'Everyday and Historic: The Photographs of David Hockney', by Jon R. Friedman in *Arts Magazine*, New York, October 1983, page 77.
3. 'A Hundred Separate Looks Across Time', by Colin Ford, in *Arts Yorkshire*, October 1984, page 16.
4. 'David Hockney on Photography', by Paul Joyce, in the *British Journal of Photography*, London, 16 December 1983, page 1326.
5. 'David Hockney at the Hayward', by Stuart Morgan, in *Artscribe*, number 44, London, 1984.
6. Interview between Paul Cornwall-Jones and Peter Webb, London, 10 January 1987.
7. *The Male Nude – A Modern View*, by François de Louville and Edward Lucie-Smith (Oxford, Phaidon, 1985), pages 12–13.
8. 'Hockney's Photographs', by Mark Haworth-Booth, exhibition catalogue, Hayward Gallery, London, 1983, page 30.
9. 'Faces, 1966–84', by David Hockney, with essay and commentaries by Marco Livingstone, Laband Art Gallery, Loyola Marymount University, Los Angeles, in co-operation with Thames and Hudson, London, 1987, page 76.
10. Conversation reported in interview between Kenneth Tyler and Peter Webb, Mount Kisco, New York, 9 February 1987.
11. 'Moving Focus', catalogue of David Hockney exhibition, Erika Meyerovich Gallery, San Francisco, 1987.
12. Interview between Kenneth Tyler and Peter Webb, Mount Kisco, New York, 9 February 1987.

CHAPTER TWELVE Los Angeles 1985–1988

1. 'Moving Focus Prints', by David Hockney, exhibition catalogue, Tate Gallery, London, 1986.
2. 'Inventive Lack of Direction', by Alistair Hicks, in *The Times*, London, 5 April 1986.
3. Interview between David Hockney and Peter Webb, London, 15 December 1985.
4. David Hockney in *Painting with Light*, transmitted by Channel Four Television, London, May 1987.
5. Interview between David Hockney and Peter Webb, London, 19 December 1985.
6. Interview between Gregory Evans and Peter Webb, Los Angeles, 13 November 1986.
7. Interview between David Hockney and Peter Webb, Los Angeles, 15 November 1986.
8. 'Home Made Prints', by David Hockney, exhibition catalogue, Emmerich Gallery, New York, and Knoedler-Kasmin Gallery, London, 1986, page 3.
9. *L.A. Weekly*, Los Angeles, April 25/May 1, 1986.

10. 'Original Copies by Hockney' by Richard Dorment, in the *Daily Telegraph*, London, 11 December 1986.

11. 'Magic out of the Photocopier', by John Russell Taylor, in *The Times*, London, 23 December 1986.

12. Interview between David Hockney and Peter Webb, Los Angeles, 15 November 1986.

13. The *Sunday Times Magazine*, London, 29 March 1987, page 40.

14. 'Art: Repro Man', conversation between David Hockney and Robert Becker in *Interview*, New York, December 1986, page 161.

15. Interview between David Hockney and Peter Webb, Los Angeles, 15 November 1986.

16. The *Telegraph & Argus*, Bradford, 3 March 1987.

17. 'Summer of the Umpteenth Doll', by Waldemar Januszczak, in the *Guardian*, London, 6 June 1987.

18. Interview between David Hockney and Peter Webb, Los Angeles, 15 November 1986.

19. Interview between David Hockney and Peter Webb, Los Angeles, 15 February 1987.

20. 'New light on Tristan and Isolde', by Stephen Spender, in the *Daily Telegraph*, London, 21 December 1987.

21. 'Shipping the Light Fantastic', by Gerald Larner, in the *Guardian*, London, 18 December 1987.

22. The *Sunday Times*, London, 6 March 1988.

23. 'Hockney Loses His Nannies', in the *Guardian*, London, 7 March 1988.

24. 'Hush, Hockney', in the *Sun*, 7 March 1988.

25. Quoted in 'Send for the British Stars' by Mike Bygrave, in the *Evening Standard*, London, 1 March 1988.

26. 'Out of the Blue', by Marina Warner, in the *Independent*, London, 12 February 1988.

27. Telephone interview between David Hockney and Peter Webb, 30 May 1987.

CONCLUSION

1. Interview between David Hockney and Peter Webb, Los Angeles, 15 November 1986.

2. Ibid.

3. Ibid.

4. 'David Hockney's Different Ways of Looking', by Milton Esterow, op. cit., page 57.

CRITICAL BIBLIOGRAPHY

This bibliography covers the main works consulted in the preparation of this book; details of others will be found in the notes and references. There is a wealth of published material by and about David Hockney, including books, pamphlets, articles, interviews, catalogues, films, videos and radio and television programmes. The following list is highly selective. For a more detailed bibliography, the reader is referred to the catalogue of 'David Hockney: A Retrospective' published by the Los Angeles County Museum of Art in February 1988.

SECTION I Books, articles and lectures by Hockney

'Image in Progress', Grabowski Gallery, London, 1962. Catalogue includes Hockney's short statement about his work, beginning 'I paint what I like, when I like, and where I like, with occasional nostalgic journeys.'

'Paintings with Two Figures', in *Cambridge Opinion*, number 37, January 1964. Hockney discusses the circumstances of *The First Marriage* (1962), *The Second Marriage* (1963) and *The Hypnotist* (1963).

'Beautiful or Interesting', by Larry Rivers and David Hockney, in *Art & Literature*, number 5, London, Summer 1964. Hockney discusses figuration versus abstraction in art in an exchange of letters with Rivers.

'The Point is, in Actual Fact . . .' in *Ark*, number 41, The Royal College of Art, London, 1967. Hockney recalls his years at the Royal College, his quarrel with the General Studies staff, the decision to dye his hair blonde, and his acquisition of a gold lamé jacket.

David Hockney by David Hockney, London, Thames and Hudson, 1976; New York, Abrams, 1977. A unique document edited by Nikos Stangos from twenty-five hours of taped interviews with Hockney. One of the most readable and honest books of its kind, but does not give a full and totally accurate picture. Introduction by Henry Geldzahler and over 400 reproductions.

'The Art of Pessimism', in *Gay News*, number 101, London, August 1976. Hockney's short review of *Francis Bacon* by Lorenza Trucchi discusses Bacon's violence and lack of humour, his brilliant re-invention of the human figure and his influence on Hockney's own early work.

Pictures by David Hockney, selected and edited by Nikos Stangos, London, Thames and Hudson, and New York, Abrams, 1979; Zurich, Diogenes, 1980; Tokyo, Orion Press, 1984. Introduction taken from *David Hockney by David Hockney*, plus selection of reproductions arranged thematically and covering work up to and including 1979.

'David Hockney', in *The Artist by Himself: Self-portraits from Youth to Old Age*, edited by Joan Kinneir, with introduction by David Piper, Frogmore, St Albans, Granada Publishing Ltd., 1980. Includes five early letters written by Hockney to his family while working in a Hastings hospital in 1958 instead of doing National Service.

Paper Pools, London, Thames and Hudson and New York, Abrams, 1980. The introduction by Hockney, entitled 'Making Paper Pools', describes the paper pulp process and how he made his experiments with this process in late 1978. All his 'Paper Pools' are illustrated.

'Looking at Pictures in a Book', London, The National Gallery, 1981. Hockney explains his fascination with photography and figurative art and the reproduction of paintings, in the catalogue of an exhibition which included his painting *Looking at Pictures on a Screen* (1977) and its source-paintings.

Foreword in *Draw, How to Master the Art* by Jeffrey Camp, London, André Deutsch, 1981. (*The Drawing Book*, New York, Holt, Reinhart & Winston, 1981). Hockney explains his belief that everyone should learn to draw.

China Diary by Stephen Spender and David Hockney, London, Thames and Hudson and New York, Abrams, 1982. Spender's account of a visit to China with Hockney in May 1981 is illustrated with Hockney's photographs and drawings and followed by an Epilogue which records a conversation between Spender and Hockney about the trip.

David Hockney Photographs, London and New York, Petersburg Press, 1982; French edition, Paris, Centre Georges Pompidou and Herscher, 1982; German edition, Munich, Schirmer and Mosel, 1983. Introduction by Alain Sayag. Hockney's text describes his use of photography from snapshots and ideas for paintings to his experiments with Polaroids of 1982. Ninety-six photographs are reproduced.

'On Photography', New York, André Emmerich Gallery, 1983, and Bradford, National Museum of Photography, Film & Television, 1985. Text of lecture given at the Victoria and Albert Museum, London, in November 1983 about photography, Cubism and visual perception in relation to Hockney's recent work.

Martha's Vineyard & Other Places: My Third Sketchbook from the Summer of 1982, in two volumes, London, Thames and Hudson, and New York, Abrams, 1985. First volume is an exact facsimile of his sketch-book; in the second volume, Hockney discusses his use of sketch-books, and the circumstances of *Martha's Vineyard*.

'*Vogue* for David Hockney', *Vogue* number 662, Paris, December 1985–January 1986. Invited to design a section of *Vogue* magazine, Hockney used the occasion to discuss his ideas on perspective, Chinese painting and Cubism and to illustrate these ideas with paintings, drawings and photo-collages. Text in French and English.

'Moving Focus Prints', London, Tate Gallery, 1986. Catalogue illustrating the series of litho-

graphs made with Ken Tyler in 1984–86 (*Mexican Courtyard, Image of Celia, Image of Gregory, Caribbean Tea Time*) with brief introduction by Hockney.

'Home Made Prints', catalogue of exhibition of office copier prints at Emmerich Gallery, New York, and Knoedler-Kasmin Gallery, London, 1986. Hockney's introduction describes how he came to make this series; all the prints are reproduced.

SECTION II Interviews with Hockney

'David Hockney in Paris: A Conversation with Melvyn Bragg', *The Listener*, London, 22 May 1975. Hockney talks about Bradford, London, New York, Hollywood and Paris.

'David Hockney und *The Rake's Progress*', by Sarah Fox-Pitt, *Du*, Zurich, July 1975. Includes well-illustrated interview with Hockney about his designs for the opera; text in German with English summary.

'An Interview with David Hockney' in *The Erotic Arts*, by Peter Webb, London, Secker & Warburg, 1975; New York Graphic Society, 1976; new revised edition, 1983. Hockney discusses pornography, sex in films, and the importance of eroticism in his work and in art in general. N.B. A limited edition of this book was published with an original print by Hockney.

'Hockney on Hockney: We Could Have Talked All Night', in *Street Life*, London, 24 January–6 February 1976. Hockney talks to Simon Stables about why he finds Paris, New York and Los Angeles much preferable to London, and why he thinks modern art began with Degas and Van Gogh rather than Cézanne.

'David Hockney', in *Gay News*, number 100, London, August 1976. Hockney talks to Keith Howes about censorship, pornography, the gay scene in London and California, his sexual preferences, the break-up of his relationship with Peter Schlesinger, and the film *A Bigger Splash*.

'R. B. Kitaj and David Hockney in Conversation', in *The New Review*, London, January/ February 1977. Hockney and Kitaj discuss the case for a return to figurative art.

'No Joy at the Tate', *Observer*, London, 4 March 1979. Miriam Gross interviews Hockney about his criticisms of the Tate Gallery's buying policy.

'An Interview with David Hockney', in *Beyond the Crisis in Art*, by Peter Fuller, London, Writers and Readers, 1980. Originally published in *Art Monthly*, London, November and December/ January issues, 1977/78. Text of 1977 interview in which Hockney criticizes much of contemporary art (Barry Flanagan, Carl Andre, Bob Law) and the Tate Gallery's buying policy; also discusses the problems involved in painting naturalistic pictures.

'David Hockney on Modern Art: An Interview with Melvyn Bragg', London, Arts Council of Great Britain; ILEA Learning Materials Service, 1982. Transcript of video cassette made in 1981

in which Hockney discusses Van Gogh, Cubism, Picasso, Matisse, abstraction, photography, and the deceptive skill behind much modern art.

'David Hockney's Different Ways of Looking', in *A R Tnews*, New York, January 1983. Interview with Milton Esterow in which Hockney discusses the work of Matisse, Marquet, Dufy and especially Picasso, his trip to China, and his recent Polaroid experiments.

'David Hockney on Photography', *British Journal of Photography* number 130, London, 16 December 1983. Interview with Paul Joyce about Hockney's recent photographic experiments.

'A Way of Seeing More', *Harpers & Queen*, London, August 1985. Interview with Anne Kelleher in which Hockney discusses his work for the stage.

SECTION III Books illustrated by Hockney

A Rake's Progress, London, Editions Alecto, 1963. A limited edition portfolio of sixteen etchings inspired by Hogarth's 'A Rake's Progress'. Later edition: *A Rake's Progress: A Poem in Five Sections by David Posner*. London, Lion and Unicorn Press, 1967. A reprint edition of Hockney's images used as illustrations to a long poem by Posner partly inspired by the etchings.

Fourteen Poems by C. P. Cavafy, translated by Nikos Stangos and Stephen Spender, London, Editions Alecto, 1966. Illustrated with thirteen etchings by Hockney, and published in five limited editions.

Six Fairy Tales from the Brothers Grimm, London, Petersburg Press, 1970. Illustrated with thirty-nine etchings by Hockney, and published in four limited editions plus a miniature reprint edition.

The Blue Guitar: The Man with the Blue Guitar, a poem by Wallace Stevens, London and New York, Petersburg Press, 1977. Illustrated with twenty etchings by Hockney, and published in a limited edition plus a reprint edition.

SECTION IV Books, articles and catalogue introductions on Hockney

'New Readers Start Here . . . Three Painters in Their Last Year at R.C.A.: Derek Boshier, David Hockney, Peter Phillips', by Richard Smith, in *Ark* number 32, Summer 1962. One of the earliest published discussions of Hockney's work, in the Royal College of Art Journal, which concentrates on his uses of popular imagery such as advertising and graphic art.

'British Painting Now', by David Sylvester, in the *Sunday Times Magazine*, London, 2 June 1963. Hockney is included as one of the young hopefuls, with Lord Snowdon's photographs of the artist (wearing his famous gold lamé jacket) and his work.

'London: The New Scene', Walker Art Center, Minneapolis, 1965. Exhibition catalogue with introduction by Martin Friedman which discusses Hockney's place among the 'new English realists'.

'David Hockney', Whitworth Art Gallery, Manchester, 1969. Illustrated catalogue with short introduction by Mario Amaya.

'David Hockney', in *Image as Language – Aspects of British Art 1950–1968*, by Christopher Finch. Harmondsworth, Penguin, 1969. Short discussion of technical devices and manipulations of style in Hockney's work of the sixties.

'David Hockney: Paintings, prints, drawings, 1960–1970', London, The Whitechapel Art Gallery, 1970. Valuable catalogue of Hockney's first retrospective, with introduction by Mark Glazebrook, interview between Glazebrook and Hockney, and an attempt at a complete catalogue of known paintings and prints together with a selection of drawings, the vast majority being reproduced, often with comments from the artist and from the press. A revised edition was published by Lund Humphries, London, 1970.

'A Consideration of David Hockney's Early Painting (1960–65) and its Relationship with Developments in British and American Art at that Time', by G. F. Watson. Unpublished M.A. thesis, Courtauld Institute of Art, London University, 1972. Includes useful information on Hockney's early career derived from interviews with the artist.

'David Hockney: Tableaux et Dessins/Paintings & Drawings', Musée des Arts Decoratifs, Palais du Louvre, Paris, 1974. Includes introduction by Sir Stephen Spender and Pierre Restany's interview with Hockney in which he compares his life in London, California and Paris. Forty-six works are illustrated in the catalogue.

'David Hockney: An episode in social aesthetics', by Bernard Denvir, in *Art Spectrum*, number one, London, January 1975. Discussion of Hockney's charisma: his social mobility, his homosexuality, and his lack of passion.

'In the Picture with David Hockney', by John Heilpern, in *Observer Magazine*, London, 2 February 1975. Illustrated article about Hockney in Paris, with his comments on his family and his recent work.

'When Love Goes Wrong', in *Quorum*, London, May 1975. Geoffrey Ryman interviews Jack Hazan about the making of his film *A Bigger Splash*. Illustrated with stills.

'The Private World of David Hockney', by Mike Arlen, in *Playguy* number 10, London, January 1976. Discussion of Hockney's homosexuality illustrated with his private Polaroids.

'Young Contemporaries at the Royal College of Art, 1959–1962: Boshier, Hockney, Jones, Kitaj, Phillips', by Marco Livingstone. Unpublished M.A. thesis, Courtauld Institute of Art, University of London, 1976. Very well researched investigation of the Young Contemporaries Group and the

development of English Pop Art, with particularly useful information on Hockney's Royal College career.

'Pop Art in England. Beginnings of a New Figuration, 1947–63', Hamburg Kunstverein, in association with the Arts Council of Great Britain, 1976. Catalogue of extensive exhibition with text by Uwe M. Schneede on Hockney's relationship to Pop.

'David Hockney', by Nigel Greenwood, London, Aquarius, Fine Art Editions number 4, 1977. Portfolio of colour reproductions with short introduction.

Oxtoby's Rockers, by David Sandison, Oxford, Phaidon, 1978. Includes David Oxtoby's memories of his student years with Hockney.

'David Hockney· Travels with Pen, Pencil & Ink. Selected Prints & Drawings, 1962–1977', London and New York, Petersburg Press, 1978. Catalogue of touring exhibition of Hockney's drawings, with illuminating introduction, 'David Hockney: A Modern Romantic', by Edmund Pillsbury and extensive selection of illustrations, including the artist's comments.

'Profiles: Special Effects', by Anthony Bailey in the *New Yorker*, New York, 30 July 1979. Long profile based on an interview in New York when Hockney was working on *The Magic Flute* for Glyndebourne, as well as conversations with Norman Stevens, George Lawson, John Kasmin, Maurice Payne, Paul Cornwall-Jones; full of interesting anecdotes.

David Hockney Prints 1954–77, London, The Midland Group and The Scottish Arts Council in association with the Petersburg Press, 1979. Long and interesting introduction by Andrew Brighton to illustrations of Hockney's complete graphic work up to 'The Blue Guitar' series of 1977, with detailed information on each print.

'Peter Blake & Howard Hodgkin in California', in *Ambit*, No. 83, London, 1980. Includes excerpts from Hodgkin's diary about the visit of the two artists to Hockney's house in Los Angeles in 1979. Illustrated with drawings by all three artists.

'David Hockney: An Intimate View', by Henry Geldzahler, in *Print Review*, number 12, New York, 1980. Illustrated text of lecture delivered at New York University, 15 April 1980, in conjunction with the exhibition 'Travels with Pen, Pencil & Ink', in which Geldzahler recalls experiences of accompanying Hockney on his travels, and of resulting pictures. Also published as 'Hockney Abroad: A Slide Show', in *Art in America* number 69, New York, February 1981.

'The Artful Eccentricity of David Hockney', by Henry Geldzahler, in *G.Q.*, New York, January 1981. Discusses the inseparability of Hockney's life-style and his art.

October, by Christopher Isherwood, Los Angeles, Twelve Trees Press, 1981. Isherwood's diary for October 1979 includes his account of a visit to Hockney's house in Los Angeles.

'Paintings & Drawings for Parade', London, Riverside Studios, 1981. Catalogue includes Mark Glazebrook's interviews with John Dexter and David Hockney about the opera project.

David Hockney, by Marco Livingstone, London, Thames and Hudson, and New York, Holt, Rinehart & Winston, 1981: updated edition 1988. An art-historical survey which affords real insight into Hockney's work. Copiously illustrated, with a useful critical bibliography.

'The Myth of Water & Dream: An Assessment of the Work of David Hockney, Paris, 1974', by Werner Spies, in *Focus on Art*, New York, Rizzoli, 1982, translated from *Das Auge am Tatort*, Munich, Prestel, 1979. Interesting interpretation of Hockney's work up to the early seventies.

'Hockney & Poetry', London, Michael Parkin Gallery, 1982. Interesting catalogue with introduction by Sir Stephen Spender and text discussing Hockney's prints relating to poetry. Included are reproductions of hitherto unpublished etchings which were not used in the 'Cavafy' set of 1966.

'David Hockney', in *The Face*, London, April 1983. Hockney talks to Anthony Fawcett about his house in Hollywood and his life-style there.

Hockney Paints the Stage, by Martin Friedman, Minneapolis, Walker Art Center, and London, Thames and Hudson, 1983. Sumptuously illustrated survey of the Glyndebourne productions (*The Rake's Progress* and *The Magic Flute*) plus the French and Stravinsky Triple Bills for the New York Metropolitan Opera. Texts are by the directors John Cox and John Dexter as well as Hockney's comments on all the projects. A specialized bibliography is included. A supplement entitled *Last Act* was published in 1985, which discussed and illustrated Hockney's recreations of his opera sets for the travelling exhibition entitled 'Hockney Paints the Stage'.

'Hockney's Photographs', London, Arts Council of Great Britain, 1983. Short catalogue of London exhibition of Hockney photographs with instructive introduction by Mark Haworth-Booth and a selection of reproductions from Hockney's album pages to his photo-collages.

'Architectural Digest Visits David Hockney', by Constance W. Glenn, in *Architectural Digest*, New York, April 1983. Discussion of Hockney's house in Hollywood, illustrated with colour photographs.

'David Hockney at the Hayward', by Stuart Morgan, *Artscribe*, number 44, London, December 1983. Highly critical review of Hockney's exhibition of photographic experiments.

David Hockney Cameraworks, London, Thames and Hudson, and New York, Knopf, 1984. Includes 'True to Life' by Lawrence Weschler as introduction to reproductions of 117 Polaroid joiners and photo-collages from 1982 to 1983.

'David Hockney, Born 1937', in *Modern English Painters* (Volume Three), by John Rothenstein, London, Macdonald, 1984. Discussion of Hockney's work in relation to modern English painting.

'David Hockney: Paintings of the Early 1960s', André Emmerich Gallery, New York, 1985. Very thoughtful introduction by Nicholas Wilder to catalogue reproducing seven early works by Hockney.

'"In an Old Book": Literature in the Art of David Hockney', by Richard Martin, *Arts Magazine*,

number 59, New York, January 1985. Text of conference paper which throws light on Hockney's preoccupations with literature.

'Words in Pictures: The Manifestation of Verbal Elements in the Work of Kurt Schwitters and David Hockney', by Charles Ingham. Unpublished thesis, University of Essex, 1985. Exploration of an important aspect of Hockney's early work, together with transcripts of two interesting and far-ranging interviews between Ingham and Hockney dating from 1979.

Ken Tyler, Master Printer, and the American Print Renaissance, by Pat Gilmour, New York, Hudson Hills Press, in association with the Australian National Gallery, 1986. Includes discussion of Hockney's work with Tyler including 'A Hollywood Collection', 'Paper Pools' and the Mexican Project.

'Art: Repro Man', in *Interview*, New York, December 1986. Hockney talks to Robert Becker about his office copier prints and about how the print entitled *Peace on Earth*, included in the magazine, was created on the presses from his original specifications.

'Hockney at Fifty: a Three-Man Salute', *Vogue*, London, August 1987. R. B. Kitaj, Sir Stephen Spender and Henry Geldzahler recall their friendships with Hockney on his fiftieth birthday.

Hockney Posters, London, Pavilion/Michael Joseph, 1987. Coffee-table book of posters using Hockney images, with brief introductions, 'Collecting Hockney Posters', by Brian Baggott, and 'David Hockney in Poster Form', by Eric Shanes.

'Faces, 1966–1984', Los Angeles, Laband Art Gallery, in co-operation with Thames and Hudson, London, 1987. Catalogue of exhibition entitled 'David Hockney: Portrait Drawings, 1966–1984', with introduction and commentaries on the sitters by Marco Livingstone and layout of illustrations designed by Hockney.

'David Hockney', special issue of *Art & Design*, London, February 1988. Well-illustrated magazine with useful contributions from John Griffiths, Marco Livingstone, Christopher Frayling, Nikos Stangos, Peter Webb, Peter Blake and Victor Arwas, as well as Webb's interview with Hockney about pictorial narrative in his work of the eighties culminating in the sets for *Tristan und Isolde* (1987), and the texts of Hockney's recent lectures on 'Picasso' and 'Perspective'.

'The Middle Age of Mr Hockney', by Gordon Burn, in the *Sunday Times Magazine*, London, 21 February 1988. Account of a visit to Hockney's house in Hollywood at the time of the opening of *Tristan und Isolde* with his designs at the Los Angeles Opera Company in December 1987.

David Hockney: A Retrospective. Los Angeles County Museum of Art, in association with Abrams, New York, and Thames and Hudson, London, 1988. Enormous catalogue of Hockney's retrospective exhibition with over 200 colour reproductions, thoughtful and provocative articles

by R. B. Kitaj, Henry Geldzahler, Christopher Knight, Gert Schiff, Anne Hoy, Kenneth E. Silver and Lawrence Weschler, a brief chronology and a very extensive bibliography which includes books, articles, films, videos, radio and television programmes and a list of solo and group exhibitions.

INDEX

Figures in bold refer to illustrations

Abstract Expressionism, 22
Accumulation (1959), 22
Adams, Bruce, 11
Adams, Norman, 13
Adhesiveness (1960), 26–7
Afternoon Swimming (1979), 178
Alan, Charles, 58, 64, 68, 70, 84, 85, 95, 98, 105, 106
Alka Seltzer (1961), 35
Alloway, Lawrence, 20, 31
Amacker, Ferrill, 41, 45, 51, 70, 90
Amaya, Mario, 60, 90, 130
American Boys Showering (1964), **53**
American Collectors (1968), 78, 80, 95–6, 98, 105
Anderson, Donald, 39
André, Carl: *Bricks*, 177
Andrews, Oliver, 64
Ann Upton Combing her Hair (1979), 179
Aperture magazine, 205
Apollo magazine, 107
Apple, Billy, *see* Bates, Barry
Arbois, Sainte-Maxime, L' (1968), 101
Arizona (1964), 69, 70
Arles, France, 106; Rencontres Internationales de la

Photographie, 228–9
Art and Design magazine, 240
Art Monthly, 168
Artist and Model (1973), 136–7
Arts Council, 167–8
Ashley, Mo, 36, 38
Ashton, Sir Frederick, 112, 195, 196, 209, 210; *Varii Capricci*, 210–11
Auden, W. H., 103, 112, 148, 149, 185, 214
Autumn (1954), 11
Ayres, Eric, 104

Bachardy, Don, 67, 78, 79, 86, 96, 97, 98, 111, 115, 120, 161, 175, 180, 182, 202–3, 214, 222, 232, **109**, **157**
Bacon, Francis, 20, 28, 30, 36, 57, 178, 181, 230, 231, 245
Bailey, David, 60, 215
Banks, Leon, 180
Baro, Gene, 98, 181
Bastian, Heiner, 103
Bates, Barry (Billy Apple), 20, 21, 31, 41, 48
Beach Umbrella (1971), 120
Beaton, Cecil, 27, 43, 94, 112, 118

Beaumarchais, Jacques de Bascher de, 134, 152
Beautiful and White Flowers (1966), 74
Beckett, Samuel, 159
Beirut, Lebanon, 73
Berg, Adrian, 20, 21, 24, 59
Berger, John, 46
Berger, Mark 26, 28, 29–30, 35, 39, 40, 41, 45, 51, 54–5, 63, 64, 70, 72, **51**
Berlin, Sir Isaiah, 112, 199
Berlin: A Souvenir (1962), 51–2, 107
Bertha Alias Bernie (1960), 24
Beuys, Joseph, 103
Beverly Hills Housewife (1966), 78, 80, 107, **72**
Bigger Splash, A (1967), 83–4, 86, 94, 107, 176, 177, 178, **70**
Bigger Splash, A (film), 116, 128, 130, 140–4, **96**, **97**, **98**, **99**, **100**
Birtwell, Celia (Celia Clark), 47, 60, 100, 103, 105, 106, 109, 111, 113, 116, 119, 127, 128–9, 134–5, 141, 142, 143, 152, 178, 199, 204, 209, 223, 224, 225, 227, 229–30, **87**, **89**, **97**, **112**, **138**, **161**

Blackwood, Michael and
 Christian: *David
 Hockney's Diaries*, 92
Blake, Peter, 20, 28, 30, 47,
 53, 55, 57, 59, 93, 168,
 181, 236, **146**
Blake, William, 23, 29
Blow, Sandra, 19
Blue Guitar . . . The
 (1976–7), 163–4
Bob, 'France' (1965), 73
Bolton Junction, (1956), **7**
Boman, Eric, 114, 115, 118,
 119, 129, 143, 167
Bonnard, Pierre, 14
Boshier, Derek, 20, 21, 30,
 31, 32, 33, 45, 46, 47,
 48, 52, 53, 59, 60, 70,
 93
Boty, Pauline, 30, 47, 53
Boucher, François:
 *Mademoiselle
 O'Murphy*, 89, **86**
Bounce for Bradford, A
 (1987), 236, **165**
Bowness, Alan, 178
*Boy About to Take a
 Shower* (1964), 65, 66,
 70, 92, **73**
Boy Named Yves-Marie, A
 (1979), 180
Boy with a Portable Mirror
 (1961), 36
Bradford City Art Gallery,
 132, 176
Bradford College of Art,
 8–12, 13–15, 17
*Bradford Telegraph and
 Argus*, 14
Brandt, Bill, 203
Bratby, John, 10

Breakfast, Cavennac (1967),
 94
Bridges, Jim, 67, 78, 86,
 111, 175
Brisley, Stuart, 168
Brown, Ford Madox: *The
 Last of England*, 33–4,
 36
Buckhurst, Lady, 220
Buckle, Richard, 55, 94
Buckley, Stephen, 99, 100,
 200
Buhler, Robert, 19–20
*Building, Pershing Square,
 Los Angeles* (1964), 69,
 70, **81**
Burns, Rodney, 19
Burr, James, 107
Burroughs, William, 112,
 199
Burton, John, 16
Burton, Margaret, 16
Butler, Reg, 7

Café in Luxor (1978), 171
Caine, Michael, 60, 141, 149
Cairo, Egypt, 58
California (1965), 71, 81
California Art Collector
 (1964), 66–7, 70, 78, 80
California Bank (1964), 69
California Seascape (1968),
 95, 98, 105
Calvi, Corsica, 126–7
Canberra, S.S., 39–40
Carennac, France, 91, 98,
 111, 116, 118, 119
*Carennac, Howards End
 and Vichy Water*
 (1970), 111, **95**

Caribbean Tea Time (1987),
 225–6, 228
Caro, Anthony, 105, 111
Caro, Sheila, 111
Caron, Leslie, 129
Cartier-Bresson, Henri, 215
Casson, Hugh, 39
Caulfield, Patrick, 20, 59, 93
Cavafy, C. P., 24, 26, 34, 37,
 42, 61, 62, 65, 73, 74,
 75, 76, **56**, **57**, **59**
Celia, 8365 Melrose Avenue
 (1973), 128–9
Celia with Guest, July 1986,
 234
*Celia with her Foot on a
 Chair* (1984), 224
Cézanne, Paul, xi, xii, 13, 71
*Cha-Cha that was Danced in
 the Early Hours of 24th
 March, The* (1961), 36,
 32, **39**
Chair and Shirt (1971), 121,
 125
*Chair with a Horse Drawn by
 Picasso, A* (1970), 110
Chassay, Melissa, 114, 129,
 160
Chassay, Tchaik, 114, 129,
 160
China, 197–8
Chinnery, George: *The
 Balcony, Macao*, 114
Chisman, Dale, 71, 74, **58**
*Christopher Isherwood and
 Don Bachardy* (1968),
 95, 96, 98, 105, 107,
 176, 177, **109**
*Christopher Isherwood in
 Blue Dressing Gown*
 (1984), 234

Clark, Celia, *see* Birtwell, Celia
Clark, Kenneth, 102
Clark, Ossie (Raymond), 47, 55, 60, 70, 72, 73, 94, 100, 103, 105, 106, 109, 111, 113, 114, 116, 118, 119, 127, 128, 129, 141, 143, 210, 219, **88, 89, 90, 112**
Clemente, Francesco, 179
Cliff (1960), 24
Closing Scene (1963), 57
Cochrane, Peter, *59*
Cohen, Bernard, *71*
Coleclough, Fred, *9*, 45
Combe, Joan, 72
Composition e 3 (1960), 28
Compton, Michael, 167
Conran, Jasper, 203
Conran, Terence, 150
Constant, Marius, 151
Contre-jour in the French Style . . . (1973), 139, 140
Conversation, The (1979), 180, 200
Conversation in the Studio (1984), 226
Cooper, Douglas, 106, 110, 141, 152
Corcoran, Dagny, 207
Cornwall-Jones, Ianthe, 91, 94
Cornwall-Jones, Paul, 43, 73, 74, 91, 94, 103, 104, 130, 180, 182, 213, 214, 215, 216–17
Cotman, John Sell, 11
Cotton, Paul, 86
Cox, John, 147, 148, 149,

151, 169, 171, 172, 175
Cribb, Don, 130, 131, 155, 161, 175
Crichton, Michael, 161
Crommelynck, Aldo, 136, 137, 138
Crown Wallpapers, 25
Cruel Elephant, The (1962), 41
Crutch, Peter, 35–6, 38, 39, 41, 42
Cubist Boy with Colourful Tree (1964), 69–70
Cubistic Sculpture with Shadow (1972), 127
Cubistic Studies (1974), 138
Cuthbert, Ken, 17
Cuthbertson, Iain, 76

Dalwood, Hubert, 10
Darwin, Robin, 19, 20, 21, 25, 43, 49
David Graves in Harlequin Shirt (1982), 206
Davie, Alan, 10, 13, 22, 24, 26, **19**
Davis, Ron, 86
Deakin, Michael, 230
Deben Art Group 16–17
Deep and Wet Water (1971), 120
Degas, Edgar, 11
Denny, Robyn, 58, 177
Desk, London (1984), 216, 224
Deuters, Janet, 26, 30, 45, 49, 51
Dexter, John, 182–3, 186–7, 188–9, 194–5, 196, 197, 210

Diapetz, Michael, 115
Different Kinds of Water Pouring into a Swimming Pool, Santa Monica (1965), 71, 93
Dine, Jim, 178
Divine (drag artist), 180, 182, 188, 191, **117**
Doll Boy (1960), 24, 31, 32, 107, **31**
Domestic Scene, Broadchalke, Wilts (1963), 55, 58
Domestic Scene, Los Angeles (1963), 55, 59, **52**
Domestic Scene, Notting Hill Gate (1963), 55, 58
Dowell, Anthony, 195–6, 211
Dream Inn, Santa Cruz (1966), 78
Dubuffet, Jean, 27, 38, 42, 71
Dulac, Edmund, 103
Dufferin, Lindy, 90, 98, 111, 116
Dufferin, Sheridan, 33, 90, 98, 111

Eagle comic, 6
Earles, Robert Lee (Bobby), III, 72–3, 88
Early Morning, Sainte-Maxime (1968), 101
Editions Alecto Gallery, 43, 59, 73, 75
Elliott, Ron, 217

Emmerich, André, 105, 119,
 125, 170
Enfant et les Sortilèges, see
 Ravel
Erection (1959), **21**
Erotic Etching, An (1972/3),
 137
Erotic Self-Portrait (1984),
 220
Erskine, Robert, 32, 40, 41
Etching is the Subject
 (1979), 163
Euston Road School, 9, 15,
 22
Evans, Gregory, 129, 133,
 137, 139, 141, 143, 146,
 152, 156–7, 160–1, 162,
 163, 164–5, 166, 168,
 170, 174, 175, 176, 183,
 190, 197–8, 203, 204,
 205, 207, 213, 217, 219,
 220, 221, 223, 224, 225,
 227, 231–2, **144**, **145**
*Experimental Canyon
 Painting* (1978), 183,
 190, 191
Eyton, Sylvia, 26, 51

Falconer, Ian, 204–5, 206,
 209, 213–14, 217, 219,
 220, 232, 237, **149**
Fawcett, David, 9, 13, 17
Feaver, William, 192
Felsen, Sid, 128, 160, 161,
 199
Ferlinghetti, Lawrence, 103
Figure in a Flat Style (1961),
 34, 46, **68**
Figures with Still Life
 (1977), 163

Fires of Furious Desire, The
 (1961), 29
First Love Painting, The
 (1960), 24, 25, **22**
First Marriage, The (1962),
 54, 110, 176
First Tea Painting, The
 (1960), 29, 30, 31, 32
Fish and Chip Shop (1954),
 11
Flanagan, Barry, 127
Flaubert, Gustave, 136, 137
Fleming, John, 9, 11, 12, 13
*Flight into Italy – Swiss
 Landscape* (1962), 46
*For the Dear Love of
 Comrades* (1961), 38,
 20
Ford, Colin, 215
Fordham, Pauline, 53, 60,
 72, 100
Forster, E. M., 75, 111
*Four Different Kinds of
 Water* (1966), 86
Four Friends (1982), 204,
 206
Four Heads (Egyptian)
 (1963), 58
Fourth Love Painting, The
 (1961), 34, 112, **65**
Foye, Raymond, 180, 204,
 205, 210
Fra Angelico, 154, 155
Francis, Sam, 178, 199
*Fredda bringing Ann and
 Me a Cup of Tea*
 (1983), 214
Freeman, Betty, 80, 81, 141,
 175
French Shop (1971), 120
Freud, Lucien, 178, 181

Friedman, Jon R., 215
Frost, Terry, 10, 20
Froy, Martin, 10
Fuller, Peter, 98, 168
Fuller, Ron, 29, 34

Gablik, Suzy, 20
Gandhi (1960), 23
Gandhi, Mahatma, 23, 29
Gaskill, William, 75
Gay News, 157
Geldzahler, Henry, 63, 78,
 83, 84, 98, 101–3, 105,
 111, 125, 126, 127, 129,
 130, 131, 133, 134, 143,
 152, 155, 158, 160–1,
 162, 167, 173, 178, 180,
 202, 234, 239, **110**, **135**
Gemini Press, 72, 128, 160,
 161, 178, 198
*George Lawson and Wayne
 Sleep* (1972,
 unfinished), 126, 153,
 244
Giant Buddha, Nara, The
 (1983), 213
Gielgud, John, 112, 185
Gilbert and George, 206
Giles (cartoonist), 6
Gillinson, Bernard, 14
Gillinson, Rose, 14, 15
Gilot, Francoise, 224
Glazebrook, Mark, 106–7
Gogh, Vincent van, xi, xii,
 106, 121, 126, 167, 174,
 179, 180, 181
*Going to be a Queen for
 Tonight* (1960), 27, 52
Goldfarb, Shirley, 138–9,
 140

Goode, Joe, 69
Goodman, Jeff, 51, 54, 63, 64
Gosling, Nigel, 59
Goulds, Peter, 181, 182, 214
Gowers, Patrick, 143
Gowing, Lawrence, 177
Gowrie, Lord, 35, 43
Graham, R. B., 8
*Grand Canyon from North
 Rim Lodge, The*
 (1982), 208
*Grand Canyon Looking
 North, The* (1982), 208
*Grand Procession of
 Dignitaries in the Semi-
 Egyptian Style, A*
 (1961), 42, 46, **63**
Grant, Alastair, 32
Grant, Duncan, 91
Grant, Keith, 116
Graves, Ann (Ann Upton),
 53, 100, 113, 119, 166,
 178, 179, 200, 214, 219,
 223, 224, 231
Graves, David, 203, 204,
 206, 209, 214–15, 217,
 223, 224, 231
Great Pyramid at Giza . . .
 (1963), 58, 171
Greaves, Derrick, 10
Green, Lindsay, 174
Greenberg, Clement, 105
Gregory Asleep (1984), 223
Gregory Reclining (1976), 161
Gregory Standing Naked
 (1975), **145**
*Gregory Thinking in the
 Palatine Ruins* (1974),
 152
*Gregory Watching the Snow
 Fall* (1983), 213

Gregory with Gym Socks
 (1976), 161
Grey, Roger de, 19, 236
Grimms' Fairy Tales (1969),
 99, 103–4, 105–6
Grose, Kenneth, 6
Growing Discontent (1959),
 22
Guardian, 141, 157, 165,
 237, 238, 240
Guinness, Jonathan, MP,
 118
Guinness, Sue, 118

Hall, Susan, 86
Hamilton, Richard, 20, 32,
 70, 98, 112, 118, 119,
 184, 231
Harlequin (1980), 189, **120**
Harrison, Charles, 83
Harvey, Laurence, 72
Hastings College of Art, 17
Hawaiian Wedding, The
 (1983), 214, 218
Haworth, Jann, 57
Haworth-Booth, Mark, 220
Hazan, Jack, 115–16, 118,
 123–5, 128, 130, 140–4,
 96
Healey, Denis, 14
Heilman, Mary, 86
Heller, André, 239
Help (1962), 48, **62**
Henderson, Robert, 173
Henry (1986), 234
Henry and Peter (1966), 78
Henry, Seventh Avenue
 (1972), 125
Henry with Bald Patch
 (1976), 161

Henry with Cigar (1976),
 161
Hepworth, Barbara, 16
Hero, Heroine and Villain
 (1961), 38, **41**
Herrick, Robert: 'Delight in
 Disorder', 6
Hervé, Yves-Marie, 134,
 139, 141, 152, 156, 180,
 122
Heyworth, Peter, 112
Hicks, Alistair, 228
Hilton, Tim, 243
Hockney, Jean
 (sister-in-law), 201
Hockney, John (brother), 2,
 4, 162, 199
Hockney, Kenneth (father),
 1, 2–4, 16, 17, 25, 71,
 116, 134, 153, 154, 166,
 202, 209
Hockney, Laura (mother),
 1–2, 3–4, 116, 134, 136,
 153, 154, 166, 209, 224
Hockney, Margaret (sister),
 2, 4, 154, 224
Hockney, Paul (brother), 2,
 4, 8, 12–13, 132, 180,
 201, 236, **13**
Hockney, Philip (brother),
 2, 4, 162
Hodgkin, Howard, 91, 98,
 166, 167, 168, 181–2,
 231, **105**
Hodgkin, Julia, 91, 98, 130,
 106
Hodgkin, Sam, 130, 169
Hogarth, William, 43, 155
'Hollywood Collection, A'
 (1965), 72
Holman, Bob, 214

Hollywood Hills House
 (1980), 201
Homage to Michelangelo
 (1975), 159
Hope-Wallace, Philip, 172
Hopper, Brooke, 161
Hopper, Dennis, 63
Hopper, Edward, 83, 177
Hotel Acatlan: First Day
 (1985), 226, 229
Hotel Acatlan: Second Day
 (1985), 226
Hotel Acatlan: Two Weeks
 Later (1985), 226
Hotel Garden, Vichy
 (1972), 127
Hotel Romano Angeles,
 Acatlan (1984), 223
House of a Man who had
 Made the journey to
 Mecca, Luxor, The
 (1963), 50
House, Palm and Pool
 (1982), 201
Hoyland, John, 168
Hudson, Tom, 9, 10
Hughes, Robert, 243
Hunt, Marsha, 119
Hutton Terrace, Bradford
 (1955), **4**
Hypnotist, The (1963), 54, 55,
 56, 58

I saw in Louisiana a
 Live-Oak Growing
 (1963), 57
Ian and Heinz, June 1986,
 233–4
Ian and Me Watching a Fred

Astaire Movie on
 Television (1982), 205
Ian Drawing Ann (1983),
 213–14
Ian with Self-Portrait
 (1982), 205
Il pleut sur le Pont des Arts
 (1973), 139, 244
I'm in the Mood for Love
 (1961), 43, 52
Image of Celia, An (1986),
 227, 228, 229, **161**
Image of Gregory, An
 (1985), 227, 229, **160**
In Memoriam Cecchino
 Bracci (1962), 51
Independent, 240
Ingham, Charles, 179
Interview magazine, 235–6
Invented Man Revealing
 Still Life (1975), 138,
 154–5, 164
Iowa (1964), 69, 70
Isherwood, Christopher,
 51, 67, 78, 86, 95, 96,
 98, 101, 103, 106, 111,
 112, 120, 128, 161, 162,
 175, 182, 184, 202–3,
 214, 222, 223, 232, **109**,
 157, **159**

Jaeger, Stefan de, 206
Jagger, Bianca, 114, 128
Jagger, Mick, 114, 118, 119,
 127, 128, 235
Januszczak, Waldemar,
 237
Japan, 120–2, 123, 213
Japanese House and Tree
 (1978), 176, 190

Japanese Rain on Canvas
 (1971–2), 123, 127, 128
Jarry, Alfred: *Ubu Roi*,
 75–6, 147
Johns, Jasper, 28, 31, 48,
 159, 178, 199
Johnson, Frank, 8, 9, 13, 15, **9**
Jones, Allen, 20, 25, 31, 32,
 52, 98, 136, 236
Jungle Boy (1964), 63

K for King (1960), 28
Kaisarion with all His
 Beauty (1961), 34–5, 41
Kallman, Chester, 148, 149
Kas reading 'Professor
 Seagull' (1979), 180
Kasmin, Jane, 91, 98, 131,
 168–9
Kasmin, John, 32–3, 35, 40,
 53, 56, 58, 59, 66, 72,
 73, 76, 91, 94, 95, 98,
 100, 105, 106, 124, 126,
 127, 130–1, 134, 140,
 141, 142, 150, 166, 169,
 176, 180, 228
Kasmin, Paul, 203, **154**
Kaye, Peter, 8, 9, 11, 12, 13,
 14, 15, 25–6
Kelly, Ellsworth, 173
Kerby (After Hogarth)
 Useful Knowledge
 (1975), 155
Kingy B (1960), 28
Kirkman, James, 33
Kitaj, Ron, 20, 21–2, 23, 31,
 32, 46, 59, 95, 100, 111,
 112, 115, 119, 139, 165,
 168, 178, 181, 236, 239,
 127, **128**, **130**

Kitchen-Sink painters, the,
 10
Kolodner, Nathan, 170,
 192, 200, 203, 214, 215,
 216, 220, 225
Kramer, Hilton, 170
Kullman, Michael, 21, 45,
 46, 48, 49

Lambe, Eugene, 131, **101**,
 102, **103**, **104**
Lambert, Arthur, 115, 155,
 162, 173, **134**
Lancaster, Mark, 72, 75, 78,
 81, 93, 99, 100, 118,
 120–3
Lancaster, Osbert, 147
Langan, Peter, 149, 150,
 166, 221, 224, **140**
Larner, Gerald, 238
Larson, Jack, 67, 78, 80, 86,
 111, 175
Lartigue, Jacques-Henri,
 116
Last of England?, The
 (1961), 33–4, **35**
Law, Bob, 168
Lawn Sprinkler, A (1966),
 86
Lawson, George, 116–17,
 118, 126, 131
Leeds College of Art, 9, 10
Léger, Fernand, 105, 151
Léger, Jean, 94, 99, 111,
 113, 129, 133, 134, 139,
 205, 210, 225
Less Realistic Still Life, A
 (1965), 71
Levin, Bernard, 192
Lichfield, Lord, 225

Lichtenstein, Roy, 179, 199
Lieberman, William, 41, 43
Life Drawing (c. 1959), 18
*Life Painting for a
 Diploma* (1962), 48, 52
Life Painting for Myself
 (1962), 48
Lightning (1973), 128
Lippscombe, Mark, 143,
 156–7
Little Splash, The (1966),
 83
Livingstone, Marco, 136,
 228; *David Hockney*,
 x, 24, 73, 77, 83, 84, 94,
 104, 153, 190, 221
Lloyd, Frank, 127
Logan, Andrew, 142
Loker, John, 8, 9, 11, 12,
 13, 15–17, 25–6
*Looking at Pictures on a
 Screen* (1977), 167, 170
*Lot More of Ann Combing
 her Hair, A* (1979), 179
Louis, Morris, 71, 94
'Love Paintings' (1960),
 24–5, 27, 31, 34, 112
Low, David, 6
Lucie-Smith, Edward, 73,
 75, 219
*Luncheon at the British
 Embassy, Tokyo*
 (1983), 213
Lyle, Frank, 9, 10, 14

McDermott, Lisa, 174, 221,
 222, 229
McDermott, Mo, 47, 52, 53,
 55, 56, 72, 74, 88, 89,
 94, 99, 100, 104, 111,

116, 117, 118, 119,
 124–5, 130, 139, 141,
 143, 148, 161, 175, 182,
 200, 217, 221, 222, 229,
 232, 237, **58**
Macdonald, Joe, 113, 128,
 130, 141, 155, 161, 166,
 178, 186, 210
McLeod, Mike, 20, 52
McShine, Kynaston, 103
Maddox, Reginald, 6
Magic Flute, The, see
 Mozart
Magritte, René, 103
Maidstone School of Art,
 53
*Mamelles de Tirésias, Les,
 see* Poulenc
Mamelles de Tirésias
 (1980), 189
Man in a Museum (1962),
 54
*Man Looking for His
 Glasses, April 1986*,
 234
*Man Reading Stendhal,
 July 1986*, 233
Man Taking Shower
 (1964), 65–6
*Man Taking Shower in
 Beverly Hills* (1964),
 65, 69, 70, 107,
 178
Mapplethorpe, Robert,
 115, **129**, **131**
Marceau, Marcel, 30
Margaret, Princess, 220
*Martha's Vineyard and
 Other Places* (1985,
 sketch-book), 207
Mason, Don, 21, 53

Master Printer of Los Angeles, The (1973), 129

Masurovsky, Gregory, 138–9

Matisse, Henri, xi, 14, 174, 186, 190, 244–5, 226

Mauxe-Roxby, Roddy, 30

Mehta, Zubin, 237, 238

Michelangelo, 51, 130, 159

Miller, Jonathan, 237

Miller, Robert, 105

Mingay, David, 142

Miranda, Paul, 108, 115

Mirror, Mirror on the Wall (1961), 36, 37, 41

Mist (1973), 128

Mr and Mrs Clark and Percy (1971), 109–10, 113, 145, 176, 244, **87**, **89**, **112**

Model with Unfinished Self-Portrait (1977), 164, 167, 168, 170, **113**

Mondrian, Piet, 14

Montcalm Avenue, Los Angeles, 199–200, 201–2, 217, 219, 221, 232

Monte, Princess Beatrice, 131

Moore, Henry, 112, 206–7, **155**

Moore, John, 32, 59, 95

More Realistic Still Life, A (1965), 71

Morgan, Stuart, 215–16

Morocco, 113–14

Morphet, Richard, 165

Morris, Robert, 127

Most Beautiful Boy in the World, The (1961), 35, 38, 39, **34**, **45**

Mount Fuji (1971–2), 123, 128

Mount Street, Bradford (1957), 13

Mozart, W. A.: *The Magic Flute*, 169, 170–3, 174, 217–18, **140**, **141**, **142**, **143**

Mulholland Drive (1980), 191, 192, 193, **118**

Mullins, Edwin, 59

Munich Olympic Games (1972), 127, 202

Muybridge, Eadweard: *The Human Figure in Motion*, 56–7, 70

My Bonnie Lies Over the Ocean (1961), 41–2

My Brother is only 17 (1960), 27

'My Bruffer John' (c. 1950), **10**

My Father (1976), **153**

My Mother (1974), **152**

My mother at the age of twenty . . . (1973), 136

My Parents (1977), 154, 166, 167, 168, 170, 178, **151**

My Parents and Myself (1975), 153–4, 155, 159, 244, **150**

Myself and My Heroes (1960), 29

Navarre, Yves, 94, 130, 151, 160

Neat Lawn, A (1967), 86–7, 94, **83**

Neville, Richard, 113, 184

New Review, The, 165–6

Nichols Canyon (1980), 190–1, 200

Nobilis, Lila di, 133

Nolan, Sidney, 231

Noland, Kenneth, 58, 71, 94, 173

November, Erection (1959), 22

Nude (1957), **11**

Nude, London (1984), 216, 224, **156**

Nureyev, Rudolf, 60, 111, 112, 187–8, 202

Observer, 59, 112, 117, 142, 177, 192, 236

Oedipus Rex, see Stravinsky

Oh For a Gentle Lover (1960), 27

Oldenburg, Claes, 42, 140, 178–9, 199

Olitski, Jules, 58

Ossie Wearing a Fairisle Sweater (1970), 111

Outpost Drive, Hollywood (1980), 191

Oxtoby, Dave, 8, 9, 12, 13, 15, 17, 21, 25–6, 53, 59, **25**

Oyler, Henry: *The Good Earth*, 91

Painting in a Scenic Style (1962), 46

Panama Hat (1972), 125
'Paper Pools' (1978), 174, 176, 225
Parade, see Satie
Parade Curtain after Picasso (1980), 189
'*Parade' with Unfinished Backdrop* (1980), 189
Parc des sources, Vichy, Le (1970), 105, 106, 107
Parker, Peter, 11
Parking Privé (1968), 101
Payne, Maurice, 73, 74, 75, 104, 116, 117, 118–19, 136, 138, 161, 166, 170, 175, 178–9
Peace on Earth (1986), 235–6, **164**
Pearblossom Highway (1986), 239
Pearlman, Joel, 86
Pembroke Studio Interior (1985), 226
Peter (1968), **77**
Peter C (1961), 39, **69, 40**
Peter Drying Himself in Anguillara (1967), 92
Peter Getting Out of Nick's Pool (1966), 82–3, 86, 89, 95, **80**
Peter Having a Bath in Chartres (1967), 92
Peter, Hotel Regina, Venice (1970), 111
Peter, Pico Boulevard, Los Angeles (1966), 78
Peter, Royal Pacific Motel, San Francisco (1966), 78
Peter Schlesinger with Polaroid Camera

(1977), 166–7, **114**
Peter, Swimming Pool, Encino, California (1966), 78
Petit, Roland, 151
Phillips, Peter, 20, 21, 31, 32, 46, 47, 48, 52, 55, 59, 93
Phillipson, Nicholas, 158
Physique Pictorial, 55–6, 63, 64–5, 66, **54, 55**
Picasso, Pablo, xi, xii, 11, 106, 110, 129, 136–8, 162–4, 189, 200–1, 204, 221, 224, 230, 244–5
Picasso, Paloma, 115
Pick, Frank, 9
Picture Emphasizing Stillness (1962), 51, 106–7
Picture of a Hollywood Swimming Pool (1964), 70–1
Picture of Ourselves, A (1977), 163–4
Pilkington, Godfrey, 111
Play within a Play (1963), 56, 58–9, 106, 107, **67**
Playguy magazine, 157
Pollock, Jackson, 22, 25
Pool and Steps, Le Nid du Duc (1971), 120, 125, 145
Pool with Two Figures (1971), *see Portrait of an Artist*
Pop Art, 31, 32, 46, 47
Pope-Hennessy, John, 182
Portrait of an Artist (Pool with Two Figures) (1972), 110, 120, 123,

124, 125, 141, 142, 145, 202, 244, **111**
Portrait of My Father (1955), 14, 39, **28**
Portrait of Nick Wilder (1966), 81–2, **79**
Portrait Surrounded by Artistic Devices (1965), 71
Posner, David, 43
Post Office Road, Eccleshill (1957), 14
Poulenc, Francis: *Les Mamelles de Tirésias*, 182, 183, 186, 188, 189, 217
Pretty Tulips (1969), 107
Priestley, J. B., 112, 131–2, 185
Prizeman, John, 131
Procktor, Nicholas, 223, 224
Procktor, Patrick, 20, 29, 31, 53, 59, 72, 84, 85, 91, 92, 93, 94, 95, 96, 100, 105, 111, 114, 141, 143, 223, 224
Punchinello On and Off Stage (1980), 189, **121**

Quantel Paintbox, the, 230–1, **162, 163**
Queer, see Yellow Abstract

Rackham, Arthur, 103
Rae, Nicky, 126, 152
Rain (1973), 128, 129
'Rake's Progress, A' (1961), 43, 45, 59

Rake's Progress, The, see
 Stravinsky
Rangoon, Burma, 122–3
Rauschenberg, Robert, 28,
 199
Ravel, Maurice: *L'Enfant*
 et les Sortilèges, 182,
 183, 186–7, 188, 189,
 218, 237
Ravel's Garden with
 Invisible Pulchinellas
 (1980), 189
Ravel's Garden with Night
 Glow (1980), 189, 203,
 119
Ray, Man, 133–4, 152, 185
Raymond Foye Looking at
 Brooklyn (1982), 210
Realistic Still Life, A
 (1965), 71
Rechy, John: *City of Night*,
 64
Red Celia (1985), 227
Red, White and Prison
 (1960), 23
Reeve, Geoff, 20
Reid, Norman, 102, 177–8
Reinhold, Johnny, 180
Renoir, Jean, 129
Restany, Pierre, 138, 145
Rezzori, Baron Gregor
 von, 131
Richard, Cliff, 24, 26, 28,
 35, 36
Richards, Ceri, 19, 55
Richardson, Tony, 100–1,
 105, 106, 110, 114, 116,
 133, 141
Rivers, Larry, 20, 46, 54,
 224, 231
Roberts, Keith, 59

Robertson, Bryan, 59, 60
Robertson, Fyfe, 168
Robinson, William Heath,
 6
Rocks, Nevada (1968), 94
Rocky Mountains and
 Tired Indians (1965),
 71, 92–3
Roeg, Nicolas, 216
Room, Manchester Street,
 The (1967), 93, 94, 109,
 141
Room, Tarzana, The
 (1967), 87, 89, 92, 94,
 107, 176, 177, **71, 84**
Rose, Gerard de, 53
Rosenthal, Manuel, 187
Rosoman, Leonard, 55
Rossignol, Le, see
 Stravinsky
Rothenstein, Sir William,
 5, 132
Rothko, Mark, 20
Rowley, George: *The*
 Principles of Chinese
 Painting, 209
Royal Academy, London,
 236–7
Royal College of Art,
 London, 15, 17, 19–20,
 21, 29–30, 48–9, 52
Rubber Ring Floating in a
 Swimming Pool
 (1971), 120
Rubin, Larry, 58, 127
Rubinstein, Sasha, 133
Running Colours with
 Brick Mountain
 (1976), 163
Rusche, Edward, 69
Russell, John, 20, 59, 60

Russell, Ken, 47
Russell, Theresa, 216
Russell, Vera, 159, 176,
 180, 182

Sacre du Printemps, Le, see
 Stravinsky
St Clair, John, 124
St Jean, Pierre, 221
Sam Who Walked Alone by
 Night (1961), 42
Samaras, Lucas, 206
San Phalle, Nikki de, 116
Santa Monica Boulevard
 (unfinished), 175–6,
 179, 183, 190, 191, 244
Satie, Erik: *Parade*, 182,
 183, 187–8, 189, 194
Sayag, Alain, 201, 205
Scaife, Richard Mellon, 181
Scarfe, Gerald, 6, 147, 219,
 208
Scheips, Charlie, 232
Schlesinger, Peter, 76–9, 82,
 84, 86, 87, 89, 90–1, 92,
 93, 94, 95, 96, 98–101,
 103, 105, 106, 111,
 113–14, 115, 116,
 117–18, 119, 120, 122,
 123, 124, 125, 127, 129,
 130, 140, 141, 142, 143,
 161, 165, 166–7, 179,
 186, 202, 232, **77, 80,**
 97, 98, 100, 114
Schloss (1968), 101
Scott, Christopher, 101,
 102–3, 111, **110**
Scott, Fred, 21
'Scouts Jumble Sale, The'
 (c. 1952), 7

Seated Woman Drinking Tea . . . (1963), 56–7
Second Love Painting, The (1960), 24, 25
Second Marriage, The (1963), 54
Second Tea Painting, The (1961), 30, 31, 32
Self, Colin, 20, 72
Self-Portrait (1954), 11, **27**
Self-Portrait (c. 1955), xiv
Self-Portrait on the Terrace (1984), 221, 224, **158**
Self-Portrait with Blue Guitar (1977), 164, 168, 170
Self-Portrait with Mirror and Cigarettes (1961), 36
Self-Portrait with Tie (1983), ii
Septentrion, 151, 155
Set for 'Parade', The (1980), 189
Seurat, Georges, 139
Shame (1960), 23
Shepherd, Richard, 149
Sherewood, Richard, 192
Showing Maurice the Sugar Lift (1974), 138, 154
Sickert, Walter Richard, 11, 14, 69
Simplified Faces (1974), 137–8
Slade School of Art, London, 15, 19
Slanz, Larry, 155–6
Sleep, Wayne, 116, 117, 118, 126, 166, 189, 195
Smith, Dick, 20, 31, 47, 52, 53, 70, 58, 95

Snow (1973), 128, 129
Snowdon, Lord, 49, 59, 60
Sohn, Jerry, 178, 179, 191, 217, 221, 229, 232, 233
Some Neat Cushions (1967), 94, 95
Sonnabend, Ileana, 201
Soutine, Chain, 204
Spear, Ruskin, 19, 39
Spencer, Stanley, 11, 12–13
Spender, Humphrey, 39
Spender, Stephen, 67, 73, 98, 105, 112, 145, 184, 197–8, 199, 238
Splash, The (1966), 83
Stafford, Derek, 9–10, 13, 14, 15, **8**
Stangos, Nikos, 73, 74, 130, 158–9, 197
Stanton, Larry, 115, 155, 162, 210, **132**, **134**
Stella, Frank, 68, 101, 199
Stevens, Norman, 9, 11, 12, 14, 15, 17, 19, 20, 25, 47, 53, 72, 100, 107, 171, 209, 236, **12**
Stevens, Wallace: 'The Man with the Blue Guitar', 162–3, 164
Still Life on a Glass Table (1971), 120, 125
Still Life with Figure and Curtain (1963), 56
Stravinsky, Igor: *Oedipus Rex*, 194, 195, 196; *The Rake's Progress*, 43, 147–51, 155, 217, 218, **136, 137, 138, 139**; *Le Rossignol*, 194, 195–6, 197, 198, 218; *Le Sacre*

du Printemps, 194, 195, 218
Student: Homage to Picasso, The (1973), 136
Study for 'Parade' with Eiffel Tower (1980), 189
Sun (1973), 128
Sunbather (1966), 81, 82, 89, **74**
Sunday Times, 57–8, 59, 192, 206, 219, 240
Sur la terrasse (1971), 114, 115, 116, 125, 141
Sutton, Philip, 57
Swinea, Jimmy, 143, 232, 237
Sylvester, David, 59

Table, A (1967), 94, 95
Taplin, Denis, 17
Tate Gallery, London, 65, 176–8
Taylor, Basil, 21
Taylor, John Russell, 192, 206, 234
Taylor, Rod, 8, 9, 11, 12, 13, 15, 25, 209
'Tea Paintings', the, 30–1, 32, 46, 107, **33**
Teeth Cleaning, W11 (1962), 48, **66**
Ten Palm Trees in Mist (1973), 128
Thierry, 126
Things as they are above a Blue Guitar (1976), 163
Third Love Painting, The (1960), 27, 31, 34, **23**

Third Tea Painting, The (*Tea Painting in an Illusionistic Style*) (1961), 30–1, 32, 46

Thompson, John, 131–2

Three Chairs with a Section of a Picasso Mural (1970), 110

Three Kings and a Queen (1960–1), 28, 29, 32

Thubron, Harry, 9, 10

Tilson, Joe, 20, 55, 93

Times, The, 46–7, 59, 141, 192, 206, 243

Tinguely, Jean, 116

Todd, Nora, 4

Todd, Norman, 4

Town magazine, 52

Tree (1968), 94

Trevelyan, Julian, 39

Tristan und Isolde, *see* Wagner

Tuchman, Maurice, 192

Turnbull, William, 167, 177

Turner, Alan, 86, 99

Two Boys aged 23 and 24 (1966), 74

Two Boys in a Pool, Hollywood (1965), 71, 81

Two Cabbages, Bunch of Carrots (1960), 23

Two Dancers (1980), 189

Two Deckchairs, Calvi (1972), 127

Two Figures on a Stage (1963), 54

Two Friends and Two Curtains (1963), 57

Two Men in a Shower (1963), 56

Two Stains on a Room on a Canvas (1967), 94

Two Vases in the Louvre (1973), 139–40

'Tyger' paintings (1960), 23, 25

Tyler, Kenneth, 72, 101, 128, 129, 173–4, 178, 180, 223–4, 225, 226, 227

Ubu Roi, *see* Jarry

Upton, Ann, *see* Graves, Ann

Upton, Byron, 178, 179

Upton, Mike, 21, 31, 53, 100, 113

Vaizey, Marina, 192, 206

Valley, The (1970), 110, 124

Vaughan, Mike, 8, 9, 15, 21, 25, 53

Vidal, Alexis, 94, 99, 111, 113, 129, 133, 178, 210, 231

Vienna: 'Luna-Luna', 239

View, Grand Hotel, Calvi (1972), 126

View of Bradford from Earls Court (1960), 27–8, **30**

Views of Hotel Well, I, II and III (1985), 226

Visit with Christopher and Don . . ., *A* (1984), 222–3, 224, 235, **157**

Visit with Mo and Lisa

. . . , *A* (1984), 222, 223, 224

Visual Aid, 231

Vogue, Paris, 229–30, 231, 232

Wagner, Richard: *Tristan und Isolde*, 237–8

'Waking Up' series (1983), 219, **147**, **148**

Walk Around the Hotel Courtyard, Acatlan, A (1985), 226–7, 228

Walker, Alexander, 144

Walking in the Zen Garden at the Ryoanji Temple, Kyoto (1983), 213

Walking Past Le Rossignol (1985), 218, 229

Walking Past Two Chairs (1985), 226

Wall, Max, 75–6

Walton, Sir William, 210

Waltz (1980), 189–90

Warhol, Andy, 63, 134, 206, 235, **123**, **126**

Warner, Marina, 240

Watkinson, Ray, 31, 46

Wathey, Ken, 224

Watts, Marinka, 166, 170

Wayne's Singlet (1977), 170

We Two Boys Together Clinging (1961), 38–9, 107, **43**, **45**, **64**

Webb, Peter: *The Erotic Arts*, 135–6

Webster, Sir David: portrait, 93, 112–13, 114, 145

Weight, Carel, 19, 20, 26, 33

Weisman, Fred, 80, 81, 95–6

Weisman, Marcia, 80, 81, 95–6

Wesselmann, Tom, 68

What is this Picasso? (1966), 163, 164

Whitechapel Art Gallery, London, 106–7

Whiteley, Brett, 47

Whitman, Walt, 26, 27, 29, 57; *Leaves of Grass*, 24, 25, 38

Whitworth Art Gallery, Manchester, 106

Wilder, Billy, 112, 161, 162, 175, 182

Wilder, Nicholas, 67, 77, 78, 81–2, 86, 96, 111, 115, 129, 141, 161, 175, 181, 182, **79**

Wilshire Boulevard, Los Angeles (1964), 68, 70

Wind (1973), 128

Woman with Sewing Machine (1954), 11

Woodward, Bernard, 8, 9, 12

Wright, John, 40

Xerox prints, 233–5

Yellow Abstract (1960), 23, 24

Yorke, Emma, 52

You make the picture, Zion Canyon, Utah (1982), 208

Young, Brian, 91

Yves-Marie in the Rain (1973), 139, 244

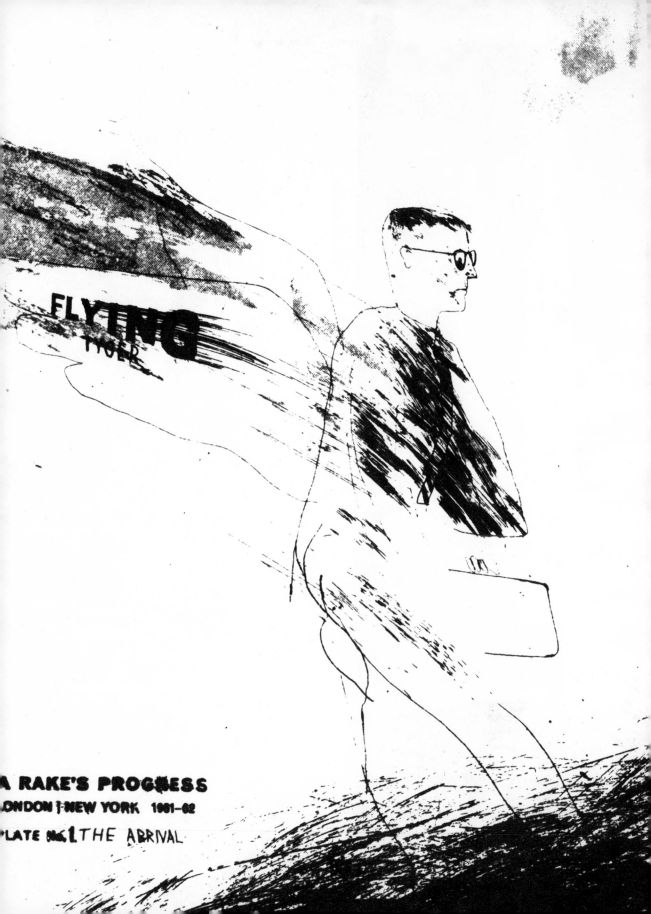

FLYMO
TIGER

A RAKE'S PROGRESS

ONDON | NEW YORK 1961-62

PLATE No. 1 THE ARRIVAL